Kathleen Christian is an Assistant Professor in History of Art and Architecture at the University of Pittsburgh, USA.

David J. Drogin is an Assistant Professor in the History of Art Department at the State University of New York, F.I.T., USA.

PATRONAGE AND ITALIAN RENAISSANCE SCULPTURE

The first book to be dedicated to the topic, *Patronage and Italian Renaissance Sculpture* reappraises the creative and intellectual roles of sculptor and patron. The volume surveys artistic production from the Trecento to the Cinquecento in Rome, Pisa, Florence, Bologna, and Venice.

Using a broad range of approaches, the essayists question the traditional concept of authorship in Italian Renaissance sculpture, setting each work of art into a complex socio-historical context. Emphasizing the role of the patron, the collection re-assesses the artistic production of such luminaries as Michelangelo, Donatello, and Giambologna, as well as lesser-known sculptors. Contributors shed new light on the collaborations that shaped Renaissance sculpture and its reception.

Kathleen Wren Christian is an Assistant Professor in History of Art and Architecture at the University of Pittsburgh, USA.

David J. Drogin is an Assistant Professor in the History of Art Department at the State University of New York, F.I.T., USA.

For John Paoletti

Patronage and Italian Renaissance Sculpture

Edited by Kathleen Wren Christian and
David J. Drogin

ASHGATE

Published by
Ashgate Publishing Limited
Wey Court East
Union Road
Farnham
Surrey, GU9 7PT
England

Ashgate Publishing Company
Suite 420
101 Cherry Street
Burlington, VT 05401-4405
USA

Ashgate website: http://www.ashgate.com

British Library Cataloguing in Publication Data
Patronage and Italian Renaissance sculpture.
 1. Sculpture, Renaissance—Italy. 2. Art patronage—Italy—History—To 1500. 3. Art patronage—Italy—History—16th century. 4. Artists and patrons—Italy—History—To 1500. 5. Artists and patrons—Italy—History—16th century.
 I. Christian, Kathleen (Kathleen Wren), 1971– II. Drogin, David.
 730.9′45′09024-dc22

Library of Congress Cataloging-in-Publication Data
Christian, Kathleen (Kathleen Wren), 1971–
 Patronage and Italian Renaissance sculpture / Kathleen Wren Christian and David Drogin.
 p. cm.
 Includes bibliographical references and index.
 ISBN 978-0-7546-6842-8 (hardcover : alk. paper)
 1. Sculpture, Italian. 2. Sculpture, Renaissance—Italy. 3. Art patronage—Italy—History. I. Drogin, David. II. Title.

 NB615.C48 2010
 730.79′45—dc22
 2010002400
ISBN: 9780754668428 (hbk)

Mixed Sources
Product group from well-managed forests and other controlled sources
www.fsc.org Cert no. SGS-COC-2482
FSC © 1996 Forest Stewardship Council

Printed and bound in Great Britain by
TJ International Ltd, Padstow, Cornwall

Contents

Illustrations

Contributors

FRANCIS AMES-LEWIS, at his recent retirement, was Pevsner Professor of the History of Art at Birkbeck College (University of London), where he had taught for 36 years. He has published several books on Italian late medieval and Renaissance art, including *Drawing in Early Renaissance Italy* (2nd edn, 2000), *The Intellectual Life of the Early Renaissance Artist* (2000), and *Tuscan Marble Carving 1250–1350: Sculpture and Civic Pride* (1997), and articles on the art patronage of the early Medici, including studies of Donatello's bronze *David*.

KATHLEEN WREN CHRISTIAN is Assistant Professor at the University of Pittsburgh, Department of History of Art and Architecture. She has received fellowships from Dumbarton Oaks, the Villa I Tatti, and the Getty. Her publications include *Empire Without End: Antiquities Collections in Renaissance Rome c. 1350–1527* (2010) and articles on the reception of antiquity in Renaissance Italy in the *Journal of the Warburg and Courtauld Institutes* (2003) and the *Burlington Magazine* (2003 and 2004). Her essay on "The Visual Arts and the Recovery of Antiquity" is forthcoming in *The Cambridge Companion to the Italian Renaissance*.

ROGER J. CRUM is Professor of Art History and College Liaison for International and Intercultural Initiatives at the University of Dayton where he has held the Graul Endowed Chair in Arts and Languages. A former member of the Institute for Advanced Study in Princeton, Crum has published with Claudia Lazzaro *Donatello Among the Blackshirts: History and Modernity in the Visual Culture of Fascist Italy* (2005) and with John T. Paoletti *Renaissance Florence: A Social History* (2008). He is currently working on a study of the international dimensions of Florentine Renaissance art.

DAVID J. DROGIN is Assistant Professor in the History of Art Department at the State University of New York, F.I.T. Professor Drogin's work on Renaissance Bologna has been presented at international conferences and is published, or is forthcoming, in several volumes on patronage and on Renaissance courts, including *Artists at Court: Image Making and Identity, 1300–1550*, edited by

Stephen J. Campbell (2004) and *Bologna, Ferrara, Urbino and the Northern Courts*, edited by Charles Rosenberg (2010). His other ongoing work in the field includes studies on narrative tactics in fifteenth-century Italian sculpture.

ROBERT W. GASTON took his Ph.D. at the Warburg Institute, University of London, and taught Art History at Bryn Mawr College, the University of Melbourne, the University Professors Program, Boston University, and La Trobe University, Melbourne. He was fellow at The Harvard University Center for Italian Renaissance Studies, Villa I Tatti, Florence, 1981–82, and Samuel H. Kress Senior Research Fellow, at The Center for Advanced Studies in the Visual Arts, National Gallery of Art, Washington D.C., 1989–90. In 2007 he was Lila Wallace-Readers Digest Visiting Professor at Villa I Tatti, and in 2009 took up an honorary research fellowship at the University of Melbourne. He co-authored the first catalogue of old master paintings in the public collections of Australia and New Zealand, edited a conference on Pirro Ligorio held at Villa I Tatti, and has published numerous articles on Bronzino, Ligorio, and on aspects of the Christian and classical traditions. His latest major publication is a critical edition of Pirro Ligorio's Naples manuscript on waters, in the Edizione Nazionale of Ligorio's works. He is currently editing (with Louis Waldman) I Tatti's San Lorenzo Project, a large-scale study of the Florentine church's history.

SARAH BLAKE MCHAM is Professor of Art History at Rutgers University, New Brunswick, New Jersey. She edited *Looking at Italian Renaissance Sculpture*, a volume dealing with fifteenth- and sixteenth-century sculpture (1998, paperback edn, 2000), to which she contributed two essays, and has written many articles about sculpture in Florence and in Venice and the Veneto. She is currently completing a book about the influence of Pliny the Elder's *Natural History* on Italian Renaissance sculpture, painting and theory.

DEBRA PINCUS is an independent scholar specializing in the painting and sculpture of late medieval and Renaissance Venice. Her book-length studies include *The Tombs of the Doges* (2000) and *The Arco Foscari: The Building of a Triumphal Gateway in Fifteenth-Century Venice* (1976). She has been a Paul Mellon Senior Fellow of the Center for Advanced Study in the Visual Arts at the National Gallery of Art and a visiting member of the School of Historical Studies, Institute for Advanced Study, Princeton. She has recently completed studies on Giovanni Bellini ("Giovanni Bellini's Humanist Signature: Pietro Bembo, Aldus Manutius and Humanism in Early Sixteenth-Century Venice," *Artibus et Historiae*, December 2008) and Tullio Lombardo ("Lo scorrere del tempo: Antonio Rizzo, Pietro e Tullio Lombardo e Michelangelo," in *Tullio Lombardo: Scultore e architetto nella Venezia del Rinascimento*, ed. Matteo Ceriana, 2007).

WILLIAM E. WALLACE is the Barbara Murphy Bryant Distinguished Professor of Art History at Washington University in St. Louis and a leading scholar of

Michelangelo. Among his books are *Michelangelo at San Lorenzo: The Genius as Entrepreneur*, the multi-volume *Michelangelo: Selected Scholarship in English*, and a forthcoming biography, *Michelangelo: The Artist, the Man and his Times*.

DAVID G. WILKINS, Professor Emeritus, History of Art and Architecture, University of Pittsburgh, was chair of the department for nine years. In 2005 the College Art Association honored him with their 2005 Award for the Distinguished Teaching of Art History. His books include *Donatello, Maso di Banco, Art Past/Art Present, History of Italian Renaissance Art, Beyond Isabella: Secular Women Patrons of Art in Renaissance Italy, The Search for a Patron in the Middle Ages and the Renaissance, The Collins Big Book of Art, The Art of the Duquesne Club*, and *A Reflection of Faith: St. Paul Cathedral, Pittsburgh*.

SHELLEY E. ZURAW is an Associate Professor of Art History at the Lamar Dodd School of Art, University of Georgia, where for more than a decade she served as Associate Director and Area Chair. Along with Hayden Maginnis she recently edited a festschrift for Andrea Ladis, *The Historian's Eye* (2009). She has published work on fifteenth-century sculpture in Florence and Rome, Mino da Fiesole, Michelangelo and Quattrocento sculpture, and is currently working on the changing role of marble sculpture in Renaissance Italy.

Foreword

Art speaks to John Paoletti. And he talks back. Whether he is writing about the contemporary work of Peter Berg, lecturing about sexuality in ancient Greece, curating exhibitions of modern art, or re-examining the relationship of Donatello and Michelangelo to their patrons, John stands up to his subjects and asks tough questions. He genuinely enjoys being bothersome, disruptive, and skeptical—always in the most polite manner possible. Beloved professor and lecturer, long-time co-director of the Wesleyan Renaissance Seminar, president of the New England Renaissance Conference and the Italian Art Society, as well as editor of *The Art Bulletin*, John has mentored and inspired students and colleagues with a rare combination of tough love and empathy. Friends, family, colleagues, and students appreciate how he wraps surgically delivered criticism and "suggestions for improvement" in velvety kindness and generosity, making it nigh impossible to resist his sway.

The topics that we address in this volume come naturally to John. From his very earliest days as an art historian he has emphasized the complex, collaborative nexus of people and social forces that brings art into being and gives it meaning. For John there is nothing simple or innocent about the ways human beings shape and interpret their visual environment. Part of this understanding has been shaped by the very topics he has addressed—the richly documented history of the Siena Baptismal Font, the adroit maneuvering of the Medici, or the self-conscious and self-referential work of Michelangelo—but even more important has been John's determination to uncover overlooked and sometimes purposefully masked meaning in what lies directly before our eyes. John has taught us to see that the implicit and the unsaid are infinitely more interesting than what seems clear and unproblematic. We offer him these essays in admiration, emulation, and sincere gratitude.

Gary M. Radke

John T. Paoletti. Photo: Bill Burkhart

Acknowledgements

There are many people to whom we are indebted for helping to bring this book to completion. For their advice and assistance at the project's formative stages, we would like to give special thanks to Gary Radke and, at Wesleyan, Laurie Nussdorfer, Joseph Siry, Clark Maines, and Lily Milroy. Also at Wesleyan, we are grateful to Carol Kearney for her assistance and especially to Judith Brown for her help in securing a publication grant from the university. Throughout this project, we have relied upon Leslie Paoletti's advice and marvelously discrete planning. Also, of course, we owe tremendous thanks to the contributors who have dedicated much time and energy to this project and offered their warm encouragement along the way.

Kathleen Christian and David Drogin

Introduction:
The virtues of the medium: the patronage of sculpture in Renaissance Italy

Kathleen Wren Christian and David J. Drogin

The patronage of Italian Renaissance sculpture: an overview

While patronage has become a key issue in the study of Italian Renaissance art, the patronage of sculpture is still too often overlooked. Discussion of patronage takes place in monographs about particular sculptors or in investigations into regional schools, but still there is little in-depth analysis of the topic, and no book-length study to treat its broader history in the manner of recent surveys of the patronage of Renaissance painting and architecture.[1] This is despite the fact that patrons played a critical role not only in the design and execution of Renaissance sculptures, but also in their reception by contemporary viewers. Many factors have contributed to the neglect of sculpture generally in art-historical writing, especially in the Anglo-American scholarship. Among them we can cite the particularities of museum display that continue to favor the exhibition of painting, or the enduring influence of Leonardo Da Vinci's *Treatise on Painting*, which condemned sculpture as dirty, labor-intensive, and colorless. Sculpture is famously difficult to reproduce in photographs and is easily disassociated from the particular urban or architectural contexts that were once so critical to its meaning. Yet another reason why scholarship has attributed a second-class status to the medium, however, is its close association with patronage, as an art form that has sometimes seemed less innovative, or less in line with the creative freedom that has seemed to define Renaissance artistic production. The essays collected here, however, take a very different view. They are interested in the collaboration between sculptors and patrons, seen against the backdrop of the remarkable changes that took place in the patronage of sculpture in Italy between the Trecento and the Cinquecento, and in the special virtues that this medium possessed for those who commissioned or collected it. The broader view of these topics takes us beyond questions of style and attribution, shedding light on the unspoken codes of perception,

often charged with political meaning, that have enlivened recent debates in patronage studies. Among the most important factors to consider are the on-going negotiation of the artist–patron relationship, or the shifting role of the patron in the creative process as artists earned greater freedom of imaginative expression. Another is the dramatic ascent of private patronage in this era, a matter of utmost importance to the invention of new genres and techniques. How did patronage change with the advent of reproductive technologies, the wider consumption of art on all levels of society, and the rise of collecting? How does the study of patronage challenge traditional concepts of authorship in the study of Italian Renaissance sculpture? What are the expectations made of "masters" or their workshops in carrying out commissions, and what are some of the strategic differences between bespoke commissions and sculpture created for the art market?

Before considering these issues, we should first step back to look at some of the overarching changes in the patronage of sculpture in Renaissance Italy. One of the notable themes just mentioned is the rise of private patronage, which took place as individuals began to match, or even exceed church authorities and local governments in their ability to commission major works of sculpture. In the Duecento and Trecento, ecclesiastical and civic authorities were by far the most important patrons of sculpture. One need only think of the reliefs and statues arrayed on church façades, the fountains set up in the town squares of Siena, Perugia, and Viterbo, or the monumental pulpits and baptistery fonts carved by the Pisani. In this era, whether commissions were overseen by the church or the state, sculpture was regarded as a preeminently communal and civic medium. Sculpture appeared in public places as an advertisement of a city's prosperity and its political power, displayed for the benefit of the local populace and for a city's rivals. Sculpture was ideally suited to carry out the task of civic celebration: it was a conspicuously visible and notoriously expensive form of art, one that was capable of proudly representing symbolic, allegorical, or political messages with great subtlety. Sculpture's importance in the civic realm also stemmed from its durability. Unlike painting, sculpture was also resistant to the elements, and could therefore be displayed out of doors, in public space.[2]

During the Trecento and Quattrocento, however, we can trace a dramatic change in the function and meaning of sculpture, as private citizens began to rival powerful civic organizations in their ability to commission major works of art.[3] As private citizens became more prominent patrons of sculpture, they commissioned works that were particularly daring in their size, their expense, or their appropriation of public space. No doubt, these patrons looked to sculpture when they transgressed unwritten rules precisely because the roots of this medium were so firmly planted in the civic realm. If private individuals could commission a large-sized sculpture and place it within communal space, they could take over the civic connotations of the medium and earn considerable political clout in return. This trend is seen most clearly in Florentine patronage of the Quattrocento and is particularly

notable in the sculptural commissions of the Medici. In the early 1420s, for example, Giovanni di Bicci de' Medici's commission of a marble tomb for the antipope John XXIII in the Baptistery of Florence reveals how the patronage of monumental sculpture could allow a private family to encroach upon civic space. Later, with the help of Donatello, the Medici's patronage of sculpture in bronze—what was then an archetypically civic medium in Florence—blurred the boundaries between public and private. Donatello's bronze doors for the New Sacristy of San Lorenzo, his pulpits for that church, or the *David* and *Judith and Holofernes* placed in the courtyard and garden of the Palazzo Medici would all contribute with great finesse to what has been called the "public privateness" of early Medici patronage.[4]

For the Medici, who numbered among the wealthiest and most powerful members of Florentine society, commissions of vastly expensive sculptures offered a form of patronage that was not easily imitated. Several factors have been cited in connection with the rise of such lavish spending for the Medici and others in early Quattrocento Florence, such as easing of societal constraints on conspicuous consumption, a sharp rise in private wealth, and the promotion of *magnificenza*, the seemingly virtuous act of commissioning art in the public eye.[5] With the argument that grandiose, expensive artworks visible in public were ornaments for the city, and could therefore confer benefits to society as a whole, *magnificenza* seemed to justify even the most extravagant and self-celebratory acts of patronage. It is a concept often discussed in relation to the patronage of architecture, yet is also relevant to the study of sculptural patronage, given the civic associations of the medium and the fact that its cost could equal that of an architectural commission. In this respect the patronage of sculpture differs from that of painting: only by factoring in the price of a sumptuous, gilded frame could the cost of a Renaissance painting match that of a large marble sculpture, while the outlay required for bronze sculpture was much more considerable.

In urban centers and in the Northern Italian courts patrons grew increasingly confident, and the patronage of sculpture became a popular method of advertising their achievements and political status in public. Wealthy patrons perpetuated their own fame by donating works of sculpture to local churches. These gifts, which could range from candelabras, to large-scale pulpits, to entire chapels bedecked in sculpture, were usually inscribed with the names and coats-of-arms of their donors. Privately funded tombs in the Quattrocento became much more monumental and celebratory, particularly those which featured life-sized effigies. The desire to be seen inspired more and more fifteenth-century patrons to order such luxurious funerary monuments and request that their tombs be displayed "in locis eminentibus." No doubt, the grandiose remains of antiquity rediscovered in the Renaissance were influential in the new desire for these celebratory monuments in marble. While antique painting had all but disappeared, an abundance of commemorative sculpture, in the form of lavish tombs, portrait statues, and marble busts, had survived. All of these traces of past glory seemed to justify Renaissance acts

of self-commemoration in sculpture, and emphasized that sculpture was an effective method of preserving one's fame for future generations.[6]

The patronage of such bluntly celebratory sculptures did not come without its own risks since, once put on open display, they could become lightning rods for public critique. This was especially the case for sculptures set up in unregulated territories where artistically aware, skeptical audiences were free to voice their own opinions about them. Such critique was not merely an expression of the aesthetic likes or dislikes of viewers, but also had the potential to disrupt the status quo, opening up social tensions in a way that could lead to political unrest. For this reason in Venice and Siena, cities which protected their republican ethos with great vigilance, the private patronage of sculpture was kept in check. Venice faced a moral dilemma, then, when their successful *condottiere* Bartolomeo Colleoni asked that a bronze equestrian portrait of himself commissioned from Verrocchio be placed in the heart of Venetian civic space, the Piazza San Marco. In the end, the Venetians got around the problem by positioning the statue in front of another Piazza San Marco, the one in front of the Scuola Grande di San Marco. In so doing, they ensured that Colleoni's monument would not compete with the unbridled bronze horses who triumphed on the façade of San Marco as proud symbols of the city's republican identity.[7] The genre of the equestrian monument had caused great concern in Venice as a commission that seemed to reach the heights of braggadocio. Yet it remained the greatest aspiration of the art patronage of the North Italian *condottieri*, who revived this antique genre of public sculpture with the hopes of winning political clout, social acceptance, and longlasting fame.

Along with commissions set up in public, the wealthiest and most powerful members of Italian Renaissance society also increasingly brought sculpture into their own *palazzi*. Wealthy patrons filled their palaces with bespoke art commissions, including sculptures in marble or bronze ordered from their favorite workshops. They bought devotional works in marble such as *tondi* and half-length images of the Madonna and Child, preferably by well-known artists who had already proven themselves in public commissions. They also brought back the antique portrait bust as a means of recording their physical appearance in stone for future generations; they pursued similar aims by commissioning portrait medals, a new genre of sculpture developed in Ferrara by Pisanello and popularized by the elite of Florence, Rome, and Naples. All of these varieties of imagery, from devotional images to secular portraits, contributed to the general splendor of Renaissance domestic interiors. The craving for domestic opulence, described in Richard Goldthwaite's history of Renaissance consumption, shifted the parameters of sculptural production and allowed sculptors to step outside the patronage system, circumventing the usual stipulations of the patron's contract by making works for the market.[8] Technical advances in bronze casting made it possible, for example, to disseminate collectable objects as domestic ornaments for well-off buyers. As a result, sculptors manufactured *bronzetti* that were tailored to suit the taste of elites; many were antique in theme. They also invented the bronze

plaquette to help satisfy the demand for sculpture among these types of consumers. Renaissance medalists, meanwhile, expanded their production and made use of stock reverses to offer a less expensive form of portrait medal and broaden their customer base.[9]

While an elite class of very well-off patrons increased their demand for one-of-a-kind artistic images, the desire to display art in one's home also extended to other, less wealthy sorts of consumers. Rather than aristocratic "patrons," these were the purchasers of mass-produced artistic images. The broader dissemination of art in Renaissance society has often been traced in the history of prints, but sculpture also played an important role in democratizing the artistic image in this era. Unlike painting, sculpture could be duplicated inexpensively in multiples, and in the fifteenth century it became common practice to produce inexpensive sculptures in larger quantities using piece moulds.[10] In this manner, sculpture became more widely available to buyers, especially in the form of devotional images cast in terracotta or gesso. Economical sculptures in wax were also produced in large quantities, even if very few examples of this type of Renaissance artwork have survived. Records from the workshop of the Florentine painter Bernardo Rosselli, for example, show that the artist ran a successful business in wax sculpture, selling everything from small devotional images to larger works carried on the street during public festivals. Rosselli also imported and sold vast quantities of sculpture in gesso. These objects depicted the Madonna and Child, busts of ancient emperors, and even replicas of public sculptures by well-known masters such as Jacopo della Quercia.[11] Another genre of sculpture produced in multiples in Renaissance Italy was the ex-voto, including all the images of human organs stamped in silver and hung up near propitious paintings and sculptures, or the life-sized wax effigies that once crowded into SS. Annunziata in Florence and other churches.

In this era the practices of collecting, art patronage, and popular consumption are inextricably intertwined, despite the divisions that have been drawn between these issues in the art-historical scholarship.[12] As if to counteract the trends in consumption that saw the widespread multiplication of sculpture, elite patrons became more determined to acquire sculptures that were utterly unique, purchasing works created by contemporary masters of particular renown, or collecting priceless and rare antiquities. Antique sculpture became the aesthetic gold standard for aristocratic consumers, patrons, and also for those sculptors who rose to the top of their profession by imitating its subjects and styles. For their own *palazzi* and villas, aristocratic patrons became increasingly daring in the revival of pagan genres of sculpture such as the freestanding nude, a type that had long been suppressed. Widespread interest in the collecting of antique sculpture offered an important impetus for experimentation among sculptors and patrons and also encouraged new ideas about the relationship between them. As Renaissance patrons learned from Pliny and other authors, antique masters (such as Lysippus) were held in very high esteem by the "illustrious men" (such as Alexander the Great)

who had sponsored them, offering a model for Renaissance elites who wished to see their status mirrored by the fame of their sculptors.

With such precedents in mind, and with the impressive results of antique patronage before their eyes, Renaissance patrons began to invest in invention with greater confidence. They sought out works that amply demonstrated sculptors' unique creative powers, and by the sixteenth century were willing to pay just as much for these modern creations as they would for genuine antiques. In the late Quattrocento and early Cinquecento, Michelangelo relied upon two major collectors of ancient sculpture—Lorenzo de' Medici and Cardinal Raffaele Riario—to develop such an approach to contemporary sculpture, one which used *all'antica* subjects as the ideal conduit for the sculptor's powers of invention. The process favored the gradual creation of both elite sculptors and elite patrons, who stood above the crowd in their ability to create or own unique works of sculpture. As a result, patrons such as Lorenzo de' Medici, Riario, Alfonso d'Este, or Isabella d'Este remade themselves into what we might call "superpatrons," individuals of such clout that their artistic choices were closely watched and imitated by others. When Isabella d'Este displayed a *Cupid* by Praxiteles next to a *Sleeping Cupid* by Michelangelo, she not only anointed Michelangelo as "equal of the ancients," she also announced her status as supreme patron and collector, defined by her commitment to invention and by her unstinting reverence for the antique. For elite patrons and their preferred sculptors, the new collecting culture had transposed standards of value in sculpture and shifted traditional notions about its patronage: the rarity of the work, guaranteed by the unique creativity of its maker, had replaced earlier criteria of value such as size, public visibility, and the expense of raw materials. The uniqueness of one's possessions, seen in the sculptures commissioned and collected by the very wealthy, had become a powerful social indicator, and eventually it alone could separate the highest level of society from the rest of the art-buying population.

Italian Renaissance patronage: methods and approaches

The first art-historical study to look at the patronage of Renaissance sculpture in depth was Martin Wackernagel's *Der Lebensraum des Künstlers in der florentinischen Renaissance*, first published in 1938. Wackernagel, deeply influenced by the cultural history of Jacob Burckhardt and Aby Warburg, made patronage a central topic in his investigation of the Florentine artist's milieu. Following an analogy made by the Renaissance architect Filarete, he compared the role of the patron to that of the father, who planted the seeds for the work of art, while the artist's "maternal" task was to bring the work of art through gestation and, finally, birth. Wackernagel's notion of the gendered, "paternal" patron can certainly be called into question. Yet his decision to treat the patronage of painting and sculpture with equal scrutiny is an admirable aspect of his study that later scholarship all too quickly abandoned.[13]

It has often been said that the modern study of art patronage began with Ernst Gombrich's seminal essay on Medici patronage, published in 1966. For Gombrich, as artists claimed a more creative role for themselves, patrons lost their status as mere donors or financial backers, instead assuming the role of enlightened sponsors of the arts, eager to provide the appropriate outlets for artistic creativity. The "deliberate patronage of art," he wrote, "is impossible without the idea of art."[14] In other words, the new creative latitude given to artists brought with it a new role for the patron, that of the enlightened sponsor. Ultimately, Gombrich's essay set out to define the various styles of patronage adopted by successive generations of the Medici, as they evolved from the time of Cosimo il Vecchio to that of Lorenzo il Magnifico. Yet in the 1970s and 1980s methodological shifts in the field brought about a reexamination of the study of art patronage, which was now distanced from the history of style and allied with the aims of social art history. After Stephen Greenblatt's *Renaissance Self-Fashioning*, published in 1980, described the Renaissance as a time of "increased self-consciousness about the fashioning of human identity as a manipulable, artful process," patrons and their self-fashioning agendas became a fully legitimate subject of study for art historians.[15] Patronage studies (focused on painting and architecture) became a popular alternative to the discussion of form, style, and iconography, as attention turned towards the role of artworks in the construction of Renaissance identities. Another, closely related approach has been to study how art patronage broadcasts a particular political ideology. In 1992, the art historian Loren Partridge and the historian Randolf Starn collaborated on the volume *Arts of Power*, which considered the art patronage of the Medici Grand Dukes as an instrument of rulership and social control tailored to the political agenda of Grand Duke Cosimo de' Medici.[16]

Patronage is a topic that crosses disciplinary boundaries, and it became the subject of several interdisciplinary conferences in the 1980s and 1990s. Among the points of general agreement at these gatherings was the central role that the Renaissance "clientage" system played in all aspects of Italian society, but above all in the life of urban elites. Mediterranean *clientelismo* was not the simple exchange of favors, but a system of social ties that bound patrons to a complex network of extended family members and neighborhood alliances. Many scholars of patronage were eager to point out the limitations of Burckhardt's model of Renaissance individuals who, freed from the constraints of medieval corporations and guilds, seemed to choose their own path in life as independent actors.[17] In a groundbreaking article published in 1994, Melissa Merriam Bullard declared the Renaissance "Maecenas" to be a myth invented by Renaissance patrons themselves and followed in Burckhardian scholarship.[18] She argued against the prevailing concept of the Renaissance patron as free agent and heroic actor, asserting instead that patronage of all sorts relied upon "dense, overlapping social networks made up of kinship, friendship, and neighborhood, which

circumscribed and informed the actions of individuals, even the Medici."[19] According to Bullard, even very recent interpretations that describe Medici patronage as an instrument of social control and political dominance cling to the notion of the patron who wields unlimited power over his or her clients. Citing a volume edited by John Paoletti and Wendy Stedman Sheard on collaboration in the Renaissance sculptor's workshop, Bullard writes of the patron's "workshop" as the web of alliances which limited his or her ability to act alone.[20]

The observations made by Bullard and others about patronage have important implications for the practice of art history.[21] If we accept the idea that no patron, no matter how powerful, wealthy, or creative, is an isolated point of origin for the work of art, it means we must modify the traditional notion that artworks are mirror reflections of an individual patron's taste. Such an approach involves finding new ways to acknowledge and account for the rise of private patronage in Italy without wholly accepting Burckhardt's theories on the individualistic, autonomous patron.[22] The notion of the patron's agency adopted, for example, in a recent study of the funerary monument of Cardinal Fonteguerri by Stephen Milner challenges longstanding Burckhardian models. While Verrocchio won the commission with the support of the Medici, the Pistoiese eventually put Pollaiuolo forward for the job. Their choice was not a purely aesthetic one, Milner argues, but also reflects Pollaiuolo's connections to Pistoia and the desire on the part of the Pistoiese to resist the political dominance of Florence. "The politics of patronage," Milner writes, "extended into every realm of civic and religious life."[23] No doubt nationalism, clan allegiances, and civic ties number among the most significant factors in every patron's decision to prefer one sculptor to another. Recently, Jonathan Nelson and Richard Zeckhauser have also challenged the centrality of the commissioner's aesthetic taste in the study of Renaissance patronage. Their volume *The Patron's Payoff* borrows from the new field of "information economics" to shed light on the topic. According to this model, artworks communicate signals designed to highlight and exaggerate their patrons' tangible wealth and intangible social status. Economic concepts such as game theory are used to illuminate how art is an investment that pays dividends; its payoffs are dependent upon how well patrons can predict the behavior of artists and viewers within particular situations.[24]

Art-historical interest in patronage has been shaped by a fascination for compelling biographies: for example, the "new man" who builds an impressive family tomb, or the woman who defies social expectations by taking charge of a grandiose commission. Yet these models fail to account for the more mundane reality of shared agency, in operation not only when an administrative committee, guild, or confraternity oversaw a commission but also when it resulted from a contract between a single artist and a single individual. The tendency has been to place a premium on innovation, such as when patrons gave artists the ability to propose new configurations,

find alternatives to older styles, or change the working methods of their own masters. Interest in innovation is a preconception built into the discipline, guided by a Vasarian notion of stylistic progression and by Romantic notions of creativity as the expression of individual vision. These models continue to keep scholarship focused on a few well-known cases of groundbreaking art patronage. They also lead art historians to overlook instances in which continuity, rather than the disruption of past traditions, might have been the patron's primary aim. After the Sforza took over the duchy of Milan from the Visconti, for example, the decision to continue their predecessors' commission of decorative relief sculpture for the façade of the Certosa di Pavia made a strong political statement by stressing an unbroken passage from the city's previous dynasty to Sforza domination. Yet the Certosa sculpture remains a rather marginalized commission in the history of Renaissance art.

It should also be stated that while the Sforza, Lorenzo de' Medici, or Isabella and Alfonso d'Este were patrons who were competing with only a few peers, it is important to remember that their variety of art patronage was not the norm. In the fourteenth century as well as the sixteenth, most sculptors kept busy with the type of commissions which art historians usually overlook. These include the sort of temporary, inexpensive works commissioned for festivals mentioned above, or all the many objects required for the day-to-day operation of Renaissance churches, such as pulpits, holy water fonts, choir stalls, and tabernacles, or smaller objects such as reliquaries and wooden crucifixes. Much more research needs to be carried out on the relationship between these objects and the more innovative works that have been the traditional focus of art-historical research.

An important methodological revision now taking place in the field is the re-consideration of the art patronage of Renaissance women. In 1996 Jaynie Anderson pointed out that art historians had long overlooked the importance of female patronage, in part because patronage was traditionally "allied more closely with historical biography than with art history."[25] Only in the last decade have many more scholars looked beyond the prominent and public figures of the Renaissance—males of high political standing, whose achievements are discussed in Renaissance biographies and documented by family archives—and recognized the significant achievements of female patrons of art. Numerous studies have shown that female monastics were very active patrons of painting and architecture, while in the medium of sculpture, widows were quite often responsible for the patronage of family tombs. According to Catherine King, between c. 1300 and 1550 women frequently took charge of funerary chapels, even if no laywomen commissioned full-sized tomb effigies for themselves, and only "a tiny number of laywomen gave themselves an effigy on a floor slab." "No laywoman," she continues, "commissioned a portrait bust for herself."[26] Social norms restricted women's patronage of

self-aggrandizing monuments such as sculpted portraits, yet a very small number of powerful and wealthy women were able to patronize other types of sculpture for themselves. Isabella d'Este collected antique sculpture and also commissioned statuettes inspired by antique marbles from the court sculptor Antico. Isabella and other powerful women were important patrons of sculpture, yet we still need to ask whether female patronage of art can—as some have suggested—be read as a straightforward statement of a woman's "identity, status and taste," and acknowledge that the problems of agency discussed above apply to women as much as they do to men.[27] Switching the subject of investigation from male to female patrons was an important achievement of first-generation feminist scholarship, but now art historians have begun to ask how to approach female patronage without underestimating the complexity of the patron–artist relationship.[28]

The patronage of women is not the only way of looking at the patronage of sculpture in order to study gender differences in Renaissance Italy. It is important to remember that the most significant events in a woman's life—marriage and childbirth—were also the most important occasions for men's patronage of domestic artworks of all varieties, including sculpture.[29] Women lived their lives surrounded by this symbolic realm, made up of devotional images, jewelry, and the whole array of decorative arts. It is no coincidence, then, that objects purchased or commissioned for the home so often speak to the roles women were expected to assume in society. Geraldine Johnson, for example, has written of the "talismanic" properties of the Marian reliefs so frequently named in the inventories of Renaissance palaces. These images of Mary and Christ, in her view, doubled as fertility charms for the young wives who prayed in front of them.[30] In this context, we must not forget that sculpture's three-dimensional presence made it authoritative and life-like, and it was often discussed as an exemplary medium capable of imparting moral lessons to its viewers. In what has become a classic study of gender-formation among Renaissance girls, Christiane Klapisch-Zuber has looked at the exemplary value of the Christ-child dolls commonly given to young Florentine women. She has argued that these objects helped "the faithful to see, or rather to feel and to relive [Christ's] childhood and vulnerability" by handling, dressing, or kissing them.[31] It is telling that sculpture sometimes appears in the background of female portraits, in which women are shown surrounded by precious objects bought or commissioned by their husbands. Elite brides are shown posing with expensive trinkets and carved gems, or standing in front of bronze statuettes; sometimes the iconography of these objects refers back to the feminine virtues the sitters were expected to possess. In Alessandro Allori's depiction of a Medici daughter—probably Giulia d'Alessandro de' Medici—before a small-scale version of Michelangelo's *Rachael*, sculpted for the tomb of Julius II, the statuette is presumably there to signal the sitter's religious piety, or to serve as ideal model for the sitter to follow in her own daily devotions (Figure I.1).[32]

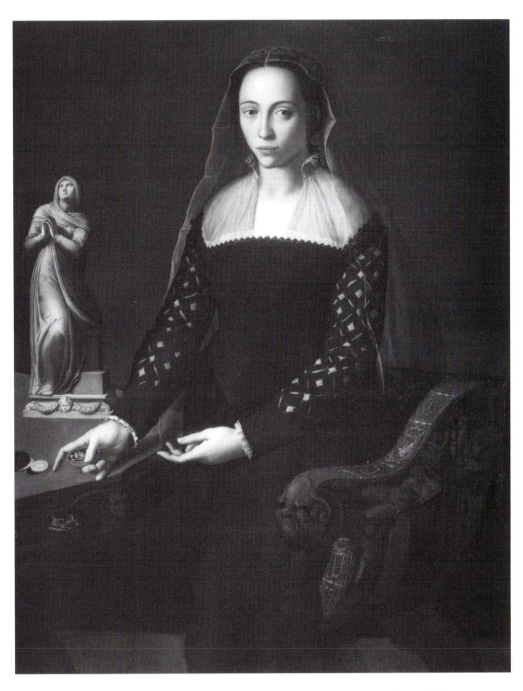

I.1 Alessandro Allori, *Portrait of a Woman (Giulia d'Alessandro de' Medici?)*

Sculptor–patron relationships

The new research and approaches discussed above pose a challenge to the traditional notions of art patronage as a transaction between two single-minded individuals: a demanding, restrictive patron on the one hand and an artist who yearns only for the expression of his creativity on the other.[33] This myth has emerged in part from the idea of patronage expressed in Vasari's *Lives*, above all in the *Life of Michelangelo*. Vasari put many of Michelangelo's trials and travails down to a lack of benevolent and enlightened patrons capable of nourishing the artist's divine creativity. As the great advocate of the Florentine Academy, Vasari had his own professional agenda in mind when he depicted the sculptor's life from this point of view. Exploring the dealings between artist and patrons, however, allows us to question just how hierarchical the relationships between artists and their patrons really were. The study of artistic contracts has, in the past, seemed to confirm the notion of that artist–patron relationships were strictly and clearly defined, since they only list the obligations of the artist and patron in standard legal formulae. Yet a more complex notion of the contract and the process of commissioning art has recently emerged, revealing that patrons and artists collaborated on a wide range of issues and that their negotiations continued well beyond the moment when such contracts were written. These documents should not be taken as evidence for a restricted creative role on the part of visual artists, nor for a limited level of interest in the manufacture of artworks on the part of patrons.[34]

As has been noted, we can trace dynamic changes in the patron–artist relationship over time, as artists were given greater leeway to operate independently from patrons and to make their own decisions about content and design. However, just when and how these changes occurred should be examined more closely, taking into account gradual changes in the working procedures of Renaissance sculptors and shifts in the creative roles assumed by artists and their sponsors. Especially in the earlier phases of Renaissance patronage, the costliness of sculpture was an issue that no doubt inspired patrons to supervise their commissions with great scrutiny: if patrons were paying high costs for raw materials and labor, they may well have wanted to have had a say in matters of design and technique. For the same reasons, we find in Trecento and early-Quattrocento contracts that the choice of materials was one of the decisions left to the patron. Thus, in this era, contracts usually specify the amount to be paid on materials, which amounted to a figure that was much more significant than the salary of the sculptor. On the other hand, sculptors seem to have also taken advantage of the restraints imposed by the materials of sculpture and the technical difficulties involved in making sculptures—especially in bronze—as a way of achieving greater creative freedom. The sculptor could present himself as the person best qualified to know what was technically possible in any given commission; the laws of nature prevented artists from creating anything that the patron might have

wanted out of bronze, wood, or marble, making it difficult for the patron to make precise specifications for the final product. While we know that iconographic advisors occasionally intervened in the design of Renaissance paintings, such a practice seems to have been less common in the case of sculptural commissions, in part perhaps because sculptural media were not deemed technically suitable for the expression of complex narrative programs devised by outsiders.[35]

Preliminary designs, in the form of drawings or terracotta models, seem to have been an obligatory part of the patronage of sculpture in the early Renaissance, serving as a guarantee of what the artist would eventually deliver. Until the mid Quattrocento, contracts for sculptural commissions included such detailed drawings, which would have legally bound the sculptor to a particular design. As an example, we can point to the surviving fragments of Jacopo della Quercia's drawing on vellum for the Sienese *Fonte Gaia*. In the later Quattrocento, however, one sees a shift away from the use of contract drawings, which is no doubt a sign of the greater freedom accorded to the sculptor. The preparatory design of greater significance for both the patron and sculptor became the terracotta model. Occasionally these have survived, such as the mock-up for Forteguerri cenotaph by the Verrocchio workshop, now housed in the Victoria and Albert Museum.[36] Sculptors also made use of the *bozzetto*, a sketch in clay or wax used to work up ideas before the creation of a full-scale model. As a dramatic sign of change, in the early Cinquecento these *bozzetti* began to be prized as artistic objects in and of themselves. Those by Michelangelo are the first we know of and, as Wackernagel pointed out, this is probably because they were the first considered worthy of preservation.[37] They were prized as traces of the sculptor's thought-process and of the creative inspiration recognized in a few high-status sculptors during the late fifteenth and early sixteenth century. Through such subtle changes in working methods and the negotiation of creative roles, sculptors tried to liberate their art from the bounds of patronage and shrugged off earlier prejudices against sculpture as a manual art. It is often assumed, following Leonardo's influential treatise on painting, that this process was easier for painters than it was for sculptors. Leonardo famously stressed the strenuous, physical work of sculpture separated it from the art of painting and kept it more closely tied to the supposedly lower mechanical arts. Yet whether or not this opinion was widely held in Italy is a question that requires much further study.

Another potentially informative, but often-overlooked facet of the patron–artist relationship is the role patrons played in wider networks of artistic communication. Italian Renaissance patrons who hailed from great banking, ecclesiastical, and ruling families traveled throughout Italy and Europe. Itinerant humanists, financial representatives, papal legations, cardinals' secretaries, and ducal ambassadors and advisors are just a handful of the types of peripatetic agents who, intentionally or otherwise, became artistic carriers. Patrons' exposure to and engagement with different styles, iconography, and foreign models of patronage could fuel changes at home, exposing artists to

currents that might otherwise have remained out of their reach. In short, as patrons' dealings with artists intersected with their daily lives, they facilitated the transmission of artistic ideas not only within their own cities, but also throughout Italy and beyond. The tendency in patronage studies has been to consider the patron–artist relationship as an isolated transaction taking place in a local community, but in this period, patrons often took a international perspective on their commissions. Particularly powerful patrons stood at the center of expansive social and intellectual networks, and as such, they could provide opportunities—increasingly tangible ones in the period considered here—for interaction and discourse between artists and men in the public eye. These intellectual circles could conspicuously affect the artist's practice, and in this respect studies of patronage must also be attentive to the "supporting cast" surrounding patrons and their artists.

Beyond the opportunity to make works of art, we should also consider the role of Renaissance patrons in shaping artists' identities and careers. To give a well-known example, if the Arte della Lana and Opera del Duomo in Florence had placed Michelangelo's *David* on a Duomo buttress as originally intended, it would have prioritized the sculpture's religious, prophetic meaning, but also would not have enabled the pro-republican identity that Michelangelo was able to cultivate once the sculpture was placed at the entrance to the Palazzo della Signoria. Similarly, we can go on to consider how a patron can impose an artist's works on targeted viewers. This can be so effective as to have unintended effects: to continue with Michelangelo, we can consider his enormous bronze of Pope Julius II, which the pontiff commissioned and installed over the entrance to San Petronio in Bologna after taking the city by force in 1506; its position lording over the Piazza Maggiore emphatically declared the city's subjugation, but one should also consider how it posited Michelangelo as the papal artist and dominant sculptor in the city. How much, then, was the sculpture's destruction by the rebellious Bolognese in 1511 a vindication of local artistic pride, as well as reassertion of Bolognese political autonomy? As these well-known examples reiterate, patrons' decisions not only produce works to signify intended ideology, but also fashion artists' careers and professional identities in ways other than mere financial sponsorship.

The relationship between patrons and sculptors extended far beyond the initial negotiation of the contract. To help us understand something of this relationship, we can investigate the common interests or sympathies that patrons and artists shared, and how these might have factored into the production and reception of sculpture. To name just a few overarching themes, both patron and sculptor often had a common interest in antiquity, a similar desire for fame, or shared the idea that they should emulate and surpass their rivals (an important catalyst for innovation).

Issues of physical context also enrich our understanding of the significance of sculptural patronage and deserve further investigation. The patron was usually in the position of setting sculpture into its context, putting works of art into a particular relationship with an architectural setting or landscape,

or juxtaposing the sculpture with other works of art in other media, such as painting. This is most conspicuously the case when the work was privately commissioned, and when the patron had tighter control over viewing circumstances (as in the case of *studiolo* objects and garden sculpture). Inside the *palazzo*, the arrangement of sculpture was an opportunity to create a carefully controlled image of artist and the patron, as patrons positioned their objects with a keen awareness of who would be able to enter various parts of the house, from the heavily-trafficked spaces of the courtyard to more secluded (but not entirely private) *camere*. Nevertheless, the original context of a sculpture, so critical to the initial meaning of the work, is often irretrievably lost or drastically altered: the original placement of a sculpture often failed to satisfy future generations, the family who commissioned a particular work might die out or fall into hard times, or the political or artistic climate might make the original setting of a sculpture no longer appropriate. Free-standing sculpture lends itself well to relocation, and there are many well-known examples in which a change of setting altered a patron's original plans and utterly transformed the meaning of a sculpture. For example, upon the exile of the Medici family, Donatello's *Judith and Holofernes* moved to the front of the Palazzo della Signoria and became a public and civic image. In these and other instances of recontextualization, we find once again the limits of the traditional notion of patronage studies as a search for the origin of the work of art.

Rather than considering the history of sculpture from stylistic or biographical viewpoints, the contributions to this volume examine how artistic productions arise out of social, political, and economic relationships. As a group, they cover a wide chronological and geographical range from the Trecento to the Cinquecento in Rome, Pisa, Florence, Bologna, and Venice. Some discuss very well-known sculptures, even canonical images in the history of Western art, while others focus attention on the patronage of lesser-known monuments. Yet they all reframe these works to illuminate how the processes of making sculpture, displaying it, and using it were collaborative efforts requiring creative input from patrons. The first essay in the volume, by Francis Ames-Lewis, examines Giovanni Pisano's sculptures on the Pistoia and Pisa pulpits, as well as on the Siena Duomo façade, to draw new conclusions about the artist's relationship to patrons. Focusing on the figures and inscriptions on the Pisa Duomo Pulpit in particular, the essay considers the sculptures' energy and expressiveness and how those qualities are echoed by the unusually forceful words of the pulpit's inscription. In the context of Pisano's sometimes-troubled relationship to his patrons, Ames-Lewis ties close analysis of the objects to the artist's own declarations about them, suggesting Pisano's unprecedented autonomy as a sculptor.

Other chapters consider lesser-known monuments created for patrons whose strategies have yet to be explored in depth. An essay by David Drogin looks at the trajectory of sculptural patronage by the Bentivoglio dynasty as the family consolidated its control over fifteenth-century Bologna. He shows that first,

as the Bentivoglio struggled to assert themselves against foreign pretenders to power, they relied on the uniquely local iconography of the professor tomb, replete with connotations of political authority, to enhance their status in the city. This is evidenced in the funerary monument to Antongaleazzo Bentivoglio, carved partly by Jacopo della Quercia in the 1430s and likely installed near the family chapel by Antongaleazzo's son Annibale. Later, as the Bentivoglio firmly established both their hegemony in Bologna and their ties to foreign rulers from the Medici and Sforza to the Holy Roman Emperor, their patronage drew on more widely recognized themes of seigniorial power. This is seen in the equestrian cenotaph commemorating Annibale Bentivoglio, probably commissioned at mid century by his cousin and successor. The essay shows how one family's patronage changed as their power increased within and beyond their city; it also considers how popular sculptural themes were emulated beyond the well-studied centers of Renaissance power.

Debra Pincus reconsiders the humanist tomb type through an analysis of Dante's tomb in Ravenna, commissioned by Bernardo Bembo from Pietro Lombardo in the 1480s. Her essay looks at how the tomb expresses the patron's illustrious identity in the context of a new hagiography of Dante which developed in the fifteenth century. Connecting the tomb's imagery to these themes, Pincus reappraises Dante imagery in the Renaissance and shows how, through a confluence of factors tied to patron, artist, and commemorative practice, the tomb was influential for the imagery of inspiration in funerary sculpture. Shelley Zuraw also looks at the patronage of Renaissance tombs, with a particular question in mind. While the patronage of sculpture is most often analyzed as a transaction between one artist and one patron, her essay asks what happens when multiple patrons or multiple artists shared the work. She looks specifically at two fifteenth-century tombs in Rome, of Bishop Giovanni Francesco Brusati in San Clemente and Cardinal Marco Barbo in San Marco. A contract survives for the first, revealing that two different sculptors collaborated on the project. The second tomb required the partnership of two different patrons, who carried out the project more than two decades after Barbo's death. While art-historical discussions of tomb sculpture follow Romantic ideals by celebrating the creative vision of the single individual (be it artist or patron), Zuraw shows how these concepts break apart in the analysis of complex, collaborative projects that unfolded over the course of decades.

The next four chapters consider the patronage of Florentine sculptors in their own city and beyond its walls. David Wilkins' overview of Donatello's sculpture draws new attention to the enormous scope of the artist's commissions, in terms of contexts, types of contracts (or lack thereof), and working practices. The analysis is complemented by a consideration of how Renaissance chroniclers described the artist's sculptural works and his relationships to his patrons. Drawing on such accounts and on documentary evidence, the essay emphasizes the exceptional relationships Donatello had with his most important patrons, including the Medici. The essay enhances our awareness of Donatello's uniqueness as a Quattrocento craftsman and

also forces us to reconsider our expectations of Renaissance patronage practices. With similar aims in mind, William Wallace looks at Michelangelo's sculptural corpus, focusing on his materials, process, and his relationship with patrons. Considering issues from his family's status to the nature of the works themselves, the essay demonstrates how Michelangelo resisted classification as a traditional artisan, first cultivating and then manipulating traditional patronage practices in ways that blur the line between *mecenatismo* and *clientelismo*. Reassessing the sculptor's work and career in this way, Wallace details how the artist achieved unprecedented, unique liberties in his sculptural practice.

Roger Crum's essay underscores the remarkable quantity of sculptures executed by Florentines for patrons outside of Florence, shedding light on the limitations that arise when patronage is only considered in its local context. The fact that patrons throughout Tuscany, Northern and Southern Italy, Rome, and even north of the Alps awarded commissions to Florentines speaks to the international reputation of the city's sculpture workshops; it also illuminates how the spread of Florence's influence in marble carving and bronze casting followed the rise of the city's commercial and banking interests abroad. Crum's essay presents a new and different conception of what the Florentine Renaissance was, showing that it extended well beyond the familiar walled city of Florence. A chapter by Sarah Blake McHam re-considers one of the best-known monuments of Florentine Renaissance sculpture, the bronze equestrian portrait of Cosimo I de' Medici commissioned from Giambologna by Cosimo's son, Grand Duke Ferdinando. Despite the stature of this monumental bronze, prominently positioned next to the Palazzo Vecchio, the work has been undervalued in the scholarly literature, and aspects such as the narrative reliefs in bronze that adorn the statue's base have received little attention. McHam's essay looks closely at the monument to analyze how it functioned visually and symbolically in its distinctive setting, where it competed with famous works by Michelangelo, Cellini, and Bandinelli. By commissioning an equestrian bronze portrait of this scale, adding inscriptions and narrative reliefs of Cosimo's *res gestae*, Ferdinando trumped earlier commemorative monuments with the most successful revival to date of an ancient type of colossal portrait-statue that Pliny the Elder had praised in his *Natural History*. McHam's study considers how this antique form of monumental sculpture could subtly communicate and reify its patron's political ambitions.

Robert Gaston's essay concludes the volume by considering antiquarian efforts at the recovery of the ancient past, another vitally important aspect of the patronage of sculpture in sixteenth-century Italy. His focus is Pirro Ligorio, influential architect, landscape designer, and life-long encyclopedist of all things ancient. Gaston looks closely at Ligorio's still-unpublished treatise on waterworks, a fascinating collection of archaeological and geological observations spun together with local lore and the author's frequent borrowings from earlier antiquarian texts. Long marginalized by classical archaeologists who derided Ligorio as a "forger," these manuscripts shed light on a wide

range of cultural and artistic notions regarding springs, fountains, and their sculptural programs. They also, according to Gaston, reveal how Ligorio keyed his archaeological research to his own professional interests, as an artist and scholar who was entirely dependent upon the patronage of wealthy elites. Ligorio devotes much of this treatise to the description of ancient fountains, combining the observation of antique places with his own creative inventions, mixed together freely as he saw fit. Gaston is not only interested in separating the authentic from the fantastic, however. He goes further to suggest that Ligorio invented his own version of the ancient patronage of fountains to suit the taste of his patrons. As Ligorio described them, ancient fountains were prominently labeled with the name of a commissioning family and a decorative program of sculptural reliefs and statues related to the cult of each particular spring. In so doing, Gaston argues, he set his own antique precedent for the garden fountains popular at the time, which often celebrated the name of an illustrious family (usually, the modern equivalent of an antique *gens*) the divine aura of the sacred spring that surfaced in their garden, and a statue of a classical guardian of the font. Gaston's essay sheds light on the grand sculptural programs of sixteenth-century gardens, conceived not as a straightforward revival of ancient prototypes, but as the clever re-combination of "real" and self-consciously falsified ones.

Notes

1 See for example, Bram Kempers, *Painting, Power, and Patronage: The Rise of the Professional Artist in Renaissance Italy*, trans. Beverly Jackson (London and New York: Penguin, 1992); David Thomson, *Renaissance Architecture: Critics, Patrons, Luxury* (Manchester and New York: Manchester University Press, 1993).

2 See discussion in Francis Ames-Lewis, *Tuscan Marble Carving 1250–1350: Sculpture and Civic Pride* (Aldershot and Brookfield: Ashgate, 1997), 1–16.

3 On the ascendancy of private patronage in this era, see Robert Sabatino Lopez, "Dal mecenatismo del Medioevo a quello del Rinascimento," *Quaderni medievali* 17, no. 34 (1992): 123–30.

4 Adrian Randolph, *Engaging Symbols: Gender, Politics, and Public Art in Fifteenth-Century Florence* (New Haven: Yale University Press, 2002), 85.

5 On *magnificenza*, see A. D. Fraser Jenkins, "Cosimo de' Medici's Patronage of Architecture and the Theory of Magnificence," *Journal of the Warburg and Courtauld Institutes* 33 (1970): 162–70.

6 See comments in Ernst Gombrich, "Sculpture for Outdoors," in *The Uses of Images: Studies in the Social Function of Art and Visual Communication* (London: Phaidon Press, 1999), 136–61.

7 Giles Knox, "The Colleoni Chapel in Bergamo and the Politics of Urban Space," *The Journal of the Society of Architectural Historians* 60, no. 3 (2001): 290–309.

8 Richard A. Goldthwaite, *Wealth and the Demand for Art in Italy, 1300–1600* (Baltimore: Johns Hopkins University Press, 1993).

9 Arne R. Flaten, "Portrait Medals and Assembly-Line Art in Late Quattrocento Florence," in *The Art Market in Italy, 15th–17th Centuries / Il mercato dell'arte in Italia, secc. XV–XVII. Atti del convegno, Florence 2000*, ed. Marcello Fantoni, Louisa C. Matthew, and Sara F. Matthews-Greico, *Istituto di Studi Rinascimentali Ferrara – Saggi* (Modena: Franco Cosimo Panini, 2003), 127–39.

10 Leonardo famously commented on the reproducability of sculpture as one of the qualities that made it inferior to painting. In his *Trattato della pittura*, he writes, "questa [la pittura] non si copia come si fa le lettere, che tanto vale la copia quanto l'origine. Questa non s'impronta, come si fa la sculptura, della quale tal e' la impressa qual e' l'origine, in quanto alla virtù dell'opera," *Trattato della pittura* 1.4. For the serial reproduction of sculpture in Renaissance Italy, see Rita Comanducci, "Produzione seriale e mercato dell'arte a Firenze tra Quattro e Cinquecento," in *The Art Market in Italy, 15th–17th Centuries / Il mercato dell'arte in Italia, secc. XV–XVII. Atti del convegno, Florence 2000*, ed. Marcello Fantoni, Louisa C. Matthew, and Sara F. Matthews-Greico, *Istituto di Studi Rinascimentali Ferrara – Saggi* (Modena: Franco Cosimo Panini, 2003), 105–13.

11 Alessandro Guidotti, "Pubblico e privato, committenza e clientela: botteghe e produzione artistica a Firenze tra XV e XVI secolo," *Ricerche storiche* 16 (1986): 535–50.

12 The need to frame the study of "art patronage" with a broader discussion of the economics of consumption and collecting is discussed in Werner L. Gundersheimer, "Patronage in the Renaissance: An Exploratory Approach," in *Patronage in the Renaissance*, ed. Guy Fitch Lytle and Stephen Orgel (Princeton: Princeton University Press, 1981), 21–2; Goldthwaite 1993. Richard Goldthwaite writes of art historians' "insistence on using the loaded term 'patronage' when treating the demand for Renaissance art would in fact suggest a certain prejudice against considering buyers of art as operating within the normal parameters of the marketplace," Richard A. Goldthwaite, "Economic Parameters of the Italian Art Market (15th to 17th Centuries)," in *The Art Market in Italy, 15th–17th Centuries / Il mercato dell'arte in Italia, secc. XV–XVII. Atti del convegno, Florence 2000*, ed. Marcello Fantoni, Louisa C. Matthew, and Sara F. Matthews-Greico, *Istituto di Studi Rinascimentali Ferrara – Saggi* (Modena: Franco Cosimo Panini, 2003), 438.

13 Martin Wackernagel, *The World of the Florentine Renaissance Artist: Projects and Patrons, Workshop and Art Market*, trans. Alison Luchs (Princeton: Princeton University Press, 1981 (orig. edn 1938)); see also comments on the study of the patronage of sculpture in Patrick Boucheron, "Production de l'oeuvre et valeur sociale: le marché de la sculpture à Milan au 15ᵉ siècle," in *Economia e arte, secc. XIII–XVIII. Settimana di Studi dell'Istituto Datini*, ed. Simonetta Cavaciocchi (Florence: Le Monnier, 2002), 611–25. For Filarete's discussion of the patron's role, see Antonio di Piero Averlino, *Filarete's Treatise on Architecture, Being the Treatise by Antonio di Piero Averlino, Known as Filarete*, ed. and trans. John R. Spencer (New Haven and London: Yale University Press, 1965), 1: 15–16).

14 Ernst H. Gombrich, "The Early Medici as Patrons of Art," in *Norm and Form: Studies in the Art of the Renaissance I* (London: Phaidon Press, 1966), 35–57; Jill Burke, *Changing Patrons: Social Identity and the Visual Arts in Renaissance Florence* (University Park: Pennsylvania State University Press, 2004), 5.

15 Stephen Greenblatt, *Renaissance Self-Fashioning: From More to Shakespeare* (Chicago: University of Chicago Press, 1980), 2.

16 Randolph Starn and Loren Partridge, *Arts of Power: Three Halls of State in Italy, 1300–1600* (Berkeley: University of California Press, 1992).

17 Much has been made of the difference between the Italian words *mecenatismo* and *clientelismo*, based on the argument that, while both can be translated as "patronage," *mecenatismo* implies the sponsorship of the arts specifically and *clientelismo* describes the all-encompassing "clienatage" system that permeated Renaissance social life. Recently, however, the point has been made that the separation between patronage and clientage is over-argued, since most patrician families in this period engaged in art patronage, and in any case the patronage of art is inseparable from the wider notion of clientage (Dale Kent, *Cosimo de' Medici and the Florentine Renaissance: The Patron's Oeuvre* (New Haven and London: Yale University Press, 2000), 8).

18 Melissa Merriam Bullard, "Heroes and their Workshops: Medici Patronage and the Problem of Shared Agency," in *The Italian Renaissance: The Essential Readings. Blackwell Essential Readings in History*, ed. Paula Findlen (Malden: Blackwell, 2002), originally published in *Journal of Medieval and Renaissance Studies* 24 (1994): 179–98; Tracy E. Cooper, "*Mecenatismo* or *Clientelismo*? The Character of Renaissance Art Patronage," in *The Search for a Patron in the Middle Ages and the Renaissance*, ed. David G. Wilkins and Rebecca L. Wilkins (Lewiston, Queenston, and Lampeter: Edwin Mellen Press, 1996), 19–32.

19 Bullard 2002, 304.

20 Bullard's reference is to John T. Paoletti and Wendy Stedman Sheard, eds, *Collaboration in Italian Renaissance Art* (New Haven: Yale University Press, 1978).

21 The argument for a less individualistic notion of patronage has been made, for example, in F. W. Kent, "Il ceto dirigente fiorentino e i vincoli di vicinanza nel Quattrocento," in *I ceti dirigenti nella Toscana del Quattrocento. Atti del convegno (Florence, 10–11 December 1982 and 2–3 December 1983)* (Impruneta: Francesco Papafava, 1987), 63–78.

22 On this issue, see F. W. Kent, "Individuals and Families as Patrons of Culture in Quattrocento Florence," in *Language and Images of Renaissance Italy*, ed. Alison Brown (Oxford: Clarendon Press, 1995), 171–92.

23 Stephen J. Milner, "The Politics of Patronage: Verrocchio, Pollaiuolo, and the Forteguerri Monument," in *Artistic Exchange and Cultural Translation in the Italian Renaissance City*, ed. Stephen J. Campbell and Stephen J. Milner (Cambridge: Cambridge University Press, 2004), 221–45.

24 Jonathan K. Nelson, Richard J. Zeckhauser, *et al.*, *The Patron's Payoff: Conspicuous Commissions in Italian Renaissance Art* (Princeton and Oxford: Princeton University Press, 2008).

25 Jaynie Anderson, "Rewriting the History of Art Patronage," *Women Patrons of Renaissance Art, 1300–1600. Renaissance Studies* 10, no. 2 (1996): 129.

26 Catherine King, *Renaissance Women Patrons: Wives and Widows in Italy c. 1300–1550* (Manchester and New York: Manchester University Press, 1998), 7.

27 The study of female patronage has been described as the rediscovery of "ingenious strategies that allowed women to explore the potential of art as a means of proclaiming their own identity and status, as well as their own taste," Cynthia Lawrence, "Introduction," in *Women and Art in Early Modern Europe: Patrons, Collectors, and Connoisseurs*, ed. Cynthia Lawrence (University Park: Pennsylvania State University Press, 1997), 7.

28 See remarks in Roger J. Crum, "Controlling Women or Women Controlled? Suggestions for Gender Roles and Visual Culture in the Italian Renaissance Palace," in *Beyond Isabella: Secular Women Patrons of Art in Renaissance Italy*, ed. Sheryl E. Reiss and David G. Wilkins, *Sixteenth Century Essays & Studies Volume LIV* (Kirksville: Truman State University Press, 2001), 37–47.

29 J.K. Lydecker, "Il patriziato fiorentino e la committenza artistica per la casa," in *I ceti dirigenti nella Toscana del Quattrocento. Atti del convegno (Florence, 10–11 December 1982 and 2–3 December 1983)* (Impruneta: Francesco Papafava, 1987), 209–21.

30 Geraldine Johnson, "Art or Artefact? Madonna and Child Reliefs in the Early Renaissance," in *The Sculpted Object, 1400–1700*, ed. S. Currie and P. Motture (Aldershot: Scholar Press, 1997), 1–24.

31 Christiane Klapisch-Zuber, "Holy Dolls: Play and Piety in Florence in the Quattrocento," in her *Women, Family, and Ritual in Renaissance Italy* (Chicago and London: University of Chicago Press, 1985), 310–29.

32 Gabrielle Langdon, *Medici Women: Portraits of Power, Love, and Betrayal from the Court of Duke Cosimo I* (Toronto: University of Toronto Press, 2006), 127–36.

33 Gunderscheimer 1981, 18–20; Milner 2004; Bullard 2002.

34 Michelle O'Malley, "Subject Matters: Contracts, Designs, and the Exchange of Ideas between Painters and Clients in Renaissance Italy," in *Artistic Exchange and Cultural Translation in the Italian Renaissance City*, ed. Stephen J. Campbell and Stephen J. Milner (Cambridge: Cambridge University Press, 2004), 17–37; see also Shelley Zuraw's chapter in this volume.

35 For instances in which a humanist "advisor" was called in to write a program, see Charles Hope, "Artists, Patrons, and Advisors in the Italian Renaissance," in *Patronage in the Renaissance*, ed. Guy Fitch Lytle and Stephen Orgel (Princeton: Princeton University Press, 1981), 293–343. All of Hope's examples relate to painting commissions.

36 Rudolf Wittkower, *Sculpture: Processes and Principles* (New York: Harper & Row, 1977), 89–92; Settis illustrates Jacopo's contract drawings, and another by Mattia Della Robbia for a *tondo* in glazed terracotta (Salvatore Settis, "Artisti e committenti fra Quattro e Cinquecento," in *Storia d'Italia, Annali IV. Intellettuali e potere*, ed. Corrado Vivanti (Turin: Einaudi, 1981), 752–3, figs 11–13).

37 Wackernagel 1981, 313; see also Wittkower 1977, 133.

"There are many sculptors, but to Giovanni remain the honors of praise:" the rhetoric of Giovanni Pisano's words and images

Francis Ames-Lewis

Giovanni Pisano's pulpit in the small Romanesque church of Sant' Andrea in Pistoia is his best-preserved masterpiece.[1] Carved between 1298 and 1301, this pulpit shows an important development in iconography and a radical shift in style from the pulpit that the young Giovanni helped his father Nicola Pisano to complete in 1268 in the Duomo of Siena. This chapter opens with an enquiry into these changes in iconographical program and in stylistic range and vocabulary by examining aspects of the style and meaning of Giovanni Pisano's figure-sculpture on the Pistoia pulpit. Parallels are then explored between his mature, highly-charged visual language and the strident rhetoric of the words and phrases used in the inscriptions that adorn his last great work, the much-damaged pulpit in the Duomo of Pisa. Finally, how Giovanni applied this new and apparently passionate concern for the rhetorical possibilities of sculpture to the cycle of *Prophets and Sibyls* carved for the façade of the Siena Duomo in the later 1280s and 1290s is considered.

Another thread that runs through this essay is the question of the nature of Giovanni Pisano's relations with his patrons. Given the paucity of documentary or other evidence on these relations, and on how his patrons regarded the sculptor, outcomes of consideration of these topics must inevitably be conjectural. Some speculative suggestions can, however be put forward, and these may guide readers' responses to the discussion in the bulk of the chapter. This is best done through a case-study of the patronage of the Sant' Andrea, Pistoia pulpit.

Little is known about the circumstances of the commission of this great work. The inscription declares that "the originator and donor of the work was Arnoldo the canon," but nothing more appears to be known about this individual. That he played a part in inter-parish rivalry in Pistoia seems clear, however, from the proposal in 1298 that the pulpit should not be inferior to

the pulpit in San Giovanni Fuorcivitas,[2] carved in 1270 by Fra Guglielmo who, like Giovanni, was trained in Nicola Pisano's workshop. Given his competitive need for a sculptor who could at least rival, if not better, Fra Guglielmo, Canon Arnoldo's choice of Giovanni Pisano may well have been informed by first-hand knowledge of the sculptor's most recent work, the *Prophets* and *Sibyls* of the Siena Duomo façade. The architectural language of the Pistoia pulpit, and notably of the sharply pointed trilobe arches of the spandrel zone, is more consciously based on north European Gothic architecture than perhaps any other work hitherto constructed in central Italy. This language is in such stark contrast with the simple, unpretentious Romanesque style of the church of Sant' Andrea itself as to suggest that Canon Arnoldo wished to make a statement about the direction in which his stylistic preferences were moving. In the pulpit sculpture also, we see a shift towards a new figural dynamism that contrasts with the comparatively staid and rather wooden figure style of the San Giovanni Fuorcivitas pulpit. If these developments did indeed reflect Arnoldo's preferences, it seems likely that he will have encouraged Giovanni to adopt a radically rhetorical and passionate style, and original techniques of carving and narrative presentation, to match the theatricality of the style of the Siena Duomo façade figures; and he may also have given Giovanni a role in evolving the unprecedented iconography.

If Canon Arnoldo did indeed have first-hand knowledge of the Siena Duomo figures, he may also have known of the difficulties, discussed later in the chapter, that Giovanni Pisano experienced in his dealings with his patrons and with other authorities in Siena. Arnoldo offered Giovanni the commission for the Pistoia pulpit at much the time that the sculptor quitted Siena, leaving the Duomo façade unfinished. That the Pistoia pulpit sculpture was carried through with such consistency in design, style and quality may suggest that Giovanni Pisano's relations with Canon Arnoldo, on the other hand, were consistently good. But Giovanni seems to have run into further difficulties, discussed in detail later, in his relationship with the *operaio* of Pisa Duomo, Burgundio di Tado, over the progress of work on the Pisa Duomo pulpit (1302–11). Whatever the problems were, his experience at the hands of Burgundio may have goaded Giovanni to the protestations about his worth, indeed about his unmatched abilities that we find in the two extraordinary inscriptions on the Pisa Duomo pulpit. That he had license to carve these inscriptions in so public a context is further indication of the unprecedented freedom that he was allowed by his patrons.

We may speculatively deduce from this sporadic evidence and its contexts that by around 1300 Giovanni Pisano had achieved an exceptional artistic independence. He was, it seems, provided with considerable creative freedom by those patrons who were in sympathy with his stylistic individuality. But he had also earned himself a notoriety that cut two ways. In terms of the originality and expressive quality of his carvings this notoriety was positive, but it was negative in terms of the difficulties that some patrons found in working with this seemingly eccentric, perhaps wayward character. In both

his independence and his notoriety Giovanni was unique amongst Italian late medieval artists, and unequalled amongst Italian sculptors before Donatello and Michelangelo.

<div align="center">* * *</div>

Perhaps the most significant contrast in the programmatic subject matter of the Siena and Pistoia pulpits was the replacement of the series of *Virtues* of the Siena pulpit with figures of *Sibyls* at Sant' Andrea, Pistoia. There are three sibyls confined to spandrels in the Siena Duomo pulpit: two are unidentifiable and the third is the Hebrew sibyl "Sabbe," the pendant to Solomon.[3] But the full-length *Virtues* at the angles of the Siena pulpit spandrel zone give way to a series of six *Sibyls* in the same position on the Pistoia pulpit. These are therefore provided with considerably more prominent positions than the Siena pulpit sibyls. Moreover they are emancipated from the architectonic confines of their precursors within the Siena pulpit spandrels, and are thereby provided with much more autonomy in movement and expressive value.

The sibyls of the ancient world were female seers inspired by Apollo, and were the vehicles through which the sun-god's prophecies were communicated to humankind.[4] The sibyls were seldom represented in medieval art, and in these rare instances only the Erythrean and Tiburtine sibyls were identified. But it came to be recognized that their oracular utterances, while pagan in origin, also foresaw important events in the history of man's salvation. The Tiburtine sibyl's prophecy, for example, was understood as foretelling the coming of Christ. Whereas the prophets spoke to the Jews, the sibyls passed on their Apollonian messages to the Gentiles; and they were intuitive rather than learned.[5] The sibyls and their oracular sayings were not widely popularized until a booklet on their prophecies was published in Rome in 1481 by Filippo Barbieri. This inspired the visual representation of sibyls in, for example, Filippino Lippi's frescoes in the Carafa chapel of Santa Maria sopra Minerva, Rome, and the group of five who complement the series of *Prophets* in Michelangelo's Sistine ceiling frescoes.

Earlier, in the Pistoia pulpit, the series of *Sibyls* also complements a series of *Prophets*. These figures are confined within the spandrels between the *Sibyls*, so that the *Sibyls* are given considerably greater prominence here than are their male peers. Dating from around 1300, this is the earliest series of sibyls known in Italy since antiquity, as opposed to occasional, isolated representations such as those on the Siena Duomo pulpit and the figure, probably the Erythrean Sibyl,[6] carved by Giovanni for the Siena Duomo façade. The *Sibyls* of the Sant' Andrea pulpit are now unidentifiable, but originally each probably had her individual oracular utterance painted onto her scroll; and each is accompanied by a godly messenger who communicated to her Apollo's prophetic message. How or why a series of sibyls should have been chosen for representation on the Pistoia pulpit is not known; but so suited are they to Giovanni Pisano's

sculptural rhetoric that it is difficult to reject the notion that he may himself have played a part in the choice.

The sibyl figures of the Pistoia pulpit had to be characterized not as abstract qualities, like the *Virtues* of the Siena Duomo pulpit, but as respondents to divine inspiration. Because Giovanni Pisano needed to communicate to the observer their prophetic wisdom, the *Sibyls'* poses and movements are more dynamic and eye-catching than those of the Siena Duomo pulpit *Virtues*. A sense of dramatic intercommunication between the divine messengers and the listening *Sibyls*, and thence between the *Sibyls* and the observer, runs through the spandrel-level figures of the Pistoia pulpit. The helical pose of one of the seated *Sibyls* is powerfully dynamic, contrasting sharply with the static poise of the Siena *Virtues* such as, for example, the seated *Justice*. As the *Sibyl* responds excitedly to the sudden apparition behind her right shoulder, she seems as much frightened as inspired by the words she hears. Pulling her veil protectively across her breast, she leans away from the approaching messenger, and twisting her head she looks over her right shoulder with an expression of concentrated anxiety. The instability of her pose and movement are emphasized by the asymmetrical placement of her legs and feet, which generates a play of complex, activated, diagonal drapery folds between and across her knees.

One of the standing *Sibyls* (Figure 1.1) leans towards the observer, freeing herself from any sense of architectonic restraint, as though about to stride forward and step down from her ledge as she twists her head round to hear the messenger's words. Her active pose again contrasts with the recessive modesty of the Siena pulpit *Humility* whose movements are constrained by the static disposition of her lower legs, emphasized by her mantle's richly decorated border. The Pistoia *Sibyl's* drapery is in contrast deeply excavated between her legs. The vigorous curvilinear edges of drapery folds that cast across her right leg and up to her left, scroll-holding hand stress her expressive urgency. Pressing forward into the spectator's line of sight from below, her face has firmly defined brows above deep eye-sockets, and a half-open mouth. The seated *Sibyl* is still absorbing the significance of the messenger's words, but the standing *Sibyl* is both listening intently and perhaps already starting to communicate her prophecy onwards, with rhetorical gesture and strongly characterized facial expression, to the observer below her.

These figures are by no means the earliest of Giovanni Pisano's exercises in sculptural rhetoric. Indeed, they push forward to its climax the expressive urgency already to be sensed in some of the now almost ruined figures from the decoration of the pinnacles on the exterior of the Pisa Baptistery (probably dating between 1269 and 1279), and in particular in the also badly damaged *Prophets* from the Siena Duomo façade (later 1280s to 1297). But because the Pistoia *Sibyls* belong to Giovanni's first major sculptural decoration for an interior liturgical furnishing, they survive in their original state and are unaffected by weathering; they therefore demonstrate Giovanni's artistic intentions considerably more clearly than earlier works can.

1.1 Giovanni Pisano, *Standing Sibyl*. Pulpit of Sant' Andrea, Pistoia

Giovanni's treatment of figure-pose, and his handling of gesture and expression in order to thrust out his messages towards the observer, are therefore sharper and more effective than his earlier exterior figures now show. The expressive strength of Giovanni's carving on the Pistoia pulpit is also reinforced by the physical closeness of his figures to the viewer, so that observers can engage more directly and emphatically with the figures' communicative qualities.

The expressive, rhetorical force of these figures as they digest their Apollonian messages and prepare to communicate their own inspirational words is, for various possible reasons, not resoundingly echoed in the relatively unaccomplished figures carved for the same positions on Giovanni Pisano's later pulpit in the Duomo of Pisa, dating from 1302 to 1311.[7] But it is, on the other hand, matched by the declamatory turn of phrase of the inscriptions that Giovanni carved onto this second pulpit. These verses are extreme examples of a tradition of sculptors' self-laudatory inscriptions that was especially highly developed in late medieval Pisa dating at least as far back as the inscription cast by Bonanus of Pisa into the bronze of his lost doors for the central portal of the Pisa Duomo façade in 1180.[8] Because of this long Pisan tradition, it comes as no surprise that Nicola Pisano should have added a laudatory, if essentially formulaic, inscription to his pulpit in the Pisa Baptistery:

In the year 1260 Nicola Pisano carved this noble work.
May so greatly gifted a hand be praised as it deserves.[9]

The verses on Giovanni Pisano's pulpits should be seen against the background of this Pisan tradition. But tradition, however long and however strong, cannot fully explain the length and the rhetorical strength of his inscriptions. That on the Sant' Andrea, Pistoia pulpit takes up the mood of Nicola Pisano's on the Pisa Baptistery pulpit. While elaborating and expanding on the same basic ideas, it also includes a pointed comparison between father and son—to the son's advantage, needless to say—that gives added forced to Giovanni's view of his own accomplishments:

In praise of the triune God I link the beginning with the end of this task in 1301. The originator and donor of the work is the canon Arnoldus ... Giovanni carved it, who performed no empty work. The son of Nicola and blessed with higher skill, Pisa gave him birth, and endowed him with mastery greater than any seen before.[10]

The later pulpit in Pisa Duomo, completed in December 1311, bears two inscriptions, as though in recognition both of its much more complex structure and iconography and of the much greater importance of its location. Each inscription is much longer and more problematical than the relatively straightforward text of self-praise on the Sant' Andrea, Pistoia pulpit. The first, running around the pulpit immediately below the narrative reliefs, essentially elaborates on the structure of the Pistoia pulpit inscription. A dated introduction of thanksgiving and an acknowledgment of support are

followed by words of praise for the sculptor. Although conventional in its vocabulary of praise, this last section is developed into the longest and most sophisticated text about a sculptor up to that date:

I praise the true God, the creator of all excellent things, who has permitted a man to form figures of such purity. In the year of Our Lord 1311 the hands of Giovanni, son of the late Nicola, by their own art alone, carved this work … and at his side Nello di Falcone who has exercised control not only of the work but also of the rules on which it is based. He is a Pisan by birth, like that Giovanni who is endowed above all others with command of the pure art of sculpture, sculpting splendid things in stone, wood and gold. He would not know how to carve ugly or base things even if he wished to do so. There are many sculptors, but to Giovanni remain the honors of praise. He has made noble sculptures and diverse figures. Let any of you who wonders at them test them with the proper rules. Christ have mercy on the man to whom such gifts were given. Amen.[11]

Giovanni Pisano claims for himself the highest praise: he is a finer sculptor than any others, and he "would not know how to carve ugly or base things." Moreover, he throws down the challenge that his works must be judged by "the proper rules"—presumably those over which Nello di Falcone, the Duomo *operaio* from 1307, "exercised control." Giovanni declares that both he and Nello di Falcone were Pisans, and therefore that both stood by "the rules on which [the work] is based." These were, by implication, a set of local conventions that guided sculptural production in Pisa, and according to which Giovanni carved the pulpit. His assertive remarks about "the proper rules" suggest that a tension may have existed at the time in Pisa between contrasting views of the sculptor's position in relation to his patrons and to the *operaio* of the Duomo works. There may also have been differing interpretations of the sculptor's stylistic responsibilities: reference to some such disagreement and its wounding outcome appears indeed to be made in the second inscription of the Pisa Duomo pulpit, where Giovanni declares that "the more I have achieved the more hostile injuries have I experienced."[12] It may be that Giovanni suffered these tribulations at the hands of Burgundio di Tado, the *operaio* who was responsible for commissioning the work, and perhaps for establishing criteria for its execution that may have been disagreeable to Giovanni. Burgundio was replaced in 1307 by Nello di Falcone and was not mentioned in Giovanni's inscription; but, not to be forgotten, he later set up his own inscription on the side of the Duomo explaining his responsibility for the commission:

In the name of the Lord. Amen. Burgundio di Tado was responsible for the making of the new pulpit which is in the Duomo. It was begun in the year 1302 and was finished in the month of December in the year 1311.[13]

In his first inscription, Giovanni seems rhetorically to be asserting his right to exercise creative license, within the limits of prevailing sculptural convention. But what were the "proper rules" to which he refers in the inscription?

Critics have been unexpectedly reluctant to speculate over this question: John White seems characteristic of the position with his rather negative observation that "it is impossible to tell what Giovanni means by these intriguing references to the laws of art, and certainly no easily reconstructed metrical systems of proportion seem to be involved."[14] Until recently, only Michael Ayrton had proposed a more positive interpretation: he suggested that Nello di Falcone "may ... have been a churchman ... whom Giovanni was required to consult as to theological niceties in the narrative programme of the work ... the 'proper rules' evolved to relate the parts, and parts of parts, to each other and to the whole were more complicated in this pulpit than in any prototype."[15] But Giovanni Pisano himself proposed that it was his "noble sculptures and diverse figures" that should be tested against "the proper rules": it thus seems probable that these rules had to do with artistic rather than with theological, or programmatic, matters. In a fascinating, if in places riskily subjective, analysis of the Duomo pulpit reliefs Jules Lubbock has recently proposed a new interpretation of the "recto jure" (here translated as "the correct law") on which the work was based.[16] Lubbock suggests that "the law in question is perspectival, that which governed the oblique views of the panels in Pistoia, but here developed by two major refinements: first, the curvature of each panel; second, a more sophisticated technique for focusing the viewer's attention on individual episodes."[17] His analysis of how Giovanni exploited oblique views from below and to the side onto the curved surfaces of the reliefs for dramatic narrative effect is persuasive and important. But this "law"—these "rules"—depend very specifically on the visual consciousness of the experienced and skilled relief carver: and it is not evident that Nello di Falcone, a Pisan administrator rather than a sculptor, would have been in a position to "exercise control" over such issues that relate distinctively to sculptural practice.

In his inscription Giovanni Pisano stressed that like himself Nello di Falcone "is a Pisan by birth;" and the artistic language, the "proper rules" that together they sought to defend may best be seen within the context of later thirteenth-century sculptural activity in Pisa. The revolutionary style of Nicola Pisano's much earlier Pisa Baptistery pulpit, dating 1258–60, was intended to revive an imperializing classicism. The patron, Archbishop Federico Visconti, sought to establish Pisa as the successor to Naples as stronghold of the Ghibelline cause after the rapid demise of the Hohenstaufen dynasty on Emperor Frederick II's death in 1250.[18] The style that Nicola evolved in response to these ambitions is in good part based in classical and classicizing sources, in his own probable training in the Hohenstaufen workshop, and in his experience of classical sculpture in Pisa and probably also in Rome itself.

Qualities of this monumental style associated with the classical past are still evident in the external decoration of the Pisa Baptistery, a project on which Nicola and Giovanni Pisano worked together in the 1270s.[19] They are especially to be seen in the monumentally solemn figures of the *Madonna and Child* and *Apostles*, originally set into the gables, for which Nicola was probably

primarily responsible. By this time, however, Giovanni was already infusing Nicola's classicism with a more dynamic articulation of forms, by investing classicizing figures with a Gothic freedom of dramatic movement. This may be seen in the pinnacle figures, for which in turn he was probably primarily responsible. In the second inscription of the Pisa Duomo pulpit Giovanni claims to have "encircled all the rivers and parts of the world endeavoring to learn much" This has been seen as good evidence of Giovanni's travels to northern Europe;[20] and although this may be a too literal reading of this clause of the inscription, his new infusion of a northern Gothic sculptural language could well have been based on first-hand experience of the sculpture that decorates the façades of such French cathedrals as Rheims and Amiens. In his carvings for the new Pisa Duomo pulpit Giovanni Pisano was perhaps required to take further those qualities of movement and rhetorical expression that may in fact have led the Pisan *operai* to choose him as the sculptor for their new pulpit.

Giovanni's declamatory clause "Let any of you who wonders at them [his 'noble sculptures and diverse figures'] test them with the proper rules" may have invited the observer in particular to "wonder at" the figures of *Fortitude* (Figure 1.2) and *Prudence*, two of the figures that appear to support the pulpit's superstructure. It is these figures that most clearly show Giovanni striving to synthesize a late medieval expressive style with classical figure-types. They were based respectively on a classical Hercules and a Venus Pudica,[21] but unlike Nicola Pisano's paraphrase of a Roman Hercules in his so-called *Fortitude* on the Pisa Baptistery pulpit,[22] the derivation seems by now to be quite distant. Through his direct, chopping chisel-work that tends if anything to distort anatomical form and proportion; through the angular movements and thrusts of the poses; and through the intensified vigor of gesture and facial expression, Giovanni formulated a new style of dramatic rhetorical communication, very different from that of the classical originals but steeped in the forthright expressiveness of the north European Gothic idiom. His pursuit of the Pisan sculptural convention, established by his father, of building on the foundations of a classical stylistic idiom is also very evident in his introduction of "classicizing volute-like consoles"[23] at spandrel level in place of the steeply pointed Gothic trilobe arches of the Pistoia pulpit, and in certain facial types such as that of the figure to Christ's left in the *Betrayal* which derives "from a classical source, that of an ugly, comic actor's mask."[24]

The expressive power and effectiveness of this very individual synthesis of classical and Gothic stylistic languages may help to explain the assertive self-praise of the first inscription. It is difficult, however, to understand how this alone could explain or justify the irritable, frustrated, almost paranoid tone of the second inscription, which presents considerably greater difficulties of interpretation.[25] Again in rhyming verse, this inscription runs around the pulpit's plinth, telling the reader that:

1.2 Giovanni Pisano, *Fortitude*. Pulpit of the Duomo, Pisa

Giovanni has encircled all the rivers and parts of the world endeavoring to learn much and preparing everything with heavy labor. He now exclaims: "I have not taken heed. The more I have achieved the more hostile injuries have I experienced. But I bear this pain with indifference and a calm mind." If the pulpit may free him from this envy, mitigate his sorrow and win him recognition, add to these verses the moisture [of tears]. He proves himself unworthy who condemns him who is worthy of the diadem. Thus by condemning himself he honors him who he condemns.[26]

This second inscription invites a reading in the light of what may be deduced about Giovanni's personality and his conflicts with authority, not least the cathedral *operai* in both Siena and Pisa. Giovanni appears here both aggressively and aggrievedly to claim that his work was undervalued, and to demand that its quality should henceforth be fully recognized. As noted above, the evidence suggests that relations between Giovanni and the first *operaio* at the time of the Pisa Duomo pulpit, Burgundio di Tado, had been strained. Similar documents for the Siena Duomo façade likewise suggest that Giovanni and the Duomo authorities did not get on well together. In 1290 he was condemned by the *podestà* for an undefined misdemeanor and fined 800 lire. More seriously, in May 1297 the Opera del Duomo officials launched an investigation into the chaotic state of the Duomo workshops, for which, as *capomaestro*, Giovanni bore considerable responsibility. Perhaps as a result of the damning report of this inquiry, Giovanni left Siena, and the yet incomplete façade and façade sculpture, for good in December 1297.[27] Such evidence as this may throw some light on the implications of the inscription, but it is not clear enough to justify attempts at psycho-biographical interpretation. It does, however, seem justified to propose that, if only from the length and poetic phraseology of his inscriptions, Giovanni Pisano's belief in his individual artistic imagination had an unprecedented strength. In its strident self-confidence and self-promotion his evaluation of his abilities is unmatched. The rhetoric of his inscriptions seems to assert that his position as a creative artist, with the skills and imagination to affect the beholder's emotions, deserved to be more widely acknowledged. As observed at the beginning of this chapter, it may also be suggested that Giovanni's freedom to carve such personal and self-praising inscriptions onto a major piece of cathedral furnishing indicates that his creative independence was respected by his patrons. But from the point of view of today's art historian, the most important feature of the inscriptions is that their verbal rhetoric can be closely matched against the visual rhetoric of Giovanni's figure sculpture. The attempt to demonstrate this through analysis of his carving practices and their outcomes is best conducted in the light of the cycle of *Prophets and Sibyls* carved for the façade of the Duomo of Siena from the later 1280s to 1297.

The originality of the *Prophets* cycle at Siena lies in the ways that each figure and each message is carefully individualized, and that their prophetic utterances are communicated to the worshipper who is about to enter the Duomo.[28] The prophets and sibyls represented in the figures ranged along the façade at tympanum level were selected for the significance of their

prophecies about the Virgin's role in the incarnation of Christ, and hence in the salvation of Man. They thereby introduce to the observer standing on the steps of the Duomo the imagery of the Virgin Mary that dominates the decoration of the interior. This iconography appeared in the pulpit of 1265–68, with its emphasis on the Virgin's central role in the incarnation and infancy of Christ; in the altar and altarpiece which survives now only as a *Madonna and Child* panel (the so-called *Madonna degli grossi occhi* in the Museo dell'Opera del Duomo in Siena) but which originally showed the Madonna and Child between scenes from the Life of the Virgin; and in the great stained-glass oculus window installed over the high altar in 1288—at much the time that Giovanni was making initial progress in constructing the façade and carving its figure sculpture—that shows the *Death*, *Assumption* and *Coronation of the Virgin*. The façade *Prophets* are now seriously worn and damaged from the effects of weather, and some are in a fragmentary or over-restored state, but many of them are still sufficiently clearly individualized to be identifiable. Fortunately, the intended identification and arrangement of all the figures is known, since their original positions on the façade are indicated by the inscription of their prophetic texts on the parapet on which they stood. These texts, that the figures communicated between each other and proclaimed in stirring messages to the people below, are appropriate as introduction to the Marian iconography of the Duomo interior.

The Siena Duomo *Prophets* cycle consists of 14 full-length standing figures, two groups of three on the north and south flanks of the corner towers, and a series of eight spread across the main front. The three on the north flank, for example, were Haggai, Isaiah, who exchanges glances with Haggai while announcing "Behold a virgin shall conceive and bear a son" (Isaiah 7:14), and Balaam, who looks round to tell his companions that "There shall come a star out of Jacob" (Numbers 24:17). At the centre of the façade the two royal prophets David and Solomon exchange their prophetic communications: as the ancestors of the Virgin, David and his son represent the lineage from the Old to the New Testament. Unprecedentedly, the Siena Duomo cycle includes both of the great classical Greek prophetic philosophers Plato and Aristotle, and two prophetesses, a sibyl (probably the Erythrean Sibyl) and Mary, Sister of Moses. The remaining group of ten Old Testament prophets is comparable in iconography to French High Gothic prophet cycles. But in the way that the sculpture is related to the façade architecture, and to the observer, the contrasts with French Gothic precedent are more telling than the similarities.

In the celebrated *Visitation* group at Rheims Cathedral, which dates from around 1230, tentative moves had already been made to link a pair of figures together expressively.[29] The independence of each figure in earlier French Gothic portal sculpture, placed as it was in a deep, isolating niche, or playing a subservient, architectonic role as a column-figure, here begins to give way to a loose, embryonic narrative interrelationship. As noted previously, in his second inscription on the Pisa Duomo pulpit Giovanni Pisano claimed that he had "encircled all the rivers and parts of the world endeavoring to learn

much." From this we may be entitled to deduce that he could have seen the Rheims sculpture. His interpretation of the Siena Duomo façade *Prophets and Sibyls* could therefore have been stimulated by north European developments. In designing these figures, however, Giovanni also extrapolated from his earlier experience of figure-sculpture in an architectural context, both on the Fontana Maggiore, completed by Nicola and Giovanni in partnership in 1278, and more prominently in the external decoration of the Pisa Baptistery. But the way in which he liberated, and indeed deliberately divorced, the Siena *Prophets* from their architectural setting is nevertheless as original as it is entirely appropriate to the subject matter of his cycle.

On the Perugian Fontana Maggiore, several of the figures are transitional in style between Nicola's Siena Duomo pulpit figures and Giovanni's Siena Duomo façade *Prophets*.[30] Set against the oblique-angled corners of the 24-sided fountain basin, figures like that of *Theology* have just enough freedom to indulge in tentative movements which, complemented by the fluid patterns of their draperies, already differ from the serene poise of Nicola's Siena pulpit figures.[31] But the style and expressive character of the Siena façade *Prophets* are more fully foreshadowed in the pinnacle figures of the decorated exterior screen of the Pisa Baptistery, dating probably between 1278 and 1284. In a Pisan document of March 13, 1284 Nicola is recorded as "quondam magistri Nicholi," which shows that he died while the Pisa Baptistery decoration was in progress. Whereas Nicola seems to have carved the monumental half-length figures set into the gables,[32] as suggested above it was probably Giovanni who was responsible for the series of free-standing figures set at the highest, and most exposed, level of the decoration.[33] These figures are now weathered almost beyond recognition, but a sense of rhythmic vitality can still be discerned in the free flow of limbs and in the thick, looping drapery that swings to and fro across and around the forms. This is an indication of the dramatic range already inherent in Giovanni's figure-carving style. His work on the Pisa Baptistery exterior moreover shows Giovanni gaining further valuable experience. In this project he had the occasion to learn both how to construct and to define figures that can be understood in their full dynamic potential along the steep angle of view from below at ground level, and how to design insistently eye-catching figures fully liberated from any limiting architectural context. This earlier experience was crucial to Giovanni Pisano's achievement in the Siena Duomo façade figures. It also perhaps accounts for the faith placed in him by the Duomo *operai* as the sculptor best able to give the *Prophets* the rhetorical urgency they needed, in order not just to capture the attention of those about to enter the Duomo but also to demand that they listen to their messages foretelling the incarnation of Christ.

The dynamic forward movement of some of the Siena Duomo *Prophets* is enhanced by the articulation of the wall surface against which they are seen. Behind each figure is a vestigial niche formed by a series of three superimposed low-relief blind arches. These arches are so designed that, when seen from ground level, they fall into a pattern that suggests that they

form a deep opening, through which the figure has emerged onto the parapet. The setting of the figures outside, and in front of, these niches consciously demonstrated their freedom from any architectural confinement. Moreover, this placement seems to encourage the figures to engage positively, even in some cases aggressively, with each other and with the observers below.

Another technique that Giovanni Pisano determinedly used to invigorate his *Prophets* was to excavate unusually deeply into each block as he carved out the active drapery folds and facial features. This had two effects: through the interplay of white marble and dark shadow the figures' visibility across the distance from the ground was increased, and the dramatic vitality of their movements was emphasized. The figure of *Isaiah* (Figure 1.3), for example, was extensively worked with the drill, which was used to pierce a series of deep holes into the block along the lines of furrows between drapery folds. Picks and chisels were then used to link together these drill-holes to generate deeply-carved fissures. These hold dark shadows that help to create strong tonal contrasts across the figure; and over time these contrasts have been reinforced by the accumulation of dirt within the furrows. In turn, these tonal contrasts increase the definition of movement both in the draperies and by extension in the anatomical forms themselves. Thus the figures retain and fully project their inherent vitality when observed from a distance below. Finally, Giovanni reinforced this vitality in many cases by designing drapery folds that slice diagonally across the body and flow as though in motion down to the feet.

As in the *Sibyls* of the Sant' Andrea, Pistoia pulpit a decade or so later, Giovanni also designed and carved his *Prophets'* facial expressiveness with relentless energy. Set on elongated and extruded necks to allow for clear visibility from the assumed angle of view from below, the figures' heads lean round or forward to present their expressive characters visibly and vigorously. Their gestures, and the strong movements of arms and hands which hold their scrolls out for ease of reading the texts, all further emphasize the rhetorical challenge of their forcefully communicating faces. The treatment of hair, beards and facial features again shows Giovanni's extensive use of the drill for deep excavation into the block. On the head of *Isaiah* (Figure 1.4) the line of the eyebrows is reinforced by a series of deep drill-holes, and the twists and curls of the beard hairs are defined as much with the drill as with the deep furrows of the chisel. Emphasized by the strong tonal contrasts produced by drilling and gouging into the block, the windswept flow of the *Prophets'* tousled hair emphasizes their didactic energy.

The challenge that these theatrical figures present to the upward-looking observer is echoed in the challenge set by Giovanni's Pisa Duomo pulpit inscriptions, where he urges any of us "who wonders at them [his figures] to test them with the proper rules." His confidence in carving deeply into the block to generate dramatic diagonals of drapery folds which invigorate the figures' outward movements is matched by his arrogant-sounding conviction that he is "endowed above all others with command of the pure art of sculpture …

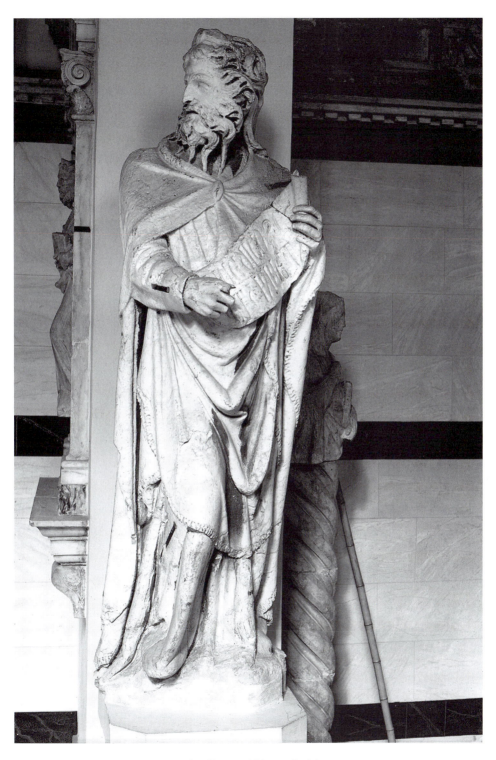

1.3 Giovanni Pisano, *Isaiah*

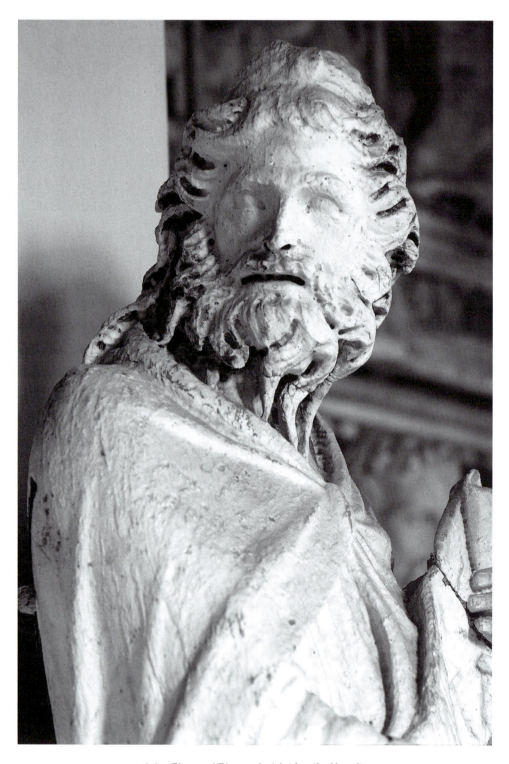

1.4 Giovanni Pisano, *Isaiah* (detail of head)

to Giovanni remain the honors of praise … Christ have mercy on the man to whom such gifts were given." Finally, the rhetorical strength and expressiveness of the discourse and prophetic communication of the Siena Duomo façade figures indeed bears out Giovanni's assertions that he has the greatest "command of the pure art of sculpture, sculpting splendid things in stone, wood and gold … He has made noble sculptures and diverse figures." Both in word and in sculptural image, Giovanni Pisano's rhetoric is amongst the most powerful in the history of Western sculpture.

Notes

1 For the Pistoia Pulpit, see especially Gian Lorenzo Mellini, *Il Pulpito di Giovanni Pisano a Pistoia* (Milan: Electa Editrice, 1970); and recently Anita Fiderer Moskowitz, *Pious Devotion – Pious Diversion. Nicola and Giovanni Pisano: The Pulpits* (London and Turnhout: Harvey Miller, 2005), 73–91.

2 See Anita Fiderer Moskowitz, *Italian Gothic Sculpture c. 1250–c. 1400* (Cambridge: Cambridge University Press, 2001), 74 and 336, n. 27.

3 Michael Ayrton, *Giovanni Pisano Sculptor* (London: Thames and Hudson, 1969), 205, n. 5; Enzo Carli, *Il Pulpito di Siena* (Bergamo: Istituto italiano d'arte grafiche, 1943), pls 93a, 93b, and 94–5.

4 For the sibyls and for their treatment in late medieval and Renaissance art, see *inter alia* Peter Dronke, "Medieval Sibyls: Their Character and their 'Auctoritas,'" *Studi medievali* 36 (1995): 581–615; William Lewis Kinter and Joseph R. Keller, *The Sibyl: Prophetess of Antiquity and Medieval Fay* (Philadelphia: Dorrance, 1967); Edgar Wind, "Michelangelo's Prophets and Sibyls," *Proceedings of the British Academy* 51 (1960): 47–84; reprinted in George Holmes, *Art and Politics in Renaissance Italy* (Oxford and New York: Oxford University Press, 1993), 263–300, especially 273–89; and Bernard McGinn, "*Teste David cum Sibylla*: The Significance of the Sibylline Tradition in the Middle Ages," in *Women of the Medieval World*, ed. Julius Kirshner and Suzanne F. Wemple (Oxford and New York: Blackwell, 1985), 7–35.

5 Ayrton 1969, 126 and 130.

6 Her scroll was originally inscribed "Et vocabit Deus et Homo"; see John White, *Art and Architecture in Italy 1250–1400* (1966; reprint Harmondsworth: Penguin Books, 1987), 117.

7 It seems now generally to be agreed that the Pisa Duomo pulpit has been underrated in the past, and that as a whole Giovanni's artistic and technical achievement here warrants to a considerable degree the praise that he accords to himself in his inscriptions, cited below. Nevertheless, on account either of later damage, workshop intervention in the carving, or surface preparation appropriate to subsequent polychrome pigmentation, some of the carving lacks the skill and expressiveness of Giovanni's work on the Pistoia pulpit.

8 "Janua perficitur vario constructa decore ex quo virgineum Christus descendit in alvum anno MCLXXX ego Bonanno Pis. mea arte hanc portam uno anno perfeci tempore Benedicti operarii;" see William Melczer, *La Porta di Bonanno nel Duomo di Pisa: teologia e immagine* (Ospedaletto: Pacini, 1988), 29. The north Italian Romanesque sculptors Wiligelmo and Niccolò had added self-praising

inscriptions to their sculpture on the façades of, respectively, the Duomo of Modena in around 1100 and the Duomo of Ferrara in around 1135: "Inter scultores quanto sis dignus onore / claret scultura nunc wiligelme tua;" see Roberto Salvini, *Wiligelmo e le origini della scultura romanica* (Milan: A. Martello, 1956), 98; "Artificem gnarum qui sculpserit haec Nicholaum / Hunc concurrentes laudent per secula gentes;" see G. H. Crichton, *Romanesque Sculpture in Italy* (London: Routledge and Kegan Paul, 1954), 22.

9 "Anno milleno bis centum bisque triceno hoc opus insingne sculpsit Nicola Pisanus laudetur dingne tam bene docta manus;" the translation is from John Pope-Hennessy, *Italian Gothic Sculpture* (1955; reprint, Oxford: Phaidon Press, 1986), 170.

10 "Laude dei trini rem ceptam copulo fini / cure presentis sub primo mille tricentis. / Princeps e[st] op[er]is pleban[us] vel dator eris / Arnold[us] dictus qui semp[er] sit benedictus / ... sculpsit Joh[ann]es qui res no[n] egit inanes / Nicoli nat[us] sensia meliore beatus / que[m] genuit Pisa doctu[m] sup[er] omnia visa;" full text and translation in Pope-Hennessy 1986, 177. Note the comparable passage in the inscription on the Fontana Maggiore in Perugia, of 1278: "The names of the worthy sculptors of the fountain are these: Nicola honored in his art and respected on all sides. He is the finest flower of honest sculptors. First comes the father, next the most dear son, whose name is Giovanni. May the Pisans be for long preserved on their course." The original text runs "Nomina sculptorum fontis sunt ista bonorum. [Arte hono]ratus Nicolaus ad [omnia gra]tus est flos sculptorum gratissimus isque proborum. Est genitor primus genit[us] carissimus imus. Cui si non dampnes nomen dic esse Ioannes. Itu [or Natu] pisani sint multo tempore sani;" see Pope-Hennessy 1986, 173.

11 "Laudo deum verum per quem sunt optima rerum / qui dedit has puras hominem formare figuras. / Hoc opus his annis domini sculpsere Iohannis / arte manus sole quondam natique Nichole / cursis undenis tercentum milleque plenis ... / hic assistente Nello Falconis habente / hoc opus in cura nec non opere quoque iura / est Pisis natus ut Iohannes iste dotataus / artis sculpture pre cunctis ordine pure / sculpens in petra ligno auro splendida tetra / sculpere nescisset vel turpia si voluisset. / Plures sculptores: remanent sibi laudis honores / claras sculpturas fecit variasque figuras / quisquis miraris tunc recto jure probaris / Criste miserere cui talia dona fuere. Amen;" original text and translation in full in Pope-Hennessy 1986, 177–8.

12 This complaint is often taken to refer to the difficulties Giovanni Pisano experienced over the Siena Duomo façade project; see below, n. 27.

13 For the text and translation, see Pope-Hennessy 1986, 178.

14 White 1987, 133. It should be noted that in Andrew Ladis, "Giovanni Pisano: Unfinished Business in Siena," *Arte Cristiana* 82, no. 762 (1994): 177–84, at 182, the author gives a distinctly different translation of the second reference to "jure:" "Whoever you are, when you have marveled [at them], then you will approve them rightly."

15 Ayrton 1969, 158.

16 Jules Lubbock, *Storytelling in Christian Art from Giotto to Donatello* (New Haven and London: Yale University Press, 2006), 115–38.

17 *Ibid.*, 117; elsewhere (*ibid.*, 123, caption to figs 79a–b) he emphasizes the second of these "refinements": "the 'correct law'" is Giovanni's "anamorphotic system of focusing and defocusing individual episodes."

18 Charles Seymour Jr., "Invention and Revival in Nicola Pisano's 'Heroic Style,'" in *Studies in Western Art. Acts of the XX International Congress of the History of Art*, ed. Millard Meiss (Princeton: Princeton University Press, 1963), 1: 207–26; Francis Ames-Lewis, *Tuscan Marble Carving 1250–1350: Sculpture and Civic Pride* (Aldershot and Brookfield: Ashgate, 1997), 70; and especially Eloise M. Angiola, "Nicola Pisano, Federico Visconti, and Classical Style in Pisa," *Art Bulletin* 54 (1977): 1–27.

19 For this project, see especially Antje Middeldorf Kosegarten, "Die Skulpturen der Pisani am Baptisterium von Pisa," *Jahrbuch der Berliner Museen* 10 (1968): 14–100.

20 Pietro Toesca, *Storia dell'arte italiana, II: il Trecento* (Turin: Unione Tipografico—Editrice Torinese, 1951), 221–3 and 225, n. 27. Parallels are often drawn in the literature between Giovanni Pisano's figure-sculpture and that especially of Rheims Cathedral, and it is often suggested that Giovanni might have visited France sometime between 1268 (the year of completion of the Siena Duomo pulpit) and 1278 (the year of commencement of the Fontana Maggiore in Perugia), during which decade there are no documentary references to him. See for example Ayrton 1969, 42–3; Pope-Hennessy 1986, 175; Moskowitz 2001, 70 and 335–6, n. 10; and most fully Robert Dan Wallace, *L'influence de la France Gothique sur deux des précurseurs de la Renaissance: Nicola et Giovanni Pisano* (Geneva: Librairie E. Droz, 1953), especially ch. 4 ("La Fontaine de Perouse"), 89–96 and pt. 4, "L'influence de la France sur l'oeuvre independante de Giovanni Pisano," 101–20.

21 Most recently, see Brendan Cassidy, *Politics, Civic Ideals and Sculpture in Italy c. 1240–1400* (London: Harvey Miller, 2007), 107–11 and 118.

22 For alternative identifications, see Angiola 1977, 15 and figs 14–15 (as Daniel), and more recently Creighton Gilbert, "The Pisa Baptistery Pulpit Addresses its Public," *Artibus et historiae* 41 (2000): 9–30, at 26–7 and fig. 8 (as Judah).

23 Moskowitz 2005, 95.

24 Lubbock 2006, 125.

25 The original of this inscription was lost after the pulpit was demolished after the fire of 1595 that destroyed large parts of the Pisa Duomo. When the pulpit was reconstructed by Peleò Bacci in the mid-1920s a new plinth was inscribed with the original text that had been preserved in two written sources: Paolo Tronci (1635; MS Archivio capitolare di Pisa, c. 152) and Pisa, Archivio di Stato MS Roncioni 339, cc. 7–8; see Pèleo Bacci, *La ricostruzione del Pergamo di Giovanni Pisano nel Duomo di Pisa* (Milan and Rome: Bestelli e Tumminelli, 1926), 49.

26 "Circuit hic amnes mundi partesque Ioannes / Plurima temptando gratis discenda parando / Queque labore gravi nunc clamat non bene cavi / Dum plus mostravi plus hostita damna probavi / Corde sed ignavi penam fero mente suavi / Ut sibi livorem tollam mitigemque dolorem / Et decus implorem versibus adde rorem / Se probat indignum reprobans diademate dignum / Sic hunc quem reprobat se reprobando probat;" translation cited from Pope-Hennessy 1986, 178. The intense, compelling rhetoric of Giovanni's inscriptions has tended to stimulate equally rhetorical comment, as for example in Ladis 1994, 177–84, where the author concludes his discussion, on 184, with respect to the second Pisa Duomo pulpit inscription, by noting that "[i]mpassioned, bitter, and conflicted, stung by condemnation, foreseeing more, and forestalling all with a conclusion seeking less to praise than to blame, Giovanni has insisted on the last word, but it is one whose inescapable shadow is guilt, perhaps about

opportunity squandered and glory unrealized." One can easily understand how this comes about in response to Giovanni Pisano's figure-sculpture; and indeed, the reader of this study may well feel that its author too has in places fallen into the same trap.

27 For the documents, see Pèleo Bacci, *Documenti e commenti per la storia dell'arte* (Florence: Casa Editrice Felice Le Monnier, 1944), 26–51, cited in summary by Ladis 1994, 180. See also *inter alia* Enzo Carli, *Giovanni Pisano* (Pisa: Pacini, 1977), 38–40; Ayrton 1969, 88–9; Moskowitz 2005, 111.

28 The discussion here of the figure-sculpture on the Siena Duomo façade is closely based on Ames-Lewis 1997, 153–60.

29 Willibald Sauerländer, *Gotische Skulptur in Frankreich: 1140–1270* (Munich: Hirmer, 1970), 58 and 53 plate IV.

30 The inscription on the Perugian Fontana Maggiore implies that these carvings were commissioned from Nicola Pisano, with whom his son Giovanni was then still working; see above, n. 10.

31 For this figure see Ayrton 1969, 49 fig. 34, and Mellini 1970, 26 and figs 44–5. Pope-Hennessy (1986, 174) noted that the figure of "Ecclesia Romana [is representative of] Giovanni's style at this time."

32 For these, see Ayrton 1969, 60–75 figs 64–79.

33 See Ayrton 1969, 76–83, figs 80–91.

Professors and princes: patronage of sculpture in the Cappella Bentivoglio, Bologna

David J. Drogin

Despite the Bentivoglio family's dominance in Bologna from 1401 to 1506, little remains of their artistic patronage. Fortunately, two sculptures at the Bentivoglio Chapel in San Giacomo Maggiore enhance our understanding of the Bentivoglio and of their patronage strategies as the city's preeminent family: the tomb of university lecturer and *condottiere* Antongaleazzo Bentivoglio (c. 1430), partially carved by Jacopo della Quercia, which joins the local professor-tomb tradition by representing the *dottore* lecturing to students; and, as a point of comparison, the equestrian cenotaph of Annibale Bentivoglio (1458), perhaps by Pagno di Lapo Portigiani, which was part of a revival of equestrian monuments in the mid Quattrocento. Both shed light on unique intersections of political power and sculptural patronage in fifteenth-century Italy, particularly in terms of how sculpture contributed to the appearance of political legitimacy when that legitimacy was threatened or was unfounded from the start. Thanks to scholars such as John Paoletti, art historians have become well informed about various ruling families' patronage practices in these delicate circumstances. Familiar paradigms include the fifteenth-century Medici and the intricacies of dominating a republic as *primus inter pares*; in the realm of courts, one can think of the Sforza of Milan and their efforts to replace authoritatively the Visconti dukes whom they supplanted at mid-century. There are some similarities in patronage strategies between the Bentivoglio and these dynasties, but because the Bentivoglio's status changed mercurially within a generation, there is a corresponding dynamic range in their artistic patronage tied to their role as leaders. This range is broader in their case than in those of their more thoroughly studied peers, perhaps because their artistic patronage was also affected by alignment with different socio-political hierarchies and by relevant lexicons of authority, which varied greatly as the Bentivoglio's status rose. The Bentivoglio Chapel sculptures offer their own compelling testimony of these circumstances and reveal the shifting strategies that the family employed to authenticate its precarious rule over Bologna.

Specifically, Antongaleazzo's tomb and Annibale's cenotaph illustrate how the Bentivoglio adjusted their representational emphasis from iconography that legitimated the family as *local* oligarchs, to imagery that associated them with broadly recognized forms of princely power.

* * *

To understand how these sculptures illustrate the intersections of power and iconography in the city, a summary of Bentivoglio ascendency is in order. From the thirteenth to fifteenth centuries, Bologna was technically a republic governed by several legislative bodies and, after the mid 1300s, jointly with a papally appointed legate.[1] The Bentivoglio were members of the Anziani, the most powerful legislative body, from the late thirteenth century.[2] Bentivoglio domination of the city began with Giovanni I, who briefly controlled the city as its *signore* from February 1401 until his assassination in June 1402.[3] Although Giovanni's rule was brief, it introduced the concept of Bentivoglio stewardship to Bologna and to Italy at large; this eventually enabled his descendants to reestablish and consolidate control over the city.

After Giovanni I's death, control over Bologna rapidly changed hands, moving from the Milanese Giangaleazzo Visconti to Legate Baldassare Cossa (later Pope Giovanni XXIII) to the standard of shared rule by the Sedici and legate. In January 1420, Antongaleazzo Bentivoglio, Giovanni I's son and one of the highest-paid professors at the University of Bologna, occupied the Palazzo del Comune and declared himself Signore di Bologna.[4] Pope Martin V and local Bentivoglio rivals led by the Canetoli family were able to exile Antongaleazzo four months later. Interestingly, while Antongaleazzo remained in exile, the papacy favored him with titles and benefices, including an appointment as papal *condottiere*.[5] Then, on December 4, 1435, after Pope Eugenius IV and Cosimo de' Medici had arranged the suppression of the Canetoli faction, Antongaleazzo reentered Bologna as its leader.[6] His stewardship was extremely short-lived, however: he was beheaded on December 22, 1435, less than three weeks after his return.[7]

Antongaleazzo's son Annibale emerged as Bologna's *de facto* ruler amidst the upheavals following his father's death in 1435. It is Annibale's use of and representation in the arts, and his identity as liberator from tyrants, that inform analysis of the Bentivoglio sculptures considered here. First, by 1438, Annibale was living in the family's traditional quarter in Strada San Donato (present-day Via Zamboni), collecting the income and favors granted by the Sedici.[8] Then, between 1438 and 1442, the Milanese Piccinino family took control of Bologna, imprisoning Annibale and suspending the republican bodies.[9] In the summer of 1443, Annibale escaped and led Bolognese forces to defeat the Piccinino and their Milanese supporters. For almost two years, Annibale and his faction controlled the city; but like his predecessors, his *signoria* was short-lived: he was assassinated by the Canetoli in June 1445.[10]

Despite Annibale's brief tenure as Bologna's *signore*, he did facilitate a permanent imprint of Bentivoglio rule. For it was in early 1445 that Annibale purchased the site of the Bentivoglio Chapel in the ambulatory of San Giacomo Maggiore, a chapel that his successors Sante and Giovanni II built and decorated in the 1450s–90s, including painting commissions from Lorenzo Costa and Francesco Francia.[11] Annibale installed the tomb to his father Antongaleazzo facing the entrance to this chapel.

The tomb (Figure 2.1) is an elevated, wall-mounted sarcophagus carved of Istrian stone. Free-standing figures of Paul, the Virgin and Child, and Peter stand above figures of Justice and Temperance on either side of a high-relief *gisant* figure of the deceased on the sloping lid. The front of the sarcophagus presents figures of Prudence and Fortitude flanking a three-paneled relief. These reliefs are the tomb's semantic core, representing the professor lecturing to his students: the center panel contains the deceased *in cathedra* while the two side panels represent a total of 21 students sitting at their desks in a variety of activities including reading and speaking to one another.

General consensus since the mid nineteenth century has been that the tomb was carved partly by Jacopo della Quercia in the early 1430s and then installed by Annibale Bentivoglio between 1443, when he returned triumphantly to Bologna, and 1445, the year he purchased the chapel site (also the year he was killed).[12] Attribution to Jacopo is sustained by comparing the monument's bulky physiognomies and undulous drapery to his contemporary work on the main portal of San Petronio in Bologna. More importantly, partial attribution is supported by documents related to Jacopo's San Petronio workshop. Documents from 1433, 1439, and 1442 explain that Jacopo had begun the tomb by 1433 for a different professor (the 1442 document refers to the tomb made for "Varis de Ferraria"), and that after the sculptor's death in 1438 the tomb was held by the Fabbrica di San Petronio because of his debts.[13] The assumption is that when Annibale returned to Bologna hailed as a liberator from Milanese despots in 1443, he was able to acquire the escrowed tomb for his father.

There may appear to be disjunctures between the tomb's iconography, Antongaleazzo's biography, and Annibale's need to celebrate the family's status in Bologna. Simply put, why would Annibale commemorate his father—a papal man-at-arms who had briefly been Signore di Bologna—with a university lecturer's tomb, particularly at such a tenuous moment in his own political ascendancy? The key is the unique status of the city's university professors, with their centuries-long tradition—exclusive to Bologna—of dominant political figures being commemorated in professor tombs.[14] This informs Antongaleazzo's monument and Annibale's appropriation of it in the context of mid fifteenth-century Bologna and the Bentivoglio's ascendency.

About a dozen of these professor monuments survive, but three definitive examples were instrumental in enabling the political semantics of Antongaleazzo's tomb. The monuments to Rolandino Passeggeri (c. 1300), Giovanni d'Andrea (c. 1350), and Giovanni da Legnano (c. 1385), commemorate university professors who had dominated Bolognese politics in their day,

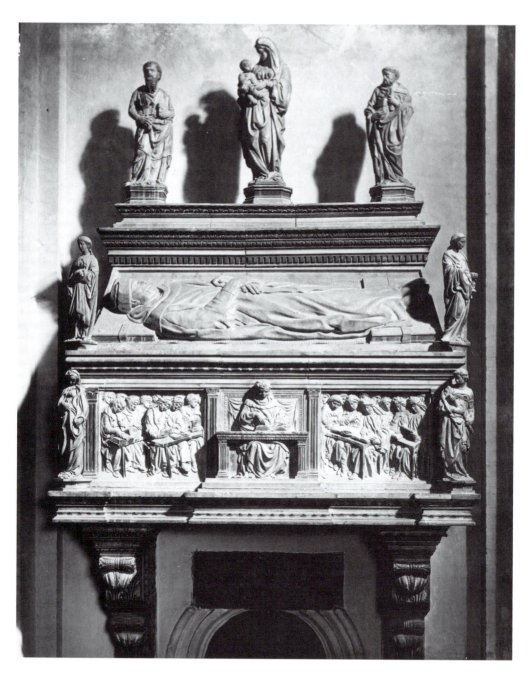

2.1 Jacopo della Quercia, *Tomb of Antongaleazzo Bentivoglio*, San Giacomo Maggiore

to the extent of being recognized internationally as its leaders. Passeggeri, a professor of civil law, had led one of the most politically powerful groups in the city as a leader of the notaries. By the late thirteenth century, he held the most important reins of power in Bologna: among other posts, he wrote city statutes, he was chief administrator of the militia, he was an *Anziano perpetuo*, and he supervised exiles.[15] His free-standing monument, a sarcophagus elevated under a pyramidal roof, was erected in the cemetery (now piazza) of San Domenico. It was commissioned from Giovanni da Viviano and Pietro di Corrado by the Compagnia dei notai shortly after Passeggeri's death in 1300. According to Panofsky, it is one of the first medieval secular tombs to glorify the deceased by representing scenes from his life rather than with eschatological iconography.[16] In this case, one side of the sarcophagus represents a schematized, profile relief of Passeggeri *in cathedra* facing four rows of students bowing over their desks before him (Figure 2.2).

2.2 Giovanni da Viviano and Pietro di Corrado, *Tomb of Rolandino de' Passeggeri* (detail), San Domenico

The sarcophagal classroom lecture scene as a signifier of authority in Bologna was further codified by the tombs of d'Andrea and da Legnano. D'Andrea (d. 1348) was the foremost professor of Canon Law in the mid 1300s and, like Passeggeri, he was also a dominant political force in Bologna: for instance, he served as judicial arbiter and ambassador abroad.[17] His tomb, presently in Bologna's Museo Civico Medievale, is an interior, elevated wall-tomb in the format that had become standard for fourteenth-century professors' monuments, and which reappears in Jacopo's monument for Antongaleazzo Bentivoglio. A tripartite relief represents the professor seated frontally and centrally between two panels of students at their desks; above, a sloping roof holds a *gisant* figure of the deceased. This is the same format as Jacobello and Pierpaolo dalle Masegne's monument to Giovanni da Legnano (d. 1383), who officially represented Bologna in its political missions of the 1370s, who was invited by the pope to present hats and titles to new Bolognese cardinals,

and who was, according to Guido Zaccagnini, "considered the *primo uomo*" of Bologna.[18]

The monuments to Passeggeri, d'Andrea and da Legnano, as well as the other surviving Bolognese professor tombs, represent the professor lecturing authoritatively to students bent submissively over their desks, imagery not inappropriate for a city ruler: the presence of books, the gesture of address, and the arrangement of subordinate figures are multivalent signifiers of authority, knowledge, and hierarchical domination. Considering this imagery along with the long tradition of the tombs in Bologna, Antongaleazzo's monument is therefore quite savvy. At a time when the city had been dominated by foreign tyrants such as the Milanese Piccinino, and Neapolitan and Venetian popes, Annibale commemorated his father with *local* iconography of civic authority, associating Antongaleazzo with native rulership in opposition to the foreign interference which had upset Bologna's political equilibrium at this time. The iconography's very local nature is emphasized by the fact that no other university city displays the same iconographic regularity in its professor monuments; furthermore, none share Bologna's classroom-lecture imagery.[19] In short, it was clearly identifiable as an emphatically Bolognese type. We should also note that, on the surface, the Bentivoglio monument represents academic service to a local academic institution; it thereby decorously maintains proper humility in a republic overseen by the papacy. Thus, in parallels to Medici patronage from the same period, Annibale cloaked his bold political claims in unassuming guises.

It should also be noted that both Giovanni da Legnano's tomb by the dalle Masegne brothers and Antongaleazzo's tomb by Jacopo della Quercia contributed additional prestige by virtue of their authorship. Both were carved by some of the most important sculptors in contemporary Italy, with major monuments in Bologna itself. The Venetian dalle Masegne were esteemed in northern Italy, but particularly in late Trecento Bologna for S. Francesco's enormous, marble high altar; the Sienese Jacopo was renowned in the mid Quattrocento for works throughout Tuscany and locally for the *Porta Magna* of San Petronio.[20]

The particularly local nature of Antongaleazzo's tomb stands out all the more when it is judged against Annibale's own funerary monument. By comparing these two works, one notices that the strategies of representation changed radically within a generation: whereas Antongaleazzo's tomb was suited for a dynasty making its first steps toward a local political hegemony able to oppose foreign rule, Annibale's cenotaph looks to seigniorial iconography common outside Bologna's walls. This demonstrates efforts to link what had become a more established and internationally recognized Bentivoglio dynasty with the imagery of powerful *condottieri*, princes, and kings outside the city. The shift to widely legible rulership imagery can also be attributed to the likely patron of the cenotaph, Annibale's successor, Sante Bentivoglio, who served as Bologna's *de facto* ruler from 1446 to 1463 after growing up in Cosimo de' Medici's Florence. With his Florentine background and with the levels of power he achieved, as described below, it is logical that his patronage

and strategies of familial self-fashioning would move beyond the strictly local focus of his predecessor.

The equestrian relief on the south wall of the Bentivoglio Chapel represents Annibale in armor on a rearing horse, holding his captain's baton (Figure 2.3). The inscription below identifies him as the liberator from tyrants who was then murdered by ungrateful masses.[21] The relief is unsigned. Although the date 1458 appears at the bottom of the fictive doorway that surrounds the figure, this cannot be when the relief was installed in the chapel, since it has been placed on top of (and has largely destroyed) a painting by Lorenzo Costa commissioned by Giovanni II Bentivoglio in the late 1480s.[22] In addition, this is likely not the relief's original location because the horse and rider face away from the altar toward the entrance, contrary to tradition.

Annibale's relief counts among the widespread, mid fifteenth-century renascence of equestrian monuments. The most relevant precedents to the Bentivoglio monument were nearby and recently completed: in Ferrara, Niccolò Baroncelli's monument to Marquis Niccolò III d'Este (1451) and, in Padua, Donatello's monument for the *condottiere* Erasmo da Narni, commonly known as Gattamelata (1453). One should also keep in mind the equestrian relief of papal captain-general Antonio Rio (c. 1450) in San Francesco Romana and the monument to French King Charles VII on the façade of the Hôtel Jacques Coeur in Bourges (c. 1450, destroyed in the eighteenth century).[23] Earlier equestrian monuments, which served as rulers' tombs, include that to Bernabò Visconti in Milan (c. 1363) and those to the Trecento lords of Verona, the Scagliere. Naturally, Renaissance types commemorating authoritative rulership invoke the surviving classical prototypes: the *Marcus Aurelius* in Rome, thought at the time to represent Emperor Constantine, and the so-called *Regisole* in Pavia (destroyed in 1796), thought to represent Emperor Theodoric.

It is apparent that, at the time Annibale's equestrian relief was carved in the mid Quattrocento, the large-scale figure on horseback was linked not only to successful men-at-arms (Gattamelata, Antonio Rio), but also, with echoes of imperial prestige, to powerful heads-of-state (the Scagliere, Bernabò Visconti, Niccolò III d'Este, and Charles VII). In fact, as Janson wrote, fifteenth-century Italians inherited and merged two types of equestrian monuments: free-standing statues of sovereigns and wall tombs for *condottieri*.[24] Annibale Bentivoglio's monument is emblematic of this conflation, not only because Annibale was both a *condottiere* and ruler of Bologna, but also because the wall-mounted relief was carved to create the illusion that the horse and rider are free-standing. Thus, as with Antongaleazzo's tomb, the Bentivoglio leader is identified as a ruler, in this case through links to seigniorial equestrian monuments, but his monument also feigns avoidance of princely imagery that would have been inappropriate in contemporary Bologna. The latter is underscored by the inscription that ties Annibale, rather than to any *signoria*, to the 1443 military victory over tyrants. Unlike the exclusively local iconography of Antongaleazzo's tomb, the equestrian relief's imagery was legible to—and indeed was borrowed from—rulers throughout Italy and Europe.

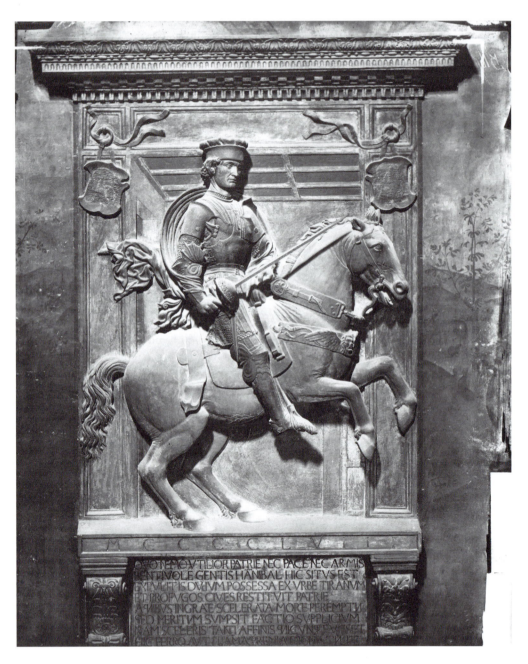

2.3 Attributed to Pagno di Lapo Portigiani, *Monument to Annibale Bentivoglio*, San Giacomo Maggiore

The relief's cosmopolitan quality is linked to its likely patron, Sante Bentivoglio. Sante was Annibale's successor as leader of Bologna, but his roots lay outside the city and his political upbringing inculcated the utility of broadly recognized rulership imagery. Sante was Annibale's first cousin, the illegitimate son of Ercole Bentivoglio, Antongaleazzo's brother. He was born c. 1425 after Ercole's tryst with the wife of Agnolo da Cascese in the Florentine *contado*, where he was initially raised by the Cascese family. When Sante was an adolescent, the Cascese sent him to Florence as a wool merchant, recommending him to Neri Capponi, the powerful Medici ally (who was as yet unaware of Sante's Bolognese lineage). After Annibale's death in 1445, a Bolognese delegation came to Florence, where they met with Capponi and Sante, revealed Sante's pedigree, and requested his return to Bologna. The Bolognese likely envisioned Sante as a temporary placeholder for Giovanni II, Annibale's young son, rather than as definitive leader of the Bentivoglio faction. In any case, Sante was reportedly reluctant to go until Capponi and Cosimo de' Medici—keen about the prospects of a Florentine ally at Bologna's helm—convinced him to assume the responsibilities (Cosimo reportedly told him he was either the son of a Bentivoglio, in which case he would face a great future in Bologna, or he was the son of provincial wool merchants, staying in Florence and doing his "little things").[25]

With roots in the Medici inner circle, Sante, more than any of his predecessors, was highly dependent on and familiar with the mechanics of power outside Bologna. Furthermore, in addition to having strong Medici connections, Sante was friendly with the Este and became closely linked to the Sforza, marrying Ginevra Sforza (niece of Francesco and daughter of Alessandro, Lord of Pesaro, and the half-sister of Battista, wife of Duke Federico da Montefeltro of Urbino). He also dealt closely and triumphantly with the papacy, most importantly in 1447 when he negotiated new accords with Pope Nicholas V. These secured new levels of Bolognese autonomy and cemented Sante's status as ruler of the city.[26] Sante continued to accrue power and prestige until his natural death in 1463, almost 20 years after he had become Bologna's ruler; one of his grandest moments had come in 1461 when Holy Roman Emperor Frederick III granted Sante the right to create knights.[27]

With such significant connections abroad, it follows that Sante's artistic patronage would favor styles and iconographies not confined to the Bolognese idiom, which in turn informs discussions about the relief's attribution. Although the relief was weakly attributed to Niccolò dell'Arca in the nineteenth century, a more recent suggestion is Pagno di Lapo Portigiani, a Tuscan sculptor and architect who worked with Donatello, Brunelleschi, and Michelozzo on Medici-related projects such as the tomb of Pope Giovanni XXIII and the Tabernacle of the Annunciation in SS. Annunziata.[28] By 1453, he was active in Bologna, and a connection to Sante's sculptural patronage is appealing because of their common connection to the Medici.[29] Some stylistic issues problematize a Pagno attribution, however, and perhaps a more satisfying attribution can be proposed.[30] The classicizing architectural framework and naturalistic horse

are conflated with the fantastical, densely decorative style of the rider and his attire; while the former points to a sculptor familiar with the Tuscan idiom, the latter suggests an artist active around Ferrara and Padua. It is worth remembering that in the early 1450s, two major Florentine sculptors were active in this area, creating equestrian monuments, no less: Niccolò Baroncelli working on the monument to Niccolò III d'Este, and Donatello working on the *Gattamelata*. The sculptor of Annibale's relief may have been an artist from the region who had worked in a Florentine's workshop: an artist familiar with Tuscan design concepts who "speaks" with a northern Italian vernacular.[31]

The artistic profile described above exactly matches that of Sante as a patron, with his Florentine roots, Bolognese dominion, and primarily northern Italian peer group. And, of course, the 1458 date on the relief coincides with Sante's rule. Furthermore, the widespread appeal of the equestrian iconography, popular among instrumental peers throughout Italy and beyond, also suggests the patronage of Sante, with his international roots and connections, and with a political biography marked by longevity and success, within and beyond Bologna.

Comparing the political biographies of Sante, Annibale, and Antongaleazzo, the changes and trajectories evident in the professor tomb and equestrian relief fall into place and provide instructive examples of patronage strategies in sculptural production. This analysis has shown how and why, because of the respective patrons' political exigencies and despite common factors in the deceaseds' biographies, Antongaleazzo and Annibale's commemorative sculptures create radically different identities for them. First, earlier in Bentivoglio ascendency, Annibale needed to establish himself and the family locally, in opposition to those beyond the walls who sought to control the city; he therefore celebrated those aspects of his father's identity that served that purpose, drawing on powerful—and exclusively—Bolognese traditions. Later, with Sante's long and stable rule, the Bentivoglio's status outpaced questions of local authority as the family became increasingly recognized as *signori* of Bologna, not only by local leaders but also by international figures ranging from northern Italian princes to the pope and emperor. At this point, sculptural patronage needed to articulate themes that not only were more esteemed than those expressed by the professor tomb, but could also present a standard image of authority legible to—and, perhaps more importantly, used by—the powerful princes with whom the Bentivoglio were most deeply connected.

Some of the iconography employed remains unique to Bologna and to the Bentivoglio's particular historical circumstances; on the other hand, the tactics addressed here are variants of broader Renaissance practices that are familiar to us from those of the Medici, the Este, the Sforza, the papacy and other European potentates. Adapting to contemporary political conditions and relying on sculpture to communicate authority (particularly in a funerary context) are common techniques in the patronage of Renaissance rulers; the Bentivoglio examples demonstrate how variations on these themes were

enacted outside the major nodes of Renaissance power, and shed light on the nuanced implementation of these patronage strategies.

Notes

* I owe thanks to many people who assisted with this study and with the larger project on Bentivoglio patronage from which it is drawn. I owe a particular debt to John T. Paoletti, who, with his inspiration, teaching and mentorship from my undergraduate years, started me on the path toward Renaissance studies and investigations of Bentivoglio patronage in Bologna, and who inculcated those skills necessary for scholarship in the field; I can never hope to equal the contributions he has made to Renaissance and patronage studies, and I cannot thank him enough for his support over my academic career. My tremendous thanks also to Kathleen W. Christian, my co-editor here and colleague for many, many years. Her friendship and feedback, particularly on this project, have been invaluable.

1 Bologna was papal territory from 1278, when Rudolf of Augsburg ceded the Romagna to the papacy. From the thirteenth century, the legislative bodies included (in descending hierarchical order): the Anziani, the Collegio dei Magistrati, and the Podestà; the Consiglio Maggiore; and the Consiglio Generale. In 1350, the Anziani sold control of the city to Archbishop Giovanni Visconti of Milan; in 1360, his successor, Cardinal Egidio d'Albornoz was named the first papal legate after giving the city to Pope Innocent VI. In 1377, an agreement was reached to share power between the Anziani and the legate. In 1393, the Anziani was replaced by the Sedici Riformatori dello Stato di Libertà, commonly referred to as the Sedici. They remained the most important legislative body in Bologna until they were dissolved by Pope Julius II in 1507. For the early history of Bologna's government, see for instance Cherubino Ghirardacci, *Della historia di Bologna*, pts I and II (Bologna: Rossi, 1596; Bologna: Monti, 1657); Ceclia Ady, *The Bentivoglio of Bologna: A Study in Despotism* (Oxford and London: Oxford University Press, 1937); Francesca Bocchi, "I Bentivoglio da cittadini a signori," *Atti e memorie della deputazione di storia patria per le provincie di Romagna* 32 (1971): 43–64; Lanfranco Berti, *Giovanni II Bentivoglio: il potere politico a Bologna nel secolo decimoquinto* (Bologna: Ponte Nuovo, 1976); Patrizia Colliva, "Bologna dal XIV al XVIII secolo: 'governo misto' o signoria senatoria?" in *Storia dell'Emilia Romagna*, ed. A. Berselli (Bologna: Università degli Studi di Bologna, 1977), 2: 13–34; Gina Fasoli, "Bologna nell'età medievale (1115–1506)," in *Storia di Bologna*, ed. A Ferri and G. Roversi (Bologna: Alfa, 1978); Giorgio Tamba, *I documenti del governo del comune bolognese (1116–1512)* (Bologna: n.p., 1978).

2 Albano Sorbelli, *I Bentivoglio, signori di Bologna*, ed. Marsilio Bacci (Rocca San Casciano: Cappelli, 1969), 8–9; Bocchi 1971, 43.

3 Giovanni had been Gonfaloniere di Giustizia and a member of the Sedici in the 1380s and '90s. In February 1401, Giovanni I forcibly occupied the Palazzo del Comune and within a month was confirmed by his allies in the Sedici as Gonfaloniere Perpetuo and Signore di Bologna, against the papacy's wishes. The Palazzo del Comune became known as the "Palazzo di Giovanni" and coins were minted with the Bentivoglio *stemma* of the five-toothed *sega* (saw). Giovanni had seized power with Visconti support, but in mid 1402 he switched Bologna's allegiance to less-threatening Florence. Milan then invaded Bolognese territory and by late June, Giovanni I was imprisoned in the Palazzo del

Comune where, in an angry confrontation with Francesco Gonzaga (leader of the Milanese forces), he was thrown from a window and stabbed to death in Piazza Maggiore. Filippo Bosdari, *Giovanni I Bentivoglio Signore di Bologna, 1401–1402* (Bologna: n.p., 1915), 215; Ady 1937, 9–10; Sorbelli 1969, 22; Berti 1976, 30; Tamba 1978, 20.

4 Antongaleazzo is documented as a lecturer at the University of Bologna from 1418 to 1420, where he was paid an annual salary of 300 lire, three times as much as most of the other lecturers. Archivio di Stato di Bologna, Ufficio della Camera, libro delle entrate e delle spese, anno 1419, fols 188r–196r; anno 1420, fols 235v–242r. Published in Umberto Dallari, *I rotuli dei lettori legisti e artisti dello Studio bolognese dal 1384–1799* (Bologna: R. Tipografia dei Fratelli Merlani, 1888–1924), 4: 41–2. See also Giuseppe Zaoli, "Lo Studio bolognese e papa Martino V," *Studi e memorie per la storia dell'Università di Bologna* 3 (1912): 146–9.

5 The papacy's favors included: in August 1420, Martin named Antongaleazzo "rettore della città, luoghi, castelli nelle provincie della Campagna e Maritima della Santa Sede"; the same year, Antongaleazzo was named feudal lord of Castelbolognese; in 1421, he was given the right to travel without toll or tax in papal territory; in 1426, there was agreement that Antongaleazzo and sons be held in "le grazie del Papa"; he was granted the tax on moneylenders in 1416 and again in 1426; and, in 1428, papal captains were ordered to give Antongaleazzo men and arms if necessary. Archivio di Stato di Ferrara, fondo Bentivoglio, serie patrimoniale, libro 2, fascicoli 27, 34, 35, 43, 44, 49, catastro †, libro 24.

6 Eugenius' and Cosimo's support for Antongaleazzo can be understood as self-serving: the pope was considering moving the Council of Basel to Bologna at this time, and Cosimo wanted to ensure fealty of a neighboring state because of the nascency of his own politically frangible *signoria*, established in 1434. Sorbelli 1969, 32–5.

7 For detailed accounts of the period and of relations between Antongaleazzo, the papacy and the Canetoli, see Gaspare Nadi, *Diario bolognese di Gaspare Nadi a cura di Corrado Ricci* (1435–1503; reprint, ed. Corrado Ricci, Bologna: Romagnoli dall'Acqua, 1886), 6; Ghirardacci, *Della historia di Bologna*, pt. III (1575; reprint, ed. Albano Sorbelli, *Rerum italicarum scriptores*, ser. 2, vol. 33, 1932), 3–47; Ady 1937, 13–15; Sorbelli 1969, 27–35; Tamba 1978, 20–21.

8 The same tax on money-lenders that had been granted to his father and grandfather. Archivio di Stato di Ferrara, fondo Bentivoglio, serie patrimoniale, libro 3, fascicolo 25.

9 After several years of shared governance by the legate and Sedici again, in 1438 Bologna requested help from Milan in ousting the legate. Milan sent Niccolò Piccinino, who, welcomed as a Bentivoglio ally, ousted the legate and installed a puppet Gonfaloniere di Giustizia. By 1441, however, Niccolò's son Francesco took autocratic control of the city and imprisoned Annibale. Nadi 1886, 9; Ady 1937, 28; Sorbelli 1969, 42.

10 Nadi 1886, 24; Ghirardacci 1932, 107; Ady 1937, 28; Sorbelli 1969, 44; Tamba 1978, 21.

11 The date of the chapel's acquisition is inscribed on the right pilaster of its entrance. It reads: "QUESTA CAPPELLA E DELLA MAGHA E GENEROSA CASA DI BENTIVOGLI ACQUISTATA E STABILITA E ORNATA CON LA SEPPULTURA P. LO MAGCO ANIBALE FIGLIUOLO DEL MAGCO E GENEROSO MISERE ANTONIO GALEAZ. DI BENTIVOGLI ILANI MCCCCXLV DI XXV DE FEBRARO." The 1445 date realistically refers to the

chapel's purchase, not its construction, given Annibale's short tenure in Bologna and given its Brunelleschian design, which dates its construction to the 1450s, when Sante Bentivoglio (raised in Florence, as addressed below) led the family and the city, and when Pagno di Lapo Portigiani (a Brunelleschi associate to whom the chapel's architecture is attributed) is documented in Bologna. The Costa and Francia paintings for Giovanni II Bentivoglio date from the 1480s and '90s. On the chapel's dates, see Francesco Malaguzzi Valeri, "La chiesa ed il portico di S. Giacomo Maggiore in Bologna," *Archivio storico dell'arte* 5, no. 5 (1894): 5–22; Ghirardacci 1932, 100; Anna Ottani Cavina, "La Cappella Bentivoglio," in *Il tempio di San Giacomo Maggiore in Bologna*, ed. Carlo Volpe (Bologna: Il Resto del Carlino, 1967), 117; Clifford Brown, "The Church of Santa Cecilia and the Bentivoglio Chapel in San Giacomo Maggiore in Bologna," *Mitteilungen des Kunsthistorischen Institutes in Florenz* 13 (1967–68): 301–24; Giordano Conti, "Cappelle di derivazione brunelleschiana a Bologna nel secolo XV," in *Filippo Brunelleschi: la sua opera e il suo tempo* (Florence: Centro Di, 1980), 53–60; Gertrude Billings Licciardello, "Notes on the Architectural Patronage in Bologna of the Bentivoglio," Ph.D. dissertation, Columbia University, 1990, 2, 13–19; Thorsten Marr, "Die Erlösungsallegorie von Lorenzo Costa in S. Giacomo Maggiore in Bologna," *Zeitschrift für Kunstgeschichte* 54 (1991): 521; David J. Drogin, "Representations of Bentivoglio Authority: Fifteenth-Century Painting and Sculpture in the Bentivoglio Chapel, San Giacomo Maggiore, Bologna," Ph.D. dissertation, Harvard University, 2003, 136–7.

12 This is the chronology suggested in Virgilio Davia, *Cenni storici-artistici intorno al monumento di Antonio Galeazzo Bentivoglio esistente nella chiesa di San Giacomo Maggiore* (Bologna: Tipi Governativi della Volpe al Sassi, 1835); I. B. Supino, *Iacopo dalla Quercia* (Bologna: Casa editrice Apollo, 1926), 68; Anna Maria Matteucci, "Le sculture," in *Il tempio di San Giacomo Maggiore in Bologna*, ed. Carlo Volpe (Bologna: Il Resto del Carlino, 1967), 73–82; Charles Seymour, *Jacopo della Quercia, Sculptor* (New Haven: Yale University Press, 1973), 73–4. Other scholarship through 1975 is summarized in Mario Terrosi, "Monumento funebre Vari-Bentivoglio," in *Jacopo della Quercia nell'arte del suo tempo*, ed. Giulietta Chelazzi Dini and Giovanni Previtali (Florence: Centro Di, 1975), 254. James Beck uniquely refused any participation by Jacopo, arguing that the tomb was by Niccolò di Piero Lamberti or by an anonymous Milanese sculptor. James Beck, *Jacopo della Quercia e il portale di S. Petronio a Bologna* (Bologna: Alfa, 1970), 73–4; Beck, *Jacopo della Quercia* (New York: Columbia University Press, 1991), 1: 197. On these arguments and in support of Jacopo's affiliation with the Bentivoglio monument, see Drogin 2003, 30–48.

13 In July 1433, Fabbrica payments record a shipment of stone for a tomb ("una piola da una archa") to Jacopo's shop. Archivio della Fabbrica di San Petronio, Giornale, 24–8 July 1433, fol. 212v, published in Beck 1991, 2: 495. Beck argued that this refers to Antonio da Budrio's tomb slab, but "una archa" refers to a raised monument (for example, the Arca of San Domenico), not a tomb slab. On January 12, 1439, Priamo della Quercia, Jacopo's brother, asked the Fabbrica for the release of funds, stating that the Fabbrica already had the sepulcher worth 250 florins. Archivio della Fabbrica di San Petronio, Miscellanea, vol. 2, no. 1, published and discussed in Davia 1835, 34; Gaetano Milanesi, *Nuovi documenti per la storia dell'arte Senese* (Siena: Onorato Porri, 1898), 2: 183; I. B. Supino, *La scultura in Bologna nel secolo XV, ricerche e studi* (Bologna: N. Zanichelli, 1910), doc. 73; Beck 1991, 2: 547. On August 31, 1442, the tomb was mentioned in Fabbrica records that refer to the tomb as "quandam sepulturam marmoream laboratam et sculptam per dictum quondam dominum Iacobum ad instatium illorum de Varis de Ferraria …" Archivio della Fabbrica di San Petronio, libro †,

vol. 1, fol. 68; Davia 1835, 35; Supino 1910, 171–6. Jacopo Vari is listed as a lecturer at the University of Bologna in 1392–93, 1395–96 and 1398–99; he is also documented at the University of Ferrara in 1419. Archivio di Stato di Bologna, ufficio per la condotta degli stipendiari, libro delle bollette, fols 45r–49r, 62r–65r, 120r–127r; Archivio di Stato di Bologna, ufficio di tesorerie o masseria, giornali di entrate e spese, fols 234r–242r; Archivio di Stato di Modena, Notaro Petrus de Lardis, III, 1, fol. 111. Published in Dallari 1924, 4: 17, 19, 24; Giuseppe Pardi, *Titoli dottorali conferiti dallo Studio di Ferrara nei secoli XV e XVI* (Lucca: A. Marchi, 1900), 12. For identification of Jacopo Vari as the tomb's intended recipient, see also Drogin 2003, 33.

14 On the Bolognese professor-tomb tradition through c. 1350, see Renzo Grandi, *I monumenti dei dottori e la scultura a Bologna (1267–1348)* (Bologna: Istituto della storia di Bologna, 1982). For a discussion of examples through the 1500s, and for their relation to political authority (particularly for the Bentivoglio), see Drogin 2003, 50–92.

15 Also, in a telling gesture, it was he—after Bologna's capture of Emperor Frederick II's son Enzo in 1245—who wrote the proud refusal to the imperial demand for his return. On Passeggeri's political career, see L. Colini-Baldeschi, "Rolandino Passeggeri e Nicolò III: pagine di storia bolognese," *Storie e memorie per la storia dell'Università di Bologna* 8 (1924): 155–84; Giovanni de' Vergottini, "Lo studio di Bologna, l'impero, il papato," *Studi e memorie per la storia dell'Università di Bologna*, ser. 2, 1 (1956): 19–95. On the tomb, see Vincenzo Amaldi, "Il monumento tombale di Rolandino Passeggeri in Bologna e la sua ricostruzione," *Bollettino d'arte* (1951): 266–70; Grandi 1982, 118–20; A. d'Amato, *La chiesa e l'università di Bologna* (Bologna: L. Parma, 1988), 148; Robert Gibbs, "Images of Higher Education in Fourteenth-Century Bologna," in *Medieval Architecture and its Intellectual Context: Studies in Honor of Peter Kidson*, ed. Paul Crossley and Eric Fernie (London: Hambledon Press, 1990), 270.

16 "It was along with (or even in advance of) the knights and generals … the professors—first the great jurists in the University of Bologna … who first insisted on being remembered rather than saved and [who] preferred the perpetuation of their academic function, lecturing, *per saecula saeculorum*, to the anticipation of their admission to paradise." Erwin Panofsky, *Tomb Sculpture: Four Lectures on its Changing Aspects from Ancient Egypt to Bernini*, ed. H. W. Janson (2nd edn, London: Phaidon Press, 1992), 70.

17 D'Andrea's *Novella in quinque Decretalium libros commentaria* and commentaries on Boniface VIII's *Liber sextus* were leading texts in canon law for centuries. For d'Andrea's university and political career, see F. K. Savigny, *Storia del diritto romano nel medioevo* (Turin: Gianini e Fiore, 1857), 2: 611–23; S. Kuttner, "Iohannus Andreae and his *Novella* on the Decretals," *The Jurist* 24 (1964): 393–408; K. Pennington, "Johannes Andreae's *Additiones* to the Decretals of Gregory IX," *Zeitschrift der Savigny Stiftung für Rechstgeschichte* 74 (1988): 328–47; Gibbs 1990, 277; Giorgio Tamba, "Giovanni d'Andrea," in *Dizionario biografico degli italiani*, vol. 55, ed. F. P. Casavola (Rome: Istituto dell'Enclicopedia italiana, 2000), 667–72. On d'Andrea's tomb, which has yet to be convincingly attributed, see Grandi 1982, 163–7.

18 Guido Zaccagnini, *Storia dello Studio di Bologna durante il Rinascimento* (Geneva: L. S. Olschki, 1930), 20. His great academic status is confirmed by the relatively astronomical salary of 620 lire a year. For his university and political career, see Zaccagnini 1930, 19–22. Only fragments of this tomb survive (in the Museo Civico), but like many of the other Bolognese professor tombs, its appearance

is recorded in Sygrfried Rybisch and Tobias Fendt, *Monumenta Sepulcrorum cum epigraphis ingenio ed doctrina excellentum virorum* (Bratislava: Cr. Scharffenberg, 1574).

19 Padua is the other university center with a substantial tradition of professor tombs with academic iconography. However, these tombs begin appearing after 1350, by which time the Bolognese tradition was well-established, and none of the tombs in Padua shares the unified classroom lecture iconography standard in Bologna. Furthermore, Padua's most prestigious professors were—by law—foreigners, while the most powerful professors in Bologna were Bolognese; this further underscores the emphatically local significance of the tombs' iconography and political import. On the Paduan professor tombs, see Jill Emilee Carrington, "Sculpted Tombs of the Professors of the University of Padua, c. 1358–1557," Ph.D. dissertation, Syracuse University, 1996. For detailed comparison to the Bolognese tradition, see Drogin 2003, 80–81.

20 On the dalle Masegne in Bologna, see I. B. Supino, *La pala d'altare di Jacobello e Pier Paolo dalle Masegne* (Bologna: Tip. Gamberini e Parmeggiani, 1915); Wolfgang Wolters, *Scultura veneziana gotica* (Venice: Alfieri, 1976), 1: 62–74, 213–19; Renzo Grandi, "La scultura tardogotica. Dai Dalle Masegne a Jacopo della Quercia," in *Il tramonto del Medioevo a Bologna. Il Cantiere di San Petronio*, ed. R. D'Amico and Renzo Grandi (Bologna: Museo Civico Medievale, 1987), 151–60.

21 The inscription reads: "QUO NEMO UTILOR PATRIAE NEC PACE NEC ARMIS / BENTIVOLAE GENTIS ANNIBALE HIC SITUS EST / EXPULIT IS DUDUM POSSESSA EX URBE TIRANNUM / ET PROFUGOS CIVES RESTITUIT PATRIAE / A QUIBUS INGRATE SCELERATA MORTE PEREMPTUM / SED MERITUM SUMPSIT FACTIO SUPPLICIUM / NAM SCELERIS TANTI AFFINIS QUICUMQUE FUISSET / HIC FERRO AUT FLAMMA PREMIA DIGNA TULIT."

22 The adjacent painting, signed and dated by Lorenzo Costa in 1488, is a family portrait of Giovanni II Bentivoglio, his wife and 11 children. The painting destroyed by Annibale's relief represented Giovanni II's ancestors; only fragments of distant figures in a landscape remain at the margins of the relief. The opposite walls are painted with *The Triumph of Death* and *The Triumph of Fame and Fortune*, signed and dated by Costa in 1490. The chapel's altarpiece, painted by Francesco Francia c. 1494, represents the Madonna and Child surrounded by saints. On these paintings and their role in the chapel, see Ghirardacci 1932, 243; Wendy Wegener, "Mortuary Chapels of Renaissance Condottieri," Ph.D. Dissertation, Columbia University, 1989, 194–205; Marr 1991; Paul Nieuwenhuizen, "Worldly Ritual and Dynastic Iconography in the Bentivoglio Chapel in Bologna, 1483–1499," *Mededelingen van het Nederlands Instituut te Rome* 55 (1996): 187–212; Drogin 2003, 188–211; David J. Drogin, "Bologna's Bentivoglio Family and its Artists: Overview of a Quattrocento Court in the Making," in *Artists at Court: Image Making and Identity, 1300–1550*, ed. Stephen J. Campbell (Boston: Isabella Stewart Gardner Museum, 2004), 87–9.

23 Rio (d. 1450) was governor of Castel Sant'Angelo under Eugenius IV and was named captain-general of papal forces by Nicholas V. On the relief, see Vincenzo Golzio and Giuseppe Zander, *L'arte in Roma nel secolo XV* (Bologna: L. Cappelli, 1968), 346 and fig. CCXI. On the Charles VII equestrian monument, see Christian de Merindol, "Nouvelle observations sur l'Hôtel Jacques Coeur à Bourges: l'hommage au roi," *Bulletin de la Société nationale des antiquaires de France* (1989): 189–210; Jean Favière, *L'Hôtel Jacques Coeur à Bourges* (Paris: Picard, 1992); Christian de Merindol, "La disposition des bustes et de la statue équestre sur la façade de l'Hôtel Jacques Coeur à Bourges," in *En Berry, du Moyen Age à la*

Renaissance: pages d'histoires et d'histoire de l'art (Bourges: Société d'archéologie et d'histoire du Berry, 1996), 245–51.

24 H. W. Janson, "The Equestrian Monument from Cangrande della Scala to Peter the Great," in *Aspects of the Renaissance: A Symposium*, ed. Archibald R. Lewis (Austin: University of Texas Press, 1967), 81.

25 On Sante's early biography and these events, see Neri Capponi, "Commentari di Neri di Gino Capponi di cose seguite in Italia dal 1419 al 1456" [1460], *Rerum Italicarum Scriptores* 18 (1731), 1209; Ghirardacci 1932, 119; Ady 1937, 32–3; Billings Licciardello 1990, 34–6; Drogin 2003, 141–4.

26 The agreement stipulated that the papal legate could not make any law without consent of local government. It also confirmed local statutes, the possibility of maintaining relations with foreign states, the right to hire *condottieri* and to maintain a standing army. Archivio di Stato di Bologna, provisioni e riformagioni, 12 luglio 1447; Ghirardacci 1932, 122–4; Ady 1937, 39–40; Colliva 1977, 18.

27 Among other honors, he was member of the Sedici from 1446, was granted an annual *stipendio* of 3,000 lire in 1454, and in 1461 was exempted by the legate from all tariffs, tributes, and tax burdens. Archivio di Stato di Ferrara, fondo Bentivoglio, serie patrimoniale, libro 6, fascicoli 18, 20, catastro †, libro 16; Ady 1937, 49; Francesca Bocchi, *Il patrimonio bentivolesco alla metà del Quattrocento* (Bologna: Istituto per la storia di Bologna, 1970), 19, 80, 81; Drogin 2003, 146–9.

28 In 1835, Girolamo Bianconi attributed the relief to Niccolò; this was accepted by Cornelius von Fabriczy and Paul Schubring, despite the stylistic dissonances. G. Bianconi, *Guida del forestiere per la città di Bologna e suoi sobborghi divisa in due parti con tavole in rame* (Bologna: C. Masi, 1835), 36; Cornelius von Fabriczy, "Niccolò dell'Arca, Chronologischer Pospekt samt Urkundenbelegen," *Jahrbuch der Königlich Preussischen Kunstsammlungen* 29 (1908): 29; Paul Schubring, *Die italienische Plastik des Quattrocento* (Potsdam: Akademische Verlagsgesellschaft Athenaion, 1924), 196. I. B. Supino wrote that the architectural elements "do not speak against Pagno di Lapo …," Supino, *L'arte nelle chiese di Bologna* (1932–38; reprint, Bologna: Forni, 1990), 2: 314. Billings Licciardello attributes the relief to Pagno. Billings Licciardello 1990, 281–2. Vasari and Ghirardacci write nothing of its authorship.

29 In Bologna, he worked on windows at San Petronio, the Palazzo Bolognini, the portico of San Pietro, and likely designed the Bentivoglio Chapel and Palace. On Pagno's biography and works, see Giorgio Vasari, *Le vite de' più eccellenti pittori, scultori, et architettori* (1550, 1568), ed. Gaetano Milanesi (Florence: Sansoni, 1878–85), 2: 445–7; Cornelius von Fabriczy "Pagno di Lapo Portigiani," *Jahrbuch der Königlich Preussischen Kunstsammlungen* 24 (1903): 119–36; Guido Zucchini, "Opere d'arte inedite (Opere di Pagno di Lapo)," *Il comune di Bologna* (September 1934): 3–8; H. W. Janson, "Two Problems in Florentine Renaissance Sculpture," *Art Bulletin* 24 (1942): 326–35; Isabelle Hyman, *Fifteenth-Century Florentine Studies: The Palazzo Medici and a Ledger for the Church of San Lorenzo* (New York: Garland, 1977), 140–41; G. Bettuzzi, *Pagno di Lapo Portigiani* (Tesi di laurea, Università degli Studi, Bologna, 1962); Billings Licciardello 1990, 255–86.

30 The plump, broad forms in the Bentivoglio relief are dissimilar to the sharp exactitude of Pagno's accepted sculpture, such as the SS. Annunziata tabernacle. Also, an accomplished sculptor from the Florentine circle of Donatello and Brunelleschi might be expected to employ exacting perspective, yet in the Bentivoglio relief, the orthogonals broadly and awkwardly converge in the lower right.

31 Cesare Gnudi, *Niccolò dell'Arca* (Turin: Einaudi, 1942), 74; Renzo Grandi, "La scultura a Bologna nell'età di Niccolò," in *Niccolò dell'Arca: Atti del convegno 26–27 maggio 1987*, ed. Grazia Agostini and Luisa Ciammitti (Bologna: Nuova Alfa, 1989), 29; Drogin 2003, 99–116.

The humanist and the poet:
Bernardo Bembo's portrait of Dante*

Debra Pincus

You, Dante, who were lying here unhappy in your tomb scarcely known to anyone …
No wonder that Bembo, inflamed by the Etruscan Muses, gave this to you.[1]

The tomb of Dante in Ravenna was commissioned by the Venetian statesman and man of letters Bernardo Bembo in the early 1480s.[2] The architectural form of the tomb is that of the round-headed tomb, given currency in the 1470s in Venice by the shop of Antonio Rizzo, a type that featured a recumbent effigy of the deceased, generally placed in the center of the tomb.[3] The tomb of Dante breaks with this tradition. Instead of the recumbent effigy there is a relief portrait of Dante, shown from the torso up, very much alive (Figures 3.1, 3.2, 3.3). Dante appears within a room-like perspective space, a coffered chamber that has the appurtenances of a study—books, ink pot, desk, and lectern. He reaches down with his right arm to a low lectern in front of him, his hand arching over the large book spread out in front of him. His left arm, propped up on a higher lectern, presses against another, smaller book.[4] The fingers of the left hand reach up to cradle Dante's chin, the little finger of the left hand lightly touching the lower lip.

The vagaries of fate lie behind the placement of Dante's tomb in Ravenna. Ravenna was where Dante, the wandering exile from Florence, had his last sojourn and died. His burial in Ravenna was hastily arranged by his host, the then lord of Ravenna, Guido Novello da Polenta, shortly before Polenta's own exile. We know very little about this first tomb. The scanty evidence suggests that the body, following a common practice, was placed in one of the antique sarcophagi that abounded in Ravenna, vestiges of Ravenna's important role as a trading center in the late antique sarcophagus trade.[5]

It was the fervent hope of the Florentines, developing by the fifteenth century into a concerted program, that the bones of Dante would be repatriated to Florence. It was only proper, in the opinion of the Florentines, that an appropriately honorific tomb be set up in Dante's own city. This was not to be.

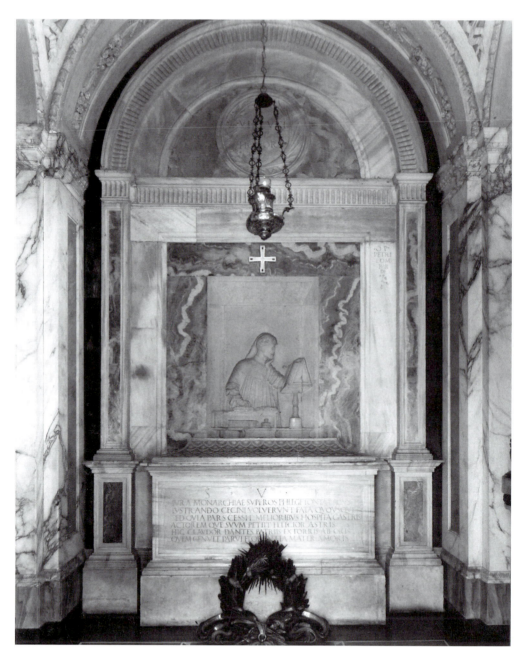

3.1 Pietro Lombardo and Workshop, *Tomb of Dante*. Precinct of San Francesco, Ravenna

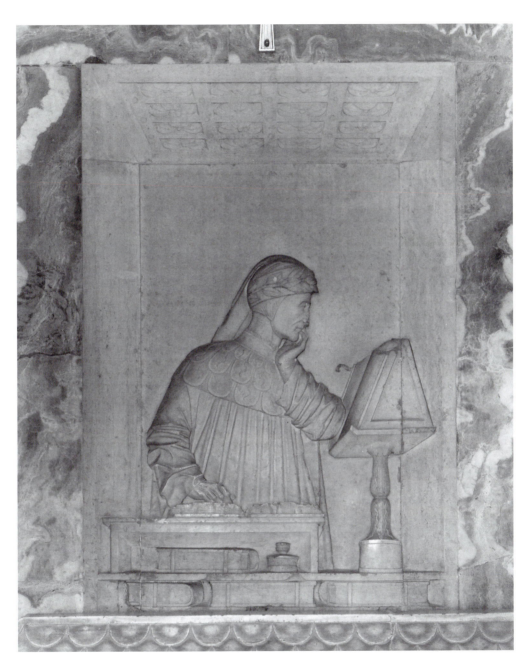

3.2 *Tomb of Dante*, detail of portrait

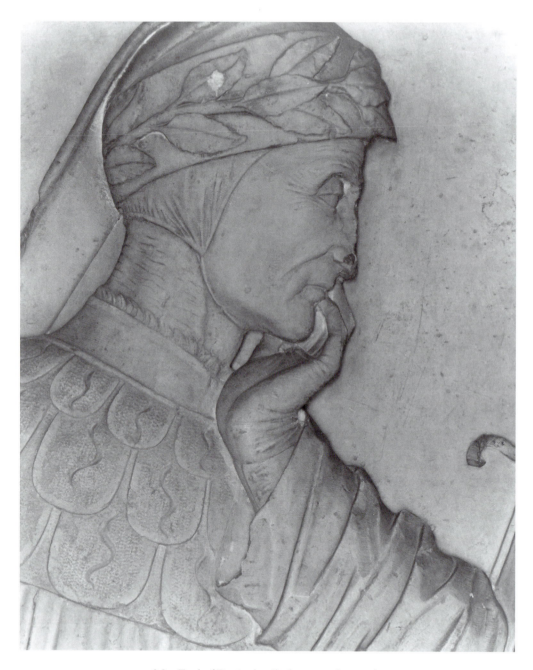

3.3 *Tomb of Dante*, detail, close-up of portrait

In the end, it was on Venetian territory, as the commission of a Venetian, that a handsome tomb for the Florentine poet was erected.

Bernardo Bembo was the perfect person to take on the task. Overshadowed in modern literature by his famous son Pietro, Bernardo was an outstanding and important figure in his own right. He represents to perfection a Venetian type that had developed over the course of the fifteenth century, brilliantly integrating the *vita attiva* and the *vita contemplativa*. A gifted orator with a winning personality and the head of a prominent Venetian family, Bembo became one of the key players in Venice's complex political maneuvering of the second half of the fifteenth century. His numerous diplomatic assignments brought him to major capitals of Europe, and in every instance we find him operating comfortably at the intersection of statecraft and the arts. In 1475 he arrived in Florence as the Venetian government's ambassador, the hope being that in the unstable world of Italian politics he could strengthen the ties between the two powers.[6]

With impressive facility Bembo inserted himself into the heart of the Florentine political and cultural scene.[7] Almost immediately on his arrival, he had enrolled himself in the splendid tournament staged by Giuliano de' Medici in Piazza Santa Croce on January 29, 1475. He became a close friend of the leading figures of the city. His friendship with Lorenzo de' Medici, surviving the political exigencies of the later fifteenth century that turned Florence and Venice into reluctant enemies, lasted until Lorenzo's death in 1492. His closest associates were the intellectuals of the Medici circle, above all Cristoforo Landino and Marsilio Ficino. The period of Bembo's first ambassadorship to Florence, 1475–76, saw the development of a program, sponsored by Lorenzo de' Medici, designed to catapult Dante into a figure of heroic proportions.[8] Dante, the exile from Florence, was being reconfigured as an emblem for the cultural hegemony of Florence. These were the years when Cristoforo Landino gave his famous lectures on Dante that became the influential and long-lived *Comento sopra la Comedia*, published in Florence in 1481.[9] Bernardo Bembo was there in the audience.

The high esteem that Bembo enjoyed in these Florentine years and the special nature of his relationship with the Medici circle is well documented. Tangible evidence of his close connection to Landino and to the Florentine Dante project is provided by the exemplar of the 1481 edition of the *Comento* specially prepared by Landino for Bembo. Preserved in the Bibliothèque Nationale in Paris, the text proper opens with a handsome decorated page, embellished with Bembo's arms, and the volume includes three hand-colored engravings. Bound into the volume as it presents itself today is the letter sent by Landino to accompany his gift. Written in Landino's own hand, the letter not only effusively praises Bembo—"my love for whom grows hourly greater within me"—but also compliments Bembo on his work in "restoring" Dante's tomb.[10]

Bembo's role as a patron of the arts was impressive. His interests were broad and his level of discernment dazzling. Manuscript illustration in the Veneto in the decades of the 1460s through the 1480s had opened up and flourished

in a remarkable way. Bernardo Bembo's position as a patron in this exploding world of manuscript illumination is well known to specialists, and due for wider acknowledgement. Working in particular with the antiquarian-scribe Bartolomeo Sanvito, he commissioned superb manuscripts, now dispersed in a number of major collections.[11] He was an assiduous collector of both ancient and modern manuscripts, a collection that was inherited and expanded by his son Pietro.[12] Somewhat less central to his collecting activities but not to be underestimated was his activity as a collector and connoisseur of paintings: he owned a first-rate diptych by Memling, believed to have been acquired during his ambassadorship to Bruges;[13] a number of paintings seen by Marcantonio Michiel in the house of Pietro Bembo appear to have originally belonged to Bernardo, a listing that suggests that Bernardo was a particular collector of portraits;[14] and it was Bernardo, one recalls, who commissioned from the young Leonardo, still in the very early stages of his career, the portrait of Ginevra de'Benci that expanded the boundaries of female portraiture.[15]

Bembo's involvement with the bones of Dante began with his Florentine experience. He may even have tried to assist the Florentines in their project to retrieve the bones of Dante from Ravenna. This is suggested by a letter of April 13, 1476, written to Lorenzo de' Medici by Antonio Manetti shortly after Bembo had been recalled back to Venice.[16] Manetti refers in his letter to a promise that "the Venetian ambassador" had purportedly made to Lorenzo that when he—Bembo—returned to Venice, he would work to repatriate Dante's bones. Whatever the facts of the matter may have been, such a promise was never fulfilled. The opportunity then came for Bembo himself to do the honors for Dante, when he was appointed by the Venetian government in February of 1482 to the powerful post of *capitano* and *podestà* of Ravenna.[17] The importance of the Florentine experience in inspiring Bernardo in his own Dante project was explicitly acknowledged in the dedicatory inscription placed by Bembo in the Dante tomb chamber.[18]

The artist chosen by Bembo for the project was the master sculptor and entrepreneur Pietro Lombardo, with whom Bernardo had worked on a number of Ravenna projects.[19] Pietro Lombardo's flourishing shop had produced during the last decades of the fifteenth century some of the most prestigious tombs of Venice.[20] The choice of Pietro and his shop for the work on the Dante tomb was a logical one; we see Pietro's signature prominently placed near the top of the tomb, on the outer frame (Figure 3.4).

Pietro's autograph hand is still being sorted out, but recent studies have highlighted that one of his strengths lay in the area of physiognomy.[21] The sculpted portrait tradition of Venice of the second half of the fifteenth century, almost exclusively a tradition of male portraiture, favored a schematic physiognomy of sharply cut facial features and deeply etched lines. Pietro's standing effigy of Doge Pietro Mocenigo, of a few years earlier than the Dante tomb, is a masterpiece of the genre, presenting Mocenigo with supra-human authority and vigor—the kind of dominating presence that Venice sought to invest in its doge during the fraught years of the later fifteenth century (Figure 3.5).[22]

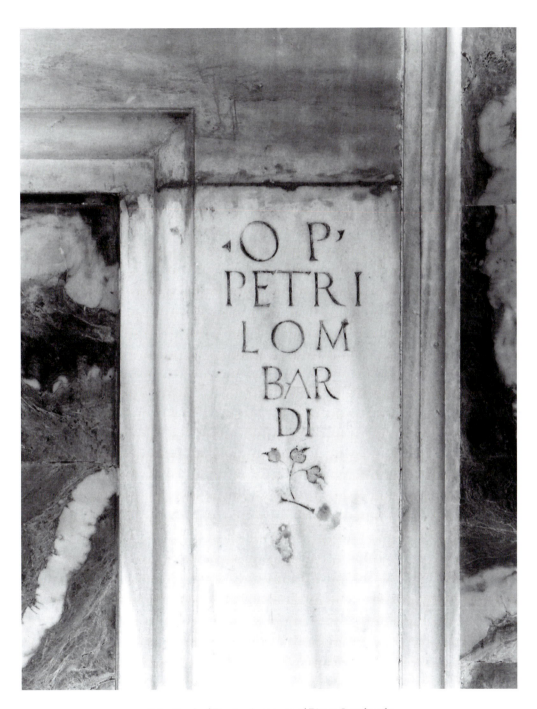

3.4 *Tomb of Dante*, signature of Pietro Lombardo

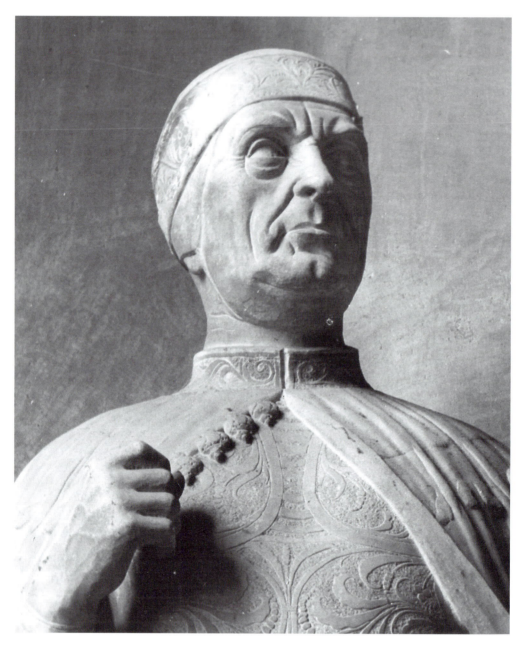

3.5 Pietro Lombardo, *Effigy of Doge Pietro Mocenigo* (detail). Tomb of Doge Pietro Mocenigo, SS. Giovanni e Paolo, Venice

The choir screen of the Frari, prepared under Pietro's supervision in the mid-1470s, gives an ensemble of 22 portraits—prophets, apostles and the Baptist—that, in a virtuoso display, presents each figure in a different pose of inspirational reverie. The Dante portrait demanded still another approach. In what needs to be seen as a collaborative relationship, we see Bernardo Bembo, the cultivated connoisseur, and Pietro Lombardo, the marble specialist, working together to produce a very special kind of portrait. Bernardo's drenching in the Dante-revival climate of 1470s Florence had presented him with a Dante that was part of a fresh wave of interpretation. In his lectures of the mid-1470s and later in his published *Comento* of 1481, Landino presented a new Dante—not Dante *poeta theologus* of fourteenth-century interpretation but Dante the promulgator of a new sense of human capacity for growth and upward development. Landino's Dante was the champion of the potential of the human soul—in short, Dante as seen through the lens of the Neo-Platonism of late fifteenth-century Florentine intellectuals.[23] A portrait needed to be crafted to reflect this new Dante. In this venture, Pietro Lombardo's most ambitious portrait undertaking, sculptor and patron have together produced one of the most interesting of the Dante depictions to have come down to us.

By the middle of the fifteenth century a number of commemorative traditions had been established for honoring the man of letters. Tombs celebrating jurists, professors, and authors whose work had brought stability and fame to the political unit were a feature of the Italian city states already by the late thirteenth century. Of particular relevance to Bembo's Dante project were the professor tombs of Bologna, presenting lively portrait images of the teacher as a living figure, book in hand, discoursing to a rapt student audience. The tomb of Matteo Gandoni, from the church of San Domenico in Bologna, now in the Museo Civico Medievale, Bologna, can stand as one example.[24] Intersecting with this honorific tradition was the practice, also with its beginnings in the thirteenth century, of honoring figures from the past with particular ties to individual Italian cities—"local heroes," as they have been categorized.[25] The monuments for these civic heroes featured animated sculpted portraits. The portrait of Livy of 1435–36, set over one of the exterior doors leading into the grand *Salone* on the upper loggia of the Palazzo della Ragione in Padua, shows the historian and scholar in a study-like setting that has much in common with what will be created at Ravenna (Figure 3.6).

Author portraits in manuscripts presented another set of models. The longstanding tradition of including author portraits in manuscripts had expanded in the Renaissance to include elaborate settings that gave increased status both to the author and his work, as in Francesco di Antonio del Chierico's portrait of Petrarch in his study, in the manuscript of Petrarch's *Trionfi*, Biblioteca Trivulziana, Milan, MS 905.[26] Author portraits were also appearing as early as the fourteenth century on a grand scale in what might be termed "halls of learning." A panorama of scholar/author portraits, dated by inscription to 1352, was frescoed on the walls of the Sala del Capitolo of the Dominican church of S. Nicolò in Treviso—40 prominent members of

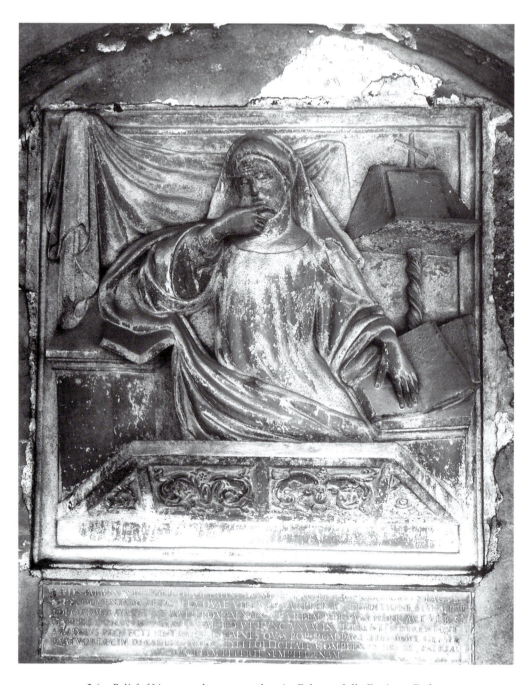

3.6 *Relief of Livy*, overdoor, upper loggia, Palazzo della Ragione, Padua

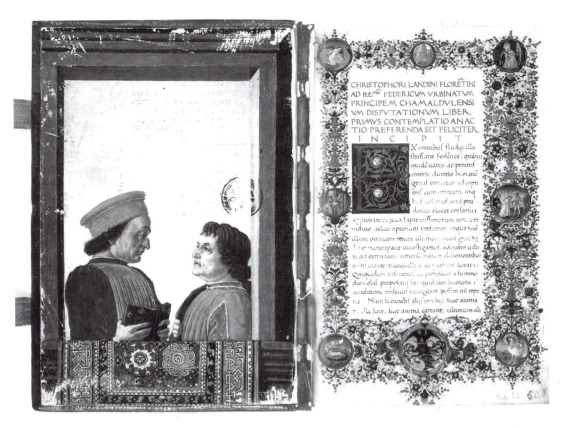

CHRISTOPHORI LANDINI FLORETINI
AD ILL.^{mu} FEDERICVM VRBINATVM
PRINCIPEM CHAMALDVLENSI
VM DISPVTATIONVM LIBER
PRIMVS CONTEMPLATIO AN AC
TIO PREFERENDA SIT FELICITER
I N C I P I T

the Order each shown in a private cell, writing, reading, or thinking.[27] An influential portrait of Petrarch shown at work in his study was included in the fourteenth-century fresco decoration of the Sala Virorum Illustrium in Padua, probably prepared shortly after Petrarch's death in 1374.[28]

Reinforcing these traditions was a major development of the fifteenth century whereby the man of action would associate himself with the world of letters—a programmatic intertwining of the *vita attiva* and the *vita contemplativa*. Federico da Montefeltro, with the resources of the duchy of Urbino at his disposal, provides an outstanding example of this. The series of portraits of illustrious men—from Virgil and Cicero to Dante and Nicholas V—commissioned c. 1474–76 for Federico's *studiolo* in Urbino, today divided between Urbino and the Louvre, functioned as a spectacular panorama of men of letters across the ages.[29] Sitting in his *studiolo*, Federico, warrior and ruler, would take his place within the world of letters and learning. More pointed in its honoring of the scholar is the double portrait on parchment pasted into the front cover of Federico's copy of Landino's *Disputationes Camaldulenses*, Biblioteca Apostolica Vaticana, Urb. Lat. 508, the presentation copy prepared by Landino of the text dedicated to Federico (Figure 3.7).[30] Added after the volume had been bound but probably prepared close to the completion of the manuscript in the early 1470s, the double portrait shows

3.7 *Portrait of Federico da Montefeltro and Cristoforo Landino*, BAV Urb. Lat. 508

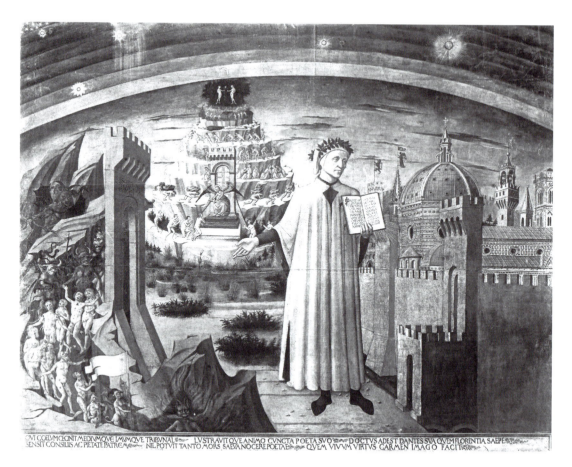

3.8 Domenico di Michelino, *Dante Presents his Poem.* Duomo, Florence

Landino and Federico together, enclosed in a perspectival window frame against an expansive backdrop of blue sky. They gaze intently at each other, author and patron in attitudes of mutual respect. An oriental rug, flung over the front of the window frame, intensifies the celebratory tone of the image.

Dante has his own place within this commemorative tradition. What can be termed the first "official" Dante portrait, dated 1465, was placed in the Duomo of Florence about a decade before Bembo's arrival in the city (Figures 3.8, 3.9).[31] Painted by Domenico di Michelino in tempera on canvas, it is the first large-scale portrait of Dante to show him crowned with laurels, the prized laurels of poetic achievement—now to become his invariable attribute.[32] The Duomo portrait gives us Dante of the fifteenth century—mild in expression, even somewhat diffident in attitude. It was still to be a number of years before the canonical Dante, Dante of the hatchet-faced physiognomy, would be arrived at.[33]

The Domenico di Michelino Duomo presentation served as the point of departure for Bembo and Pietro Lombardo in crafting the Ravenna portrait. But more was involved here. Operating within the frame of the Landino re-interpretation of Dante, the Ravenna Dante was to be a Dante of quasi-divine

3.9 Domenico di Michelino, *Portrait of Dante* (detail)

insight. And it was Dante's hand that was to carry this message. For the feature that distinguishes the Bernardo Bembo–Pietro Lombardo Dante portrait from all previous Dante portraits is the idiosyncratic, even bizarre, gesture assigned to Dante's left hand (Figure 3.3). The right hand calls attention to the large volume, its crinkled pages suggesting parchment, that rests on the low lectern in front of him. But it is the left hand that commands attention—slightly open palm, fingers stretching upwards, little finger touching the lower lip. Totally absent is the action of either reading or writing traditional in author portraits. Rather, what we have is something much more subtle and elusive—the reception of an idea.

The gesture has proved daunting to its interpreters. Almost without exception, writers on the tomb have seen what a conventional author portrait might be expected to present, Dante reading or—unlikely as it may seem in terms of the image—writing. Nor have copyists done well in attempts to reproduce the gesture. An abortive attempt at conveying something of its strangeness may lie behind its curious rendition in the engraving in the *Monumenta sepulcrorum* of Tobias Fendt of 1574, an image widely reprinted and circulated (Figure 3.10). The Fendt version shows Dante's eyes half-closed, hand pressed to forehead in a pose that seems more agony than intuition.[34] In another failed attempt, Gasparo Cardoni, in his nineteenth-century history, *Dante in Ravenna*, includes an etching that for the most part faithfully reproduces the lines of the portrait, but makes a complete muddle of it when it comes to replicating the gesture of that problematic left hand (Figure 3.11).[35]

The deliberateness with which the gesture has been presented in the Ravenna Dante calls for consideration. Strange though it may seem at first glance, this is a gesture that, as an attribute of the thinker, belongs to a long and important tradition, a tradition very much alive in fifteenth-century culture. Greek and Roman art had developed the type of the thinker—the "man of the muses"—with the hand pointing to or supporting the head as signifier.[36] The gesture was a standard trope already by the fourteenth century as the mark of the scholar, as seen in presentations of the studious Dominicans in the Chapter House of S. Niccolò at Treviso, discussed above.[37] During the Renaissance, the gesture was widespread as a way of indicating the special vision of religious figures, noted writers and above all, poets. A woodcut of the Milanese poet Bernardo Bellincioni, seated at his desk, head propped on hand, was included on the first page of his *Rime*, published in Milan in 1493 (Figure 3.12).[38] The gesture lives on as one of the canonical poses taken by writers, philosophers, and intellectuals of all stripes. It was the pose struck on Byzantine ivories by Adam as he sat contemplating his fallen state. It was the pose struck by the Minnesinger Walther von der Vogelweide as he sat ruminating on "how to live in the world."[39] It was the pose taken by Dürer's *Melencolia I*, deep in meditation on the challenges and perils of the work of the mind.[40] At a later point it was to become in effect an emblem of the intellectual's malady of melancholia. A rhetorical version of the pose shows the index finger extended,

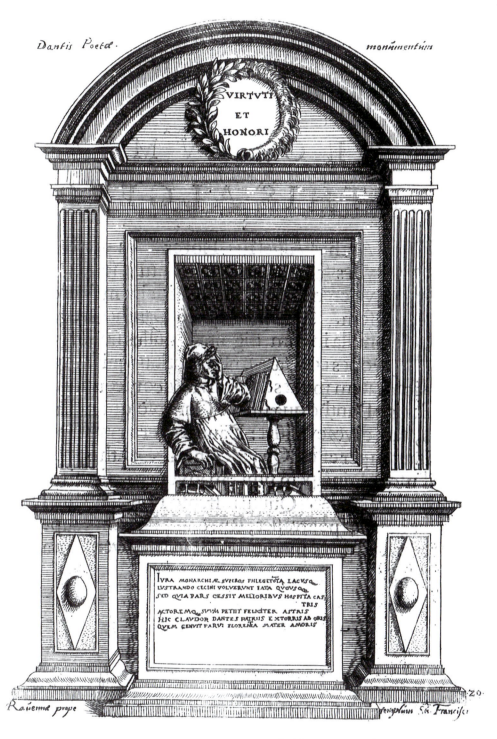

VIRTVTI
ET
HONORI

IVRA MONARCHIÆ SVPEROS PHLEGETOTA LACVSQ
LVSTRANDO CECINI VOLVERVNT FATA QVOVSQ
SED QVIA PARS CESSIT MELIORIBVS HOSPITA CAS
TRIS
ACTOREMQ SVVM PETIIT FELICITER ASTRIS
HIC CLAVDOR DANTES PATRIIS EXTORRIS AB ORIS
QVEM GENVIT PARVI FLORENIA MATER AMORIS

Ravenna prope Xenophum Sti Francisci 20.

3.10 *Portrait of Dante*, in Tobias Fendt, *Monumenta sepulcrorum
cum epigraphis ingenio et doctrina excellentium Virorum*

3.11 *Portrait of Dante* (frontispiece), in Gasparo Martinetti Cardoni, *Dante Alighieri in Ravenna*

as if the person depicted were about to expound on or elaborate a point, as in Niccolò Pizzolo's St. Gregory roundel (destroyed), c. 1448–53, from the Ovetari Chapel in the Eremitani, Padua.[41] In the Dante portrait we are dealing with the variant that singles out the mouth for emphasis. What is being adduced is the concept, again, with an important history behind it, of drinking in inspiration—a trope that has its roots in the image of the ancient singer who pours out from heart, soul, and mouth the great mythic stories of Homer and the Bible.[42] *Solerita*—Ingenuity—on Orcagna's tabernacle in Orsanmichele, Florence, presses her index finger to her lips to signify the interior working of the mind (Figure 3.13).[43] In a variant, the hand presses directly below the mouth to indicate thought and meditation, as in the depiction of Livy on the overdoor of the upper loggia of the Palazzo della Ragione in Padua (Figure 3.6). An intriguing image from the mid-thirteenth century on the west portal of San Marco, the crippled figure who points emphatically and suggestively to his open mouth, may also participate in the idea of the mouth as the avenue of high knowledge.[44]

One of the most delicate expressions of this variant was produced by Botticelli. The suite of drawings on vellum illustrating the *Commedia*—very likely Botticelli's second set of illustrations for the *Commedia*—includes a striking page for Dante's entrance into Paradise, Canto II.[45] Dante has arrived

BELINZONE

RIME DEL ARGVTO ET FACETO
POETA BERNARDO BELINZONE
FIORNTINO

Diuo Iampo O Delphico Splendore

a iiii

3.12 *Bernardo Bellincioni in his Study*, opening page to Bellincioni's *Rime*

3.13 Orcagna, *Solerita*, Tabernacle, Orsanmichele, Florence

at the first sphere of the Planets. Virgil, who can go no further, has given
Dante over to Beatrice; it is Beatrice who will shepherd the seeker on his road
to the higher mysteries. Dante describes for the reader his deeply nurtured
"thirst"—"inborn and perpetual"—to understand the divine mysteries—"la
concreata e perpetua sete del deii forme regno."[46] The drawing for this Canto
is a depiction of the moment when the thirst will begin to be satisfied. Dante
stands stock still in wonder as Beatrice gently touches his lower lip with the
tips of her fingers (Figure 3.14). In a single compact image, Botticelli manages
to convey the profundity of Dante's final journey toward full understanding.

Bernardo Bembo and Pietro Lombardo, working in collaboration, have
profited from the highlighting of this gesture in its late fifteenth-century
Florentine content.[47] Neither reading nor writing, the Dante of Ravenna
pauses to ponder, as if literally drinking in the knowledge that his books
bring him. The open perspectival space functions as a space—much as in the
Federico da Montefeltro–Cristoforo Landino image—that carries the charge
of the largeness of the poet's vision.

Yet in the end, the Bernardo Bembo–Pietro Lombardo Dante portrait was
an experiment that failed. Viewed from a narrow perspective, it was a portrait
that was a dead-end. Writers ignored it, artists were unable to reproduce it,
and the arrival of a new Dante type suddenly made it thoroughly outdated.
Scholars have found the Ravenna tomb portrait of little interest.[48]

3.14 Sandro
Botticelli, *Dante
Entering Paradise*.
Illustration to
Canto II, *Paradiso*

But this overlooked and criticized portrait brought a new idea into the Dante portrait tradition—the idea of inspiration. Attached to Dante, who was increasingly being propagandized as the pre-eminent poet of Italy, the idea was to have a significant aftermath. Tullio Lombardo, who himself almost certainly played a role in the production of the Dante tomb, drew in an interesting way on his father's Dante for the portrait of Saint Mark that he prepared for Mark's altar in the church of San Marco in Ravenna, later transferred to the Duomo in Ravenna.[49] Dated to 1491, less than ten years after the Dante tomb, Tullio's Mark is one of the great statements of inspiration to come out of the fifteenth century (Figure 3.15). Although powerfully moving beyond his father's presentation of inspiration, Tullio retains the core idea of a Renaissance sculpted portrait in which the figure is entirely submerged in the fervor of thought.

And perhaps one sees—highly absorbed and highly transformed—the Bernardo Bembo–Pietro Lombardo invention resonating in the background behind Michelangelo's great, complex Lorenzo de' Medici—a portrait of everything that is involved when the *vita attiva* crosses over the threshold into the *vita contemplativa*.[50]

The pioneering foray into the realm of inspired transport engineered by the Bernardo Bembo–Pietro Lombardo team—cultivated Venetian patrician and master sculptor, working in tandem—points up the Quattrocento sensitivity to tradition and the simultaneous ambition to move into new territory. We see the groundwork for the great leaps of the sixteenth century being put into place. Maybe Vasari had it right after all.

Appendix: Stages in the development of the Dante portrait image

The earliest portraits of Dante, appearing in illustrated manuscripts of the *Commedia*, make no attempt at a distinctive portrait image.[51] There was not much to go on. The description of the poet given by Dante's near-contemporary and devoted admirer, Boccaccio, provides only a general description, emphasizing the special quality of Dante's expression—thoughtfulness verging on sadness:

Our poet was of moderate height, with a long face, aquiline nose, large jaw, and extended lower lip that protruded somewhat in front of the upper one. His shoulders were somewhat curved, his eyes rather large than small and of brown color, his hair and beard abundant, curly, and black. He had always a melancholy and pensive aspect.[52]

The history of a distinctive portrait image of Dante begins with the Domenico di Michelino painting set up in the Duomo of Florence in 1465, a learned and influential production that drew on developing Dante scholarship of the fifteenth century (Figures 3.8, 3.9).[53] The movement to celebrate Dante in terms of his native city—riding roughshod over Dante's personal history as

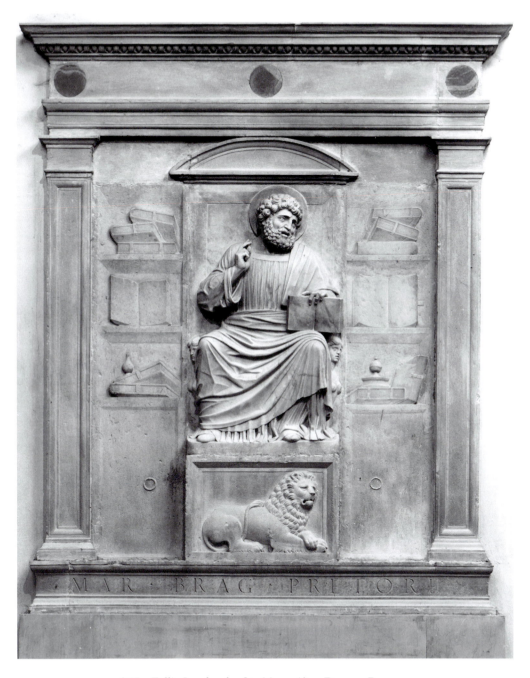

3.15 Tullio Lombardo, *San Marco Altar*. Duomo, Ravenna

a Florentine exile—had began in earnest in the 1420s, and the Domenico di Michelino portrait represents the culmination of this first phase of the Florentine Dante propaganda program. Incorporating motifs that had been developed in *Commedia* manuscript illumination, the painting allots separate areas to each of the three books of the poem. On the left is the chasm of *Inferno*, a rocky road downward, populated by tortured and despairing souls. Behind Dante stands the mountain of *Purgatorio* rising out of the river of *Phlegaton*. Adam and Eve are shown at the top of the mountain about to eat the forbidden fruit. Along the slopes of *Purgatorio* the flawed souls carry out their penitential assignments in hope of being able to enter Heaven through the golden doors of Paradise. The depiction of the gates of Paradise with its large gilded panels suggests the gilded doors made by Ghiberti for the Florentine Baptistery some ten years before, and *Paradiso* itself, on Dante's right, is the city of Florence, present in all its mid-fifteenth century glory. Dante stands in the foreground of the painting, book in hand open to the first Canto, the first lines inscribed in handsome, readable majuscules. The book gives off golden rays.[54] The Duomo portrait is the first monumental depiction of Dante to show him with a laurel crown—those laurels which, writing in the middle years of the fourteenth century, Boccaccio bemoaned as not yet having been awarded to Dante.[55]

Domenico di Michelino's Dante captures something of the look suggested by Boccaccio's description: the slightly protruding chin, the largish nose, the thoughtful and rather preoccupied gaze.[56] But not, withal, a forceful physiognomy. This quasi-official portrait of Dante served Bernardo Bembo and Pietro Lombardo as their starting point.

In less than two decades the tradition of Dante portraits was to change radically. The type of Dante, in terms of physiognomy, enshrined at Ravenna, was out of date virtually at the moment of its production. The change takes place in Florence in the late fifteenth century during the years of the intense activity of Lorenzo de' Medici's cultural propagandizing campaign. The new decoration program of the Palazzo della Signoria, set in motion in 1472, was part of this campaign.[57] Featured in the renovation of the building was the creation of two large new meeting rooms on the second floor, the Sala dei Gigli and the Sala della Udienza. Particular attention was given to the doorway linking the two rooms, marked on each side by an imposing marble frame with crowning sculptures and wooden intarsia door panels, prepared by the shops of Francesco di Giovanni (Francione) and Giuliano and Benedetto da Maiano in 1478–81. It is in the decoration of this doorway that a new Dante surfaces. The intarsia doors on the Sala dei Gigli side are inset with the portraits of Florence's pre-eminent cultural heroes, Petrarch and Dante—and here we meet for the first time the new Dante. The mild-mannered, humble Dante of Domenico di Michelino yields to a severe Dante in profile, crowned with a luxuriant laurel wreath, formidable in his emphatically chiseled features and aggressively jutting nose. The first step has been taken toward the hatchet-faced Dante, unmistakable in any setting, whose features will spread across Europe.

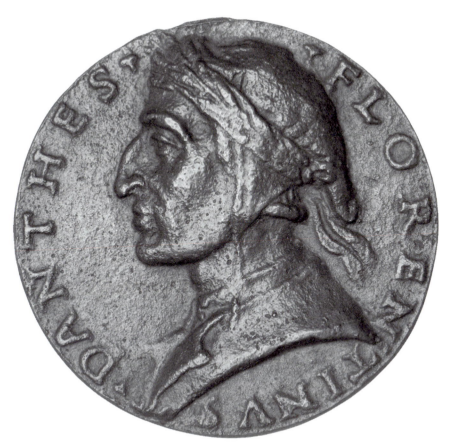

3.16 *Portrait of Dante*, commemorative medal of Dante, obverse

The precise artistic hand behind the new Dante remains to be determined. Benedetto da Maiano, with a known specialty in portraiture, is one likely candidate; Filippino Lippi and Botticelli have also been proposed.[58] Whoever the specific artist may have been, the recasting of Dante is part of the larger picture of the interest in portraits of character that comes to the fore in Florence during the late 1470s and 1480s, finding expression in a variety of media. The workshops of Verrocchio and Benedetto da Maiano appear to be a major locus.[59]

The newly heroic Dante is rapidly absorbed into Dante iconography. Signorelli uses the new type, prominently crowned with laurel, in the fresco cycle of the Cappella di S. Brizio, Orvieto Cathedral.[60] It receives confirmation and dissemination in the Dante medal produced at the end of the fifteenth century (Figure 3.16). This is the first Dante medal to be issued, and forms part of a commemorative series of medals of Florentine scholars and intellectual heroes, including Boccaccio, Petrarch and Coluccio Salutati, loosely based on the earlier medallic style of Niccolò Fiorentino. The Dante medal is the best of the series, the profile head well-placed on the field of the obverse, the inscription "• DANTHES • FLORENTINVS" along the outer rim. As the

inscription suggests, this is a Florentine Dante, and the verso does homage to Florence's major Dante monument of the fifteenth century, the Domenico di Michelino Duomo painting of 1465, showing Dante with his book and Adam and Eve crowning the mount of *Purgatorio*. Dante's portrait on the obverse recapitulates the aggressively jutting profile of the Sala dei Gigli intarsia.[61]

The definitive transformation takes place in the hands of Raphael. His two depictions of Dante in the Stanza della Segnatura of the Vatican of c. 1510, placing him both among the theologians of the *Disputà* and among the poets of *Parnassus*, have become the standard—the "true" Dante, as it were—against which all Dante images have tended to be assessed.[62]

Notes

* I owe my involvement in Dante's tomb to Wendy Stedman Sheard, one of the most generous, encouraging and insightful of art historians. Her death in March of 1998 has left a lacuna that time has not filled. It was my honor to begin research on the tomb working in tandem with Wendy, work that bore fruit in a paired lecture that we gave at the Renaissance Sculpture Symposium, Provo, Utah, 1984. Wendy's own approach to the tomb and her attention to the patronage of Bernardo Bembo can be seen in her brilliant essay on Bernardo as a patron of the arts, published in the exhibition catalogue, *Tiziano: amor sacro e profano* (see below, n. 6). I have gone on to investigate some of the manifold issues of the tomb, always having the sensation in this work that Wendy was watching over my shoulder with her usual enthusiasm and encouragement.

I would like to thank Sarah Blake McHam, Shelley E. Zuraw, Jonathan Alexander, Davide Banzato, Karen Serres, Joe Pincus, and my collaborator on an earlier Dante essay, Barbara Shapiro Comte, for their help in this project. For photographic assistance I am indebted to Ralph Lieberman, to whom I owe the handsome views of the tomb and portrait relief; to David Finn, for his photograph of the *Solerita* from the tabernacle of Orsanmichele; to Massimo Ferretti for the Tullio *San Marco* altar; and to Motoaki Ishii for providing me with photographs at the beginning of this work. Deborah Parker, Caroline Elam, and Rachel Jacoff offered generous assistance at an early stage of the project. Throughout this work I have profited from the generosity and insights of Tiziana Dolfi, who has prepared a brilliant thesis on the manufacture and restoration of the tomb and tomb chamber, "La tomba di Dante Alighieri a Ravenna: costruzione, restauri e manutenzione programmata," Università degli Studi di Firenze, Facoltà di Architettura, Dipartimento di Restauro e Conservazione dei Beni Architettonici, Anno Accademico 2006–2007, under the direction of Professor Daniela Lamberini. Finally, a special word of thanks to John Paoletti, whose interest in patronage has been an important influence on the approach taken in this essay. His friendship and support, in this as in other projects, has been one of the bright lights of my scholarly career.

The current essay is the third in an ongoing series of investigations of the Dante tomb. The first, Pincus, "La tomba di Dante a Ravenna: le epigrafi e la loro storia," in *La bottega dei Lombardo. Architettura e scultura a Venezia tra '400 e '500*, ed. Andrea Guerra, Manuela M. Morresi, and Richard Schofield (Venice: Marsilio, 2006), 121–35, dealt with the dedicatory inscriptions. The second, written in collaboration with Barbara Shapiro Comte, presented an unpublished drawing relating to the tomb, "A Drawing for the Tomb of Dante Attributed to

Tullio Lombardo," *The Burlington Magazine* 148 (2006): 734–46. Analysis of the architecture of the tomb constitutes a separate issue that I hope to take up at a later date.

1 From the dedicatory inscription written by Bernardo Bembo and placed in the enclosure for the tomb of Dante:

EXIGVA TVMVLI DANTES HIC SORTE IACEBAS
SQVALENTI NVLLI COGNITE PENE SITV
AT NVNC MARMOREO SVBNIXVS CONDERIS ARCV
OMNIBVS ET CVLTV SPLENDIDIORE NITES
NIMIRVM BEMBVS MVSIS INCENSVS ETHRVSCIS
HOC TIBI QVEM IMPRIMIS HAE COLVERE DEDIT
ANN SAL M CCCC LXXXIII VI KAL IVN
BERNARDVS • BEMBVS • PRAET • AERE • SVO • POS

The inscription is present in an early twentieth-century replacement in the much altered chamber that today encloses the tomb. For discussion of this and other inscriptions associated with the tomb, see Pincus 2006.

2 Bembo's dedicatory inscription (note 1) bears the date May 27, 1483, which can be taken as the *terminus ante quem* for the project.

3 See Anne Markham Schulz, *Antonio Rizzo: Sculptor and Architect* (Princeton: Princeton University Press, 1983), 44–64, 171–7.

4 The clear distinction between the two books calls for consideration. I have argued elsewhere for their interpretation as the two seminal books that lie behind Dante's production: Virgil's *Aeneid*, spread out in front of him, his right hand virtually clawing at its pages, and the Bible, raised up high on the lectern, the solid support for Dante's "hand of inspiration."

5 Fernando Rebecchi, "Sarcofagi cispadani di età imperiale romana. Richerche sulla decorazione figurata, sulla produzione e sul loro commercio," *Mitteilungen des Deutschen Archäologischen Instituts, Römische Abteilung* 84 (1977): 107–58. The Bembo–Pietro Lombardo tomb displays a box-like lidded component that bears a close resemblance to the lidded Ravennate sarcophagus type. After the opening of the tomb in 1921, Ricci concluded that Dante's original tomb chest was absorbed into the new structure, with much of its bulk being recessed into the wall behind. Issues regarding the first tomb are summarized by Corrado Ricci, *L'ultimo rifugio di Dante*, ed. Eugenio Chiarini (Ravenna: Longo, 1965), 313–19. The first tomb of Dante almost certainly did not include a portrait image.

6 For a recounting of Bembo's career and patronage activities, see Nella Giannetto, *Bernardo Bembo: umanista e politico veneziano* (Florence: Olschki, 1985), to be supplemented by Wendy Stedman Sheard, "Bernardo e Pietro Bembo, Pietro, Tullio e Antonio Lombardo: metamorfosi delle tematiche cortigiane nelle tendenze classicistiche della scultura veneziana," in *Tiziano: amor sacro e amor profano*, ed. Maria Grazia Bernardini (Milan: Electa, 1995), 118–32. Bembo had two ambassadorships to Florence. The *commissio ducalis* for his first tour of duty is dated December 23, 1474. He is recorded as present in Florence from late January 1475 and leaves in April of 1476. The second tour of duty, July 1478–May 1480, was a disaster, from which he asked to be recalled (Giannetto 1985, 131–52).

7 Vittorio Cian, "Per Bernardo Bembo. Le sue relazioni coi Medici," *Giornale storico della letteratura italiana* 28 (1896): 348–64, and Arnaldo Della Torre, "La prima ambasceria di Bernardo Bembo a Firenze," *Giornale storico della letteratura italiana* 35 (1900): 258–333.

8 For Lorenzo's strategy of cultural propaganda and carefully planned patronage, see Melissa M. Bullard, *Lorenzo il Magnifico: Image and Anxiety, Politics and Finance* (Florence: Olschki, 1994), 109–30, and Caroline Elam, "Art and Diplomacy in Renaissance Florence" (Selwyn Brinton Lecture), *Royal Society of Art Journal* 136 (1988): 813–26, esp. 816–20.

9 Cristoforo Landino, *Comento sopra la Comedia*, ed. Paolo Procaccioli (Rome: Salerno Editrice, 2001), 4 vols, and the useful review by Deborah Parker, *Renaissance Quarterly* 58 (2005): 896–8. For Landino's text in a Medici context, see Anne Dunlop, "'El Vostra Poeta:' The First Florentine Printing of Dante's 'Commedia,'" *Revue d'art canadienne* 20 (1993): 29–42. The 1481 publication, an extraordinarily ambitious project in both its literary and pictorial ambitions, presented the first fully annotated edition of Dante's text and maintained its position as the pre-eminent Dante edition well into the sixteenth century. (For the engravings included in the publication, see below, n. 45.) Landino's lectures on Dante, see Roberto Cardini, "Landino e Dante," *Rinascimento*, ser. 2, 30 (1990): 175–90, and Arthur Field, "Cristoforo Landino's First Lectures on Dante," *Renaissance Quarterly* 39 (1986): 16–45.

10 Paris, Bibliothèque Nationale, Réserve des livres rares, Rés. Yd. 17; see Ursula Baurmeister, Dominique Hillard, and Nicolas Petit, eds, *Bibliothèque Nationale de Paris, Catalogue des incunables, vol. I, fasc. 3, C–D*, and Cristoforo Landino, *Comento sopra la Comedia*, ed. Paolo Procaccioli (Rome: Salerno Editrice, 2001), 1: 137, no. 83. As the book presents itself today, there is another item bound into the volume, a colored drawing of the tomb on a folio sheet of paper; for discussion of this, see Pincus and Shapiro 2006.

11 Bembo's patronage of the innovative manuscript illuminator Bartolomeo Sanvito is discussed by James Wardrop, *The Script of Humanism: Some Aspects of Humanistic Script, 1460–1560* (Oxford: Clarendon Press, 1963), 29–30; discussion of some of the Bembo commissioned manuscripts is to be found in Jonathan J. G. Alexander, ed., *The Painted Page: Italian Renaissance Book Illumination 1450–1550*, exh. cat. (London and New York: Prestel, 1994), for example, nos 73 and 74. For Bembo's role in the development of the frontispiece in manuscripts, see Otto Pächt and Jonathan J. G. Alexander, *Illuminated Manuscripts in the Bodleian Library, Oxford*, vol. 2, *Italian School* (London: Blackwell, 1970), nos 603 and 605.

12 Giannetto 1985, 259–358; Pierre de Nolhac, *La bibliothèque de Fulvio Orsini. Contributions à l'étude de la Renaissance* (1887; reprint, Geneva and Paris: Droz, 1976) for full discussion of the Bembo manuscripts that entered the Vatican collections; and Massimo Danzi, *La biblioteca del cardinal Pietro Bembo* (Geneva: Droz, 2005).

13 Giannetto 1985, 126; John Oliver Hand and Martha Wolff, *Early Netherlandish Painting* (Washington, D.C.: National Gallery of Art and Cambridge University Press, 1986), 193–201. Isabella d'Este asked to borrow the painting; Pietro Bembo took it with him to Urbino. Now divided between the National Gallery, Washington, D.C., and Munich, the diptych is considered one of Memling's finest works. The reverses bear a sophisticated iconography that one wants to consider in terms of the reverse prepared for the Ginevra de'Benci portrait.

14 [Marcantonio Michiel], *Notizia d'opere di disegno publicata e illustrata da Jacopo Morelli*, ed. Gustavo Frizzoni (Bologna: Zanichelli, 1884), 40–83.

15 David Alan Brown, ed., *Virtue and Beauty: Leonardo's Ginevra de' Benci and Renaissance Portraits of Women*, exh. cat., National Gallery of Art, Washington, D.C. (Washington, D.C.: National Gallery of Art, 2001), 142–6, with relevant bibliography.

16 For transcription and reproduction of the letter, see Sebastiano Gentile, ed., *Sandro Botticelli: Pittore della Divina Commedia* (Rome and Milan: Skira, 2000), 1: 243. The importance of the letter was first signaled by Isidoro Del Lungo, *Archivio storico italiano*, ser. 3, 12, pt. 2 (1870): 150.

17 Giannetto 1985, 152–66, and Marino Berengo, "Il governo veneziano a Ravenna," in *Storia di Ravenna*, ed. Lucio Gambi (Venice: Marsilio, 1994), 11–14.

18 See above, n. 1.

19 Corrado Ricci, "Monumenti veneziani nella Piazza di Ravenna," *Rivista d'arte* 3 (1905): 25–34; Giordano Viroli, "Colonne e pilastri lombardeschi in San Francesco a Ravenna," in *Il monumento a Barbara Manfredi e la scultura del Rinascimento in Romagna*, ed. Anna Colombi Ferretti, *et al.* (Bologna: Nuova Alfa, 1989), 119–20.

20 The Pietro Lombardo workshop, which included his two talented sons Tullio and Antonio, is due for a serious modern treatment. Fundamental is still Pietro Paoletti, *L'architettura e la scultura del Rinascimento in Venezia* (Venice: Ongania-Naya, 1893), 190–215. An extensive overview with full bibliography is provided by Matteo Ceriana, "Lombardo, Pietro," in *Dizionario biografico degli italiani*, vol. 65 (Rome: Istituto della Enciclopedia Italiana, 2005), 519–28; see also Sarah Blake McHam, "Pietro Lombardo," in *The Dictionary of Art*, ed. Jane Turner, vol. 19 (London: Grove, 1996), 551–5; and Alison Luchs, "Lombardo Family, Pietro Lombardo," in *The Encyclopedia of Sculpture*, ed. Antonia Boström, vol. 2 (New York and London: Fitzroy Dearborn, 2004), 965–7 and 969–70.

21 For a discussion of issues related to Pietro Lombardo and portraiture, see Anne Markham Schulz, in collaboration with Manuela Morresi and Toto Bergamo Rossi, *La Cappella Badoer-Giustinian in San Francesco della Vigna a Venezia* (Florence: Centro Di, 2003), 58–9, and for a discussion of the Venetian portrait bust, Alison Luchs, *Tullio Lombardo and Ideal Portrait Sculpture in Renaissance Venice, 1490–1530* (New York and Melbourne: Cambridge, 1995), 9–20. Pietro's portrait style was taken up by sculptors in the circle around him, notably Giovanni Buora.

22 For the tomb of Doge Pietro Mocenigo, see Ursula Mehler, *Auferstanden in Stein. Venezianische Grabmäler im späten Quattrocento* (Cologne and Weimar: Böhlau), 78–90, and for a discussion of tomb politics in late fifteenth-century Venice, Sarah Blake McHam, "La tomba del doge Giovanni Mocenigo: politica e culto dinastico," in *Tullio Lombardo: scultore e architetto nella Venezia del Rinascimento. Atti del Convegno di Studi, Venezia, Fondazione Cini 4–6 aprile 2006*, ed. Matteo Ceriana (Verona: Cierre, 2007), 81–98.

23 Procaccioli 2001, vol. 1, Introduction; Deborah Parker, *Commentary and Ideology: Dante in the Renaissance* (Durham and London: Duke University Press, 1993), 78–9; Emilio Bigi, "La tradizione esegetica della *Commedia* nel Cinquecento," in Bigi, *Forme e significati nella "Divina Commedia"* (Bologna: Cappelli, 1981), 173–209; Manfred Lentzen, *Studien zur Dante-Exegese Cristoforo Landinos* (Cologne and Vienna: Böhlau, 1971); and E. N. Tigerstedt, "The Poet as Creator: Origins of a Metaphor," *Comparative Literature Studies* 5 (1968): 455–88.

24 Renzo Grandi, *I monumenti dei dottori e la scultura a Bologna (1267–1348)* (Bologna: Istituto per la Storia di Bologna, 1982). Appropriations of the Bologna professor tomb type had reached the Veneto already by the late fourteenth century.

25 Sarah Blake McHam, "Renaissance Monuments to Famous Sons," *Renaissance Studies* 19 (2005): 458–86, making clear just how widespread this phenomenon

was. Pietro Lombardo's portrait of Dante is mentioned by McHam in connection with this tradition, 472, n. 35.

26 Annarosa Garzelli, ed., *Miniatura fiorentina del rinascimento 1440–1525: un primo censimento*, 2 vols (Florence: La Nuova Italia, 1985), 1: 124–5. For an overview of the tradition of author portraits, see Joyce Kubiski, "*Uomini illustri:* The Revival of the Author Portrait in Renaissance Florence," Ph.D. dissertation, University of Washington, 1993. The inclusion of a well-equipped study space in manuscript author portraits of the Renaissance coincides with the development of the independent *studiolo*, a space for study and contemplation; seeWolfgang Liebenwein, *Studiolo: Die Entstehung eines Raumtyps und seine Entwicklung bis um 1600* (Berlin: Gebr. Mann, 1977), esp. 44–52, and Dora Thornton, *The Scholar in his Study: Ownership and Experience in Renaissance Italy* (New Haven and London: Yale University Press, 1988), esp. 53–75. The expansion of author portraits in Renaissance manuscripts will be taken up more extensively in Jonathan J. G. Alexander's forthcoming study on Italian Renaissance illumination. I am grateful to Prof. Alexander for discussions on this topic.

27 The series is one of the most complete examples of monastic decoration to have survived; see Liebenwein 1977, 53, and Robert Gibbs, *Tommaso da Modena: Painting in Emilia and the March of Treviso, 1340–1380* (Cambridge and New York: Cambridge University Press, 1989), 63–87.

28 Theodor E. Mommsen, "Petrarch and the Decoration of the Sala Virorum Illustrium in Padua," *Art Bulletin* 34 (1952): 95–116; Roland Kranz, *Dichter und Denker im Porträt: Spurengänge zur deutsche Porträtkultur des 18. Jahrhunderts* (Munich: Deutscher Kunstverlag, 1993), 27; Liebenwein 1977, 44–52. The room, redecorated by Domenico Campagnola in 1539 and renamed the Sala dei Giganti, is located in the Liviano, the seat of the Facoltà di Scienze, Lettere ed Arti of the University of Padua (Piazza Capitaniato, No. 7). The original portrait of Petrarch, much repainted, has been preserved in the renovated room.

29 Nicole Reynaud and Claudie Ressort, "Les portraits d'Hommes illustres du Studiolo d'Urbino au Louvre par Juste de Gand et Pedro Berruguete," *Revue du Louvre* 41 (1991): 82–113. The ensemble originally consisted of 28 portraits, of which 14 are today preserved in the Louvre. Dante in the series is already depicted with his laurel crown. Also to be considered within Federico's author celebration is the intriguing pen and ink drawing on vellum, enriched with blue gouache and brown wash, Lehman Collection, Metropolitan Museum of Art. A scholar or man of letter is shown being presented by two muse-like female figures, all three positioned in an open oculus against a deep blue background. The drawing has been attributed to Francesco di Giorgio, with dating proposals varying from c. 1475 to the 1490s. It has been seen as the *modello* for an honorary wall monument, a tomb, or as the frontispiece for a book (for example, for Francesco di Giorgio's *Trattato di architettura*); see Anna Florlani Tempesti, *The Robert Lehman Collection*, vol. 5, *Italian Fifteenth- to Seventeenth-Century Drawings* (New York and Princeton: Metropolitan Museum of Art and Princeton University Press, 1991), 202–7, and Andrea De Marchi in *Francesco di Giorgio e il Rinascimento a Siena 1450–1500*, ed. Luciano Bellosi (Milan: Electa, 1993), 312.

30 For discussion of the identity of the figures and dating of the manuscript, see Gentile 2000, 1: 72–3; Alexander 1994, 98–9; and Cristoforo Landino, *Disputationes Camaldulenses*, ed. Peter Lohe (Florence: Sansoni, 1980), ix–xiii. The names of a number of artists have been proposed for the portrait, including Francesco di Giorgio. An appreciative discussion of the portrait, with an attribution to the Florentine illuminator Francesco di Antonio del Chierico, is given in Garzelli 1985, 1: 141–2; see also Jonathan Alexander in Alexander 1994, 98–9.

31 Rudolph Altrocchi, "Michelino's Dante," *Speculum* 6 (1931): 15–59; Cesare Marchisio, *Il monumento pittorico a Dante in Santa Maria del Fiore* (Rome: Fratelli Palombi, 1956). Annamaria Bernacchioni in Gentile 2000, 1: 218–19. An attempt to assign the cartoon for the work to Alesso Baldovinetti, still surfacing in the literature, has been refuted by Ruth Wedgwood Kennedy, *Alesso Baldovinetti: A Critical and Historical Study* (New Haven and London: Yale University Press, 1938), 133–5. For further discussion of the painting, see Richard Thayer Holbrook, *Portraits of Dante from Giotto to Raffael* (London and Boston: Philip Lee Warner for the Medici Society and Houghton Mifflin, 1911) and the Appendix to this chapter.

32 For the issue of poet's laurels, see J. B. Trapp, "The Owl's Ivy and the Poet's Bays: An Inquiry into Poetic Garlands," *Journal of the Warburg and Courtauld Institutes* 21 (1958): 227–55, reprinted in Trapp, *Essays on the Renaissance and the Classical Tradition* (Aldershot and Brookfield: Ashgate/Variorum, 1990).

33 See Appendix to this chapter.

34 Tobias Fendt, *Monumenta sepulcrorum cum epigraphis ingenio et doctrina Excellentium Virorum* (Wroclaw, 1575), engraving of the tomb, c. 20, with Bembo's dedicatory inscription for the tomb chamber on c. 21. It would appear that the designer of the engraving had only a description of the tomb on which to base the reproduction; the inscriptions, however, are quite accurately rendered, the dedicatory inscription, the "*Virtuti et Honori*" of the lunette and the "*Iura Monarchiae*" of the tomb chest. The Fendt engravings were reissued in later editions; see Marcus Zverius Boxhorn, *Monumenta Illustrium Virorum et Elogia* (Amsterdam, 1638 and Utrecht, 1671). The engraving, with adaptations, is included in Girolamo Rossi's *Storia di Ravenna* (reproduced by Fontana 1994, 191).

35 Gasparo Martinetti Cardoni, *Dante Alighieri in Ravenna. Memorie storiche con documenti* (Ravenna: Gaetano Angeletti, 1864), frontispiece.

36 Henri-Irénée Marrou, *Mousikos Aner: Etude sur les scènes de la vie intellectuelle figurant sur les monuments funéraires romains* (Rome: Bretschneider, 1964), see pl. 4; Paul Zanker, *The Mask of Socrates* (Berkeley and London: University of California Press, 1995), 90–108, "The Rigors of Thinking;" Karl Schefold, *Die Bildnisse der antiken Dichter, Redner und Denker* (Basel: Schwabe, 1997), esp. 238–9, 310.

37 See note 27.

38 Bellincioni, whose *Rime* lean heavily on the visionary mode, was attached to the Milanese court of Ludovico Sforza and was a friend of Leonardo's (Pietro Fanfani, ed., *Le rime di Bernardo Bellincioni riscontrate sui manoscritti* (Bologna: Gaetano Romagnoli, 1876), esp. 15–29). See also Carlo Amoretti, *Memorie storiche su la vita, gli studi e le opere di Leonardo da Vinci* (Milan, 1804), 39; Paul Kristeller, *Die lombardische Graphik der Renaissance* (Berlin, 1913; reprinted Hildesheim and New York, 1975), 20–21, 31, 35, 83. An engraving in the Louvre, Cabinet des Estampes, Collection Eduard Rothschild, H.589.53, has been cited as the model on which the woodcut was based and perhaps reflecting the presumed Leonardo drawing behind the image (see also Dora Thornton, *The Scholar in his Study* (New Haven and London: Yale University Press, 1988), 6. The connection of the Bellincioni woodcut with Leonardo has been brought into modern Leonardo literature by Ludwig Goldscheider, *Leonardo da Vinci* (8th edn, London and New York: Phaidon, 1967), 23, and subsequent editions). I am indebted to Wendy Stedman Sheard for her intuition regarding the importance of the image.

39 Walther von der Vogelweide, *Grosse Heidelberger Liederhandschrift: Codex Manesse*, Heidelberg, Universitätsbibliothek, beginning of fourteenth century:

"… Ich hatte in meine Hand das Kinn und eine meiner Wangen geschmiegt. So dachte Ich angestrengt darüber nach, wie man auf der Welt leben sollte."

40 See, with a summary of earlier literature, the beautiful discussion of the gesture by William S. Heckscher in his "Camerarius on Dürer's *Melencolia I*," in *Joachim Camerarius (1500–1574): Beiträge zu Geschichte des Humanismus im Zeitalter der Reformation*, ed. Frank Baron (Munich: Wilhelm Fink, 1978), 49–50, 86–7, putting the gesture within the frame of Aby Warburg's *Pathosformeln*.

41 Keith Christiansen, *Andrea Mantegna: Padua and Mantua* (New York: Braziller, 1994), 46 and fig. 55. The same gesture was used earlier by Mantegna in his *Saint Mark*, Städelsches Kunstinstitut, Frankfurt, of c. 1448–50; see Pincus, "Mark Gets the Message: Mantegna and the *praedestinatio* in Fifteenth-Century Venice," *Artibus et Historiae* 35 (1997): 135–46, and Keith Christiansen in Jane Martineau, ed., *Andrea Mantegna*, exh. cat. (New York: Metropolitan Museum of Art, and London: Royal Academy, 1992), 119–21.

42 See *Homer: Der Mythos von Troia in Dichtung und Kunst*, exh. cat., Antikenmuseum Basel und Sammlung Ludwig (Basel, 2008). The hand-to-mouth gesture is one of the gestures of inspiration used for early depictions of the Evangelists (Albert M. Friend, Jr., "Portraits of the Evangelists in the Greek and Latin Manuscripts," *Art Studies* 5 (1927): 115–47 and *Art Studies* 7 (1929), 3–29). The idea of wisdom imbibed through drinking, in the most literal sense, is explored in the thoughtful essay by John Moffitt, "Image and Meaning in Velazques's Water-Carrier of Seville," *Traza y Baza* 7 (1978): 5–23.

43 Gert Kreytenberg, *Orcagna's Tabernacle in Orsanmichele, Florence* (New York: Harry N. Abrams, 1994), 45, 167, pls 126, 130. The depiction of *Solerita* is found in the bottom register, on the north side of the structure. The finger-to-lips gesture will have a later history in emblematic literature. *Hermes Mystagogue* places his index finger on his mouth as revelation reaches him from on high in Achille Bocchi, *Symbolicae quaestiones*, 1575, nos 64 and 143 (Edgar Wind, *Pagan Mysteries in the Renaissance* (2nd edn, New York: Norton, 1968), 12, n. 40 and 124, figs 23, 24). Wind connects the gesture to the idea of complete knowledge, seeing it as a depiction of "mystical silence" accompanying inward revelation. An intriguing discussion of the hand, in medieval reliquaries, as a signifier of God's power is given by Cynthia Hahn, "The Voices of the Saints: Speaking Reliquaries," *Gesta* 36/1 (1997): 20–31.

44 This interpretation of the enigmatic figure in the archivolt of the Months, central door, west facade of San Marco (inner face of second archivolt, left side, bottom figure) has been suggested to me be Wendy Stedman Sheard. The strange and compelling figure—majestically seated in a throne-like chair, marked out as a cripple by his two large crutches—has been proposed as the architect of the church. Time has erased his original gesture—still visible in older photographs—in which he points emphatically to his open mouth. It may well be that we have here an early expression of what is so fully laid out in Dürer's image—divine creativity to which flawed, "crippled" mortality aspires.

 The figure is discussed, somewhat inconclusively, by Guido Tigler, *Il portale maggiore di San Marco a Venezia: Aspetti iconografici e stilistici dei rilievi duecenteschi* (Venice: Istituto Veneto di Scienze, Lettere ed Arti, 1995), 259–62; and in the catalogue entry by Tigler in Otto Demus, *Le sculture esterne di San Marco* (Milan: Electa, 1995), 168–9, no. 164. For a photograph of the sculpture before loss of the hand-to-mouth gesture, see Otto Demus, *The Church of San Marco in Venice: History, Architecture and Sculpture* (Washington, D.C.: Dumbarton Oaks, 1960), pl. 80.

45 Hein-Th. Schulze Altcappenberg, ed., *Sandro Botticelli: The Drawings for Botticelli's Divine Comedy* (Berlin and London: Thames & Hudson, 2000), 220–21. Botticelli's Dante suite of 93 drawings on vellum—now divided between Berlin and the Vatican—were, according to early notices, executed for Lorenzo di Piero Francesco de' Medici, Lorenzo de' Medici's nephew and ward. The relationship between these exquisite silverpoint drawings and the engravings—perhaps also indebted to Botticelli—prepared for Landino's 1481 edition of the *Commedia* has been much debated. For summaries of the problem see Arthur M. Hind, *Early Italian Engraving* (New York and London: M. Knoedler, 1938), 1: 99–116, and Peter Keller in Altcappenberg 2000, 326–33. Only 19 engravings (through *Inferno* XIX), to which the name of Baccio Baldini has been attached, were completed for the Landino edition. Printing the engravings together with the text proved daunting, and no more than three were ever printed together with the page in the run of published volumes (in some exemplars additional engravings have been pasted into the reserve spaces left for them). For Botticelli's Berlin–Vatican drawings see, in addition to the above, Ronald Lightbown, *Sandro Botticelli* (Berkeley and Los Angeles: University of California Press, 1978), 1: 147–51, and Herbert P. Horne, *Botticelli: Painter of Florence* (London: George Bell, 1908; reprint, Princeton: Princeton University Press, 1980), 75–255. Horne dates the Berlin–Vatican drawings to shortly after 1492, but it seems clear that Botticelli was involved in the problem of envisioning images for Dante's narrative at an earlier date—possibly already at the time of the Landino lectures in the mid-1470s. Horne emphasizes Botticelli's involvement with Dante, applying to him the phrase that Vasari applied to Michelangelo: "il suo famigliarissimo Dante" (76–7).

46 "La concreata e perpetua sete / del deii forme regno cen portava / veloci quasi come 'l ciel vedete" (Dante Alighieri, *The Divine Comedy*, with translation and comment by John D. Sinclair, vol. III, *Paradiso* (New York: Oxford University Press, 1958), 32–3).

47 See also Ghirlandaio's frescoed portrait of *Saint Jerome*, c. 1480, for the church of the Ognissanti in Florence (Bert W. Meijer, *Firenze e gli antichi Paesi Bassi, 1430–1530: dialoghi tra artisti* (Livorno: Sillabe, 2008), 89–90).

48 For explicitly negative judgments, see Holbrook 1911, 56: "And as for Pietro Lombardo's low-relief, if it is in truth his, either he was not well informed in Dante iconography, or he had not the skill to carry out the best design that he had managed to shape in his imagination;" and Edmund G. Gardner, *Dante in Art* (London: Medici Society, 1916), 12: "we have the monument executed by Pietro Lombardo in 1483, which can hardly be accepted as a worthy presentment of the world's greatest poet."

49 Massimo Ferretti, "Il *San Marco* del Duomo di Ravenna: Tullio Lombardo caccia due intrusi dal *Thieme-Becker*," *Prospettiva* 95–6 (1999): 2–23. I am grateful to Massimo Ferretti for his generosity in providing me with photographs of the altar.

50 The pose is described by De Tolnay as "one which expresses contemplation in silence." Charles De Tolnay, *Michelangelo*, vol. 3, *The Medici Chapel* (Princeton: Princeton University Press, 1970), 140, and 141 for interpretations of the figure that stress a reference to the contemplative life. Erwin Panofsky, *Studies in Iconology* (New York: Oxford University Press, 1939), 211, characterizes the placement of the hand as "the gesture of Saturnian silence," in line with what he sees as the strain of melancholy in the figure.

51 See Ludwig Volkmann, *Iconografia Dantesca* (London: H. Grevel & Co., 1899), 25–53, and Holbrook 1911, 219–23. A survey, with good illustrations in color, is

given by Zygmunt G. Barański, "'Honour the loftiest poet': Dante's Reception in Fourteenth-Century Italy," in Barański and Martin McLaughlin, eds, *Italy's Three Crowns: Reading Dante, Petrarch and Boccaccio* (Oxford: Bodleian Library, 2007), 9–22; see also Peter Brieger, Millard Meiss and Charles S. Singleton, eds, *Illuminated Manuscripts of the Divine Comedy* (Princeton: Princeton University Press, 1969), 2 vols and Holbrook 1911, "Portraits in Manuscripts," 219–23. The manuscript Biblioteca Apostolica Vaticana, Barb. Lat. 4112 of the *Comedia*, dated 1419, with a handsome *en buste* portrait of Dante in the "N" of the opening Canto, was highlighted in Gentile 2000, 1: 233.

Various attempts have been made to identify portraits of Dante in fourteenth-century frescoes. The most famous—and persistent—of these is the so-called "Kirkup" portrait (a drawing of it by Seymour Stocker Kirkup was widely circulated and reproduced), based on a figure included in the scene of Paradise on the east wall of the former Magdalen Chapel in the Bargello believed to have been painted by Giotto; see Ernst H. Gombrich, "Giotto's Portrait of Dante?," *Burlington Magazine* 121 (1979): 471–83; Paola Barocchi and Giovanna Gaeta Bertelà, *Dal ritratto di Dante alla Mostra del Medio Evo 1840–1865* (Florence: Spes, 1985); and Graham Smith, *The Stone of Dante and Later Florentine Celebrations of the Poet* (Florence: Olschki, 2000), 45–9. Shown conclusively to have no connection to Giotto, it may still have some claim as a portrait of Dante, although this also is open to doubt. For a wonderful discussion that transmits the enthusiasm for this portrait of an earlier age, see Holbrook 1911, 73–103.

52 "Fu il nostro Poeta di mediocre statura, et ebbe il volto lungo et il naso aquiline, le mascelle grandi et il labbro di sotto proteso tanto, che alquanto quell di sopra avanzava; nelle spalle alquanto curvo, e gli occhi anzi grossi che piccioli, et il colore bruno, et i capelli e la barba spessi, crespi e neri: e sempre nel viso malinconico e pensoso," Giovanni Boccaccio, *Della origine, vita, costumi e studii di Dante Alighieri di Firenze*, in *Le vite di Dante scritte da Giovanni e Filippo Villani, da Giovanni Boccaccio, Leonardo Aretino e Giannozzo Manetti*, ed. G. L. Passerini (Florence: Sansoni, 1917), 33. Boccaccio, who had never met Dante, was working at second hand; no known portraits of Dante include the thick, curly beard mentioned by him. Boccaccio's reverence of Dante, interestingly, contrasts dramatically with that of Petrarch; see Aldo S. Bernardo, "Petrarch's Attitude Toward Dante," *Publications of the Modern Language Association* 70 (1955): 488–517.

53 See above, n. 31.

54 The idea of Dante's text as "divine" may already be operating here, although the epithet of divine came to be applied to the poem only in the sixteenth century (edn of 1555 by Gabriel Giolito de Ferrari, with the title *La Diuina Comedia di Dante*; see Pio Rajna, "L'epiteto 'divina' data alla 'Commedia' di Dante," *Bullettino della Società Dantesca Italiana* 22 (1915): 107–15, 255–8, and Heckscher 1978, 44, with discussion of the adjective "divine" as transferred from poets to artists). Rajna, 109, notes that Landino's introduction to the first Canto of the poem applies the epithet divine to Dante: "*Canto primo della prima cantica o vero comedia del divino poeta fiorentino Danthe Aleghieri.*"

55 The issue of laurels awarded to poets was of course primarily allegorical, but Petrarch *did* receive an actual laurel crown as part of his Coronation ceremonies on the steps of the Capitoline in Rome in 1341 (Ernest Hatch Wilkins, "The Coronation of Petrarch," *Speculum* 18 (1943): 155–97; see also Trapp 1958). The small roundel image of Dante in the frame of Benozzo Gozzoli's St. Francis fresco cycle, dated by inscription to 1452, in the church of S. Francesco, Montefalco, appears to be the first image of Dante with a laurel crown

(Domenico Bechelloni, *Le pitture di Benozzo Gozzoli nella Chiesa di S. Francesco in Montefalco* (Perugia, 1892); and Franz Xaver Kraus, *Dante: sein Leben und sein Werk* (Berlin: G. Grote'sche Verlagsbuchhandling, 1897), 191 [illustration] and 194).

56 The sensitive portrayal of Dante by Andrea del Castagno in the *Famous Men and Women* cycle for the Villa Carducci, Legnaia (now Uffizi), c. 1448–49, the most imposing representation of Dante prior to the Duomo presentation, was drawn on by Domenico di Michelino. Intensified in the Duomo portrait is the pensive, melancholy gaze, almost certainly representing input from Boccaccio's description, *"e sempre nel viso malinconico e pensoso."* Dante does not yet have his laurel crown in the Castagno portrait (Josephine M. Dunn, "Andrea del Castagno's Famous Men and Women," Ph.D dissertation, University of Pennsylvania, 1990, 215–50; and for discussions of the Castagno portrait within the context of Dante representations, see Annamaria Bernacchioni, in Gentile 2000, 1: 216–17).

57 The renovation program has been placed in the context of Lorenzo de' Medici's cultural propaganda campaign by Melinda Hegarty, "Laurentian Patronage in the Palazzo Vecchio: The Frescoes of the Sala dei Gigli," *Art Bulletin* 78 (1996): 264–85.

58 Alessandro Cecchi, "Filippino disegnatore per le arti applicate," in *Florentine Drawing at the Time of Lorenzo the Magnificent, Papers from a Colloquium Held at the Villa Spelman, Florence, 1992*, ed. Elizabeth Cropper (Bologna: Nuova Alfa, 1992), 55–61, esp. 56, and Cecchi, "Giuliano e Benedetto da Maiano ai servigi della Signoria fiorentina," in *Giuliano e la bottega dei da Maiano. Atti del Convegno Internazionale di Studi, Fiesole 13–15 giugno 1991*, ed. Daniela Lamberini, Marcello Lotti, and Roberto Lunardi (Florence: Franco Cantini, 1994), 148–57, esp. 152–3.

59 The much-discussed sculpted portrait of Giuliano de' Medici, National Gallery of Art, Washington, D.C.—from the Verrocchio shop if not from the hand of Verrocchio himself—newly aggressive in terms of its projection of an image of power and authority, is one of the works to be considered in terms of this shift in portrait thinking.

60 Rose Marie San Juan, "The Illustrious Poets in Signorelli's Frescoes for the Cappella Nuova of Orvieto Cathedral," *Journal of the Warburg and Courtauld Institutes* 52 (1989): 71–84. Holbrook 1911, includes, between 192 and 193, a good color reproduction. The use of a perspectival frame—maintained for the full run of "authors of inspiration" in the Orvieto scheme—as well as the profile pose and the two prominent books of consultation suggests that Signorelli drew here on the Ravenna Dante portrait.

61 A quite separate problem is presented by the much discussed, problematic portrait painted on parchment in thick tempera, pasted into the front cover of a paper manuscript copy, considered to date c. 1440–50, of Dante's *Rime* (Riccardiana 1040). Most recently placed in the mid-fifteenth-century circle of Pesellino, it is an image that awaits its definitive discussion. The boldness and simplicity of the image—the emphasized, and somewhat mechanical, shading lines and the brilliance of the color—all this intensified by the deep black background apparently applied after the image had been completed to silhouette the portrait—give it a meretricious appeal. At one point considered to date contemporaneously with the manuscript to which it has been applied, the portrait is now acknowledged as an extraneous object, thus leaving the dating issue entirely open. Although the legend "• DANTE •" at the top of the image, brushed on in gold, could conceivably be a later addition, it would seem that

the crude letters—neither sans serif nor antique majuscules—aim for the same archaizing effect as the portrait—one of the numerous later efforts to remedy the lacuna of an "authoritative"—that is, sufficiently heroic—early portrait image of Dante. The absence of a laurel crown may well be another piece of the archaizing intent of the image. The lines of poetry beneath the image, written in a sixteenth-century hand, are an abridged version of the sonnet below Domenico di Michelino's Duomo portrait. The portrait of Riccardiana 1040 needs to remain an image still under discussion. (The bibliography on Riccardiana 1040 is extensive; for summaries see Marisa Boschi and Alvaro Spagnesi, in *I Dante riccardiani: parole e figure*, ed. Giovanna Lazzi (Florence: Edizioni Polistampa, 1996), 69–72; Alvaro Spagnesi, "L'immagine di Dante e quella di altri 'Huomini Illustri' nel primo Quattrocento," in *Immaginare l'autore. Il ritratto del letterato nella cultura umanistica*, Convegni di studi, Firenze, 26–7 marzo 1998, ed. Giovanna Lazzi and Paolo Viti (Florence: Edizioni Polistampa, 2000), 71–9, and Giovanna Lazzi in Gentile 2000, 1: 237–8). A crude and derivative version of the Riccardiana portrait is found in Biblioteca Apostolica Vaticana, Urb. Lat. 683, fol. 38v (Bernhard Degenhart and Annegrit Schmitt, *Corpus der italienischen Zeichnungen 1300–1450*, vol. 1, pt. 2 (Berlin: Gebr. Mann, 1968), 283).

The portrait of Riccardiana 1040 bears an intriguing resemblance to the so-called "life-masks" of Dante, thoroughly bogus objects which have been shown to date no earlier than the sixteenth century. For their evaluation as pious confections, see Holbrook 1911, 36–52, and Corrado Ricci, "La maschera di Dante," *Rassegna d'arte antica e moderna* 21 (1921), 289–95.

62 Luitpold Dussler, *Raphael: A Critical Catalogue of his Pictures, Wall-Paintings and Tapestries* (London and New York: Phaidon, 1971), 71–6. The head of Dante on the beautiful pen and ink drawing of three poets' heads for the *Parnassus* fresco is a telling document, showing Raphael in the process of working out his Dante type (Martin Clayton, *Raphael and his Circle: Drawings from Windsor Castle* (London: The Royal Collection, 1999), 73–4). Marcantonio Raimondi's engraving of the *Parnassus*, recording an early stage of Raphael's envisioning of the fresco, also suggests that the final Dante image was only gradually arrived at (Innis H. Shoemaker, *The Engravings of Marcantonio Raimondi* (Lawrence: Spencer Museum of Art, 1981), 155–7). The idea of Raphael's portrait as that of the "real" Dante is perfectly expressed by Aloisio Fantoni, "Lettera," *Giornale del Centenario di Dante Alighieri*, Sett. 20, no. 23 (1864): 185–6: "Dobbiam dunque credere che in quello del Vaticano sta il vero sembiante di Dante: e chiamarci fortunati ci sia stato nella naturale grandezza, non impiccolito, trasfigurato, e dalla mano di un Raffaello."

Partnerships in commemoration:
the patronage and production of the Brusati and Barbo tombs in Quattrocento Rome*

Shelley E. Zuraw

The dramatic stories told about the creation of works of art in the Renaissance usually have one hero, the exceptional artist whose genius allowed him to transform an idea into a brilliant visual statement. Over the last half century it has become increasingly obvious that another name has to be added to these narratives of invention—that of the patron, who ordered and paid for the work of art. Discussions of patronage often presume the responsible a single person or entity. In this sense, our notion of the Renaissance patron still conforms to the Romantic vision of the individual, be it artist or patron. Nowhere does the relationship between heroic artist and single powerful patron seem more evident than in tomb sculpture where the artist and the deceased are joined in perpetuity. But Roman fifteenth-century tombs were not made this way; one patron did not commission one artist to carve his tomb. Typically, more than one master artist was engaged by multiple patrons. Roman fifteenth-century tombs vary widely in form, style, size, and history, but the one constant is that they are all the product of changing partnerships between artists and patrons.

The partnerships required in order to fund and produce tombs in Quattrocento Rome suggest a corporate structure. Instead of the productions of solitary individuals, tombs were the result of teamwork. Different people could be involved at different times, the amount of time required to complete a tomb could be short or long, and tombs could be inventive or ordinary, but regardless of these variables, they all depended on the collective enterprise of numerous people. Representative of this process are two tombs, virtually unknown today: one dedicated to Bishop Giovanni Francesco Brusati (d. 1477) in San Clemente (Figure 4.1), the other in honor of Cardinal Marco Barbo (d. 1491) in San Marco (Figure 4.2). The program and structure of the Brusati tomb is typical and its artistic merit unexceptional. Its distinction lies in the

fact that the contract of commission survives, making this the only tomb among the extraordinary number created in fifteenth-century Rome for which we have a contract. The patron, a relative of the deceased, awarded the commission for the tomb in 1485 to two independent sculptors: Giacomo di Domenico della Pietra and Luigi di Pietro Capponi. While we have no names that can be associated with the production of the Barbo tomb, its form and materials are unique. Here the corporate nature of the process is illustrated by the multiple patrons. The project was initiated by Cardinal Barbo as early as 1468, but only brought to completion by two executors, also cardinals, after Barbo's death more than two decades later. Each of these tombs, then, highlights different aspects of the sorts of collective arrangement required in the erection of a marble tomb. While allowing for remarkable diversity in style and meaning, the assemblage system in place in Rome for ordering and making works of art, especially tombs, assured that these commissions were completed in a timely fashion.

Two groups were essential to the completion of a tomb: artists and patrons. In both cases, Roman Renaissance tombs involved collaboration within and among these groups. Along with the deceased, who may or may not have planned for his own tomb, the family, immediate heirs, and executors could all, at different times, play a role in the tomb's realization. Such changes in patronage were the inevitable result of the length of time it could take to complete a tomb. Nevertheless, Roman patrons usually wanted their monuments to be put up quickly and such demands for speed often led to the participation of more than one sculptor, sometimes even more than one workshop. Although the Barbo tomb and Brusati tomb could not, on the face of it, be less alike, their superficial differences mask a profound similarity. Both tombs document the flexibility and cooperation between and among patrons and artists that was required of all Roman Renaissance tombs.

In the case of the Brusati monument, the two sculptors hired to produce the tomb, Giacomo della Pietra, from Carrara, and Luigi Capponi from Milan, are named in the contract of 1485.[1] According to their agreement, a drawing of the tomb, divided in half and shared by the notary and the artists, bound the parties legally to the form of the projected tomb. This process replicates the one employed by the representatives of the Sienese Commune in their negotiations with Jacopo della Quercia for the Fonte Gaia in 1409.[2] The Roman contract drawing has not been preserved and there is only limited evidence of any kind of sculptors' drawings in fifteenth-century Rome. One notable survivor is a drawing made c. 1500 of a now lost sacrament tabernacle in San Lorenzo in Damaso. Only half of the tabernacle is actually depicted, apparently because both sides of the work were identical.[3] The artist responsible must have assumed that his audience, whether the patron, notary, or another artist, would have be able to reconstruct the intended appearance of the whole tabernacle from the fragment provided. The sculptors engaged on the Brusati tomb project are likely to have worked with similar drawings regularly.

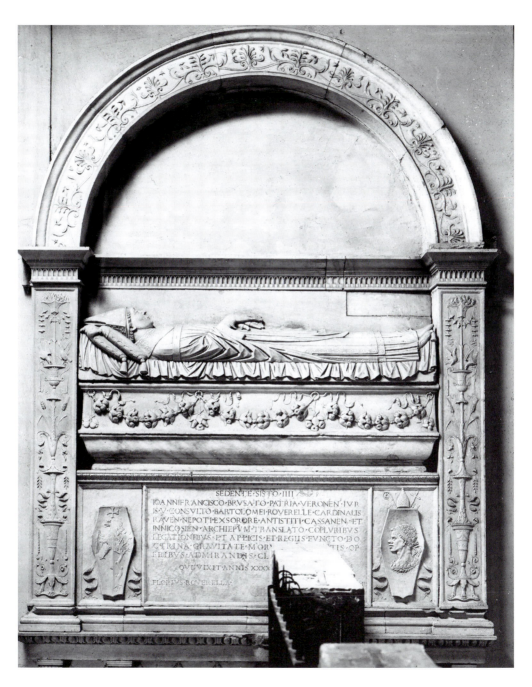

4.1 Luigi Capponi and Giacomo della Pietra, *Tomb of Giovanni Francesco Brusati*, San Clemente

4.2 *Tomb of Cardinal Marco Barbo*, San Marco

The mention of this drawing in the contract suggests that the patron expected that Giacomo della Pietra and Luigi Capponi would use it as a record of the agreed-upon design for the tomb. Since the drawing no longer survives, it is not possible to determine its author or if, in consequence, one of the two sculptors was the chief artist for the project. Although they might well have employed the drawing as a means to allocate the actual assignments between them, neither the contract itself nor reference to the drawing can be used to identify a principal sculptor. Other, more complex tombs from the same period seem to have been almost obsessively divided into equal portions by two, equally prominent sculptors, leaving no evidence of a lead sculptor.

The written evidence for the Brusati design reveals that the process by which sculptors and patrons produced a single tomb was not haphazard or circumstantial. Decisions about form and content and, therefore, also responsibility for different parts were made early in the process and with the knowledge of the patron. In this case, however, the patron was not the deceased. Brusati, the Bishop of Verona and Archbishop of Nicosia, had died in 1477 during the reign of Pope Sixtus IV (1471–84), a fact announced at the beginning of the epitaph by the handsome Latin majuscules—"SEDENTE SISTO IIII."[4] The tomb contract and, therefore, the tomb itself are posthumous.

The inscription concludes with the name of the tomb patron, Florio Roverella, the bishop's uncle.[5]

The completed tomb still occupies a spot on the wall of the east aisle of San Clemente. It is easily ignored because it is so completely overshadowed by the tomb immediately to its left (Figure 4.3), the monumental wall tomb erected to honor Brusati's uncle, the Cardinal of San Clemente, Bartolomeo Roverella (d. 1476).[6] The differences between the two tombs articulate the relative status of both men. While Brusati's monument is a wall tomb that elevates him, quite literally, above those whose tomb markers remained on the floor, it does not occupy the entire height of the wall as does the tomb of Cardinal Roverella. Together the Roverella and Brusati tombs claim a certain family space within San Clemente for these two clerics. Although the two tombs were not commissioned for or by the same men, both were commissioned from two independent sculptors' shops, working in tandem. In the case of the Brusati tomb, a document assigns the tomb to Giacomo della Pietra and Capponi. Although no such literary evidence exists for the Roverella tomb, variations in style make it clear that the work was shared by two of the most important sculptors working in Rome in the 1470s, Andrea Bregno and Giovanni Dalmata. The balance between Bregno's classicism, seen in the putti who support the cardinal's coat of arms and the angels in the spandrels, and Dalmata's more naturalistic figures is maintained throughout the design. Close examination reveals that both major and minor portions of the tomb were assigned equally to the two shops. The Roverella tomb is one of the most splendid wall tombs of the late Quattrocento, composed of a deep, classical niche that shelters the sarcophagus and effigy. Most striking of all is the treatment of the rear wall as an apse, complete with a relief depicting the patron being presented to the Madonna and Child by Saint Peter with Saint Paul looking on, and a figure of God the Father blessing from the semi-dome above. The Brusati tomb is much smaller and simpler. In Rome the shapes of tombs varied widely; here, a rectangular relief with sarcophagus, effigy, and inscription is surmounted by a lunette, suggestive of an arcosolium.[7] Since so many of the Roman Quattrocento tombs have been dismantled and reconstructed, it is not always possible to ascertain the original form of each, but reduced variants of larger wall tombs were produced regularly in Rome. The Brusati tomb represents, in a minor key, the same standards and practices employed on the Roverella monument.

Even the simplest tomb, like the relatively modest Brusati tomb, required a high degree of cooperative planning. The stages of production were comparable to those involved in much more elaborate tombs. This is a question of process; but the same can be said of composition. Smaller tombs in Rome replicate the essential elements of their monumental predecessors—the effigy with its sarcophagus, the prominent inscription, and a crowning element with a scene of intercession. These three distinct parts are each equally important to the tomb's function and meaning. Conventions of style and form employed in the workshops of master sculptors such as Mino da Fiesole, Giovanni Dalmata,

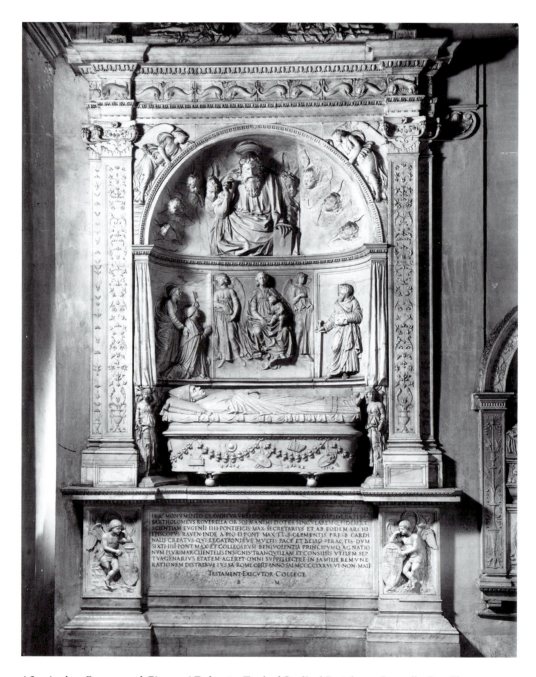

4.3 Andrea Bregno and Giovanni Dalmata, *Tomb of Cardinal Bartolomeo Roverella*, San Clemente

and Andrea Bregno were reiterated with surprising regularity in the smaller, sometimes nameless shops that were responsible for the countless minor tombs dispersed throughout the churches of Rome.

The lowest portion of the Brusati tomb, resting on corbels, includes the lengthy inscription.[8] Contained within a simple carved frame it is, in turn, flanked by smaller panels on which are displayed the two coats of arms, the Roverella arms on the left and Brusati's on the right.[9] The Brusati effigy, made at least eight years after the death of the bishop and therefore not likely to be a true portrait, is a replica of an effigy type that appears frequently in the work of Andrea Bregno. The effigy on the tomb of Cristoforo della Rovere (d. 1478) in Santa Maria del Popolo provides an especially close parallel.[10] That tomb was executed by Bregno in collaboration with Mino da Fiesole. It is, in every sense, a more complicated and important work than Brusati's tomb, comparable to the tomb of Cardinal Roverella, and it, too, appears to be the work of two master sculptors. Whereas the great cardinals' tombs of this period tend to include three-dimensional effigies, Brusati's effigy, appropriately, is a simpler relief. A similar relationship exists between the elaborate and elegantly garlanded sarcophagi typically found on Bregno's more monumental tombs and that on the Brusati tomb.

The sculptors of the Brusati tomb were evidently very familiar with tombs in the repertoire of Andrea Bregno's shop. Although we know nothing about Giacomo della Pietra, documentary evidence exists for the career of the north Italian sculptor Luigi Capponi. The work of two sculptors is clearly distinguishable on the Brusati tomb.[11] La Malfa assigns the effigy to the otherwise unknown Giacomo della Pietra, the coat of arms with the moor's head and the pilasters to Luigi Capponi. That Giacomo della Pietra also was familiar with Bregno's shop production is clear from the effigy. Despite evident differences in style (the waves of rounded cloth that define the outer arm on Cristoforo della Rovere's effigy have become sharp and pointed folds on the Brusati tomb), the bishop's effigy is a simplified version of Bregno's effigies for cardinals. The Brusati tomb contains the first certain work by Luigi Capponi; his early style, like that of his collaborator's, confirms the connection with Andrea Bregno and his shop. Significantly, the Brusati contract refers to Luigi as "de mediolano," the same description used by Andrea Bregno as part of his signature, also from 1485, on the Piccolomini Altar in Siena.[12] It is very likely that both Capponi and Giacomo della Pietra had experience in Bregno's workshop before setting out on their own. The practices, including the design process and the division of labor, of the larger workshops shaped the production of even minor tombs in Rome. In this case the otherwise unknown Giacomo della Pietra seems to have done the more important part, the effigy and sarcophagus. whereas Luigi Capponi, the artist whose later career we can trace, was responsible for the decorative portions. Given the restricted format of this tomb, the sculptors shared the work as evenly as possible.

Just as the style of the Brusati effigy is based on models provided by contemporary tombs for cardinals, the decision to include an effigy on this

simpler relief tomb underscores the central role the effigy plays in Quattrocento Roman tombs. Only rarely distinguishable as actual portraits of the deceased, these effigies are symbolic actors, present at each ceremonial event in the church or chapel. The churches of Rome are literally peopled with the effigies of cardinals, bishops, archbishops, and others, who model, through their tombs, the progress of the soul from burial through salvation. The monumental tomb for Roverella installs the effigy within a sacred space, the apse of a church. The cardinal is presented to the Virgin and Child, their intercession is assured by the appearance of God the Father in the semi-dome. Brusati's tomb is a reduction of this scheme in every part, including the act of intercession.

The arched lunette that surmounts Brusati's tomb is now empty but it once contained an image of the bishop kneeling in prayer before the Madonna and Child. In his publication on the tombs of Rome from 1842, Tosi included a depiction of this group (Figure 4.4).[13] Although this element does not appear in the seventeenth-century drawing of the tomb preserved in the Codex Albani, in this detail and in all other ways, Tosi's image is more complete than the Albani drawing, suggesting that the scene of intercession was an actual element on the tomb.[14] A painted, specifically frescoed image above a carved effigy is not unknown in Rome; the tomb of Bishop Diego del Coca in Santa Maria sopra Minerva still retains its painted decoration as does the tomb in Santa Maria del Popolo for Giovanni della Rovere.[15] An image of Brusati in prayer before the Madonna and Child would have required the services of yet another artist, a painter this time. If executed in fresco, his work would have been added after the tomb was both carved and installed.

What makes the Brusati tomb so interesting in the current discussion is the fact that the contract engages two sculptors to produce it and the completed tomb may even have required the services of a painter. This raises a fundamental question: why would two sculptors who were not, apparently, sharing a workshop, agree to collaborate on a single tomb? And, further, why would the patron require that arrangement? It is the presumption of most scholars that a "primary" artist typically received a commission for an important work such as a marble tomb. While he, in turn, might employ assistants to work with him, in the end the completed tomb should be attributed to one designing mind. When more than one distinctive hand is visible, it is often easiest to assume that while one of the sculptors was in charge, the other was involved briefly because of some now mysterious exigent circumstance.[16] The existence of the Brusati document provides the evidence needed to prove a different arrangement, one that seems to have been widespread in Rome.

Such shared commissions served both artists and patron because of their presumed efficiency. An examination of Quattrocento Roman tombs reveals that in a surprising number of cases the work was produced by different hands. The Roverella tomb is one example, another is the even more famous tomb of Pope Paul II (1464–71), originally installed in St. Peter's. A project shared between Mino da Fiesole and Giovanni Dalmata, the assigning of different tasks to different sculptors (and their workshops) was carefully calculated.

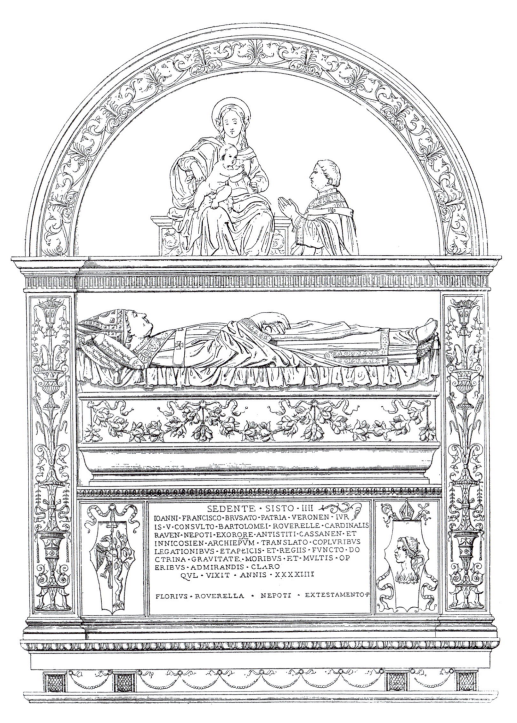

SEDENTE · SISTO · IIII
IOANNI · FRANCISCO · BRVSATO · PATRIA · VERONEN · IVR
IS · V · CONSVLTO · BARTOLOMEI · ROVERELLE · CARDINALIS
RAVEN · NEPOTI · EXORORE · ANTISTITI · CASSANEN · ET
INNICOSIEN · ARCHIEPVM · TRANSLATO · COPLVRIBVS
LEGATIONIBVS · ETAPLICIS · ET · REGIIS · FVNCTO · DO
CTRINA · GRAVITATE · MORIBVS · ET · MVLTIS · OP
ERIBVS · ADMIRANDIS · CLARO
QVI · VIXIT · ANNIS · XXXXIIII

FLORIVS · ROVERELLA · · NEPOTI · EXTESTAMENTO · P

4.4 Illustration of *The Tomb of Giovanni Francesco Brusati*, in Francesco M.
Tosi, *Raccolta di monumenti sacri e sepolcrali scolpiti in Roma*

Mino and his assistants were responsible for half the number of the standing apostles, half of the flying angels, half of the basement relief, three of the five panel reliefs above it, one of the two monumental narrative reliefs, and the sarcophagus, but not the effigy. The precision with which these tasks were divided reveals an almost obsessive desire for parity between the two shops.[17] For this to function, a detailed design would have been developed and agreed upon by all parties, patrons as well as artists, before any work on the tomb began. Furthermore, according to Vasari, the tomb took less than two years to make. Seventy-five years after its original installation, the tomb of Paul II was still famous for the speed with which this largest of all Quattrocento Roman funerary monuments was completed.[18] Surely the Brusati contract, which required that the tomb be completed in four months, is an echo of the process, on a far more modest scale, that also existed in other cases. Such methodical divisions of labor across an entire commission were not limited to tombs in Quattrocento Rome. The two-year decoration in the Vatican papal chapel under Sixtus IV, overseen by Perugino, but with contributions by several other high-ranking, independent artists, follows a similar pattern. The scheme for all the frescoes, including, of course, their typological parallels, was worked out before individual scenes were assigned.[19] And, although certain key elements were required to be similar from scene to scene, no attempt was made to mask the divergent style of the different artists involved in the project.

The Brusati contract, signed in 1485, required that the tomb be completed in four months, but this desire for speed was of concern by then almost a decade after the bishop's death. The number of interested parties, as well as legal issues of succession and inheritance, help to explain this lag between the bishop's death and the execution of the tomb, a period that might well have been extended by the kind of deliberations involved in the commissioning and erection of any tomb. An example of a tomb that included an even more diverse group of people active in its genesis is the sepulcher for Cardinal Marco Barbo (d. 1491). It is likely that in this case more than 20 years passed from ideation to completion. The tomb must have been conceived by the cardinal as part of the grand project to restore the basilica of San Marco, which had become the cardinal's titular basilica after his uncle, Paul II, acceded to the throne of Peter. Even though it ranks as one of the most elegant tombs produced in the Quattrocento, it is far less known than the marble tomb for Bishop Brusati, perhaps because it is not a wall tomb at all, but is set into the pavement of the church. The carving of the Barbo tomb cannot be assigned by style or contract to any sculptor. The obscurity of the tomb and its artist, however, cannot be the fault of the powerful patrons marshaled into its production. Three cardinals are named in the epitaph: Barbo, Oliviero Carafa of Naples, and Francesco Todeschini Piccolomini, nephew of Pius II and the future Pius III. The collaboration of these most prominent princes of the Church suggests the tomb's value, both in terms of its cost and conceptual meaning.[20]

Marco Barbo, the nephew of Pope Paul II was once at the center of curial power. By the end of his life, he was famous for his piety and widely respected

for his devotion to literature and learning.[21] His tomb, for which contemporary documents are lacking, seems doomed to permanent anonymity of authorship. Today located in the right aisle in front of the Chapel of the Sacrament at San Marco, the tomb is an unadorned floor slab surrounded by a complex cosmatesque pavement. The very modesty of the epitaph is one of its most striking features. A single piece of red porphyry stone contains a short, elegant statement naming the deceased and his titles, recording his hopes, documenting his death, and listing his executors (Figure 4.5).[22] It does not, as was usual, enumerate his accomplishments in life. The inscription on the tomb of Paul II, for example, goes on at length about the deeds and virtues of the deceased, including the fact that the pope had, in the ancient manner, supplied the city of Rome with grain.[23] But Marco Barbo's epitaph is poetry, not prose. Both the brevity of the epitaph and its vertical format recall, not contemporary wall tomb inscriptions, but antique *cippus* tombs.[24] In form and lettering Barbo's epitaph is clearly intended to evoke the elegance of ancient letters and ancient memorials.

In its unadorned simplicity, the Barbo tomb appears to epitomize Christian humility. The slab is devoid of sculptural decoration, the deep reddish purple color of the stone its only opulence. The inscription fills the entire field, with just a small metal plug in the center, presumably used to lift the lid in order to gain access to the burial chamber below. This lack of overt display recalls the desire of Cardinal Barbo's contemporary, Cardinal Jacopo Ammanati-Piccolomini, to be buried in St. Peter's below a simple marker on the pavement at the foot of the tomb of his great patron, Pius II.[25]

Yet three aspects of the Barbo tomb were intended to distinguish it from a mere grave marker. The first is the choice of material. Porphyry was a precious stone, one associated with both the Church and with imperial glory.[26] This large slab might have been the focus of attention as early as 1468 when Marco Barbo had the medieval pulpit of San Marco dismantled, resetting the stones in front of the high altar.[27] In other words, this impressive bit of spolia was specific to this church and this site. Its reuse for the tomb slab of the titular cardinal thus represents a continuation with the past. Its type and placement in front of an altar recalls another highly visible example of Renaissance commemoration, the tomb of Cosimo de' Medici at San Lorenzo in Florence, it too set directly into the pavement and employing red and green porphyry.

The second aspect of the tomb that is critical for its reconstruction is its missing sculptural adornment. Cardinal Marco Barbo apparently wanted his own tomb to be set beneath a monumental sacrament tabernacle (Figure 4.6). Although the tabernacle is today displayed in the sacristy at San Marco, originally it was immured in the niche to the right of the high altar and the tomb was located at its base.[28] Cardinal Barbo commissioned the tabernacle from Giovanni Dalmata and Mino da Fiesole, the same sculptors responsible for the tomb of Paul II in St. Peter's, commissioned by the same patron. Marco Barbo did as he had done for the tomb of his uncle; he hired two artists to produce the tabernacle. And they, in turn, repeated the lessons learned

4.5 *Tomb of Cardinal Marco Barbo*, detail of inscription

from the earlier project; here, as there, they methodically divided their responsibilities as can be clearly seen when one compares the style of the reliefs. Just as each section of the tomb, from large reliefs to small decorative details, was apportioned to maintain a carefully calibrated parity between the two sculptors, the four major fields of the tabernacle are split evenly between Mino and Giovanni Dalmata. The unusually elaborate sacrament tabernacle, with flanking reliefs of *Isaac Blessing Jacob* by Giovanni Dalmata and *Abraham and Melchizedek* by Mino da Fiesole, illustrate Old Testament prefigurations of the Institution of the Eucharist. These narratives, along with the figure of the God the Father who replicates the same figure in the semi-dome of the

Roverella tomb, both by Giovanni Dalmata, expand both the scale and meaning of the rather traditional sacrament tabernacle, by Mino da Fiesole, that they frame. The complexity of this work was possibly intended to compensate for the lack of figural decoration on the actual tomb. This possibility allows for the suggestion that both tabernacle and tomb were conceived as a unit, not merely liturgically, but also formally. The cardinal's tomb places him directly beneath the tabernacle, that is, in perpetual association with Christ and the means of human salvation.[29] The sacrament tabernacle, like the Roverella tomb, is curved in an apse shape. It was clearly intended to be an integral part of the surrounding architectural niche, not merely to hang as though suspended in front of it. This provides a parallel to the tomb which is not merely on the floor, but forms part of it. In both cases, the Cardinal literally sets his memorial into the fabric of his church.

The elaborate program at San Marco—of altar decoration and tomb—was further enhanced by an extensive cosmatesque design that surrounds the tomb slab. This frame, a recreation of a medieval type, recalls the venerable history of San Marco.[30] The porphyry tomb is contained within a large square cosmatesque pavement composed of intricate geometric patterns formed with pieces of porphyry and other colored stones. Such floors, initially associated with Roman workshops in the late eleventh and twelfth centuries, became popular again in the fifteenth. The earliest Renaissance example is the pavement in the Chapel of the Cardinal of Portugal at San Miniato al Monte.[31] But by the last quarter of the century in Rome, such floors appeared in both sacred and secular spaces. The floor for the Sistine Chapel and the one for Cardinal Giuliano della Rovere set into the palace at Santi Apostoli are two examples that are probably close in time to Marco Barbo's pavement and tomb, commissioned and likely installed in the 1470s. Another example, dating to c. 1491, was installed by Cardinal Oliviero Carafa in his chapel at Santa Maria sopra Minerva.[32] The number of such pavements created in Rome in the last third of the fifteenth century, makes clear that there were artists who specialized in this work.[33] The presence of such a pavement as part of the Barbo tomb project might imply, therefore, the existence of yet another member of the collaborative puzzle, the master and shop responsible for designing and insetting the cosmatesque floor.

The actual pavement surrounding the Barbo tomb slab is a square within which is inscribed another square. In the center of the interior square is the porphyry epitaph, itself a rectangle. Three bands—of marble, inset stone, and marble—frame the center. At each corner are the peripheral loops of the quincunx, in this case a poised square quincunx, a pattern used in earlier cosmatesque floors. This extraordinary shape, implying a circle and a cross simultaneously, is the formal and symbolic essence of the tomb's design. Although there are a number of distinguishable campaigns of repaired and restored cosmatesque work at San Marco, probably none of the original twelfth-century pavement remains intact. Portions of it were re-used when the floors were restored in later periods. It is also possible that some of the cosmatesque

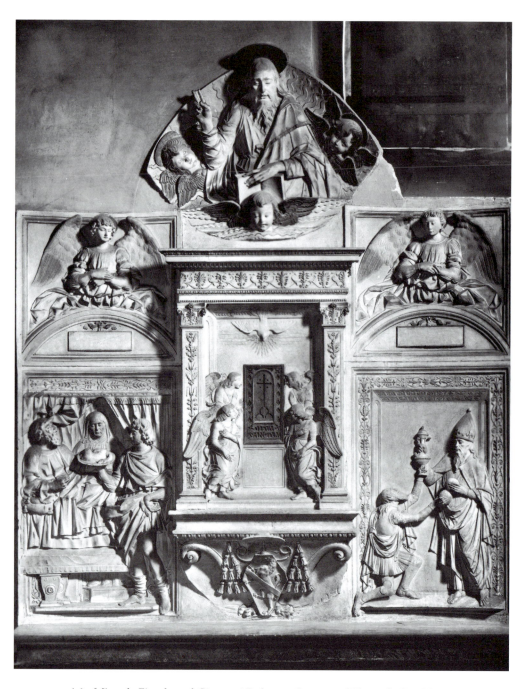

4.6 Mino da Fiesole and Giovanni Dalmata, *Sacrament Tabernacle*, San Marco

pavement beyond the porphyry slab of Barbo's tomb is reworked older stone, perhaps from the basilica itself. Both the tesserae and the design employed by Marco Barbo's workers seem intentionally to evoke the medieval style of the dismantled and lost pavement.[34] By using a cosmatesque floor for his tomb, Marco Barbo literally embeds his memorial in the basilica's structure. The seamless transition from contemporary to medieval paving links the present with the past, literally, as one walks down the nave passing over a series of different pavements.

Both Marco Barbo and his uncle, Paul II, were engaged in restoring San Marco; this 40-year effort was intended to return the church to its original glory.[35] The addition of a cosmatesque pavement was an essential part of that scheme.[36] The extraordinary popularity of the revitalized pavement in late Quattrocento Rome confirms its significance for the cardinal's contemporaries. As important as the type of floor itself was the quincunx shape; its cosmological force, embodied in its controlled use of the circle, cross, square, and center, is highly appropriate for a tomb, especially one placed before the sacrament altar, where the divine and the earthly are united in the Eucharist itself.[37] The combined cosmatesque pavement and porphyry epitaph serve as the cardinal's tomb. The apparent modesty of the choice of a floor monument, where those who come to pray for the deceased, as instructed in the inscription ORATE PRO EO, literally walk on his tomb, is misleading. The materials, the scale, form, and the proximity to the sacrament altar, all elevate the value and eminence of this sepulcher. Barbo's tomb, imbedded for all eternity in the very fabric of the church, is elegant, luxurious, and sophisticated. This pious act of humility is made in the grandest of manners. It is also unique. The cardinal's tomb could not have been commissioned and completed in four months; it is a labor of decades. Marco Barbo's comprehensive patronage of this spot at San Marco, for the sacrament altar and for his tomb, suggests a very deliberate and personal vision, but one that only reached a conclusion because his executors were willing to complete the project.[38]

Marco Barbo died in 1491. According to the inscription, he began the tomb while he was alive, but it was completed by his executors after his death. How much was left for them to do is uncertain. The names of two of the most powerful cardinals then active in Rome—Cardinals Oliviero Carafa, and Francesco Todeschini Piccolomini—appear in the inscription. Yet according to a letter written by Cosimo Orsini describing the cardinal's death, Marco Barbo had three executors: the Cardinals Carafa, Piccolomini, and Jean Balue.[39] Between them, they represented three of the great kingdoms of Europe: Spain (and Naples), England (Cardinal Francesco became cardinal protector of the English nation in 1492), and France. Since Cardinal Balue died in October, six months after Cardinal Barbo's own death, it is clear why he was not included in the epitaph. His death becomes, therefore, a usable *terminus post quem* for the inscription.[40] The length, elegance, and refinement of the inscription are striking. Following Vasari's description of the rediscovery of the technique of carving porphyry in late sixteenth-century Florence, it has long been assumed that this sort of work could not have been

accomplished in the fifteenth century.[41] It is, however, becoming clear that inscriptions were being carved in porphyry by this date. As was noted by Sara Magister, Cardinal Giuliano della Rovere's acorn and the date 1482 are inscribed into the porphyry portions of the cosmatesque pavement installed in his palace at Santi Apostoli.[42] Although only the inscription can be assigned with certainty to Barbo's executors, it is worth recalling that it was just at this time that Cardinal Carafa installed a cosmatesque floor in his own chapel.

When seen as intended, the tomb of Marco Barbo turns out to be one of the most luxurious and elegant tombs produced in Renaissance Rome: porphyry, cosmatesque work, and the gilded, marble sacrament altar together formed a commemorative site worthy of Marco Barbo's status, while still carefully maintaining the fiction of his humble nature. The full program was only completed in 1491 by the cardinal's executors, when they added the inscription to the porphyry tomb slab. The assemblage required to complete this project—artists, artisans, and the cardinals who executed his testament—once again underscores the complexity of tomb patronage. Here, as with the Brusati tomb, the completion of the tomb depended on the collaboration of many people over time. Whereas one is a grand monument, highly original and thus suitable to the memory of the cardinal, the other, a much humbler affair, is a rapidly produced pastiche of a standard tomb design in Rome. Yet both these examples of shared responsibility record essential aspects of tomb production in Renaissance Rome that are otherwise ignored. The cooperation of artists and patrons, among themselves and with each other, was required in order to bring to completion any monumental enterprise.

Notes

* It is a great honor to offer this article to John Paoletti, whose contributions to the study of Quattrocento Italian sculpture has shaped my own vision of the field. It is impossible to measure my debt to him, but a pleasure to acknowledge it. I would also like to thank Denise Allen and Jack Freiberg for their unstinting aid, as well as Debra Pincus and Tiffanie Townsend for their kind assistance.

1 The contract was published by Domenico Gnoli, "Nuovi documenti: Contratti per opere di scultura di Luigi Caponi, milanese," *Archivio storico dell'arte* 6 (1893): 127–8; its location in the archives was cited earlier by Antonino Bertolotti, *Artisti lombardi a Roma nei secoli XV, XVI e XVII: studi e ricerche negli archivi romani*, 2 vols (Milan: Hoepli, 1881), 2: 285. On Roman contracts, see Anna Maria Corbo, "I contrati di lavoro e di apprendistato nel secolo XV a Roma," *Studi romani* 21, no. 4 (1973): 469–89.

2 James Beck, *Jacopo della Quercia*, 2 vols (New York: Columbia University Press, 1991), 1: 67–71 and 148–50 and 2: 347, doc. 25. See also, on the role of artists' drawings in contracts, Frances Ames-Lewis, *Drawing in Early Renaissance Italy* (New Haven: Yale University Press, 1981), 128–31; for a recent discussion of the Venetian sculptors and their drawings, see Debra Pincus and Barbara Shapiro Comte, "A Drawing for the Tomb of Dante Attributed to Tullio Lombardo," *Burlington Magazine* 148 (2008): 734–46.

3 Francesco Caglioti, "Paolo Romano, Mino da Fiesole e il tabernacolo di San Lorenzo in Dàmaso," *Prospettiva* 53–6 (1988–89): 245–55, fig. 2; the drawing is in the Gabinetto Nazionale delle Stampe. It should be noted that the small figures of Christ which overlap the center line are complete, both on the door and in the lunette. Some sketches made in the sixteenth century of Roman tombs, especially those for the tomb of Paul II, demonstrate how many of the details might be left off a sketch: see Francesco Caglioti's treatment, with three different drawings from the sixteenth century, of the Paul II tomb in Antonio Pinelli, ed., *The Basilica of St Peter in the Vatican*, vol. 2 (Modena: Franco Cosimi Panini, 2000), 819–25, esp. figs 474 and 475 (surely the drawing illustrated in fig. 476 is actually of the tomb of Pius II).

4 For the life and career of Bishop Brusati, see Konrad Eubel, *Hierarchia catholica medii aevi sive Summorum Pontificum, S.R.E. cardinalium, ecclesiarum antistitum series, e documentis tabularii praesertim Vaticani collecta, digesta, edita. 2. Ab anno 1431 usque ad annum 1503 perducta* (Regensberg: Monasterii, 1901), 134, 244; Primo Griguolo, "Per la biografia del cardinale rodigino Bartolomeo Roverella (1406–1476): la famiglia, la laurea, la carriera ecclesiastica, il testamento," *Atti e memorie dell'Accademia Galileiana di scienze, lettere ed arti in Padova, già dei Ricovrati e Patavina* 115, no. 3 (2002–2003): 133–70, esp. 162, n. 77 and, most recently, Primo Griguolo, "Per la biografia di Giovanni Francesco Brusati (1433–1477): il testamento e i libri," *Quaderni per la storia dell'Università di Padova* 39 (2006): 183–97. The inscription, as recorded in Vincenzo Forcella, *Iscrizioni delle chiese e d'altri edificii di Roma*, 14 vols (Florence and Turin: Ermanno Loescher, 1884), 4: 506, no. 1250 reads:

SEDENTE . SISTO . IIII/
IOANNI FRANCISCO . BRVSATO , PATRIA . VERONEN .IVR/
IS . V. CONSVLTO . BATOLOMEI . ROVERELLE . CARDINALIS/
RAVEN . NEPOTI . EX. SORORE . ANTISTITI . CASSANEN . ET/
IN NICOSIEN . ARCHIEPVM8 TRANSLATO./
LEGATIONIBVS . ET APL0ICIS . ET . REGIIS . FVNCTO . DO/
CTRINA . GRAVTATE . MORIBVS . ET . MVLTIS . OP/
ERIBVS . ADMIRANDIS . CLARO/
QUI . VIXIT . ANNIS XXXXIIII/
FLORIVS . ROVERELLA . NEPOTI. EX TESTAMENTO . P.

On the use of "Sedente Sisto IIII," see Daniela Porro, "La restituzione della capitale epigrafica nella scrittura monumentale: epitafi ed iscrizioni celebrative," in *Un pontificato ed una città: Sisto IV (1471–1484)*, ed. Massimo Miglio, Francescao Niutta, *et al.* (Rome: Istituto storico italiano per il medio evo, 1986), 408–27, esp. 415.

5 On Florius or Florio Roverella, see Griguolo 2006, 187, n. 33; Stephen Campbell, *Cosmè Tura of Ferrara: Style, Politics, and the Renaissance City, 1450–1495* (New Haven and London: Yale University Press, 1997), 104, and on the family in general, see 102–13.

6 On the Roverella tomb, see Johannes Röll, *Giovanni Dalmata* (Worms am Rhein: Wernersche Verlagsgesellschaft, 1994), 92–101; Michael Kühlenthal, "Andrea Bregno in Rom," *Römisches Jahrbuch der Bibliotheca Hertziana* 32 (1997/98): 206–17.

7 Some examples in Rome of the rectangular niche tomb include those for Alfonso de Paradinas (Santa Maria in Monserrato), Filippo della Valle (Santa Maria in Aracoeli), and Raffaele Riario (Santi Apostoli). Tombs such as those of Giovanni della Rovere (Santa Maria del Popolo), Marcantonio Albertoni (Santa Maria del Popolo), Cardinal Bocciacio (Santa Maria della Pace) or Francesco Tornabuoni

(Santa Maria sopra Minerva) represent elaborations of this type, comparable to the Brusati tomb. The arched lunette might recall a particular type that was widespread in the Quattrocento, where the sarcophagus appears within an arcosolium, or arched niche. In Florence, such tombs, often without effigies, were employed by important local families. For discussions of Florentine arcosolium tombs, see Andrew Butterfield, "Social Structure and the Typology of Funerary Monuments in Early Renaissance Florence," *Res* 26 (1994): 47–67; and Sally J. Cornelison, "The Tomb of Giovanni di Bicci de' Medici and the Old Sacristy at San Lorenzo," in *The Sculpted Object*, ed. Stuart Currie and Peta Motture (Aldershot: Scolar Press, 1997), 25–42, esp. 28, n. 28.

8 Based on the condition of the corbels and the chips on the sides of the tomb as well as from the rough plaster visible along its exterior, it is probable that the tomb has been dismantled and restored at some point in its history.

9 The arms located to the left, beneath Brusati's head, are those of the patron, Florio Roverella; the same *stemma* appears on the tomb of the Cardinal Bartolomeo Roverella. Beneath the bishop's feet the shield shows a moor's head in profile, rising from the flames, with a bishop's miter, a crosier, and a cross on a staff behind it. Although not uncommon in the Quattrocento, this particular moor's head is unusual because of the flames that surround the bust. This flaming bust, possibly a pun on "Brusati/*bruciare*" recalls depictions of souls in purgatory, famously illustrated in Irving Lavin, "Bernini's Portraits of No-Body," in *Past-Present: Essays on Historicism in Art from Donatello to Picasso* (Berkeley: University of California Press, 1993), Appendix B, 129–39. For the literature on "Africans" and moors in Renaissance Italy, see Thomas. F. Earle and Kate J. P. Lowe, eds, *Black Africans in Renaissance Europe* (Cambridge: Cambridge University Press, 2005), esp. Kate J. P. Lowe, "The Stereotyping of Black Africans in Renaissance Europe," 17–47; and Jean Devisse and Michel Mollat, *The Image of the Black in Western Art, II: From the Early Christian Era to the "Age of Discovery" 2. African in the Christian Ordinance of the World (Fourteenth to the Sixteenth Century)*, trans. William G. Ryan (New York: William Morrow and Co., 1979).

10 For a recent discussion of these tombs with excellent images of the effigies, see Kühlenthal 1997/98, 179–272.

11 Claudia La Malfa, "Luigi Capponi scultore," in *Sisto IV. Le arti a Roma nel primo Rinascimento, atti del convegno internazionale di studi*, ed. Fabio Benzi (Rome: Edizioni dell'Associazione Culturale Shakespeare and Company 2, 2000), 353–83.

12 For the inscription on the Piccolomini Altar, see Harold R. Mancusi-Ungaro, Jr., *Michelangelo, The Bruges Madonna and the Piccolomini Altar* (New Haven and London: Yale University Press, 1971), 12. The author's recent review of the growing literature on that monument is available as "Erasing Tradition: Michelangelo and Andrea Bregno," in *The Historian's Eye: Essays in Honor of Andrew Ladis*, ed. Hayden B. J. Maginnis and Shelley E. Zuraw (Athens: Georgia Museum of Art, 2008), 151–66. Another document affirms Capponi's responsibility for a later relief of the *Crucifixion* in Santa Maria della Consolazione: see Gnoli, "Nuovi documenti," 1893, 127–8. Recently La Malfa has attempted to refine the catalogue of Capponi's work, relying on close stylistic parallels with the Brusati tomb and *Consolazione* relief: La Malfa 2000, 353–83. For a traditional view of Capponi's production, see Domenico Gnoli, "Luigi Capponi da Milano," *Archivio storico dell'arte* 6 (1893): 85–101; Francesco Negri Arnoldi, "Luigi di Pietro Capponi da Milano," *Arte lombarda* 6 (1961): 195–201; Vincenzo Golzio and Giuseppe Zander, *L'arte in Roma nel secolo XV, Instituto di studi romani* (Bologna: Licinio Cappelli Editore, 1968), 341–2.

13 Francesco M. Tosi, *Raccolta di monumenti sacri e sepolcrali scolpiti in Roma* (Rome: Presso l'editore, 1856), tav. 50; the image is reproduced in Gnoli, "Luigi Capponi," 1893, 86.

14 The Codex Albani (Cod. 201, Albani) is now housed in the Royal Library, Windsor. A photograph of the drawing (inv. no. 11.832) is available as U. Fi. AII, 238e in the Fototeca Hertziana, Rome.

15 Both are illustrated in Nicholas Clark, *Melozzo da Forlì. Pictor Papalis* (Faenza: Le Lettere, 1989), pls. VIII and LVIII.

16 The literature on the Cristoforo della Rovere (Santa Maria del Popolo) and Pietro Riario (Santi Apostoli) tombs, where carving by Andrea Bregno and Mino da Fiesole is visible on both, exemplifies the desire of scholars to identify the artist who, if not responsible for every portion of the carved tomb, was the solitary designer. See Joachim Poeschke, *Die Skulptur der Renaissance in Italien. Band 1: Donatello und seine Zeit* (Munich: Hirmer, 1990), 158–60; Meredith J. Gill, "The Fourteenth and Fifteenth Centuries," in *Artistic Centers of the Italian Renaissance*, ed. Marcia B. Hall (Cambridge and New York: Cambridge University Press, 2005), 80–81.

17 For the tomb of Paul II, see Shelley E. Zuraw, "The Sculpture of Mino da Fiesole, 1429–1484," Ph.D. dissertation, Institute of Fine Arts, New York University, 1993, 876–904; Röll 1994, 60–84 and Caglioti 2000, 819–25.

18 Giorgio Vasari, *Le vite de' piu eccellenti pittori, scultori ed architettori*, ed. Gaetano Milanesi, 9 vols (1906; reprint edition, Florence: Sansoni, 1981), 3: 118.

19 Sylvia Ferino Pagden, "Perugino al servizio dei Della Rovere: Sisto IV e il Cardinale Giuliano," in *Sisto IV e Giulio II, mecenati e promotori di cultura*, ed. Silvia Bottaro, Anna Dagnino, *et al.* (Savona: Comune di Savona, 1989), 73–86; for a recent revision of this view, focusing on equal collaboration between the painters, see Arnold Nesselrath, "Perugino tra i pittori della Cappella Sistina," in *Perugino, il divin pittore*, ed. Vittoria Garibaldi and Francesco Federico Mancini (exh. cat. Perugia: Galleria Nazionale dell'Umbria, 2004), 105–11.

20 It should be born in mind that Marco Barbo was the patron of his uncle's tomb in the first years of the 1470s while Cardinal Todeschini Piccolomini likewise patronized the tomb for his uncle for St. Peter's, followed in the next decade by his work on a second Piccolomini tomb chapel, the Piccolomini Altar in Siena. Cardinal Carafa was working on both his funeral chapel in Naples and his chapel in Sant Maris sopra Minerva just as work on the Barbo tomb came to an end in the early 1490s.

21 On Cardinal Marco Barbo (1420–91) see *Dizionario biografico degli italiani* 6 (1964), 248–52. On his later life, see Pio Paschini, *Il carteggio fra il Cardinale Marco Barbo e Giovanni Lorenzi (1481–1490), Studi e testi* 137 (Vatican City: Biblioteca Apostolica Vaticana, 1948), 1–19.

22 Forcella 1884, 4: 348, no. 823:

MARCVS . BARBVS/
CAR. S 8CI . MARCI . PA/
TRIARCHA . AQLEI/
ENSIS . ITA . SIBI . VIV8ES/
FIERI . VOLVIT . ORATE/
P + EO AD . DOMIN8V/
OBIIT . ANNO . SA/
LVTIS . M. CCCCLX/

XXXI . DIE . II . MA/
RTII . OLI . ET . FRA/
CAR . EXEQ . B. M./
POS.

23 Iiro Kajanto, *Papal Epigraphy in Renaissance Rome*, Annales Academiae
 Scientiarum Fennicae, Ser. B, vol. 222 (Helsinki: Suomalaisen Tiedeakatemian
 Toimituksia, 1982), 70.

24 On these ancient inscriptions and tombs, see Porro 1986, 421–7; Silvia Maddalo,
 "Il monumento funebre tra persistenze medioevali e recupero dell'antico," in
 Un pontificato ed una città: Sisto IV (1471–1484), ed. Massimo Miglio, Francescao
 Niutta, *et al.* (Rome: Istituto storico italiano per il medio evo, 1986), 429–52;
 and Sandro Santolini, "Pietro e Mario Millini fondatori di una dinastia di
 collezionisti antiquari," in *Collezioni di antichità a Roma tra '400 e '500*, ed. Anna
 Cavallaro (Rome: De Luca, 2007), 51–5.

25 This request was made by the cardinal in his will: see Zuraw 1993, cat. no. 61,
 pp. 1006 and 1019. For the significance of floor tombs, see Ingo Herklotz,
 "Sepulcra" e "monumenta" del Medioevo. Studi sull'arte sepolcrale in Italia (Rome:
 Edizioni Rari Nantes, 1985), 230–31; and Alison Wright, *The Pollaiuolo Brothers:
 The Arts of Florence and Rome* (New Haven and London: Yale University Press,
 2005), 376–8.

26 For the history of porphyry, see Suzanne B. Butters, *The Triumph of Vulcan:
 Sculptors' Tools, Porphyry, and the Prince in Ducal Florence*, 2 vols (Florence: Leo S.
 Olschki, 1996). For the *rota*, see William Tronzo, "The Prestige of Saint Peter's:
 Observations on the Function of Monumental Narrative Cycles in Italy," *Studies in
 the History of Art* 16 (1985): 93–112; Andreas Beyer, "Funktion und Repräsentation:
 die Porphyr-Rotae der Medici," in *Piero de' Medici "il Gottoso" (1416–1469)*, ed.
 Andreas Beyer (Berlin: Akademie, 1993), 151–67. See also Lucilla de Lachenal,
 Spolia. Uso e reimpiego dell'antico dal III al XIV secolo (Milan: Longanesi & C., 1995),
 213–14; Lex Bosman, "Spolia and Coloured Marble in Sepulchral Monuments in
 Rome, Florence and Bosco Marengo: Designs by Dosio and Vasari," *Mitteilungen
 des Kunsthistorischen Institutes in Florenz* 49, no. 3 (2005): 353–76.

27 The document, published by Eugène Müntz, *Les arts à la cour des papes pendant le
 XVe et le XVIe siècle: recueil de documents inédits tirés des archives et des bibliothèques
 romaines*, 3 vols (1879–1882 ; reprint edition, Hildesheim: Georg Olms, 1983),
 2: 76 (1468, 30 May), is discussed in Angela Dressen, *Pavimenti decorati del
 Quattrocento in Italia* (Venice: Marsilio, 2008), 309–10.

28 For the sacrament altar and tomb together, see Sible de Blaauw, "Das 'opus
 mirabile' des Kardinals Quiñones in S. Croce in Gerusalemme zwischen
 Memoria und Liturgie," in *Tod und Verklärung: Grabmalskultur in der Frühen
 Neuzeit*, ed. Arne Kartsen and Philipp Zitzlsperger (Cologne: Böhlau, 2004),
 137–56, esp. 147. On the sacrament altar, see Zuraw 1993, 1075–86 (with, as
 noted by de Blaauw, numerous errors) and Röll 1994, 85–91. For its position in
 San Marco, see Christoph L. Frommel, "Francesco del Borgo: Architekt Pius' II.
 und Pauls II. II. Palazzo Venezia, Palazetto Venezia und San Marco," *Römisches
 Jahrbuch für Kunstgeschichte* 21 (1984): 71–164, esp. 108.

29 I would like to thank Denise Allen for reminding me that Sixtus IV's tomb put
 him at the foot of the altar on which was placed, on special occasions, a *capsa* for
 the Eucharist: see Giacomo Grimaldi, *Descrizione della basilica antica di S. Pietro
 in Vaticano (Codice Barberini Latino 2733)*, ed. Reto Niggl (Vatican City: Biblioteca
 Apostolica Vaticana, 1972), 485–6, fig. 297.

30 See Dorothy F. Glass, *Studies on Cosmatesque Pavements*, British Archeological Reports, International Series 82 (Oxford: British Archeological Reports, 1980), 104–7 for a discussion of the pavements in San Marco.

31 Paul Binski, "The Cosmati at Westminster and the English Court Style," *Art Bulletin* 72 (1990): 6–34, esp. 28–33 and Linda A. Koch, "The Early Christian Revival at S. Miniato al Monte: The Cardinal of Portugal Chapel," *Art Bulletin* 78 (1996): 527–55, esp. 551.

32 Arnold Nesselrath, *Vaticano. La Cappella Sistina. Il Quattrocento* (Milan: FMR, 2003), 13; Sara Magister, *Arte e politica: la collezione di antichità del Cardinale Giuliano della Rovere nei palazzi ai Santi Apostoli, Atti della Accademia Nazionale dei Lincei: Memorie, ser. 9, vol. 14, fasc. 4* (Rome: Accademia nazionale dei Lincei, 2002), 389–631, esp. 439–40 and 491–5.

33 See Dressen 2008, esp. 104–11.

34 For Dressen's earlier and fascinating discussion of the genesis of the Carafa floor, see Angela Dressen, "Oliviero Carafa committente 'all'antica' nel Succorso del Duomo di Napoli," *Römische Historische Mitteilungen* 46 (2004): 165–200, esp. 169–72.

35 The restoration of the basilica of San Marco is discussed by Frommel 1984, 84–9 and 115–22. See also Stefano Borsi, Francesco Quinterio, *et al.*, *Maestri fioretini nel cantieri romani del Quattrocento*, ed. Silvia Danesi Squarzina (Rome: Officina, 1989), 139–56. This process, beginning with Pastor (Ludwig Pastor, Frederick Ignatius Antrobus, *et al.*, *The History of the Popes from the Close of the Middle Ages* (London: K. Paul, Trench, Trübner & Co., Ltd., 1906), 4: 76 and Müntz 1983, 74–81), emphasizes the work done on the Palazzo Venezia. But both Paul II and his cardinal nephew Marco Barbo expended considerable energy and funding on the church itself. This interest in restoration of ancient churches, initiated in fifteenth-century Rome by Martin V, given a grand vision by Nicholas V (see Carroll W. Westfall, *In the Most Perfect Paradise: Alberti, Nicholas V, and the Invention of Conscious Urban Planning in Rome, 1447–55* (University Park: Pennsylvania State University Press, 1974)), and pursued energetically by Sixtus IV (Fabio Benzi, *Sisto IV renovator urbis: archtettura a Roma 1471–1484* (Rome: Officina, 1990)), was not unique to Paul II, although his activities are often ignored. It should be recalled that he also contributed to the restoration of other churches in Rome (Müntz 1983, 81–90). The complex theme of ecclesiastical restoration in Renaissance and Baroque Rome is outside the scope of this paper, but is beautifully described by Michael Hill, "Reform and Display in Cardinal Borghese's Restoration of San Sebastiano fuori le mura, 1607–1614," *Fabrications* 15, no. 2 (2005): 15–42, esp. 15–16. I owe this reference to Jack Freiberg.

36 On the classical links, see, for example, Enrico Bassan, "La memoria dell'Impero: I Cosmati e l'antico," *Art e dossier* 20 (2005): 40–45.

37 For the symbolism of the quincunx, see Paloma Pajares-Ayuela, *Cosmatesque Ornament: Flat Polychrome Geometric Patterns in Architecture*, trans. Maria Fleming Alvarez (London: Thames and Hudson, 2002), 238–46.

38 De Blaauw 2004, 146–9, 154–5. It is worth recalling that the combination of sacrament devotion and tomb chapel is made into a monumental statement by Sixtus V at Santa Maria Maggiore.

39 Giuseppe Zippel, "La morte di Marco Barbo," in *Scritti storici in memoria di Giovanni Monticolo* (1922), reprinted in Giuseppe Zippel, *Storia e cultura del Rinascimento Italiano*, ed. Gianni Zippel (Padua: Antenore, 1977), 483–93.

In the excellent entry on the tomb by Anett Ladegast on the Requiem database (http://www2.hu-berlin.de/requiem/db/default.php?comeFrom=goo accessed: 9/23/2008), the two executors are listed as Cardinals Oliviero Carafa and Francesco della Rovere. This is surely incorrect, since after his ascent to the Chair of Peter in 1471 Sixtus IV would no longer be described as Cardinal Francesco. On Cardinal Jean Balue, see Henri Forgeot, *Jean Balue, Cardinal d'Angers (1421?–1491)* (Paris: Emile Bouillon, 1895), 149 where his simple tomb slab and inscription set in the floor of Santa Prassede in November 1481 by Cardinal Antonio Pallavicini is described (the entire text is available on Gallica at http://gallica2.bnf.fr/ark:/12148/bpt6k33074v.r=jean+balue.lan accessed: 9/24/2008).

40 Dressen 2008, 309–10, argues that the lettering is inconsistent and that, therefore, the tomb inscription was begun earlier and only completed after 1491. But the inscription fits so neatly into the rectangle that one might be better off assuming that the expanded spacing between the letters is deliberate. The inscription is legible from its base, but when looking in the opposite direction, in other words notionally turning back from the altar and the sacrament tabernacle, the letters although seen upside down, coalesce. The effect is almost as if one is watching the inscription unfurl before you. I would like to thank Jack Freiberg for his many attempts to guide me through the problems associated with this pavement and tomb.

41 For history of porphyry carving, see G. Baldwin Brown, *Vasari on Technique*, trans. Louisa S. Maclehose (1907; reprint edition, New York: Dover, 1960), 26–34; and Daniela Di Castro, "The Revival of the Working of Porphyry in Sixteenth-Century Florence," *Apollo* 126 (1987): 242–8.

42 Magister 2002.

Donatello and his patrons

David G. Wilkins

When studied within the context of the Quattrocento, the works of Donatello are extraordinary in iconographic interpretation, unexpected in execution, and startling in expressive range. No other European fifteenth-century sculptor or painter treated such a wide range of subject matter, manipulated so many media so expressively, and probed the human emotional experience with such insight.[1] These accomplishments have often been discussed as indications of the artist's personality, as the remarkable revelations of a uniquely creative person. There is sufficient evidence from Renaissance sources that Donatello was a complex individual—in 1458, he is described as "molto intricato" (very difficult or, perhaps, given the context, unpredictable)[2]—and because the intensity of experience communicated by his figures suggests an artist with a profound interest in human behavior, such an interpretation does not seem surprising. But this fascination with artistic personality—however interesting in the case of Donatello and compelling to our modern sensibilities—diverts attention from the other personalities who played roles in the creation of his exceptional works, Donatello's patrons. This essay is about them.

Patronage, already of interest to Giorgio Vasari, has been brought to the forefront in recent art-historical scholarship and its terminology, processes, and theoretical bases examined. In this essay, I study the documents and early sources to establish what can be determined about the relationship between Donatello and those who commissioned, purchased, or received his works.[3]

What role did the individuals and groups who commissioned works from Donatello play beyond the obvious one of setting into motion his works' creation? Did Donatello's patrons simply support him in a sequence of personal artistic adventures, or did their requests and expectations play a part in the creative process? Was their presence felt only at the initiation of a project, or were they consulted during the course of a work's development? If the latter, when and how were patrons involved, and how often was their opinion sought? While these questions are in many instances impossible to answer, this chapter sets out to explore these issues.

As noted in the Introduction to this volume, the genesis of a Renaissance sculpture in marble or in bronze — the media of most of Donatello's sculpture — was an expensive proposition given the cost of materials and was, therefore, unlikely to be undertaken without a specific commission. Because of cost, a patron may have been especially interested in being engaged in the work's creation. And because sculpture is often intended for a public setting, a patron may have been particularly concerned with issues of presentation and reception and thus more likely to seek involvement in the creative processes.

The main sources for information on Donatello's patrons are documents from the artist's lifetime and the writings of early writers and of Vasari. Because of their genesis after the artist's death, the stories offered by these individuals may be less dependable and relevant than the information offered by legal documents of commission and payment.

A survey of Donatello's known and presumed patrons reveals a remarkably diverse group (see Appendix). In addition, Donatello traveled widely and had a number of non-Florentine patrons; documentary evidence reveals an interest in employing him in Faenza, Ferrara, Mantua, Modena, Naples, Orvieto, Padua, Prato, Rome, Siena, and Venice. His works could be seen in at least six of these cities during his lifetime.[4] Since patronage played at least a minor role in the creation and ultimate appearance of works of art during the Renaissance, it seems reasonable to postulate that the diversity of Donatello's patrons and of the centers from which he received commissions may in part explain the variety in subject matter, execution, and expression that is so remarkable in his works.

The documents

Some evidence for patronage is offered by the contracts signed by Donatello and his patrons, although they are not available for every work and are most often found for his earlier works. Renaissance contracts were binding documents that were both predictive, stating what is expected in the future, and restrictive, outlining the limits within which the artist should work to fulfill the contract; when punishments for failing to follow stipulations are included, the contract might also be described as preventative. While contracts indicate what clients expected from Donatello, his expectations were usually limited to a description of the process of payment. In some cases, no amount is given, suggesting that Donatello trusted the patron to compensate appropriately; in other cases, contracts state that appraisers would determine value, another indication of artists confident in the fairness of what must have been a traditional process.[5] When contracts survive, they are sometimes followed by a series of later documents that negotiate issues and payments; for the Prato *pergamo*, for example, more than 150 documents survive.

Despite the trust suggested above, on occasion Donatello had trouble collecting the final payment he assumed was owed him upon completion of

a work.[6] The fact that legal recourse was available to the artist if there were a problem with a patron is revealed by a 1450 lawsuit in which Donatello sued Petruzzo, a patron who had not paid him for a model of a chapel; assistants who testified in Donatello's favor said that they had attended the meeting with Petruzzo, suggesting the absence of a written contract. Although the outcome of the suit is not known, the records imply that in this case Donatello worked without a contract.[7] These documents also reveal that on occasion an artist may have had suspicions about a patron's intent; Donatello states that he hesitated to give Petruzzo the model, fearing that he would have it reproduced by Venetian artists.

Contracts did not record the first meeting of artist and patron but were, rather, drawn up after initial verbal negotiations.[8] As a result, they often identify the works only by subject matter and intended location; in some cases the artist was required to adhere to a model that had been presented.[9] Since patrons understood that successful artists had large workshops, some contracts specified that the artist must complete the work "eius propria manu" (by his own hand), indicating that patrons were reluctant to accept workshop intervention visible in the finished product.[10] Penalties were sometimes specified if the contract were not followed.[11]

The requirement most often stipulated in contracts is date of completion. Patrons expected that agreed-upon deadlines would be met, as is clear in the documents of commission for Donatello's *St. Mark* and its tabernacle for the Arte dei Linaiuoli e Rigattieri at Orsanmichele. The April 3, 1411 document for Donatello's figure stipulates that it must be "completely finished, including the gilding and other suitable ornamentation, and installed by 1 November 1412."[12] Just three weeks later, the guild commissioned two stoneworkers to make the tabernacle, specifying that it be completed "within eighteen months," just a little more than a month before Donatello's figure was due. Despite this careful scheduling, neither deadline was met, and on April 29, 1413, guild members were given the authority to "see to it that figure and tabernacle … be finished to the extent necessary."[13]

This episode is not unusual, for several documents reveal that Donatello, like other artists, sometimes failed to fulfill his obligations in terms of date.[14] This disjunction between the agreed-upon completion date and the date when a work was delivered may have been a result of the changing nature of the creative process during this period: the repetitive nature of Trecento sculpture would have made production times easier to estimate than was possible in the innovative new style, which required artists to rethink traditional norms and practices.[15] The gap between expected and actual completion dates might also be the result of the greater number of commissions, leading artists to accept new commissions before the old had been completed.

In several cases, patrons used finances and/or threats to transfer the commission to another artist in an attempt to convince Donatello to finish a work. On April 16, 1415, for example, Donatello was threatened with a penalty of 25 florins if he did not complete his *St. John the Evangelist* for the

Duomo façade by the end of May.[16] In early March 1425, the Siena Cathedral workshop asked Donatello and Ghiberti to return the money they had been paid because the baptistery font reliefs had not been completed on time; there is no evidence that this threat was carried out.[17] A document between the Arca del Santo in Padua and Donatello with five members of his workshop set the price for reliefs for the Padua Altar and stipulates that the artists could not "work on any other commissions until they have completed these tasks, on pain of having to refund all the money received, plus damages and interest."[18] Janson summarizes another Paduan document as stating that "Donatello must proceed without delay and complete the work within eight months' time, otherwise the officials reserved the right to transfer the commission to other hands, and Donatello would be penalized to the extent of fifty ducats, plus damages."[19] When Donatello left Florence for Padua in the early 1440s, he had yet to cast the bronze sacristy doors commissioned by the Opera del Duomo; in 1446, while he was still away, the Opera, through Cosimo de' Medici "and his associates," informed the sculptor that they would not pay him the amount due for the *Cantoria* until six months after he had cast the doors, thus delaying the final payment on a completed work to force the artist to make progress on an unfinished one.[20] Donatello never made the doors, and there is no document of final payment for the *Cantoria*. In another instance, Ludovico Gonzaga, Marchese of Mantua, threatened to replace Donatello with another artist were he not to complete the Arca di Sant'Anselmo.

The July 14, 1428 contract that Donatello and Michelozzo signed for the "pergamo esterno" (exterior pulpit) for Prato Cathedral records that they promised to have everything finished by September 1, 1429. Progress must have been slow, for the patrons became worried about the sculptors' dedication. In an addendum of November 14, 1428, four months after the original contract, Donatello and Michelozzo agreed that if they did not finish the *pergamo* they would return the money and materials they had received. Nevertheless, it was still incomplete in April 1433, when Pagno di Lapo was sent to Rome to fetch Donatello and his partner; by later that year, progress was being made and payments recorded.[21] Although payments continued throughout 1434 and 1435, the *pergamo* remained incomplete. The patrons' frustration is expressed in a document of November 17, 1436, which authorizes a payment to Maso di Bartolomeo for a trip to Florence undertaken to bring the sculptor back to Prato. Donatello did not return, and the document concludes—in a rare Quattrocento example of documented pique on the part of a patron—by stating that Donatello "had made fools of them" ("e fececi la beffa").[22] In fact, the *pergamo* was not completed until 1438, ten years after the signing of the original contract.[23]

Documented stipulations that go beyond the usual deadlines and payment information reveal that patrons sometimes felt they had to use legal force to compel Donatello to follow certain extraordinary instructions. The documents for the so-called *Cantoria* for the Duomo stipulate that Donatello be paid 40 florins for each panel as good as those of Luca della Robbia, and up to a maximum of 50 florins if the quality of his panels is judged superior; a caveat,

however, states that the total price of Donatello's gallery could not exceed that of Luca's.[24] The documents seem to be an attempt to force Donatello to conform in some way. Because the two galleries were to be pendants, consistency would have seemed desirable and, because Luca had received the contract for his gallery in 1432 (or perhaps as early as 1431), by 1433 he presumably would have had a well-advanced design and style that, it seems, Donatello was expected to emulate.

This attempt to force Donatello's work to be consistent with that of another artist may have been galling because Luca was more than a decade younger and less experienced as a sculptor.[25] Donatello's response is found in his finished gallery, for his six reliefs of putti are not divided into distinct panels that the appraisers could compare, one-on-one, with the ten reliefs of Luca's gallery. It seems astonishing that Donatello would so willfully ignore the Opera's stipulations; perhaps the unprecedented design of his gallery, with continuous relief sculptures recessed behind free-standing colonettes, was in part a reaction to the stipulations, an act of defiance by an artist determined not to be controlled by legal obligations that he found offensive. And the rough suggestiveness of Donatello's reliefs, in contrast to Luca's careful finish, might be interpreted as Donatello's bold response to the document's language, since the reference to quality implied by the phrase "provided the workmanship is at least as good as Luca's" may be an attempt by the Opera to force Donatello to achieve a certain level of finish.[26] In this case, innovation may have been the result of the patron's attempts to force Donatello to conform.

That Donatello's surface finish was of concern to patrons is also suggested in documents for the Padua Altar, one of which required that Donatello and his assistants clean certain bronze reliefs "with the utmost diligence, so that there will be no spots or holes left"[27] The phrase "utmost diligence" and the reference to "spots or holes" suggests that questions of finish and technique may have been a problem with earlier works by Donatello for the altar. A later Paduan document mentions reliefs that had been cast but were "rough and imperfect" ("rudes et imperfect") and stipulates that they "must be cleaned and finished [chased] to perfection" and that "goldsmiths and other experts" would review the works to see if they were ready to be gilded.[28] These and other documents suggest that the Altar's patrons or their representatives were regularly reviewing the work in process, a practice that may have been the rule rather than the exception.[29] While demands for cleaning are not the sole purpose of these documents, which seem primarily to be concerned with payments and completion dates, the mention of cleaning indicates that the patrons wanted to add legal force to their request. These references are among the rare passages in Quattrocento documents or texts that reveal a patron with a particular expectation in terms of quality.

Is it possible to read backwards from a finished work to suggest that the patron proposed a certain style or stylistic detail to the artist? Since the finished object is the ultimate document of the artist/patron relationship, such a question is not beyond the scope of this essay. One reasonable proposal

concerns Donatello's tabernacle for the Parte Guelfa at Orsanmichele. In her exhaustive study, Diane Zervas proposed that the classicism of the niche, the first of the Orsanmichele tabernacles to use an architectural vocabulary drawn from antique sources, was stipulated by the Parte Guelfa because of "the extent of the involvement of party members with humanists and with *all'antica* artistic projects, and in view of the party's identification with and commitment to Leonardo Bruni's humanist ideas"[30]

Competition was sometimes used to encourage artists to do their best work, the implication being that patrons or appraisers would be able to distinguish quality, although on what basis is not clarified.[31] The 1408 documents pertaining to the Evangelists for the Cathedral façade reveal that the patrons thought they could encourage artists to create higher quality works if they competed. The contracts commissioning the first three figures from Donatello, Nanni di Banco, and Niccolò di Pietro Lamberti stated that the fourth would be assigned to the one who executed the best figure.[32]

Patron reaction to a finished work is seldom known, but surviving documentation records the rejection by the Siena Cathedral workshop of a bronze tabernacle door (*sportello*), approximately 40 by 20 centimeters (16 by 8 inches), that had been commissioned for the Baptistery Font; Donatello's *sportello* was eventually replaced with one made by the Sienese Giovanni di Turino. The document includes an accounting of the amount owed Donatello for his work on the font, which included the *Feast of Herod* and several figures.[33] It states that Donatello's door was rejected because it did not please the patrons, but it also clarifies that they want to use discretion in dealing with the Florentine master. So that his time and effort would not be lost, they credited the sculptor with 38 lire and 11 soldi; since Donatello's account was said to be overdrawn by 18 lire, 11 soldi, the sum credited seems to have been selected so that 20 lire would be paid to compensate the artist for the rejected door. The document demonstrates the patrons' desire to be tactful when dealing with Donatello as well as their understanding that he should be paid for his efforts even if his work did not fulfill expectations. In addition, the rejected *sportello* was to be returned to Donatello. That the artist would retain the expensive bronze purchased by the patrons for the door is unexpected, but they seem to have decided that melting down his *sportello* to reuse the bronze was not a satisfactory resolution to what may have been perceived as an awkward situation. Bronze was a valuable commodity and even if Donatello was unlikely to be able to sell a work that had been made for a specific context, the inherent value of the materials meant that he was receiving a substantial remuneration in addition to the 20 lire.

Ultimately, despite what documents tell us about the sometimes rocky relationships Donatello had with patrons, they reveal little about other aspects of the patron–artist relationship: how each work evolved in the minds of the two parties and how it came into being at the artist's hands. This is no surprise: the purpose of these documents was to define legal terms and not to deal with issues that were matters of conversation and debate between the parties.

Works with no documentation of patronage

There are works by Donatello for which no documents of commission or payment are known, but this does not mean there is no evidence of their patronage. Examples include works that can be connected with members of the Medici family and those for which a certain type of patron can be presumed.

Although the works executed by Donatello for the Medici at San Lorenzo reveal that the family should be considered among his most important patrons, no documentation survives for these or any other works by Donatello associated with them or presumed to have been commissioned by them (see Appendix). The documentation may be lost or unknown, of course, but its absence may also indicate that the relationship between Donatello and the Medici was an informal one that did not require legal definition.[34] Such a possibility is supported by the many, varied connections between the artist and Medici family members. Giovanni d'Averardo de' Medici, for example, was one of the executors of Baldassare Cossa's will and most likely one of the group who commissioned Donatello and Michelozzo to produce his tomb.[35] Cosimo and/or Lorenzo di Giovanni de' Medici may have been among the executors of the estate of Cardinal Rainaldo Brancacci, for their 1427 *catasto* reports that Donatello and Michelozzo are in debt to them in connection with their work on that tomb.[36] Cosimo was also an executor for the will of Bartolommeo Aragazzi, whose tomb was commissioned from Donatello and Michelozzo. After Donatello returned from Rome in 1433, he rented a studio from the Medici, at what was a modest rate.[37] Although the relationship between the Medici and the Prato *pergamo* is uncertain, payments to Donatello and Michelozzo were made through Lorenzo di Giovanni de' Medici and when the Prato *operai* wanted to convince Donatello to return from Rome to finish it, Cosimo de' Medici was among those who wrote him.[38] While Donatello was in Padua, the Medici seem to have acted as his representative in Florence; in 1446, the Opera del Duomo informed "Cosimo and his associates" that they would pay Donatello the amount the opera owed him for the *Cantoria* only after he had cast the sacristy doors.[39] In 1454, Piero de' Medici ordered that several objects owned by Donatello be forwarded from Faenza to Florence, and a letter of 1455 indicates that Giovanni di Cosimo de' Medici had purchased two Madonnas from Donatello and commissioned either a marble writing desk or a marble-paneled study.[40] The fact that Piero de' Medici gave permission for Donatello to be buried near family members in San Lorenzo confirms the intimate nature of his relationship with the family.[41]

Many of the works executed or presumed to have been executed for the Medici family stand out as exceptional not only in Donatello's oeuvre but in the Quattrocento as a whole. There is, for example, no parallel in the early fifteenth century for Donatello's sculptural program for the Old Sacristy at San Lorenzo, the Medici family burial chapel. The architecture is noteworthy as well: designed by Brunelleschi, the sacristy is one of the earliest Quattrocento

structures decorated with an architectural vocabulary derived from ancient models. Donatello's program includes portals with bronze doors, partially painted and gilded narrative scenes in relief, and arched panels with standing figures. Earlier Florentine sacristies had been Gothic in style and decorated with paintings, if at all. The new integration of sculpture with architecture in the San Lorenzo Sacristy is reminiscent of the manner in which these media were united in Greek and Roman temples and may be based on ancient textual references.[42] The sculptural scheme is unusual in its iconographic complexity, which combines references to the Medici and evangelists, apostles, and martyrs with the themes of death and resurrection appropriate for a family burial chamber.[43] The unique nature of every aspect of this decorative program exposes Donatello's inventive imagination and suggests the support and possible participation of remarkable patrons.

Most scholars now agree that Donatello's bronze *David* and *Judith and Holofernes* were commissioned by the Medici. Both are unprecedented in terms of design and interpretation, as well as in their placement as life-sized, in-the-round sculptures within a domestic setting. Two of the Quattrocento's most sophisticated marble *schiacciato* reliefs, the *Ascension and Delivery of the Keys* and the *Feast of Herod* (attributed), are first documented in a Medici inventory, suggesting that these examples of brilliant technique may have been initially created as tour-de-force demonstrations for collectors.[44] Donatello's final works, dated 1465 but left unfinished at his death a year later, were created for a Medici project of still uncertain function and are known collectively as the *San Lorenzo Pulpits*; these reliefs offer the most dramatic examples of Donatello's reinterpretation of traditional iconography, his most profound experimentation with the representation of space in relief sculpture, and his unwillingness to be constrained by Quattrocento patterns of composition and framing.[45]

That all these works for the Medici are apparently without documentation suggests a symbiotic relationship between artist and patron, a creative partnership that may not have required legal certification. Whatever the processes of evolution, making these works for the Medici must have been experiences that encouraged Donatello's invention and experimentation.

The patronage of certain works without documentation can be suggested or presumed because of their subject matter. The *Atys-Amorino*, for example, was almost certainly a private commission for a secular location, perhaps a garden or courtyard. Another private commission is the *Bust of a Youth*. The *Pazzi Madonna* was probably commissioned for a home as a devotional image; Madonna reliefs were usually intended for domestic use, although it is also possible that some may have been commissioned or purchased by monks or nuns. *The Madonna of the Clouds* was likely domestic, as it is probably the work recorded in the Medici collection in the late Quattrocento.[46] Ecclesiastical patronage can be presumed for the Tabernacle now in the Treasury of St. Peter's in Rome, while the patrons for the Crivelli and Pecci tomb slabs were probably the executors of the respective estates.

Other works without documented patronage include four wooden sculptures: the *Crucifixes* at Santa Croce and Bosco ai Frati, the *Baptist* in Venice, and the *Penitent Magdalene*.[47] Perhaps wood—much less expensive than marble or bronze—did not require a legal document of commission. For works in marble and bronze the patron either provided the materials or paid the artist to acquire them; because wood was readily and reasonably available, perhaps a verbal agreement was sufficient to begin work. While lack of documentation in these four cases means that questions about patron, function, audience, and reception remain largely matters of conjecture, their devotional subjects and survival in churches suggests they were originally placed in such a setting; their relative lightness and the hinged arms of the *Santa Croce Crucifix* indicate that they may have been moved as liturgy or popular religious practices necessitated. Their patrons might have been ecclesiastic authorities, monastic orders, confraternities, or pious individuals or families. Because the *Bosco ai Frati Crucifix* was found in a church near a Medici villa, their patronage has been proposed in this case. The *Baptist* was identified by Vasari as a gift to the Florentine community in Venice.

Did Donatello ever produce a work without having a patron? Knowing this would contribute to understanding the changing nature of the patron–artist dynamic in the fifteenth century and later. Some of the sculptures listed in the Appendix as produced for unidentified patrons are crafted from expensive materials; Donatello would have been unlikely to initiate any of these on his own in the expectation of finding a buyer later. Donatello's Madonna and Child reliefs in such modest materials as stucco and terracotta, however, may have been produced on speculation; among the widely-accepted examples are those in London, Berlin, and Paris.[48] Donatello may also have produced works for sale when he made the small bronze Madonna and Child reliefs in Vienna and London and the gilded copper repoussé Madonna in Cologne.[49] A letter of 1455 records the Medici purchase of two Donatello Madonnas of unidentified size and material; this unique reference to the sale of already-completed works by Donatello may document a not uncommon occurrence.[50]

The physician Giovanni di Maestro Antonio di Chellino records in his diary that on August 27, 1456 the bronze *Madonna and Child* roundel in the Victoria and Albert Museum was presented to him by Donatello, "in consideration of the medical care I had given him."[51] Whether it was created by Donatello explicitly to be given to Dr Chellini seems dubious because, as the doctor testifies, "the other side is hollowed on the outside so that molten glass can be cast on it." It is unlikely that the doctor would have commissioned a work that could be used to produce glass reproductions, but the utility of such an object for an artist is obvious: the mass production of Madonna and Child roundels in glass—or some other medium—could provide a continuing source of revenue. Donatello seems to have executed the work in north Italy, where experimentation in glass was common; after returning to Florence in 1454, he may have discovered that it was unlikely that Florentine artisans would be able to use a mold for the production of glass roundels.[52] It seems likely that

Donatello presented to his physician a work made without a patron that was no longer useful to him.

Without the evidence drawn from Dr Chellini's diary, we would have assumed that a bronze sculpture such as this, albeit modest in size, would have been commissioned for a particular patron; the evidence is a reminder that we should be careful in making assumptions about issues of production and patronage in the fluid social and artistic milieu of Quattrocento Italy. The case of the Chellini roundel also raises questions about the gift culture during this period. While some scholars have presumed that Donatello offered the roundel to his physician in lieu of a payment for medical services, Patricia Rubin concludes that it was a gift, stating that it "typifies an economy that was not solely monetary, in which prestige, friendship, and obligation were fundamental elements of exchange."[53]

In the case of the Victoria and Albert roundel, the intent of the presentation is unknown; are there other works by Donatello that were intended as gifts or that became gifts when they no longer functioned as originally intended? Possibilities include sculptures owned by the Martelli and the wooden *St. John the Baptist* in Venice.

To summarize, works without documentation provide additional, important evidence about Donatello's relationship with his patrons. The constellation of innovative sculptures for the Medici hints at a family tradition of allowing Donatello's creativity free rein. Because works created for domestic settings and those carved in wood remain undocumented suggests that their evolution may have been the result of verbal agreements that remained unrecorded. That Donatello sometimes worked without a contract is confirmed by the lawsuit he filed in 1450 against the client Petruzzo, for whom he had designed a chapel. Some works may have been presented as gifts, and some Madonna and Child reliefs in modest materials may have been made on speculation, revealing the possibility that on occasion Donatello worked without a patron.

Chronology, patronage, and style

Donatello's patronage changed as a result of new patterns of social history and artistic production.[54] His earlier works were largely commissions from religious, civic, and communal organizations, including guilds and the Florentine Opera del Duomo. His later patronage is dominated by private and familial commissions, especially his work for the Medici family. His major early patrons were the Opera del Duomo and the Florentine guilds, both of which commissioned marble figures of saints and prophets; by the 1420s the exterior of the Duomo and the tabernacles and figures at Orsanmichele were largely completed. In the 1420s, Donatello began to work in bronze, a more expensive medium that required a wealthy patron for large-scale works. In addition, Donatello began to receive commissions from outside Florence. In the 1430s, he continued to work for the Opera del Duomo, but on works for the interior: the *Cantoria*, the unfinished *Altar*

of St. Paul, the commission for bronze doors for the sacristy (unfulfilled), and the stained-glass *Coronation of the Virgin*. At the same time, he began to receive commissions for works intended for domestic settings that included Old and New Testament themes, portraiture, and one mythological subject. There is a change in the paper trail as well; while most of the earlier works are well documented, the majority of his later works lack documentation.

Dating Donatello's undocumented works is difficult because style can no longer be used as an indicator of date. Many earlier studies of his works, including Janson's *The Sculpture of Donatello*, were created during a period when stylistic differences were used to create a chronology in which undocumented works could be dated on the basis of what was perceived to be a continuous stylistic trajectory. But the discovery that the wooden *St. John the Baptist* bore the unexpectedly early date of 1438 immediately rendered such an approach irrelevant. It is now clear that Donatello worked in different styles simultaneously, suggesting that style was at least in part dependent on the particular commission and, therefore, the result of the artist's perception of his patrons' needs and wishes. Patrons must have been confident that he could find the expressive tools he needed to create the works they were requesting. The variety in Donatello's works and the fact that many of them are extraordinary in iconographic interpretation, unexpected in execution, and startling in expressive range should be credited, in part, to the demands made by and the encouragement of his patrons.

The early writers

When we turn from legal documents to the statements about patronage made by early writers and by Vasari, the possibility of exaggeration and falsification must be kept in mind. As John Burrow points out, vernacular chronicle-writing during this period did not imply detachment but was, rather, engaged with parochial patriotism and an emphasis on personal and familial interests. Burrow also emphasizes that the classically trained humanists who were beginning to write histories in Florence were interpreting the facts within an overview that intended to offer a reflection on the lessons of history.[55] Rather than reporting, chroniclers and early historians were using evidence for other ends.

For example, we must approach with skepticism the tales about Donatello, including two concerning patrons, relayed in the *Giornale* of Angelo Poliziano, a series of witticisms and quips (*facetie*) written in the late 1470s. The goal to amuse would have encouraged simplification and fabrication.[56] Donatello, who appears in seven anecdotes, is the only artist mentioned more than once, an indication of his status as a personality during the later Quattrocento.[57] In one tale, Donatello refused to work for an important patron who had requested his services several times. In the second vignette, the artist smashed the head of Gattamelata in frustration because "he was being pressed too hard for it." The stories suggest that from the patron's point of view, Donatello could be difficult and had an unpredictable temper. While there is no guarantee

that either story is based on an actual event, they reveal Donatello's position within contemporary popular culture as an individual who could be expected to behave in such a manner.

Vespasiano da Bistici's *Lives of Illustrious Men*, written in the 1480s, offers additional evidence for Donatello's relationship with the Medici in the lengthy biography of Vespasiano's client Cosimo de' Medici. Although Vespasiano's work has been praised as balanced, his motive for including each individual is not completely transparent. Vespasiano reports:

[Cosimo] took great delight in his dealings with painters and sculptors, and had some work by each master in his house. He had a particular understanding for sculpture, being a generous patron of sculptors and all worthy artists. He was a good friend of Donatello, and of all painters and sculptors; and because in his time the sculptors found scanty employment, Cosimo, in order not to have Donatello be idle, commissioned him to do some bronze pulpits for S. Lorenzo and some doors which are in the sacristy. He ordered the bank to pay every week enough money for the master and his four assistants, and in this way supported him.[58]

Vespasiano also related that because Cosimo was disappointed in how Donatello dressed, he sent the artist a rose-tinted cloak, hood, and cape. Vespasiano's story is intended to demonstrate Cosimo's largesse (*liberalità*) toward those he loved, while the modesty of the artist is suggested when Vespasiano states that Donatello returned the garments to Cosimo because he was not comfortable wearing them.[59]

Vespasiano's references to Donatello, the only artist named, formed part of a tribute to Cosimo as a patron of painters and sculptors. Vespasiano interpreted their relationship as one of friendship and concluded with the unexpected notice that Cosimo paid Donatello a weekly stipend that supported the artist and allowed him to keep working on a regular basis in a workshop with assistants. These payments should be interpreted as patronage, not charity, for the works created while Donatello accepted this support belonged to the Medici. No other such arrangement is known in Quattrocento Florence, and, because Donatello's latest works, the *San Lorenzo Pulpit Reliefs*, are found in a Medicean context, it seems likely that Vespasiano's report records an actual arrangement.[60] Whether Donatello's San Lorenzo Sacristy doors were produced under a similar arrangement seems dubious, given that during the period in which they were made Donatello seems to have been working on commissions for other patrons. Vespasiano's account makes it easier for us to accept Vasari's later report of the symbiotic relationship between the Medici and Donatello.

It is not surprising that early writers such as Francesco Albertini (1510), Antonio Billi (before 1530), the unknown author of the *Codice magliabechiano* (c. 1537–42), and Giovanni Battista Gelli (c. 1550) make no mention of patronage; at the time, it would have been assumed that figures on the Duomo or campanile had been commissioned by the Opera, that works in a home were commissioned by the family, that works at San Lorenzo were Medici

commissions, and that everyone would know which guild commissioned each tabernacle at Orsanmichele.

Antonio Billi provides a story that offers insight into Donatello's relations with patrons, although no supporting evidence guarantees that it is based on an actual event. Billi reports that Donatello left incomplete the bronze *St. John the Baptist* for the Opera del Duomo in Siena because he had not received his full pay: "And when he left Siena he said that if they wanted him to finish the statue they would have to pay him as much as they had paid for the rest of the figure." The story is repeated by Gelli and by Vasari, who reported in the first edition of his *Vite* that Donatello had stated that "he would not finish the figure unless he were paid twice the amount he had already received."[61] Documents reveal that the figure was delivered in three pieces, with one arm missing, on October 24, 1457; most scholars agree that the arm on the figure today, which is only documented in 1474, is not by Donatello.[62] Janson dismisses the stories of Donatello's request for additional payment as a "fictional embellishment," but the missing arm suggests that there was some problem between Donatello and patron that remained unresolved at the time of the sculptor's death in 1466.

Vasari

In researching and writing *Le Vite*, Vasari had a number of motives beyond documenting and defining the trajectory of Florentine and, to some extent, Italian art.[63] He certainly wished to please Duke Cosimo de' Medici, to whom the book is dedicated and whom he hoped would be his patron.[64] As Patricia Rubin points out, Vasari also wanted to educate the amateurs (*amatori*) and *signori* who were his audience, emphasizing how to study and understand art and "how much their reputations would profit from supporting the arts."[65] He encouraged patrons to be well informed and criticized those who were not, emphasizing that a good artist would be careful to accept honorable patrons.[66] Vasari exalted his favorite Florentine artists, the most obvious being Michelangelo. In his *vita* of Donatello, Vasari emphasized both Donatello's significance for the history of Quattrocento Florentine art and Cosimo de' Medici's role in supporting him; by emphasizing how much Michelangelo, who also worked for the Medici, was inspired by Donatello, Vasari linked the best artists of the Quattrocento and the Cinquecento with the Medici family. The value of Vasari's *vita* in illuminating Donatello's relationships with his patrons, however, is uncertain, given the time that had passed since the artist's death and given Vasari's interest in incorporating other authors' stories and in promoting his own ideas about art and patronage.

Several of Vasari's tales emphasize how Donatello dealt with an ill-informed patron. In his discussion of Donatello's *St. Mark* for the Arte dei Linaioli e Rigattieri tabernacle at Orsanmichele, for example, Vasari writes:

This figure was worked by Donatello with such good judgment that, while on the ground, its excellence was not recognized by people lacking in understanding, and the members of the guild were unwilling to have it erected, but Donatello asked them to put it up, saying he wanted to show them that after he worked on it further, it would turn out different. Once they agreed, he covered it up for fifteen days and then, without retouching it in any other way, he uncovered it, filling everyone with amazement.[67]

While the story is most likely intended to emphasize how Donatello adjusted his figures compositionally to make them work well in their intended setting—a theme suggested at other points in Vasari's *Vita di Donato*—it also conveys the notion that Donatello's "good judgment" could not be understood by these particular patrons. Vasari may also be suggesting that these guild members lacked the sophistication expected from a patron such as Cosimo de' Medici.[68] Vasari does not suggest that Donatello should have explained this to the guild members; for patrons such as these only a visual demonstration could demonstrate the artist's "good judgment."

Another of Vasari's anecdotes concerns a head (a portrait?) commissioned from Donatello by a Genoese merchant with Cosimo de' Medici's encouragement. When the head was presented to the merchant at the Medici Palace, he quibbled about the price; in response Donatello threw it from a window, smashing it on the street below. Donatello then told the merchant that "in a moment" ("un centesimo d'ora") he had destroyed "the value of a year's work" ("la fatica e'l valore d'uno anno"), adding that the merchant was more used to "trading in beans than in statues."[69] Vasari's patron was a foreign merchant, not a Florentine *signore* who might more readily have appreciated the worth of a head by Donatello. The words Vasari puts into Donatello's mouth are revealing, for rather than emphasizing the quality of the work, Donatello underlines the length of time it had taken him to create it. A merchant should have been able to understand the artist's investment of time and labor. Donatello refused to redo the head for twice the price despite Cosimo's encouragement. Vasari thus emphasized the artist's unwillingness to work for a patron who was not, in his opinion, honorable, no matter how much money was being offered.

In another example, the Florentine chaplain of a Paduan convent asked Donatello to make an exact copy of an old and clumsy ("vecchio e goffo") wooden figure of St. Sebastian. Vasari reports that Donatello did not produce an exact copy because "even in the imitation of that clumsy work, he could not avoid displaying his usual brilliance and skill."[70] If Donatello produced such a figure, it is not known to survive, and it is uncertain if any aspect of the story is true; in any case, Vasari's point is that the patron could not understand that Donatello would be unable to make a mechanical reproduction. Although the patron in this case was a Florentine, there may be an implication that he did not understand Donatello's natural creativity because he was a priest. In addition, by not indicating if the chaplain was pleased with Donatello's reinterpretation of the original work, Vasari

suggests that such a patron would have been unlikely to understand why his commission turned out as it had.

In addition to stories that demonstrate the distinct worlds of patron and artist, the *Vita* of Donatello suggests that a special relationship existed between Donatello and members of the Martelli family. It is documented that the family owned a number of the sculptor's works, and Vasari reports that these had been presented as gifts "to attest to the sense of duty and love [Donatello] bore that family," having been raised in their home. Neither of Vasari's assertions is supported by earlier evidence, and it is possible that the Martelli acquired some of these works through commissions or purchase. That Donatello had a special relationship with members of the family is suggested, however, by their ownership of two unfinished works, the marble *David* (in the National Gallery in Washington, perhaps "finished" by Antonio Rossellino) and the marble *St. John the Baptist* (now thought to have been finished by Desiderio da Settignano and in the Museo Nazionale); since unfinished works were not saleable during the Renaissance, the Martelli family's possession of these works seems to support Vasari's version of how they were acquired.[71] In addition, Vasari stated that the Martelli owned "many scenes in marble and bronze" and that Roberto Martelli had bequeathed the *St. John the Baptist* to his heirs in trust so that it "could never be pawned, sold, or given away, without incurring heavy penalties, as evidence and proof of the affection his family felt for Donatello, who had given it to them because, having recognized his talent, they had protected and encouraged it."[72] In addition, Donatello designed for the Martelli two works that express family identity: their coat of arms, for display in or on the family home, and a tomb for the burial of family members in San Lorenzo.[73] The evidence supports the intimate association between Donatello and one or more members of the Martelli family that is put forward in Vasari's *Vite*.

Members of the Medici family stand out as Donatello's most important patrons in the writings of Vasari, who implies a special patronage relationship between the artist and Cosimo: "And so great was the love that Cosimo bore for Donato's virtue, that he kept him continually at work, and Donato, on the other hand, bore so great a love for Cosimo that he could divine his every wish from the slightest sign and continually obeyed him."[74] While Vasari usually emphasized the role of the artist in the creative process, here he suggests that Donatello was focused on satisfying what the patron had anticipated. This blanket statement, however, must be tempered with our knowledge of Vasari's intent to exalt the Medici within the history of Florentine art.

While Vespasiano reported that Cosimo had supported Donatello through a regular salary and payments for assistants, Vasari states that it was Cosimo's son Piero, in response to his father's commendation of Donatello, who tried to support the aged sculptor by giving him a farm, which Donatello returned, and who then provided weekly installments of cash: "And as the servant and friend of the Medici family, [Donatello] lived happily and without care for

the rest of his life."[75] Vasari may have changed Vespasiano's earlier report of a salary into a stipend in order to increase the reader's perception of Medicean generosity.

The ultimate indication of the deep connection between Cosimo and Donatello is the sculptor's burial near the tomb of Cosimo. In Vasari's words: "[Donatello] was buried in the Church of San Lorenzo near the tomb of Cosimo, as he himself had ordered, and just as in life he had always been close to Cosimo in spirit, so, too, now in death, his body could rest near that of Cosimo."[76]

Vasari also tells us that Donatello made the wooden *St. John the Baptist* in Venice as a gift to the Florentine community there; the scale of the figure, which is 47 centimeters shorter than the *Penitent Magdalene*, indicates a modest outlay for materials and supports the possibility that this might have been donated by the artist, as does the highly personalized interpretation of the saint as an impassioned zealot: emaciated, condemnatory, and, with his drooping eyelid, suffering from ptosis. The representation of the saint is compelling, but is this how the Florentines would have chosen to have their saint presented to those whose patron was the distinguished evangelist Saint Mark? Can this interpretation of the Baptist be used to support Vasari's statement that Donatello made the work as a gift and not on commission?

Before concluding, it is important to reconsider the relationship between Donatello and the Medici. The primary evidence is the works themselves, combined with the testimony, albeit perhaps biased, of Vespasiano and Vasari. The exceptional works that Donatello created in concert with his Medici patrons suggest that the relationship between sculptor and patron may have been unusually symbiotic. This conclusion is supported by the lack of documentation for the Medicean works, even for the extensive and clearly expensive decorations for the Old Sacristy, which were executed in a period when most of Donatello's other commissions are quite fully documented. When the evidence from the undocumented works is combined with Vespasiano's report that Cosimo supported Donatello with a weekly stipend, and with Vasari's conclusion that Donatello "lived happily without a care for the rest of his life" as a "servant and friend of the Medici family," it is easy to conclude that this is a unique situation in the history of the patronage of sculpture in Quattrocento Florence, if not in Europe as a whole. Even within the courtly cultures of the Quattrocento there is no parallel, not even in the area of painting. Michelangelo in the Cinquecento did not have a patron who both provided him with commissions over a long period of time and engaged him in the making of a series of diverse but revolutionary works, nor did Cellini or Giambologna. The closest parallel might be the paintings, architecture, remodelings, and festival decorations created and/or managed by Vasari for the Medici family in the sixteenth century. Whether the family's encouragement and support of Donatello's creativity had an impact on how the sculptor approached his other commissions deserves further consideration.

Conclusion

The diversity of Donatello's patrons and the multiplicity of centers in which he worked may be responsible in part for the variety of subject matter, execution, and expression that is so remarkable in his works. An examination of patronage drawn from documents, early chroniclers, and Vasari exposes the role Donatello played in liberating the Renaissance artist from traditional constraints and transforming the artist–patron relationship during the Quattrocento. That we can describe many of Donatello's works as extraordinary, unexpected, and startling when compared to works by his contemporaries suggests that these remarkable sculptures must also have astonished those who commissioned them, but whether Donatello's patrons were pleased is unknown. Donatello's unpredictability may have been frustrating to some clients, exhilarating to others. We can only wonder how each patron may have responded to the experience of working with this volatile artist.

The fact that patrons continued to commission works from Donatello indicates that some prospective patrons were satisfied and even inspired by what he had produced for others. We do not know what motivated patrons to commission works from Donatello, although it is important to remember that practical considerations—price, the unavailability of other artists, his ability to work in certain materials—may have played a role. Once his career had developed significantly, some patrons may have selected him because of their desire to be associated with an artist with an international reputation. Others may have liked him as a person and decided to engage him in a creative endeavor. It is also possible that some selected Donatello because of a desire to be surprised. Some patrons, in particular the Medici, seem to have recognized that because Donatello could produce the unexpected, he should be allowed the freedom to explore new solutions to their commissions. Perhaps those patrons who trusted Donatello the most should be recognized as having supported the production of his most unprecedented works. If this is the case, the role of these patrons, while undefined in detail, must be seen as crucial for understanding the works they commissioned.

The most tantalizing remaining questions for me are related to our inability to understand more fully the evolution of the creative relationship between patron and artist that could explain Donatello's most innovative works. The Padua Altar, for example, is unprecedented in the history of Italian sculpture: although there is not enough evidence to produce a convincing visual reconstruction of its appearance (the existing visual proposals are each, in some way, unsatisfactory), the documents clarify the altar's exceptional nature. Seven life-sized bronze figures stood on a painted *pavimento* under an architectural canopy that had a cupola with a stone figure of God the Father and painted and gilded marble moldings and cornices. The canopy was supported and framed by eight marble columns; four were round with fluting, four were square. The base featured 20 bronze reliefs of various sizes (some of which are documented as being "adorned" with both gold and silver highlights), a pierced bronze

relief of *Christ as the Man of Sorrows*, and a large stone relief of the *Entombment*, as well as two sets of steps in different materials. Some parts of the altar were carved of alabaster and there were also "certain flowers" made by a potter, who also provided terracotta tiles and border strips. Almost every detail of this altar would have been a surprise; the totality must have been astonishing. But who first came up with the idea of an open architectural pavilion with bronze figures? Did Donatello suggest such a possibility to the patron, or did the patron ask if Donatello had any ideas for a new kind of altar? Or did the idea evolve gradually, in the course of one or more animated conversations? And how did each subsequent idea and detail evolve? Who developed the complex iconographic program, which encompasses not just the Madonna and Child with six saints, but also a representation of God the Father, scenes from the legend of St. Anthony of Padua, Christ as the Man of Sorrows, symbols of the four evangelists, and 12 reliefs of *putti*? Which party proposed the terracotta flowers, who suggested the painted *pavimento*? These questions must be kept in mind in order not to misrepresent this problematic work. Being able to answer such questions for this or another similarly complex work would enhance our understanding of fifteenth-century patronage practices in general. How often and in which situations might an artist encourage a patron to participate in the development of a work, or when might a patron intrude with an opinion, whether followed or not, or a demand? These are broad questions, the answers to which would greatly enlighten our understanding of the artist–patron relationship during a period when social and economic relationships were increasingly fluid and, therefore, unpredictable.

The unprecedented nature of the Padua Altar as a whole and the surprises revealed by such documented details as a painted floor and terracotta flowers mean that there are no comparative works on which to base a reconstruction. That these patrons were willing to proceed with a completely unprecedented work reveals their acceptance of Donatello's curiosity and experimentation. While we might expect that it would be easier to negotiate innovation with an individual, in this case the patrons were the officials of the Arca del Santo, a group which might be expected to be rather conservative.

A comment in a letter written by Ludovico Gonzaga, Marchese of Mantua, suggests that the sculptor paid little attention to his patrons' opinions and provides one of the rare Quattrocento assessments of Donatello's relationship with a patron. Ludovico wrote that Donatello had "a brain made in such a way that whatever did not originate from him, it was no use hoping for." Dale Kent has suggested that Ludovico's phrase means that "Donatello's patron could only draw upon the artist's creativity; he could not control it," implying that a patron could play little role in the evolution of the sculptor's works.[77] This assessment of the artist–patron relationship, however, was written by a patron for whom, in the end, Donatello did not produce any work. Ludovico commissioned the sculptor to make the Arca di Sant'Anselmo, an altar or a shrine for the relics of Saint Anselmo, but the work was never completed. The Marchese's comment implies that he has been unable to control or direct

Donatello's creativity, which leads us to wonder if this is why Donatello did not complete this commission. In contrast, among the several surviving references to Donatello's relationship with members of the Medici family, none suggests that they were frustrated in their dealings with the artist. Indeed, Vasari's version of the relationship between Donatello and Cosimo de' Medici suggests that Donatello's works were revelations of what Cosimo desired: "Donatello felt such affection for Cosimo that he could guess exactly what Cosimo wanted from the slightest indication, and he always responded to his wishes."[78] It would seem that a symbiotic relationship between artist and patron led to better results than one in which the patron was "in control."

The idea that Donatello was a liberated artist drawing on his creativity to make the unexpected must be understood in relationship to the patrons who allowed and perhaps even encouraged his experimentation. It is no surprise, given the challenges with which he presented himself, that many of Donatello's works were late, some were never completed, and one was rejected. Visual and documentary evidence from the Trecento describes a period in which there seems to have been a mutual understanding between patron and artist: the patron knew what kind of product to expect and the artist understood how to fulfill that expectation. The new experimental and innovative artistic culture that developed in the early Quattrocento meant that patrons could not foresee the final outcome, and that a "modern" artist was one who would be challenged to find new solutions for every commission. In addition, the gradual increase in individual and familial commissions during the Quattrocento must have led to more personal relationships between patrons and artists; witness Donatello's relationship with the Medici. Donatello's late or unfinished works may be an indication of the artist's inability to find a satisfactory conclusion for the challenge of a particular commission; an alternative interpretation, of course, is that Donatello misjudged the time and energy available to complete these commissions, or that he abandoned commissions when a new opportunity presented itself. The evidence of the rejected work for the Sienese Opera demonstrates that on occasion the greater freedom within the Quattrocento patronage system did not lead to a happy result. The new, more fluid and trusting relationship between Donatello and his patrons that emerges from this study of documents and chroniclers provides yet another reason why Quattrocento Florence is often referred to as the "birthplace of the modern world."

Appendix: Donatello's known and presumed patrons, including patrons of works not completed

This appendix reduces a series of patronage situations to a simplified list for the purpose of analysis. The list of works accepted here as by Donatello is based on the limited lists found in Janson (1963) and Bennett and Wilkins (1984), with some additions from the more expansive lists found in Avery (1991) and Pope-Hennessy (1993).

Guilds

ARTE DEI CORAZZAI E SPADAI
St. George and Reliefs (c. 1420; Florence, Orsanmichele, and Museo Nazionale)[79]

ARTE DEI LINAIOLI E RIGATTIERI
St. Mark (c. 1411–c. 1415; Florence, Orsanmichele Museum)

Political

PARTE GUELFA
St. Louis of Toulouse and Tabernacle (c. 1422–c. 1425; Florence, Museo di Santa Croce, and Florence, Orsanmichele)

Civic officials

FLORENCE
David, marble (reworking of 1416, Florence, Museo Nazionale)[80]

Dovizia, for the Mercato Vecchio (c. 1430; lost)[81]

MODENA
Statue of Borso d'Este, Duke of Ferrara, gilded bronze (commissioned 1451, payments 1452; documented sketch is lost; work was never completed)

VENICE, SENATE
Equestrian Statue of Gattamelata, with base (c. 1445–53; Padua, Piazza del Santo)

Rulers

KING ALFONSO I OF NAPLES
(proposed; exact details never specified)

LUDOVICO GONZAGA, MARCHESE OF MANTUA
"Arca di Sant'Anselmo" (commissioned 1450; never completed)

Private families

BONI
Boni Stemma (designed by Donatello, executed by Desiderio and Geri da Settignano? ; c. 1456–58; Detroit, Institute of Arts)

BARBIGIA, BERNARDO OR NICCOLÒ?
Wooden Crucifix with moveable arms (c. 1410–c. 1425; Florence, Santa Croce)[82]

CAVALCANTI
Annunciation Tabernacle with terracotta putti (1430s; Florence, Santa Croce)

MARTELLI
Martelli Stemma (c. 1455–57; designed by Donatello, executed by Desiderio da Settignano; Florence, Museo Nazionale)[83]

Sarcophagus for Niccolò and Fioretta Martelli (c. 1463–64; designed by Donatello, executed by Desiderio da Settignano and his assistants; Florence, San Lorenzo)[84]

MEDICI
Bronze Reliefs, now mounted on pulpits (1460s; Florence, San Lorenzo)

Restoration of antiquities collected by Cosimo (undated; as reported by Vasari)

Sculptural decoration for the Old Sacristy, San Lorenzo (after 1428–c. 1440; Florence)

MEDICI (PRESUMED)

Ascension and Delivery of the Keys (1420s–early 1430s; London, Victoria and Albert Museum)

Bosco ai Frati Crucifix (late 1430s–early 1440s; S. Piero a Sieve, Convento di Bosco ai Frati)

David, bronze (c. 1446–c. 1460; Florence, Museo Nazionale)

Feast of Herod, marble (1420s–1430s; Lille, Musée des Beaux-Arts)

Judith and Holofernes (c. 1446–c. 1460; Florence, Palazzo Vecchio)

UZZANO (PRESUMED)

Bust of Nicolo da Uzzano (1430s?; Florence, Museo Nazionale)[85]

ADDITIONAL FAMILY/PRIVATE COMMISSIONS (PRESUMED)

"Atys-Amorino," bronze with gilding (1430s–1450s; Florence, Museo Nazionale)[86]

"Pazzi" Madonna and Child (1420s–1430s; Berlin, Bode Museum)

"Madonna of the Clouds" (c. 1425–28; Boston, Museum of Fine Arts)

Bust of a Youth, bronze (c. 1440; Florence, Museo Nazionale)

CATHEDRAL AND CHURCH CONSTRUCTION ORGANIZATIONS

FLORENCE, OPERA DEL DUOMO

Two Marble Altars for the Tribune of the Duomo (a wax model for the Altar of St. Paul documented in 1439 is now lost)[87]

Bronze Doors for the Sacristy (commissioned 1437; never executed)

Busts of Prophet and Sibyl for the Porta della Mandorla (1422; Florence, Duomo)

Campanile Prophets (some executed in collaboration with other sculptors; 1415–36; Florence, Museo del Opera del Duomo)

"Cantoria" (1433–39; Museo del Opera del Duomo)

Coronation of the Virgin, stained glass (design; 1434–37; Florence, Duomo)

David, marble (1408–1409, 1416; Florence, Museo Nazionale)[88]

Hercules, for the Duomo (with Brunelleschi; 1415; stone model with gilded lead drapery; lost)

Joshua ("homo magnus") for the Duomo (1410–12; model and full-scale figure, both lost)

Marzocco (c. 1418–20; Florence, Museo Nazionale)[89]

Prophets, for the Porta della Mandorla (1406; lost)

St. John the Evangelist (1408–15; Florence, Museo del Opera del Duomo)

ORVIETO, OPERA DEL DUOMO

St. John the Baptist, statuette for the Baptistery Font (commissioned 1423; never completed)[90]

PADUA, ARCA DEL SANTO
 Crucifix, bronze (1444–49; Padua, Santo)

 High Altar with figures, reliefs, architectural details (1446–50; Padua, Santo)

PRATO, OPERA DEL CINGOLO
 Exterior Pulpit (with Michelozzo; 1428–38; Prato, Duomo)

SIENA, OPERA DEL DUOMO
 Bronze Doors for Duomo (1458–59; never completed, but the bronze *Lamentation* at the Victoria and Albert Museum in London may be related to this project)

 Feast of Herod, bronze relief, and bronze figures for the Baptismal Font (1423–29; Siena, Baptistery, and Berlin, Bode Museum)

 Madonna "del Perdono," marble, from the Duomo (1457–58; Siena, Museo del Opera del Duomo)

 Tabernacle door (c. 1430; rejected, presumably lost)

 St. John the Baptist, bronze (c. 1457; Siena, Duomo)

ECCLESIASTIC PATRONS

ARCHBISHOP OF ZARA
 Designs for architectural decorations for the Archbishop's Palace (1453; never executed?)

BISHOP FRANCESCO DAL LEGNAME OF FERRARA
 Unknown object/subject, never executed (payment 1451)[91]

UMILIATI MONKS AT OGNISSANTI, FLORENCE
 Reliquary Bust of San Rossore (1422–27; Pisa, Museo Nazionale)

UNKNOWN ECCLESIASTIC PATRON (PERHAPS POPE EUGENIUS IV)
 St. Peter's Tabernacle (1432–33; Rome, St. Peter's Basilica, Treasury)

ESTATES (THE EXECUTORS OF THESE ESTATES MIGHT REASONABLY BE CONSIDERED AS THE PATRONS OF THESE WORKS)

Tomb of Anti-Pope Baldassare Cossa (with Michelozzo; 1421–c. 1428; the executors were Bartolommeo di Taldo Valori, Niccolò da Uzzano, Giovanni d'Averardo de'Medici, and Vieri Guadagni; Florence, Baptistery)

Tomb of Cardinal Rainaldo Brancacci (with Michelozzo; c. 1425–c. 1428; among the executors was Giovanni di Bicci de'Medici; Naples, Sant'Angelo a Nilo)

Tomb of Archdeacon Giovanni Crivelli (1432–33; Rome, Santa Maria in Aracoeli; executors unknown)

Tomb of Archbishop Giovanni Pecci (c. 1426; Siena, Cathedral; executors unknown)

WORKS FOR UNIDENTIFIED PATRONS

Penitent Magdalene, wood (late 1430s–1450s; Florence, Museo dell'Opera del Duomo)

Lamentation, bronze relief (1457–59?; London, Victoria and Albert Museum; perhaps related to commission for doors for the Sienese Duomo)

WORKS PERHAPS MADE ON SPECULATION

"Chellini Madonna and Child," bronze roundel (1440s–1456; London, Victoria and
 Albert Museum)

Madonna of Humility with Two Angels, bronze roundel (c. 1444; Vienna,
 Kunsthistorisches Museum)

Madonna and Child, pigmented terracotta relief (1440s; Berlin, Bode Museum)

Madonna and Child, pigmented terracotta relief (1440s; Paris, Musée du Louvre)

Madonna and Child, terracotta relief, prepared for pigmenting, with *verre eglomisé*
 (c. 1460; Paris, Musée du Louvre)

Madonna and Child, gilded terracotta relief (1450s; London, Victoria and Albert
 Museum)

Madonna and Child, pigmented terracotta relief (1443–60; Boca Raton, Cryan
 Collection)

Madonna and Child, gilded copper repoussé (1420s–1430s; Cologne, Schnütgen-
 Museum)

Madonna and Child, terracotta, originally pigmented (c. 1450; Fort Worth, Kimbell
 Museum of Art)

Madonna and Child under an Arch, gilded bronze (c. 1450; London, Wallace Collection
 and Washington, National Gallery)

WORKS PERHAPS CREATED AS GIFTS

St. John the Baptist, wood (according to Vasari; 1438; Venice, Santa Maria Gloriosa dei
 Frari)

WORKS PERHAPS PRESENTED AS GIFTS

"Many scenes of marble and bronze" in the Martelli home including, perhaps, the
 bronze *Crucifixion* relief today in the Museo Nazionale[92]

UNFINISHED WORKS, PERHAPS PRESENTED AS GIFTS

Martelli John the Baptist, with Desiderio da Settignano? (according to Vasari; date
 uncertain, "completion" by Desiderio dated c. 1457–59; Florence, Museo
 Nazionale)[93]

Martelli David, with Antonio Rossellino? (according to Vasari; date uncertain,
 "completion" by Rossellino dated c. 1457–59; Washington, National Gallery of Art)[94]

Notes

1 I owe many thanks to Bonnie A. Bennett, my co-author for *Donatello* (London:
 Phaidon, 1984), from which some of the ideas in this essay have been
 developed. English translations are taken from H. W. Janson, *The Sculpture of
 Donatello* (Princeton: Princeton University Press, 1963), unless otherwise stated.
 Documents are cited by the numbers established by Volker Herzner, "Registi

Donatelliani," *Rivista dell'Istituto Nazionale d'Archeologia e Storia dell'Arte*, ser. 3, vol. 2 (1979): 169–228, as indicated by the letter H followed by the document number. The current locations of the works cited are included in the Appendix. For further references to the scholarship on Donatello's works, see the major monographs and their bibliographies.

2 H380.

3 I have chosen to use the terms "patron" and "client" interchangeably because the evidence for a distinction between them during this period is too slim to make a difference meaningful.

4 For a summary of Donatello's travel and work outside of Florence, see Bennett and Wilkins 1984, 30.

5 The December 19, 1408 contract that commissions Evangelist figures for the Duomo façade from Donatello, Nanni di Banco and Niccolò di Pietro Lamberti states that their pay would be determined at a later date (H10), perhaps in part because there was little precedent for such large-scale marble figures.
 In the case of the guild commission for the figure of St. Mark at Orsanmichele, "the price will … be determined by the five guild members in charge of the project, who will deduct the 28 florins already spent for the block. Donatello agrees in advance to accept their appraisal" (Janson 1963, 17; H23). It is interesting that no amount could be set for the figure, while the contract for the carvers making the tabernacle states that they will be paid 200 florins; this suggests that patrons (and perhaps also artists?) were unwilling to fix a price for a more creative commission.
 A document of June 1, 1425 regarding the figure that Donatello had just finished for the Campanile in Florence states that "the *operai* are free to grant him such payment for it as they deem suitable" (Janson 1963, 34; H84).

6 Donatello's *Feast of Herod* relief for the Baptismal Font in Siena was delivered in April 1427, but in July he was still waiting to be paid (H98, H96). Perhaps the delay in receiving final payment two months after delivery is not surprising, given that Donatello had accepted an advance for the relief in May of 1423 (H76), when it was expected that the relief would be delivered before March 1425 (H80).
 In August 1434, Donatello sent his *garzone* (assistant) Pagno di Lapo to the Cathedral workshop in Siena "to press his demands" for a "final accounting" of what was owed him, although it must be added that the delay in payment in this case may have been because the Sienese Cathedral workshop was rejecting a work that Donatello had created specifically for them (Janson 1963, 66; H175).
 In 1456, Donatello appointed the stonemason Francesco di Simone from Ravenna to be his agent in collecting what he was still owed for his work on the Padua Altar (Janson 1963, 167; H351).

7 H324. On this episode, see Janson 1963, 187–8.

8 Michelle O'Malley, *The Business of Art: Contracts and the Commissioning Process in Renaissance Italy* (New Haven and London: Yale University Press, 2005), 5.

9 This is the case with the contract for the Prato *pergamo*, which refers to the model that Donatello and Michelozzo had made ("facto di loro mano") and deposited in the sacristy of the Cappella della Cintola (H103).

10 H168.

11 A later document for the Prato *pergamo* specifies a penalty of 200 florins if the terms of the current document and previous agreements are not fulfilled (H168).

12 H23.

13 H33.

14 On April 16, 1415 Donatello was warned that he would have to pay a penalty of 25 florins if he did not complete his figure of *St. John the Evangelist*. Perhaps in this case the threat had some force, for he delivered the figure by October of that year. He received the final payment after the figure had been installed and appraised (H36, 39).

 In 1425, the Opera del Duomo di Siena decided to ask for the return of the money advanced to Donatello and Ghiberti because the reliefs that they were preparing for the baptismal font had not been completed on time (H80); there is no documentary evidence that the money was ever requested from the artists or refunded.

15 Unprecedented sculptural commissions during this period include mythological subjects, allegorical works (Donatello's *Dovizia*), the sculptural decoration of the Old Sacristy at San Lorenzo (Donatello), free-standing figures and figural groups (Donatello's bronze *David* and *Judith and Holofernes*), multiple figures in a single niche (Nanni's *Quattro Santi Coronati*; Verrocchio's *Christ with Doubting Thomas*), tombs for chancellors (Bernardo Rossellino, Desiderio da Settignano), and portrait busts (Donatello, Mino da Fiesole, Benedetto da Maiano, and others), as well as commissions that demanded new technical skills such as large-scale bronze casting (Ghiberti's two sets of bronze doors and *St. John the Baptist*, Donatello's *Equestrian Monument to Gattamelata*), overall fire-gilding (Donatello's *St. Louis of Toulouse*), and the decoration of bronze reliefs with gold and silver highlights (Donatello's *Padua Altar*) and enamel details (Donatello's *St. Louis of Toulouse*). New techniques developed during this period include *schiacciato* relief (Donatello, Desiderio da Settignano) and pictorial or continuous relief (Donatello, Ghiberti). On the latter, see David G. Wilkins, "The Invention of 'Pictorial Relief,'" in *Depth of Field: Relief Sculpture in Renaissance Italy*, ed. Donal Cooper and Marika Leino (Bern: Peter Lang, 2007), 71–96.

 The willingness of an artist to undertake a new technical challenge is demonstrated in the contract for Ghiberti's over life-sized bronze figure of St. John the Baptist for the Arte di Calimala at Orsanmichele. No bronze figure on this scale had been cast since antiquity, and the guild was so unsure of Ghiberti's ability to succeed that the contract stated that they would owe him nothing should he fail. The confidence on the part of the artist that he could succeed is, I would point out, matched by the willingness of the guild to accept what must have been Ghiberti's proposal.

 The expectation on the part of the patron that the artist would produce something new and artists' fears that new ideas might be co-opted by others may explain documents suggesting that they were trying to prevent others— artists, patrons, and/or the general public—from seeing works in progress. On July 17, 1410, the chapels in the Duomo where Nanni di Banco, Niccolò di Pietro Lamberti, Bernardo Ciuffagni, and Donatello were working on the evangelist figures for the façade were closed from view, and in 1415 a payment was made for a key so that Donatello's chapel could be locked (Janson 1963, 13; the 1410 document is not listed by Herzner, the 1415 document is H340); given that Ciuffagni's sculpture is a pastiche of the new elements drawn from the evangelist figures by the other three, it seems likely that Ciuffagni was the focus of these attentions. In any case, the documents suggest that there were reasons why artists working in a period of new developments would want to keep their work secret until completed. In 1433, the window of the chapel where Donatello was working on the *Cantoria* was repaired and a linen curtain purchased for it,

although this may have been general maintenance rather than a matter of secrecy (Janson 1963, 119; H157).

16 H36; further payments to Donatello are documented in May and June (H37, 38) and it is recorded that by October 8 the figures had been appraised and installed on the Duomo façade (H39). No record that the penalty was exacted is documented; I am not aware of any instance in which such a penalty was paid.

17 H80.

18 Janson 1963, 163; H259.

19 Janson 1963, 164, H265.

20 Janson 1963, 121, H254.

21 H103, 108, 142.

22 H205. The document does not mention Michelozzo.

23 As Janson points out, the documents do not include a final accounting (1963, 111).

24 H155, 150. The specific emphasis on quality, unusual in documents of this period, is also found in a document of payment to Luca, which states that he is being paid more per relief than had been specified in an earlier document not only because the execution had taken more time but also because they were better and more beautiful ("dicte storie quas fecit ad presens sunt pulcriiores ac meliores"). See John Pope-Hennessy, *Luca della Robbia* (Ithaca: Cornell University Press, 1980), 24–5.

25 In Donatello's first documented commission, in 1408, he was asked to create a work that would be a pendant to the work of another artist; the contract stipulates that his *David* should be executed "in the manner, under the conditions, and at the rate of *salario* (pay) previously stipulated in a contract with Nanni di Banco, who had undertaken to do the figure of another prophet" (Janson 1963, 3). In this case, the document does not refer to quality, and he may have accepted the restrictions more easily because Nanni was about a decade his senior and the son of a sculptor who worked in the Cathedral workshop. In its pose Donatello's *David* (Florence, Museo Nazionale) is, indeed, an appropriate pendant to Nanni's figure of *Isaiah* (Florence, Duomo); the manner in which these two figures echo each other in pose is one of the reasons why the identification of the Museo Nazionale *David* as the figure mentioned in the 1408 document has seemed reasonable. Another figure has been proposed as the 1408 *David*; see John Pope-Hennessy, *Donatello: Sculptor* (New York: Abbeville Press, 1993), 17–20.

26 In 1446, the *operai*, in consultation with "experts," determined that the price of Donatello's gallery, including labor and materials up to that point, should be 896 florins. Unfortunately there is no comparable document for Luca's gallery, but Pope-Hennessy, using partial information about payment, concludes that the total payment may have been 1138 florins (1980, 227–8). A document of April 22, 1435 had increased Luca's payment for each of his ten reliefs from 60 to 70 florins, suggesting that the range of 40 to 50 florins that Donatello had accepted in 1433 may have been lower than that of Luca (H155).

27 H259 (April 27, 1447). Janson 1963, 163, incorrectly dates the document April 29. For the text of the original document, see Antonio Sartori, *Documenti per la storia dell'arte a Padova* (Fonti e studi per la storia del Santo a Padova, III), ed. Clemente Fillarini (Vicenza: Neri Pozza, 1976), 88–9.

28 Janson 1963, 164. H265. For the full original text, see Sartori 1976, 89. The need to clean works is also mentioned in a document concerning a payment to Antonio Chellini for cleaning an angel relief cast "by the hand of Donatello" (Janson 1963, 164; H274).

29 For full transcriptions of the Padua Altar documents, see Sartori 1976.

30 Diane Finiello Zervas, *The Parte Guelfa, Brunelleschi and Donatello* (Locust Valley: J. J. Augustin, 1987), 119. Zervas suggests that, after Donatello had been selected to produce the figure and tabernacle, "There would have been meetings between the tabernacle *operai* and Donatello at which the party's general desires would have been presented. Working with such a brief and taking into account both expense and the earlier tabernacle designs for Orsanmichele, Donatello (very possibly in collaboration with Brunelleschi), may then have presented several versions of the tabernacle for comment and approval to the *operai* and captains, just as Brunelleschi, according to Manetti, did for San Lorenzo" (121).

31 Patricia Lee Rubin, *Images and Identity in Fifteenth-Century Florence* (New Haven and London: Yale University Press, 2007) points out that "competitions and competition were facts of Florentine artistic life" (343) and cites the relevant bibliography in n. 89. The most important example of this is the 1401–1403 competition for the bronze doors for the Florentine Baptistry, with surviving presentations by Brunelleschi and Ghiberti (see Frederick Hartt and David G. Wilkins, *History of Italian Renaissance Art* (6th edn, Upper Saddle River: Pearson/Prentice-Hall, 2007), 177–9, and John T. Paoletti and Gary M. Radke, *Art, Power, and Patronage in Renaissance Italy* (3rd edn, Upper Saddle River: Pearson/ Prentice-Hall, 2005), 205–7).

32 H10. Apparently because all three sculptors were slow in completing their figures, on May 29, 1410 the fourth evangelist was commissioned from Bernardo Ciuffagni.

33 H175. For a transcript of the document, see John T. Paoletti, "The Siena Baptistry Font: A Study of an Early Renaissance Collaborative Program, 1416–1434," Ph.D. dissertation, Yale University, 1975, 356–7, document 287. Whether Donatello's *sportello* was purely decorative or depicted a specific subject is unknown, but Turini's replacement door features a representation of the Madonna and Child, raising the possibility that it may have been a Madonna and Child composition that decorated the rejected *sportello*.

34 Burke reports that it was during the Quattrocento that "the association between maker and purchaser is transformed from a contractual commercial transaction … to a more complex relationship in which the patron is expected to grant latitude to the artist: this ensures the quality of the work …," adding that the notion of "amicizia is new, endows the relationship with an air of virtù." Jill Burke, *Changing Patrons: Social Identity in the Visual Arts in Renaissance Florence* (University Park: Pennsylvania State University Press, 2004), 97.

35 On the relationship between the Medici and Cossa, see Dale Kent, *Cosimo de' Medici and the Florentine Renaissance: the Patron's Oeuvre* (New Haven and London: Yale University Press, 2000), 27, 294. Vasari later reported that the commissioner of the tomb was Cosimo de' Medici (1550). McHam has suggested that Cosimo's role in creating this impressive marble and bronze monument in the Baptistery may have been a "carefully disguised tactic of Medici self-promotion." Sarah Blake McHam, "Donatello's Tomb of Pope John XXIII," in *Life and Death in Fifteenth-Century Florence*, ed. Marcel Tetel, Ronald G. Witt, and Rona Goffen (Durham: Duke University Press, 1989), 156. On the relationship

between Cossa and the executors Niccolò da Uzzano and Giovanni d'Averardo de' Medici, see Janson 1963, 60.

36 A tradition dating to 1624 reports that it was Cosimo who ordered the tomb from Donatello and Michelozzo (Janson 1963, 89).

37 H147; Isabelle Hyman, "Notes and Speculations on S. Lorenzo, Palazzo Medici, and an Urban Project by Brunelleschi," *Journal of the Society of Architectural Historians* 34 (1975): 108.

38 For the payment, see H148. That Cosimo had written a letter is indicated in H142.

39 Janson 1963, 121; H254.

40 Philip Foster, "Donatello Notices in Medici Letters," *Art Bulletin* 62 (1980): 148–9.

41 Vasari, *Life of Donato*. For information on the location of Donatello's burial place and that he was buried here "per commissione Dal mag.ᶜᵒ piero di cosimo de medici," see R. W. Lightbown, *Donatello and Michelozzo: An Artistic Partnership and its Patrons in the Early Renaissance* (London: Harvey Miller, 1980), 2: 327–8.

42 Ancient literary sources known in the Quattrocento that describe how sculpture was used to adorn religious or memorial architecture include Pausanias on the Temple of Zeus, Olympia; Pliny's and Vitruvius's descriptions of the Mausoleum at Halicarnassos; and Pliny's mention of the pediment statues of the Pantheon by Diogenes the Athenian, among many others. Thanks to Sarah McHam for her assistance with these references.

43 On the function of the Old Sacristy as a family burial chapter, see John T. Paoletti, "Donatello's Bronze Doors for the Old Sacristy of San Lorenzo," *Artibus et historiae* 21 (1990): 39–69, and Roger J. Crum, "Donatello's *Ascension of St. John the Evangelist* and the Old Sacristy as Sepulchre," *Artibus et historiae* 32 (1995): 141–61. Crum proposes that Donatello's relief of the *Ascension of St. John the Evangelist* contains a portrait of Giovanni de' Medici.

44 On the proposal that *schiacciato* reliefs may have been commissioned by connoisseurs as virtuoso productions for their collections, see Wilkins 2007, 95–6.

45 For an analysis of the exceptional stylistic and iconographic aspects of these reliefs, see Bennett and Wilkins 1984, ch. 1.

46 Janson 1963, 86.

47 In 1591, Francesco Bocchi identified the patron of the *Santa Croce Crucifix* as "Bernardo or Niccolò del Barbigia," but without citing any evidence for this identification. John Pope-Hennessy attributed the *Bosco ai Frati Crucifix* to Desiderio (1993, 321). On the idea that the wooden figure of *John the Baptist* in Venice may have been a gift, see below.

48 The tremendous popularity of this type of domestic devotional object, which was often reproduced in multiples, has recently been studied by Sarah McHam. Sarah Blake McHam, "Now and Then: Recovering a Sense of Different Values," in *Depth of Field: Relief Sculpture in Renaissance Italy*, ed. Donal Cooper and Marika Leino (Bern: Peter Lang, 2007), 305–50. See also John T. Paoletti, "Familiar Objects: Sculptural Types in the Collections of the Early Medici," in *Looking at Italian Renaissance Sculpture*, ed. Sarah Blake McHam (Cambridge and New York: Cambridge University Press, 1998), 79–110.

49 On the example in Cologne, see Bennett and Wilkins 1984, 49, fig. 34. Although our attribution of this tiny work has not found acceptance, the high quality of design and craftsmanship support it.

50 Foster 1980, 148–9.

51 For a summary of the bibliography on the roundel, see Rubin 2007, 323. For the translations from Chellini's *Le ricordanze* given here, see *ibid.*, 60. Rubin emphasizes the importance of the uniqueness of the object Donatello presented to his physician (*ibid.*, ch. 2). The physician does not offer an aesthetic or iconographic assessment of the work but notes that Donatello is "the singular and outstanding master of bronze, wood, and terracotta figures," a statement that indicates that Donatello's breadth of media was worthy of comment.

52 Working in glass was well established in Venice by this time. On the important Paduan glass artisan Angelo Barovier, see Bennett and Wilkins 1984, 125.

53 Rubin 2007, xiv. Those who presume that the roundel was given to the doctor to pay off a debt for medical service include Marc Bormand, Beatrice Paolozzi Strozzi, and Nicholas Penny, eds, *Desiderio da Settignano: Sculptor of Renaissance Florence* (exh. cat., Washington, D.C.: National Gallery of Art, 2007), 2, 62.

54 See Burke 2004, especially 97.

55 John Burrow, *A History of Histories: Epics, Chronicles, Romances and Inquiries from Herodotus and Thucydides to the Twentieth Century* (London: Allen Lane, 2007), 275–6.

56 The anecdotes apparently collected by Poliziano were first published in 1548 by Lodovico Domenichi, *Facetie et motti arguti* (Florence: Torrentino, 1548). For a complete set in English, see Bennett and Wilkins 1984, 19, 31. For bibliography on the collection, see Patricia Lee Rubin, *Giorgio Vasari: Art and History* (New Haven and London: Yale University Press, 1995), 326, n. 23.

57 In discussing Vasari's *Vita* of Donatello, Rubin points out "Donatello's survival in the Florentine storytelling tradition" (1995, 339).

58 Janson 1963, 132. The original text is published in Vespasiano da Bisticci, *Le vite*, ed. Aulo Greco (Florence: Istituto Palazzo Strozzi, 1976), 2: 193–4.

59 For Vespasiano's original Italian text, see Rubin 2007, 281, n. 46.

60 The only Quattrocento parallels are for court artists: Mantegna's work for the Marquis of Mantua and Leonardo's work for Ludovico Sforza in Milan. Whether Cosimo was thinking of Donatello as his "court artist" is unknown.

61 Interestingly, Vasari's 1550 version of this story had changed by 1568, when he reported only that Donatello left the figure unfinished "because he had not been paid in full." For original texts, see Giorgio Vasari, *Le vite de' piu èccelenti pittori, scultori e architettori; nelle redazione del 1550 e 1568*, ed. Paolo Barocchi and Rosanna Bettarini (Florence: Accademia della Crusca, 1994), 3: 217.

62 Pope-Hennessy 1993, 288, suggests that it "must be the work of a later Sienese bronze sculptor, perhaps Giovanni di Stefano."

63 Vasari's *Vite* have in recent years been subjected to extensive historical and cultural analysis; see especially Rubin 1995, and Anne B. Barriault, Andrew T. Ladis, Norman E. Land, and Jeryldene M. Wood, eds, *Reading Vasari* (London: Philip Wilson, 2005).

64 There is also a section devoted to another prospective patron, Pope Julius III; see Rubin 1995, 410.

65 *Ibid.*, 407.

66 *Ibid.*, 407, 404.

67 Giorgio Vasari, *The Lives of the Artists*, trans. Julia Conaway Bondanella and Peter Bondanella (Oxford: Oxford University Press, 1991), 151.

68 Janson 1963 argues that it was not "compensatory distortion" but a lack of surface finish that caused the guild members to question the sculpture's quality (20).

69 See Rubin 1995, 336. For the original Italian text, see Vasari 1994, 3: 212. Rubin draws attention to the "Plinian echoes" of this narrative and emphasizes that Vasari's anecdote removes Donatello "from the normal commerce of craft."

70 Original text in Vasari 1994, 3: 215.

71 On the two Martelli figures, see Bormand 2007, 63–9, where it is presumed that the *St. John* was given to Roberto, along with a low relief in bronze of the *Crucifixion* widely accepted as a work by Donatello (now in the Museo Nazionale), and the marble *David* (now in Washington) to Roberto's older brother Ugolino.

72 Vasari 1991, 154. For Rubin's interpretation of Vasari's emphasis on the Martelli family, see Rubin 1995, 348.

73 The *Martelli Stemma*, which earlier authors had attributed to Donatello, was reintroduced into his oeuvre by Bennett and Wilkins 1984 and is now widely accepted. The *Martelli Sarcophagus* has been less fully accepted, but its unusual design and Vasari's reference support this attribution. Both attributions are rejected by Pope Hennessy 1993, 351 n. 4.

74 The original text is found in Rubin 1995, 353, n. 129, and Vasari 1994, 3: 211.

75 Vasari 1991, 159–60.

76 Vasari 1991, 160. Original text in Vasari 1994, 3: 222.

77 The Italian phrase, which is difficult to translate, is "Lui ha un cervello facto a questo modo che se non viene de lì non li bisogna sperare …" H381. Kent 2000, 344.

78 Vasari 1991, 153.

79 For this new, slightly later dating, see Wilkins 2007, 71–96.

80 For the purposes of this essay, the figure of *David* that is documented as having been reworked in 1416 for placement in the Palazzo della Signoria is identified as the figure now in the Museo Nazionale.

81 Although the statue is undocumented, it most likely was a civic commission; see Adrian Randolph, *Engaging Symbols: Gender, Politics, and Public Art in Fifteenth-Century Florence* (New Haven and London: Yale University Press, 2002), 35.

82 See n. 46 above.

83 The latest publication on the *Martelli Stemma* states that it "was probably designed and made under the direction of Donatello in about 1455–57 for Roberto's new Palazzo Martelli, though in the workshop of Geri and Desiderio" (Bormand 2007, 69).

84 The latest publication on the *Martelli Sarcophagus* states that it was made for Niccolò and Fioretta Martelli, paid for in 1463–64, and "Desiderio and his assistants must have worked on it, though to Donatello's design" (*ibid.*, 69).

85 Because it has been demonstrated that the bust was based on a mask taken while Uzzano was living, the sitter was most likely the patron, perhaps as a willing participant in this new technical experiment. Uzzano was one of the four executors named in the will of Baldassare Cossa (H57).

86 The recently discovered documents of 1432 for the garden at the Medici's *casa vecchia* mentions a gilded *spiritello*; see Doris Carl, "La Casa Vecchia dei Medici e il suo giardino," in *Il Palazzo Medici Riccardi di Firenze*, ed. Giovanni Cherubini and Giovanni Fanelli (Florence: Giunti, 1990), 41–2. While there is no later mention of such a figure in Medici inventories, it is not impossible that this might be a reference to the so-called "Atys-Amorino." The replacement of such a secular figure with Donatello's bronze *David* and *Judith and Holofernes*, figures of civic and religious heroism complete with pointed inscriptions, is consistent with the profile of Cosimo de' Medici drawn by Kent 2000.

87 H236 (April 6, 1439) states that the two altars were commissioned to Donatello but that he had not begun them. H237, dated two weeks later, transfers the commission to Luca della Robbia but states that he has to follow the wax model of the Altar of St. Paul found in the Opera.

88 For the purposes of this essay, the *David* commissioned in February 1408 is identified as the figure now in the Museo Nazionale. Recently, however, a figure now in the Museo dell'Opera del Duomo has been identified with the 1408 documentation, a suggestion accepted by Pope-Hennessy 1993, 17–19. For a discussion of this problematic attribution, see Paoletti and Radke 2005, 210–11.

89 The payments for the *Marzocco* were made through the Opera del Duomo. Dale Kent reports, however, that Donatello's lion was commissioned by the Comune (2000, 167).

90 H74.

91 Stephen J. Campbell, "'Our eagles always held fast to your lilies': The Este, the Medici, and the Negotiation of Cultural Identity," in *Artistic Exchange and Cultural Translation in the Italian Renaissance City*, ed. Stephen J. Campbell and Stephen J. Milner (New York: Cambridge University Press, 2004), 138–61, at 139–40.

92 Bormand 2007, 63.

93 *Ibid.*

94 *Ibid.*

Reversing the rules:
Michelangelo and the patronage of sculpture*

William E. Wallace

At the outset, I would like to emphasize the particular character and many constraints of Michelangelo's preferred medium: marble sculpture. Michelangelo's rival, Leonardo da Vinci, has left us some of the most vivid and derogatory remarks about the practice of carving sculpture:

The sculptor undertakes his work with greater bodily exertion than the painter, and the painter undertakes his work with greater mental exertion. The truth of this is evident in that the sculptor when making his work uses the strength of his arm in hammering, to remove the superfluous marble or other stone … This is an extremely mechanical operation, generally accompanied by great sweat which mingles with dust and becomes converted into mud. His face becomes plastered and powdered all over with marble dust, which makes him look like a baker, and he becomes covered in minute chips of marble, which makes him look as if he is covered in snow. His house is in a mess and covered in chips and dust from the stone.[1]

But for all his prejudice against sculpting, Leonardo scarcely begins to characterize the peculiarities of the profession. Sculpture—whether in bronze, marble, wood or stucco—is difficult and extremely messy. It is a blue-collar profession, not quite as unpleasant as leather tanning, but certainly not a refined activity. While painting also involves messy materials, including laborious preparation and clean up, Leonardo minimizes these aspects of the craft. He describes the painter as a gentleman who comfortably works in fine clothes, in a clean residence adorned with delightful pictures, and in the company of authors and musicians "without the crashing of hammers and other confused noises."[2] The sculptor rarely works before an audience. His sweaty manual labor is not a matter of controlled movement and is scarcely suited to polite company. Indeed, we have a remarkable eye-witness account by Blais de Vignère describing the speed and energy of Michelangelo's carving:

I have seen Michelangelo, although more than sixty years old and no longer among the most robust, knock off more chips of a very hard marble in a quarter of an hour

than three young stone carvers could have done in three or four, an almost incredible thing to one who has not seen it; and I thought the whole work would fall to pieces because he moved with such impetuosity and fury, knocking to the floor large chunks three and four fingers thick[3]

In one important respect, Leonardo and Michelangelo are similar. Leonardo managed to avoid the world of largely impecunious artists who entered into collaborative enterprises, and mostly lived hand to mouth competing for commissions.[4] Leonardo was successful in pursuing a highly independent career without establishing a *bottega* in a fixed location. He obtained few official commissions, neglected many contractual obligations, and completed little more than a dozen paintings—scarcely enough to pay the rent or put food on the table had he been running a more conventional workshop such as his contemporaries Lorenzo de' Credi and Sandro Botticelli. Leonardo succeeded because he identified and cultivated enlightened patronage. Rather than struggling in the competitive world of Florence, he offered his services, with varying degrees of success, to a succession of powerful patrons, including Lodovico Sforza, Isabella d'Este, Cesare Borgia, Pope Leo X, and King Francis I. Ultimately he managed to avoid a traditional artistic profession and instead successfully fashioned himself into a much sought after artist/courtier. Leonardo, therefore, offered an important precedent and role model for Michelangelo who, as a sculptor, necessarily faced even greater challenges in achieving his own artistic independence.

A sculptor required a greater array of tools and equipment than a painter, more assistance, and more space. These logistical factors imply considerable expense—in rent, wages, tools and materials—that implicitly involve patronage. A sculptor cannot afford to work except on commission; indeed, a working premise and the provision of materials were regular features of contractual arrangements. Patronal involvement was a necessary concomitant of sculpture. Given such logistical considerations, including the specifically physical requirements of carving marble, it is curious that we know so little about many of Michelangelo's so-called "commissions." For example, we have little idea where he actually carved his sculptures. Donatello, Desiderio da Settignano, Bernardo Rossellino, and the Pollaiuolo brothers all had well-established workshops in rented premises.[5] Where did Michelangelo carve the Pitti and Taddei *tondi*, *Bruges Madonna*, *David/Apollo* or two versions of the *Risen Christ*? Are we really certain that he carved the *Battle of the Centaurs* in the Medici garden? Although it appears of modest size in reproduction, the marble relief weighs in excess of 400 pounds. Sometime shortly before the Medici expulsion in 1494, Michelangelo must have arranged for a handcart to transport it ... but to where? Even more surprising, some years later Michelangelo requested that his father move the much larger *Bruges Madonna* "into the house."[6] We are uncertain whether Michelangelo carved the statue in the cathedral workshops, in the courtyard of the Buonarroti city dwelling, or outdoors in Settignano. If Ludovico acquiesced to his son's laconic request, one must ask how he moved a statue that weighs close to a ton.

The enormous feat of moving the *David*, first in the sixteenth century and again in the nineteenth century, reminds us of an obvious but rarely considered fact: one does not easily move a block of marble. It required three days to haul the *David* from the cathedral workshop to Piazza della Signoria, which does not include a week or more needed to construct the cart to transport it, and an additional apparatus to lift the monolith into position.[7] In the same amount of time, Leonardo could draw a full-size cartoon, roll it up, and take it to Milan to show a potential client.

We should also inquire where Michelangelo acquired his marble. Except for his earliest sculptures in Florence and Bologna, Michelangelo generally created life-size or larger figures. Unless it was purchased from the cathedral, the acquisition of good quality statuary marble required trips to distant quarries, time to locate and extract suitable blocks, and an expensive logistical organization to safely transport the material.[8] Michelangelo was provided marble for his two early reliefs and for the statuettes on the tomb of Saint Dominic, as well as for the *Bacchus* and *David*.[9] In every other instance, he had to obtain marble, arrange for its transport, locate a place to carve it, and secure the necessary tools, equipment, and assistance. The painter faced many fewer logistical problems. Leonardo, for example, could purchase his materials from middlemen, and he could work in the comfort of his or his patron's home. No one wanted a sculptor carving a block of marble in his private living quarters.

Because of the inherent value of statuary marble, one never abandons it, even if, as in the case of the *David*, it required some 40 years to find a practical use for the block. Likewise, the block from which Michelangelo eventually carved the Florentine *Pietà* was quarried many years earlier for the tomb of Julius II. Unused in constructing the final monument, the valuable block was "free" to be used for a different purpose. The Florentine *Pietà* is an example— the Louvre Slaves and *Victory* are others—of how marble quarried for one project was redirected to another (something that occurred with surprising frequency in Michelangelo's practice).[10] When Michelangelo abandoned the Florentine *Pietà*, it did not immediately leave his house. Because of problems moving such a massive block—the largest he ever carved after the *David*—it may have remained in his Roman house in Macel de' Corvi until as late as 1561.[11] Although Michelangelo gave up on the sculpture, he still lived with it, and one wonders if his late poetry, laden with notions of futility, is partly inflected by this insistent, physical reminder of failure. Similarly, throughout the many vicissitudes of the Julius tomb project, the figure of *Moses* sat on Michelangelo's workshop floor for approximately three decades before it was finally installed in San Pietro in Vincoli—a constant reminder of the incomplete tomb and his stunted ambitions.

The *Moses* raises another obvious but thorny question of where Michelangelo carved the sculptures for the tomb of Julius II. Much of the marble for the project remained at the riverside port where it first had been deposited, and from where it was gradually pilfered (again, marble never goes to waste).[12]

Michelangelo actually carved the tomb figures at a workshop in front of St. Peter's near the subsequently demolished church of Sta. Caterina.[13] When he was given use of the larger property at Macel de' Corvi in 1513, he moved much of the marble to this new location.[14] It must have been a sight to see the *Moses* in a cart crossing Ponte Sant'Angelo and slowly traversing much of inhabited Rome. Although the individual blocks were not as large as the *David*, the job of moving all the tomb marbles must have been considerable and costly.[15]

The physical facts of making and moving marble sculpture draws attention to little considered aspects of Michelangelo's unconventional practice. Given the constraints imposed by the material facts of marble sculpture, Michelangelo was excessively dependent on patronage. Aspects of nearly every project he undertook, from money and material to workspace and assistance, imply a heavily invested patron. However, when we look at a Michelangelo sculpture, we admire the artist's originality and give little consideration to the patron's contribution. How did Michelangelo achieve such apparent and real independence? By selectively surveying his career, we will better understand how Michelangelo first cultivated, then resisted, and finally manipulated the terms and expectations of patronage, thereby reversing the rules.

<p style="text-align:center">* * *</p>

Michelangelo never should have become an artist in the first place, much less a sculptor. His father had every reason to object to such a profession. Given that Ludovico's eldest son, Lionardo, had entered the Dominican order, Michelangelo was the *de facto* eldest son and breadwinner of the family. And, given the family's aristocratic pretensions, an artistic career was a dubitable means of re-establishing the family's fortunes.[16] So, why and how did Michelangelo become a sculptor?

Michelangelo grew up among the many artisan families of Fiesole and Settignano. In the midst of a Florentine building boom, there was a tremendous demand for door and window surrounds, lintels, moldings, and more ornamental stonework such as corbels, friezes, fireplaces, and coats of arms.[17] Michelangelo could have found work in one of the local stone quarries, or he could have apprenticed with one of the area's many stoneworking firms. However, we first learn of Michelangelo not in the stone trade, but as a member of the enormously prestigious city-based workshop of the painter Domenico Ghirlandaio. Michelangelo was 12 and already four to five years older than most beginning apprentices. Apprenticeships were contractual arrangements lasting six, seven, or more years. These agreements were not undertaken lightly, as they importantly served both parties. A successful artist such as Ghirlandaio required many assistants who, in turn, learned skills that would permit them to join the guild and help launch an independent career. Apprenticeships were legally binding: boys were expected to live with and

obey their masters, while the masters were expected to provide lodging and sometimes clothes, as well as instruction for the stipulated period.

Contrary to common assumption, we do *not* have the contract of Michelangelo's apprenticeship with Ghirlandaio, merely Vasari's claim to have seen such an agreement.[18] However, we do have a document that unequivocally places Michelangelo in Ghirlandaio's entourage in June 1487, nearly a year prior to the date reported by Vasari.[19] This document does not describe Michelangelo as an apprentice—for example, an "alunno" or "garzone di Ghirlandaio"—rather, it suggests his social status by identifying him by his family name, as the son of Ludovico Buonarroti: "Michelangelo figlio di Ludovico Buonarroti." Moreover, the document records that Michelangelo collected a large sum of money on behalf of Ghirlandaio, which is not an errand that the older master would likely have entrusted to a beginning apprentice.

Everything about Michelangelo's abbreviated time with Ghirlandaio suggests that the association was not a traditional apprenticeship, but a special arrangement extended to a youth with comparatively elevated family connections. If we entertain this possibility, then it becomes less difficult to explain, for example, why Michelangelo was given access to the master's drawings and to his copy of Martin Schongauer's print, *The Temptation of St. Anthony*. Drawings and prints were among the most precious objects of an artist's studio and access normally would have been granted only to the most advanced apprentices. There is, moreover, no evidence that Michelangelo was involved in the laborious day-to-day tasks of grinding and mixing pigments, slaking plaster, pricking and transferring cartoons, fetching water and supplies, and cleaning up at the end of an eight to ten-hour day. Rather, Michelangelo was granted time to learn from the "old masters," Giotto and Masaccio, as well as to copy Ghirlandaio's own drawings. He even had time "to draw the scaffolding and trestles and various implements and materials, as well as some of the young men who were busy there" when, if a beginning apprentice, he should have been helping in the routine tasks of a busy workshop.[20] But most importantly, Michelangelo remained with Ghirlandaio scarcely two years, less than one third of the time of a regular apprenticeship. Their special arrangement is further revealed by the fact that there were neither complaints nor legal action when Michelangelo left Ghirlandaio to join the Medici household.

We are succumbing to fiction and hagiography if we uncritically accept that Michelangelo entered the Medici household thanks to the casual notice of Lorenzo de' Medici.[21] Little considered in the usual recounting of Michelangelo's life is the central role played by his father. Ludovico was determined to see his (now) eldest son well placed. Ludovico could claim a distant relationship to the Medici and legitimately could have referred to his near contemporary, Lorenzo de' Medici, as "famiglia" and more intimately as "cugino."[22] They were distant cousins, related via Michelangelo's grandmother Bonda Rucellai. Such a distant relationship was more important to the Buonarroti than the

Medici, yet it afforded Ludovico entrée to the powerful family and a means of securing a position for his son. It was precisely by doing such favors that the Medici built and maintained their political support in Florence.

Michelangelo's life in the Medici household was just as unconventional as his time with Ghirlandaio. But it is "unconventional" only if we persist in seeing Michelangelo as an artist in training. Rather, he was a member of the Medici "famiglia," with access to the family's resident artists and humanist scholars. He was exposed to philosophy, literature, and poetry, and to the Medici art collections. As a young adult—and it is important to insist on his age, that is, approximately 15 to 17 years—Michelangelo was in the company of the greatest minds of his time. No artist in Renaissance Florence was given such an opportunity. This is patronage of a different sort, with long-term implications rather than immediate results, more social and cultural than artistic or specifically practical.

Michelangelo received the beginnings of a humanist education, which was more important than the one or two sculptures he may have carved while a member of the Medici household. In fact, the experience did little to further an artistic apprenticeship. If anything, the time spent in the Medici entourage encouraged Michelangelo to avoid a conventional artistic career. None of Michelangelo's earliest works was made on commission, and none left his personal possession. By the time the Medici were expelled from Florence in 1494, Michelangelo was 19 and he still had not created a single work of art for any purpose other than his own self-serving education. Not until he carved the figures for the tomb of San Domenico in Bologna did Michelangelo make something for somebody else. Yet, this latter task cannot be considered a traditional commission since Giovan Francesco Aldovrandi, a member of the Bolognese ruling elite, made all the arrangements. Naturally, the Bolognese artists were envious.[23] They had to run workshops, pay rent, and compete for commissions. Michelangelo was given the opportunity to carve figures for Bologna's most prestigious monument; he was provided with the marble, a place to work, and all the time lived with one of Bologna's leading citizens.

Michelangelo returned to Florence in 1495, but he still did not pursue a profession in a traditional manner by joining or opening a *bottega*. Rather, he depended on the largesse of Lorenzo di Pierfrancesco de' Medici for whom Michelangelo supposedly carved a young St. John. We can call this work "on request"—a category familiar in modern times but not common in Renaissance Florence.[24] Such activity permitted Michelangelo to curry favor but not to earn a steady living. Without the ties and obligations of regular employment, Michelangelo was free to visit Rome in June 1496. He was 21 years old and still without a proper profession or a single contracted commission.

Michelangelo arrived in Rome armed with letters of introduction from his Medici patron, which gained him access to Raffaele Riario, one of the most powerful men in the Roman curia. As in Bologna, Michelangelo was given marble and the opportunity to carve a sculpture, to "see what I could do," all the while enjoying the Cardinal's hospitality.[25] In these ideal circumstances,

Michelangelo carved the *Bacchus*. Although clearly intended to impress the patron and to elicit further employment, the *Bacchus* failed, at least with the Cardinal. Michelangelo could have remained gainfully employed carving window surrounds, cornice moldings, or coats of arms for the giant new palace Riario was then constructing.[26] (It is intriguing to imagine Michelangelo, even temporarily, working as a journeyman carver.) Or, he could have found work in one of many sculptors' shops in Rome, such as that operated by Andrea Bregno. Instead, he acquired marble, the first he ever purchased, and claimed to be "working for my own pleasure"—something one might expect of a highly successful rather than an unemployed sculptor.[27] Moreover, the block proved bad, which indicates a lack of experience in judging stone, an area critical to the sculptor's livelihood. Without prospects, Michelangelo bided his time and for a period found himself living in straitened circumstances, to the extreme consternation of his father.[28]

Michelangelo's first contract was for the *Pietà*, when he was 23. And even this first commission was achieved by unusual means. The owner of the rejected *Bacchus*, Jacopo Galli, recommended Michelangelo to the powerful French Cardinal, Jean de Bilhères. In a surprising demonstration of confidence, Galli guaranteed the contract and promised that Michelangelo would carve the "most beautiful work of marble in Rome."[29] Despite the seemingly traditional aspect of the transaction—a commission with a written guarantee (signed only by Galli and the Cardinal)—the unusual factors outweigh the traditional ones. Galli's guarantee, in a sense, freed the artist to fulfill the commission in a novel way. Rather than carving a piece of extant marble, the artist spent months in the distant marble quarries obtaining a block of exceptional quality.[30] And, unlike most artists, he did not accept any other work during the time, devoting himself entirely to creating a single work of art. Again, one should ask where he carved it: at St. Peter's or possibly on Jacopo Galli's property? The uncertainty reminds us that Michelangelo still did not have a workshop premise, assistants, or a regular artistic practice.

To this point in his life Michelangelo, now 25 years old, had lived entirely by the favors and fruits of patronage. His relations with patrons were not those commonly extended to artists (*mecenatismo*), but a version of the relations that more commonly characterize political patronage (*clientelismo*), where friends, family, and neighborhood are critical mechanisms. Repeatedly, Michelangelo received opportunities via friends, family connections, and special arrangements. He was already making choices that indicate his intention to forge an unconventional path. But, such unfamiliar and un-business-like behavior naturally distressed his father, who was deeply concerned for the welfare of his son and urged him to secure gainful employment in Florence.

Michelangelo finally left Rome in 1501 with an unfulfilled contract to furnish a painting for the church of Sant'Agostino and a new contract to carve some figures for the Piccolomini altar in Siena.[31] Both of these commissions might suggest that Michelangelo was now proceeding in a more conventional manner, that is, by signing contracts and accepting available work. Neither

commission, however, was ever completed. Thus, instead of marking the beginning of a traditional artistic career, these two commissions are salient examples of how Michelangelo repeatedly abandoned obligations when a better opportunity presented itself. In this case, the *David*.

With the *David*, Michelangelo became a creator of marvels, thereby establishing himself as Florence's premier and most coveted sculptor. He would never again be unemployed.[32] With numerous opportunities, he was freer to accept and carry out work on his own terms. Thus, from this point forward, Michelangelo often managed without contracts, and increasingly pushed the boundaries of taste and expectation. Every work was an *unicum*. By never repeating himself, his creations would never be mistaken for conventional workshop production.[33] The Pitti and Taddei *tondi* are as close as Michelangelo ever came to producing look-alike objects of the same genre. But, in fact, they are different and both unusual. Most obviously, they were made from marble when most Florentine *tondi* were painted.[34] Such extremely heavy objects could not be easily moved or displayed, and they certainly did not function like traditional *tondi*. And neither one was completed to a degree of finish commensurate with prevailing taste and expectation, as may be gleaned from the many painted examples. The material, scale, and differing degrees of finish all place an onus on the object's recipient. They do not fully "explain" themselves; rather they shift this burden to owner and spectator. Although ostensibly belonging to a conventional type, they push the boundaries of the genre and patronal expectation.

Traditionally, a work's destination and context dictated its form, size, and subject matter, but Michelangelo resisted and loosened such parameters—as in the case of all three *tondi* he made for Florentine patricians (Pitti, Taddei, Doni). Throughout his career, Michelangelo made works that did not fit comfortably within familiar contexts and genres. Even works that began with a fixed purpose sometimes escaped their motivating *raison d'être* to become independent works of art. For example, the two Louvre Slaves, originally carved for the tomb of Julius, never joined the final ensemble. Freed from their original context, they served an altogether different function, for a different patron. The same is true of the Accademia Slaves, the *Victory*, and the *David/ Apollo*. All began life ostensibly associated with a commission yet eventually found themselves entirely removed from their originating purpose. In each of these instances, Michelangelo never finished or delivered the sculptures. The ultimate recipients of these orphaned sculptures were not the original patrons, but they willingly accepted the works on new terms: unfinished, without context, as examples of Michelangelo's art.[35]

Jürgen Schulz has estimated that nearly three-fifths of Michelangelo's sculptures remain unfinished in some fashion. It is even more important to realize that, aside from being unfinished, more than a third of Michelangelo's sculptures were abandoned. Of 37 still extant marbles, Michelangelo abandoned 13—not just left them unfinished, but also never delivered the sculptures to the projects or patrons for which they were intended.[36]

Schulz argued that many of the unfinished sculptures could be explained by practical exigencies of time and multiple demands. I would suggest that, in some cases, Michelangelo might have used such exigencies as ready excuses not to finish or deliver expected work. The numerous examples suggest that patronage, traditionally a contractual arrangement between artist and commissioner, was for Michelangelo a slippery notion.

On the other hand, there is nothing slippery about Michelangelo's commission to carve 12 Apostles for the Florentine Cathedral.[37] The artist's behavior in accepting and then failing to complete the project is not readily explained unless we recognize it as yet another episode in Michelangelo's bid for artistic autonomy. The commission was a golden opportunity to shape the future direction of Florentine sculpture. It guaranteed steady employment, a house, and a workspace for 12 years—a luxuriously long time in the generally hand-to-mouth existence of most Renaissance artists. What, at first, may have been the ideal commission for a marble sculptor quickly proved a burdensome obligation since Michelangelo found himself beholden to a contract supervised by a changing group of insistent, self-important officers of the Arte della Lana. While he could earn 24 florins per year carving apostles, Michelangelo could earn more money and prestige by working for private patrons who, thanks to their influence and social connections, were also more likely to further his career. Thus, shortly after signing the Apostles contract, Michelangelo instead carved two marble *tondi*, the Bruges Madonna, and painted the Doni *tondo*. For the Bruges Madonna alone, he earned 100 florins (a sum equivalent to carving four Apostles), and possibly even more for the Doni *tondo*. Even if Vasari greatly exaggerated the sum Michelangelo demanded for the latter work, the dispute reveals the artist asking for payment in accordance with an abstract scale of worth set by the artist rather than by the patron or by contract.[38] The wrangling over the *tondo*'s price is the opening salvo in a battle not fully won until the nineteenth century when, for example, James McNeil Whistler demanded a price, not according to a picture's size, materials, or length of manufacture, but "for the knowledge gained through a lifetime."[39] In many respects, Michelangelo was already battling for such autonomy 350 years earlier.

Michelangelo began but never finished just one sculpture for the Cathedral, the *St. Matthew*. When presented with a better opportunity, Michelangelo did not hesitate to abandon the commission, as he had with the Sant'Agostino and Piccolomini projects. How much easier it would have been for Michelangelo to remain in Florence, to be gainfully employed, and to gain "honor at home," as his father recommended.[40] Yet, Michelangelo gave up this and other standing obligations (such as the *Battle of Cascina*) for an uncertain prospect in distant Rome. Clearly, Michelangelo was pursuing his best options rather than a steady and lucrative profession. Most importantly, like Leonardo before him, he sought an enlightened patron who would extend a measure of freedom and independence.

As was often the case in his career, Michelangelo had an introduction to his new patron, Pope Julius II, probably from the papal architect, Giuliano da

Sangallo. No part of Michelangelo's biography is more fraught with fiction than the artist's relationship with Julius. In whatever manner we envisage this near mythic encounter, however, we should acknowledge that the two men fundamentally altered the traditional relationship between artist and patron. They talked and understood one another. Together, Michelangelo and Pope Julius imagined not merely an imposing work of art, but the eighth wonder of the world. Surprisingly, not a single drawing survives from this first project.[41] And there was no contract. Money was a matter of trust, not terms. No contract, no firm deadline, no clear monetary limit, no presentation drawing to which the artist would be contractually beholden. The absence of constraints is remarkable and unprecedented.

Rather than rehearse the entire tomb history, I would emphasize the critical early stages when Julius conferred incredible stature on Michelangelo by extending, if not free reign, at least an extremely loose bridle and an open pocketbook. From this point forward, Michelangelo sought patrons who accorded him similar freedom, and, conversely, he bristled at efforts to curb his independence.[42] Indeed, the remaining history of the Julius tomb can be stated as an axiom: the frequency of contracts is in inverse relation to work actually accomplished. The more the heirs tried to exercise control, the less Michelangelo obliged them. We should pay particular attention, therefore, to the moment when the project was actually completed. After more than four decades, multiple contracts, and innumerable delays, the tomb was finished in 1545, under the aegis of Guidobaldo II della Rovere. More than previous executors, Guidobaldo treated Michelangelo with tact, patience, and generosity. Michelangelo was no less busy and he had an arsenal of ready excuses, especially since he was in the full-time employ of Pope Paul III. By this time in his career, Michelangelo could afford to work only for persons he esteemed. Everyone else was either refused—usually with claims of old age and prior obligation—or had to be satisfied with vague promises. Guidobaldo, therefore, deserves some credit for the tomb's completion, just as his predecessors must be partly culpable for its delay. In the comparatively short span of two years, Michelangelo not only assembled the tomb but carved two wholly new figures, *Rachel* and *Leah*, which is especially impressive given that he was approaching 70 years of age, was desperately ill in mid 1544, and was still working on the Pauline Chapel. Thus, the long, drawn-out history of the Julius tomb can be explained partly by a failure of a succession of patrons to adjust to new terms—personal rather than contractual—demanded if not always explicitly articulated by the artist.

For the *Risen Christ*, Michelangelo did sign a contract in 1514. However, in contrast to the standard legal document in which an artist was narrowly circumscribed by stipulations, the Roman patrons merely asked for a life-size, nude figure "in quell'attitudine che parrà al detto Michelagniolo."[43] The invention of the figure was left entirely to the artist. Despite numerous delays and a flawed first sculpture, the patrons never lost patience and continued to treat Michelangelo with extreme courtesy. Michelangelo was so grateful

that when the finished second statue was supposedly damaged, he offered to carve the entire figure yet again—a third time![44] For his considerate Roman clients, Michelangelo carved two larger-than-life marble statues; in contrast, the imperious Pietro Aretino was unsuccessful in extracting, either by cajoling or extortion, a single drawing from the artist.

Both the *Risen Christ* commission and Michelangelo's handling of Aretino belies the normally obsequious behavior exhibited by many artists toward their patrons. An additional axiom pertains: deference and respect were the preconditions for extracting work from the famously recalcitrant artist. Piero Soderini was perhaps the first of Michelangelo's many patrons to realize this important point. Although oftentimes treated as a buffoon who lacked critical judgment, Soderini, in fact, was a longtime admirer and astute handler of the artist.[45] When Michelangelo set off to Bologna to be reconciled with Pope Julius II in 1506, Soderini wrote a remarkable and prescient letter to his brother who was traveling with the pope:

> The bearer will be Michelangelo the sculptor, whom we send to please and satisfy His Holiness. We certify that he is an excellent young man, and in his own art without peer in Italy, perhaps even in the universe. It would be impossible to recommend him more highly. His nature is such that he requires to be drawn out by kindness and encouragement; but if love is shown him and he is well treated, he will accomplish things that will make the whole world wonder.[46]

Soderini continued to act as Michelangelo's friend, patron, and protector for more than 20 years. Even when he was in exile from Florence, Soderini was successful in eliciting work from the extremely busy artist, largely because of their longstanding relationship of mutual respect.[47] Michelangelo agreed because Soderini, a fellow Florentine, was less a traditional patron insisting on a contract and a deadline than the artist's steadfast supporter.

Thanks to an equally special relationship between Pope Clement VII and Michelangelo, the only contracts for the chapel and library at San Lorenzo originated with the artist who signed the agreements with the quarrymen, craftsmen, and artists who worked for him. Rather than attempting to control his artist, Clement acted as Michelangelo's collaborator, repeatedly assuring him that everything should be done the artist's own way ("a vostro modo"). The phrase "a vostro modo" recurs frequently in the correspondence and neatly summarizes the mutually respectful relations between two persons close in age who had known one another for more than 30 years.[48] Given such consideration, which he also enjoyed with popes Paul III and Julius III, Michelangelo proved willing and indefatigable. With these "patrons," the rules of patronage were not so much reversed as relaxed, to accommodate a gifted and temperamental artist who helped to re-define patronage as a relationship built upon trust, friendship, and mutual respect. While these cases are individually familiar to us, their cumulative impact on Michelangelo's attitude and artistic practice was far-reaching.

* * *

Patronage studies have shifted the emphasis from the creator to the agent, and from the specific products of patronage to the personal dynamics between individuals. In this essay, I have explored those dynamics with the aim of better understanding the dialectic between opportunities afforded Michelangelo and those created by him. Birth and upbringing endowed Michelangelo with some rare advantages; it was his personal and professional acumen that permitted him to cultivate and ultimately manipulate the patronage system.[49]

Michelangelo's early career followed a desultory course largely independent of the fiercely competitive world of artisan Florence. Artists typically spent a half dozen or more years in a rigorous apprenticeship before entering into short and long-term collaborations to ensure financial security and as a means of winning commissions. Michelangelo never maintained a conventional workshop, and he avoided the type of professional cooperation that was a fact of life for most Renaissance artists. He never matriculated into a professional guild, and he never established a "typical" business practice in a fixed location. Rather, he lived on the basis of comparatively few commissions, obtained by skillfully navigating a dense web of personal relations. Having resisted becoming an artisan, he was particularly sensitive about being treated as one and he adamantly denied ever running a *bottega*: "I was never a painter or sculptor like those who run workshops."[50]

After 1526, Michelangelo stopped signing himself "Michelangelo sculptore" and instead insisted on using his full family name. In the last 30 years of his life, he completed just three sculptures: the *Rachel* and *Leah*, and the *Bust of Brutus*. The artist's biographer, Giorgio Vasari, was well aware of this paucity when he wrote, "there are few finished statues ... and those he did finish completely were executed when he was young."[51] In the final three decades of his life, Michelangelo largely gave up the practice of marble sculpture, except to satisfy his own needs, as with the Florentine and Rondanini *Pietàs*.

Michelangelo never produced the objects common to a Renaissance *bottega* since almost every commission presented him with a different opportunity. His career is marked by a series of *unica*—unique objects that are never repeated and scarcely inimitable: *Bacchus*, *Pietà*, *David*, the bronze statue of Pope Julius II, the Sistine Chapel ceiling.[52] More than any previous artist (although Donatello and Leonardo set important precedents), Michelangelo, by creating unique objects, flaunted both authorship and genius, thereby fostering further demand in a world that prized originality. Once demand increased, Michelangelo could begin dictating the rules and expectations— thereby reversing the rules of patronage. Such behavior was both a career strategy and an implicit claim of intellectual property.[53] With demand far outweighing supply, Michelangelo could be more selective of his patrons, and he became gradually less beholden to their demands. Thus, rather than the patron dictating the terms, subject matter, medium, and price to the artist, Michelangelo exercised increasing control over all aspects of artistic

production. Michelangelo largely operated outside the strictures of the well-regulated artisan world while successfully maneuvering within an aristocratic world of patronage and favor. For him, art making was more about *clientelismo* than *committenza*.

Many aspiring patrons, realizing they could not dictate terms, requested work from Michelangelo regardless of subject or medium—as, for example, Alfonso d'Este, King Francis I, and Cardinal Domenico Grimani. Alfonso and Francis kept up their hope of obtaining a Michelangelo for 20 and 25 years respectively. Grimani deposited 50 ducats in advance and left everything to the artist: subject, invention, and medium, whether painting, bronze, or marble.[54] When Grimani began to pester the artist with reminders, the artist expressed surprise at the Cardinal's insistence and gave him, via a middleman, less than he desired and less than a promise: "I will do my best when I can."[55]

Ultimately it became imperative to obtain a Michelangelo, of whatever sort and by whatever means. As the likelihood of obtaining a work "di sua mano" grew increasingly unlikely, patrons became beggars and little more than collectors of any vestige of his genius. Condivi noted that "when he was asked by growing numbers of lords and rich people for something from his own hand, and they gave lavish promises, he rarely did it, and when he did it was rather from friendship and benevolence than from hope for reward."[56] Condivi may have been exaggerating, but not much. Michelangelo's relations with his patrons were extensions of social bonds founded on favor, friendship, and family ties. Michelangelo was an artist, but also a patrician, and he insisted on being treated in a manner consistent with his social station and self-perception.

Like Leonardo da Vinci before him, Michelangelo attempted to live as a sort of artist/courtier blurring the distinctions between artist and patron, between professional and personal obligations. By the time he moved to Rome in 1534, Michelangelo operated less according to a traditional pattern of patron–client relationships and more within an aristocratic culture of gift exchange. It is stunning how many persons, unwilling to accommodate to this fundamental shift in the relationship between artist and patron, failed to receive works they expected from Michelangelo: when Piero de' Medici acted in bad faith, Michelangelo reneged on a promised work; when Piero Aldobrandini complained, Michelangelo gave the bronze dagger he had designed to a more appreciative client; when Agnolo Doni quibbled, Michelangelo demanded double the price for the Doni *tondo*; when Alfonso d'Este acted duplicitously, Michelangelo refused to deliver the *Leda*; when Baccio Valori proved to be a Medici toady, he was denied the *David/Apollo*; when the Piccolomini continued to hound Michelangelo for their 15 statues, they got just four, two of which were carved by a lesser artist; when Pietro Aretino and Domenico Grimani failed to treat the artist with proper respect, their requests were ignored; when Cardinal Riario failed to recognize Michelangelo's true worth, he was ridiculed by the artist's biographers; and when the Medici proved petty tyrants, Michelangelo lived the remainder of his life in Rome.[57] Any one of these instances might

be interpreted as rebelliousness on the part of a willful artist, however, their frequency suggests something much more important and calculated. Different from the seemingly irrational and headstrong behavior of a Caravaggio or Rembrandt, Michelangelo's actions were a demand for respect born of lifelong privilege. Michelangelo was an artist, but first a patrician, and he demanded to be treated as such. More than any of his contemporaries, he significantly raised the stature of his profession and helped substantially to alter the relationship between patron and artist. In their own way, Caravaggio, Rembrandt, Rubens, and Velazquez, as well as many subsequent artists, all benefited from Michelangelo's redrafting of the rules of patronage.

Notes

* This essay pays tribute to two scholars I have long admired, who have done much to amplify our knowledge of patronage, sculpture, and Michelangelo. John Paoletti, who is esteemed for substantial contributions to our study of Renaissance sculpture and issues of patronage, even as he pursued a varied scholarly career, received early nourishment from his highly esteemed mentor, Charles Seymour. In comparison to John's enviably catholic tastes, I have more narrowly focused on Michelangelo.

 I would also like to thank Katherine M. Wallace for reading drafts of this essay and offering many valuable comments.

1 Leonardo's *Trattato* quoted from *Leonardo on Painting*, ed. Martin Kemp (New Haven and London: Yale University Press, 1989), 38–9.

2 *Ibid.*, 39.

3 Quoted from Irving Lavin, "David's Sling and Michelangelo's Bow: A Sign of Freedom," in *Past-Present: Essays on Historicism in Art from Donatello to Picasso* (Berkeley: University of California Press, 1993), 43.

4 Of course, John Paoletti has been instrumental in studying the collaborative nature of Renaissance patronage and art making, beginning with *Collaboration in Italian Renaissance Art*, ed. Wendy S. Sheard and John T. Paoletti (New Haven and London: Yale University Press, 1978), and including such essays as John T. Paoletti, "Fraternal Piety and Family Power: The Artistic Patronage of Cosimo and Lorenzo de' Medici," in *Cosimo "il Vecchio" de' Medici, 1389–1464*, ed. Francis Ames-Lewis (Oxford: Clarendon Press, 1992), 195–219, and "… ha fatto Piero con voluntà del Padre … Piero de' Medici and Corporate Commissions of Art," in *Piero de' Medici "il Gottoso" (1416–1469): Kunst im Dienste der Mediceer*, ed. Andreas Beyer and Bruce Boucher (Berlin: Akademie Verlag, 1993), 221–50. See also Harriet Caplow, "Sculptors' Partnerships in Michelozzo's Florence," *Studies in the Renaissance* 21 (1974): 145–75; Yael Even, "Artistic Dependence and Independence in Mid-Quattrocento Florence," *Fifteenth Century Studies* 14 (1988): 65–71; Anabel Thomas, *The Painter's Practice in Renaissance Tuscany* (Cambridge: Cambridge University Press, 1995); Linda Wolk-Simon, "Competition, Collaboration, and Specialization in the Roman Art World, 1520–27," in *The Pontificate of Clement VII: History, Politics, Culture*, ed. Ken Gouwens and Sheryl E. Reiss (Aldershot and Brookfield: Ashgate, 2005): 253–76, and Michelle O'Malley, *The Business of Art: Contracts and the Commissioning Process in Renaissance Italy* (New Haven and London: Yale University Press, 2005).

5 Anabel Thomas, for example, emphasizes the critical importance for business of the physical space of the workshop, "established on a defined site, within a particular part of the urban fabric;" see Anabel Thomas, "The Workshop as the Space of Collaborative Artistic Production," in *Renaissance Florence: A Social History*, ed. Roger J. Crum and John T. Paoletti (New York: Cambridge University Press, 2006), 416.

6 *Il carteggio di Michelangelo*, ed. Paola Barocchi and Renzo Ristori, 5 vols (Florence: S.P.E.S. Editore, 1965–83), 1: 12.

7 An estimate based on the cart/cradle built to move the *David*, as reconstructed in the BBC film special "The Divine Michelangelo" (2004), for which I was a consultant. See also Franca Falletti, ed., *The Accademia, Michelangelo, the Nineteenth Century* (Livorno: Sillabe, 1997).

8 See Christiane Klapisch-Zuber, *Les maîtres du marbre: Carrare 1300–1600* (Paris: Ecole Pratique des Hautes Études, 1969), and William E. Wallace, *Michelangelo at San Lorenzo: The Genius as Entrepreneur* (Cambridge and New York: Cambridge University Press, 1994), esp. ch. 1.

9 Vasari specifically notes that Poliziano and Aldovrandi gave Michelangelo the marble ("datogli da quell signore" and "fattogli dare il marmo") from which he carved, respectively, the *Battle of the Centaurs* and the figures for the tomb of St. Dominic (Giorgio Vasari, *Le vite de' più eccellenti pittori, scultori e architettori nelle redazioni del 1550 e 1568*, ed. Rosanna Bettarini, 6 vols (Florence: Sansoni Editore, 1966–87), 6: 11, and 6: 14). It seems that Michelangelo acquired (by purchase?) an imperfect piece of marble from which he carved the Taddei *tondo*; see John Larson, "The Cleaning of Michelangelo's Taddei Tondo," *Burlington Magazine* 133 (1991): 844–6, and Michael Hirst, "The Marble for Michelangelo's Taddei Tondo," *Burlington Magazine* 147 (2005): 548–9.

10 Such shuffling of blocks happened especially during his simultaneous work on the Julius Tomb, the façade of San Lorenzo, and the Medici Chapel, for which see Wallace 1994, 70–73.

11 Jack Wasserman, *Michelangelo's Florence Pietà* (Princeton and Oxford: Princeton University Press, 2003), 75–6.

12 Barocchi and Ristori 1965–83, 3: 8. See Alessandro Parronchi, "I due doppi sepolcri del Cardinale Armellini," *Opere giovanili di Michelangelo II: Il paragone con l'antico* (Florence: Olschki, 1975), 235–80.

13 Described by Michelangelo as "in sulla piazza di Santo Pietro, dove havevo le stanze dreto a Santa Catherina" (Barocchi and Ristori 1965–83, 4: 152). All the marble could not be safely stored inside, and hence some was "sacked:" "et quasi tutti e' marmi che io havevo in sulla piazza di Santo Pietro mi furno sacheggiati, et massimo i pezzi piccoli" (Barocchi and Ristori 1965–83, 4: 155). Sta. Caterina was demolished to make way for Bernini's exedra, see Christian Hülsen, *Le chiese di Roma nel medio evo* (Rome: Edizioni Quasar, 2000), 236. See also Michael Hirst, "Michelangelo in 1505," *Burlington Magazine* 133 (1991): 766 (Appendix B).

14 As Michelangelo states in reviewing the tomb history: "… io condussi e' marmi al Maciello de' Corvi, et feci lavorare quella parte che è murata a Santo Pietro in Vincola et feci le fighure che ò in casa" (Barocchi and Ristori 1965–83, 4: 152). The marbles at Macel de' Corvi were inventoried in 1517 (Rab Hatfield, *The Wealth of Michelangelo* (Rome: Edizioni di Storia e Letteratura, 2002), 98–9).

15 Transport rates for marble depended on the size and weight of the blocks, irrespective of distance and time required for moving them; see Wallace 1994, 59. On the many difficulties attendant to lifting and moving marble, see *ibid.*, 54–60.

16 On Michelangelo's aristocratic pretensions, see William E. Wallace, "Michel Angelus Bonarotus Patritius Florentinus," in *Innovation and Tradition: Essays on Renaissance Art and Culture*, ed. Dag T. Andersson and Roy Eriksen (Rome: Edizioni Kappa, 2000), 60–74, and "How did Michelangelo Become a Sculptor?" in *The Genius of the Sculptor in Michelangelo's Work* (Montreal: The Montreal Museum of Fine Arts, 1992), 151–67.

17 Richard Goldthwaite, *The Building of Renaissance Florence: An Economic and Social History* (Baltimore and London: Johns Hopkins University Press, 1980).

18 Vasari 1966–87, 6: 6. The putative document was only cited in the second edition once Vasari's initial account had been called into question by Condivi's rival life. Vasari's "quotation" of the document is a truth claim, occurring early in the life and hence promising the veracity of the remainder of his account. Vasari's purpose is clearly stated: "… in order to show that everything I wrote earlier and am writing now is the truth." There are many suspect aspects to Vasari's "document" including the unusually brief three-year term, the fact that Michelangelo was to be paid, and the supposed date of April 1, 1488, which is not easily reconciled with the document located by Jean Cadogan that explicitly places Michelangelo in the Ghirlandaio entourage nearly a year earlier, in June 1487 (see following note).
 Vasari's life is a great work of literature that belongs to a long tradition of imaginative and epideictic biography, in which narrative fictions and fictionalized history are common tools of the writer's craft. Beginning with Herodotus and Thucydides, claims to "historical truth" were buttressed by fictional eyewitness accounts, cited authorities, or composed speeches. In general, see Glen W. Bowersock, *Fiction as History: Nero to Julian* (Berkeley: University of California Press, 1994); Hayden White, *Metahistory: The Historical Imagination in Nineteenth-Century Europe* (Baltimore and London: Johns Hopkins University Press, 1973); and *The Content of the Form* (Baltimore and London: Johns Hopkins University Press, 1987). Examples of this practice are legion, but one I particularly like is Stendhal's *Roman Journal*. The "journal" purports to be a day-to-day record of places visited and persons Stendhal encountered in Rome—but was written largely from other persons' notes and guidebooks in a Parisian Hotel years after the one visit the author made to Rome. The opening line of the *Journal* has the air of documentary truth: "The author entered Rome for the first time in 1802 …," which is pure fiction since he first visited the city in 1811.

19 Jean K. Cadogan, "Michelangelo in the Workshop of Domenico Ghirlandaio," *Burlington Magazine* 135 (1993): 30–31.

20 Vasari 1966–1987, 6: 7–8; Vasari, *Lives of the Artists*, trans. George Bull (1965; reprint, London: Penguin, 1987), 329. Cristina Acidini Luchinat further suggests that Michelangelo might have had access to the extremely precious Codex Escurialensis (Cristina Acidini Luchinat, *Michelangelo pittore* (Milan: Federico Motta Editore, 2007), 19).

21 As recounted in Vasari's tale of the marble faun, for which see Paul Barolsky, *Michelangelo's Nose: A Myth and its Maker* (University Park and London: Pennsylvania State University Press, 1990), *The Faun in the Garden: Michelangelo and the Poetic Origins of Italian Renaissance Art* (University Park and London: Pennsylvania State University Press, 1994), and "Michelangelo's Marble Faun

Revisited," *Artibus et historiae* 40 (1999): 113–16; Paul Barolsky and William E. Wallace, "The Myth of Michelangelo and Il Magnifico," *Source: Notes in the History of Art* 12 (1993): 16–21.

22 See Wallace 2000, 60. Thus, for example, the Buonarroti referred to Lorenzo's granddaughter, Clarice de' Medici, as "di casa" because they belonged to the same extended family (*Il carteggio indiretto di Michelangelo*, ed. Paola Barocchi, Kathleen L. Bramanti, and Renzo Ristori, 2 vols (Florence: S.P.E.S. Editore, 1988 and 1995), 1: 126).

23 As related by Condivi; see *Michelangelo: Life, Letters, and Poetry*, trans. George Bull (Oxford and New York: Penguin, 1987), 19.

24 Sheryl Reiss suggests that Raphael, for example, may have made a few paintings early in his career "on spec;" see Sheryl E. Reiss, "Raphael and his Patrons: From the Court of Urbino to the Curia and Rome," in *The Cambridge Companion to Raphael*, ed. Marcia B. Hall (Cambridge and New York: Cambridge University Press, 2005), 47.

25 Barocchi and Ristori 1965–83, 1: 1.

26 Subsequently known as the "Cancelleria," as it became the Vatican Chancellery. See Christoph L. Frommel, "Raffaele Riario, la Cancelleria, il teatro e il *Bacco* di Michelangelo," in *Giovinezza di Michelangelo*, ed. Kathleen Weil-Garris Brandt, *et al.* (Florence and Milan: Artificio Skira, 1999), 143–8.

27 Barocchi and Ristori 1965–83, 1: 4.

28 Barocchi and Ristori 1965–83, 1: 7–8 and 9–10. A visit from his brother indicates that Michelangelo was living in reduced circumstances and was probably unemployed.

29 "… et serà la più bella opera di marmo che sia hoge in Roma …" (*I contratti di Michelangelo*, ed. Lucilla B. Ciulich (Florence: S.P.E.S. Editore, 2005), 5).

30 Michael Baxandall has observed that an artist's control over the sources of his materials was a mark of independence from traditional contractual obligations (Michael Baxandall, *The Limewood Sculptors of Renaissance Germany* (New Haven and London: Yale University Press, 1980), 103–4).

31 Ciulich 2005, 5, 7–11. The relevant documents for the Sant'Agostino commission were first published by Harold R. Mancusi-Ungaro, Jr., in *Michelangelo: The Bruges Madonna and the Piccolomini Altar* (New Haven and London: Yale University Press, 1971), 152–3; see also Michael Hirst, "Michelangelo in Rome: An Altar-Piece and the *Bacchus*," *Burlington Magazine* 123 (1981): 581–93, and Acidini Luchinat 2007, 47–55.

32 William E. Wallace, "Michelangelo in and out of Florence between 1500–1508," in *Leonardo, Michelangelo, and Raphael in Renaissance Florence*, ed. Serafina Hager (Georgetown: Georgetown University Press, 1992), 55–88.

33 Tiberio Calcagni recorded Michelangelo's comment, "if you want to do well, always vary," in a marginal note to Condivi's *Life*; for which, see Caroline Elam, "*Ché ultima mano!*: Tiberio Calcagni's Marginal Annotations to Condivi's *Life of Michelangelo*," *Renaissance Quarterly* 51 (1998): 492.

34 See Roberta J. Olson, *The Florentine Tondo* (New York and Oxford: Oxford University Press, 2000).

35 This situation is radically different from that described by Roger Crum and John Paoletti in which "names of artists are so infrequently connected to actual works

of art" and "the efficacy of the crafted object was most often its patron's primary concern" (Crum and Paoletti 2006, 10).

36 Schulz counts 24 (or nearly three-fifths) of 42 sculptures as unfinished. See Jürgen Schulz, "Michelangelo's Unfinished Works," *Art Bulletin* 57 (1975): 366–73. Vasari was equally aware of the number of unfinished sculptures, although he counted only 11: *Bacchus, Pietà, David, Risen Christ*, two Medici *Dukes, Night, Dawn, Moses, Rachel*, and *Leah*, "which altogether do not amount to eleven, the others, I say, and there were many of them, were all left unfinished" (Giorgio Vasari, *La vita di Michelangelo nelle redazioni del 1550 e del 1568*, ed. Paola Barocchi, 5 vols (Milan and Naples: Riccardo Ricciardi Editore, 1962), 1: 99). The abandoned sculptures are: *St. Matthew*; first version of the *Risen Christ*; *Madonna and Child* in the Medici Chapel; *David/Apollo* in the Bargello; *Victory* in Palazzo Vecchio; Rebellious and Dying *Slaves* in the Louvre; Four *Slaves* in the Accademia; Florentine *Pietà*, and Rondanini *Pietà*. Naturally, we look upon the Louvre *Slaves* or the *Victory* as "finished," but like the *Madonna and Child* in the Medici Chapel, the latter two sculptures were never installed in their intended locations by Michelangelo, and only were removed from his workshop well after the artist departed Florence in 1534. On similar grounds one might count the four Times of Day in the Medici Chapel as similarly abandoned; however, I believe they are sufficiently finished to warrant being counted as "completed."

 The literature on Michelangelo's *non-finito* is immense. For a good introduction, see Vasari 1962, 4: 1645–70, and for more recent studies, with reference to the extensive older literature, see Paula Carabell, "Image and Identity in the Unfinished Works of Michelangelo," *RES: Anthropology and Aesthetics* 32 (1997): 83–105; John T. Paoletti, "The Rondanini *Pietà*: Ambiguity Maintained Through the Palimpsest," *Artibus et historiae* 42 (2000): 53–80; and Creighton E. Gilbert, "What is Expressed in Michelangelo's *Non-Finito*," *Artibus et historiae* 48 (2003): 57–64.

37 Ciulich 2005, 5, 18–23. See Michaël J. Amy, "Michelangelo's Commission for Apostle Statues for the Cathedral of Florence," Ph.D. dissertation, New York University, 1997, and "The Dating of Michelangelo's St. Matthew," *Burlington Magazine* 142 (2000): 493–6.

38 William E. Wallace, "Doni's Double," *Source: Notes in the History of Art* 25 (2006): 10–15.

39 Quoted from *A Documentary History of Art*, vol. 3, ed. Elizabeth Gilmore Holt (Garden City: Doubleday & Co., 1966), 393.

40 Barocchi and Ristori 1965–83, 1: 7–8.

41 Since Michael Hirst attributed the "Study for a Wall Tomb" in the Metropolitan Museum of Art (no. 62.93.1) to Michelangelo in 1976, many scholars have followed Hirst in accepting it as a design from 1505 (see Michael Hirst, "A Project of Michelangelo for the Tomb of Julius II," *Master Drawings* 14 (1976): 375–82). Not only is the drawing weak and unlikely to be autograph, but also it almost certainly does not date that early. The sheet bears a watermark (closest to Briquet 6281) indicating that it was drawn on Florentine paper of 1515–16. When scientific data is so often craved in art-historical debate, it seems perverse to so willfully ignore this evidence, as has been the case in most discussions of the sheet. I raised the issue of the watermark in my review of the exhibition and catalog, *Michelangelo: Draftsman/Architect*, in *Master Drawings* 27 (1989): 70, n. 2. However, scholars abhor a vacuum, and thus we are eager to find some trace of the 1505 project. In this case, the complete absence of evidence is itself significant.

42 For instance, in working at San Lorenzo, Michelangelo begged Pope Clement VII to entrust him with sole authority over all operations: "I beg You not to have authorities set over me in my own trade ('nell'arte mia'), but to have faith in me and give me a free hand" (Barocchi and Ristori 1965–83, 3: 132).

43 Ciulich 2005, 554. See also, Gerda Soergel Panofsky, *Michelangelo's "Christus" und sein römischer Auftraggeber* (Worms: Wernersche Verlagsgesellschaft, 1991).

44 See William E. Wallace, "Miscellanae Curiositae Michelangelae: A Steep Tariff, a Half Dozen Horses and Yards of Taffeta," *Renaissance Quarterly* 47 (1994): 330–36.

45 Soderini's reputation as a laughable character is largely derived from the story told at his expense in which he criticized the size of *David*'s nose. Of course, in relating the anecdote, Vasari is complicit in Michelangelo's claim for artistic and critical autonomy; see Vasari 1966–87, 6: 20–21.

46 Quoted in Howard Hibbard, *Michelangelo* (New York: Harper and Row, 1974), 95.

47 See William E. Wallace, "Friends and Relics at San Silvestro in Capite, Rome," *Sixteenth Century Journal* 30 (1999): 419–39.

48 William E. Wallace, "Clement VII and Michelangelo: An Anatomy of Patronage," in *The Pontificate of Clement VII: History, Politics, Culture,* ed. Ken Gouwens and Sheryl E. Reiss (Aldershot and Brookfield: Ashgate, 2005), 189–98.

49 In relation to Raphael, Sheryl Reiss has aptly called this "playing the patronage game" (Reiss 2005, 38).

50 "… ché io non fu' mai picture né scultore come chi ne fa boctega" (Barocchi and Ristori 1965–83, 4: 299).

51 Vasari 1966–87, 6: 92.

52 The idea of making "inimitable" works of art was well understood and practiced by subsequent artists, such as Benvenuto Cellini; see Jane Tylus, "Cellini, Michelangelo, and the Myth of Inimitability," in *Benvenuto Cellini: Sculptor, Goldsmith, Writer*, ed. Margaret A. Gallucci and Paolo L. Rossi (New York and London: Cambridge University Press, 2004), 7–25.

53 See the discussion by Elizabeth Cropper in *The Domenchino Affair: Novelty, Imitation, and Theft in Seventeenth-Century Rome* (New Haven and London: Yale University Press, 2005), esp. 199.

54 Letters to and from Bartolommeo Angelini: Barocchi and Ristori 1965–83, 2: 376, 381, 383, and Barocchi, Bramanti, and Ristori 1988 and 1995, 1: 199.

55 Michelangelo to Bartolommeo Angelini: "… sono disideroso di servire Suo S[ignori]a reverendissima, e ingiegnieromene quante potrò e più presto che potrò" (Barocchi and Ristori 1965–83, 2: 384).

56 Condivi 1987, 70.

57 On the circumstances regarding the first four of these instances, see Wallace 1992, 160; William E. Wallace, "Manoeuvering for Patronage: Michelangelo's Dagger," *Renaissance Studies* 11 (1997): 20–26; Wallace 2006, 10–15; and William E. Wallace, "Michelangelo's *Leda*: The Diplomatic Context," *Renaissance Studies* 15 (2001): 473–99.

Passim:
sculptors and sculptural patronage in and beyond Florence in the fifteenth century

Roger J. Crum

The sculptor was a ubiquitous presence in fifteenth-century Florence. Records indicate where sculptors lived and worked, and when this evidence is taken together with the works themselves—and with such collateral data as Nanni di Banco's Orsanmichele relief of sculptors plying their trade or the local "color" of the contemporary tale *The Fat Woodcarver* (*Il grasso legnaiuolo*)—we have a rich image of sculptural production in the city.[1] Florentine sculptors made a substantial proportion of their wares for fellow Florentines and for the city's palaces, country villas, churches, guild halls, hospitals, street corners, public buildings, and public spaces. Even today we can traverse streets that run past locations where Ghiberti, Donatello, Andrea della Robbia, and Andrea del Verrocchio worked and then, within a few paces, admire Ghiberti's first set of bronze doors at the Baptistery, Donatello's *Annunciation* at Sta. Croce, Andrea della Robbia's roundels at the Hospital of the Innocents, or Verrocchio's *Christ and Doubting Thomas* at Orsanmichele. On more than one level, the designation "Florentine sculpture" really means work produced in Florence by Florentines for Florentines.

So abundant was this local production and patronage that the incentives have been few to look beyond the city for the full story of Florentine Renaissance sculpture. In addition to the works that long remained *in situ*—in and around the Cathedral, Orsanmichele, the Palazzo della Signoria, the Piazza della Signoria, the Loggia dei Lanzi, and the city's many churches—the major museum collections of signature artists at the Museo dell'Opera del Duomo and the Museo Nazionale del Bargello, coupled with the rich holdings of more obscure works in places like the Museo Bardini, more than suffice to provide the material for a substantially complete history of local sculpture. Charles Avery is thus within our expectations when he focuses predominantly on local patronage and production in his survey of Florentine Renaissance sculpture. Avery frames his discussion of local works and explains his occasional inclusion of sculpture produced away from the

city by acknowledging that "when the career of a sculptor [has led] outside the confines of Florence, the narrative, for the sake of logical continuity, has followed."[2] Avery's narrative takes us to Siena with Ghiberti and Donatello, Padua with Donatello, Venice with Andrea del Verrocchio, Milan with Leonardo, and Rome with Antonio del Pollaiuolo and Michelangelo. We also follow Avery to Montepulciano with Michelozzo, to Prato with Michelozzo and Donatello, to Naples with Benedetto da Maiano, and to Pistoia with Verrocchio. The reader is thus treated to a respectable tour of Florentine sculpture around Tuscany and the rest of the peninsula. Nevertheless, Avery always returns us as promised to a focus on Florence.[3]

But was Florentine sculptural production beyond the walls of Florence really so peripheral that it can be accommodated only by the occasional aside in the interest of narrative continuity? Avery's "within the walls" approach could be regarded as a kind of scholarly equivalent to "*campanilismo*," a pride in all things local to one's hometown (or the adopted "home/research site" of the scholar), that may earlier have motivated Michelangelo to inscribe his *St. Peter's Pietà* "Michaela(n)gelus. Buonarot(t)us. Florentin(us) Faciebat."[4] According to Vasari, while the sculptor wanted to make it clear that he was Florentine, he also needed to claim his authorship of the work, which some initial viewers had misattributed to the Milanese sculptor Cristoforo Solari.[5] Nonetheless, Michelangelo's Florentine identity was something he periodically underscored as, for example, when he returned to Florence to receive the commission for the *David*, insisted on the employment of Florentine assistants on the Sistine ceiling project, purchased land in and around the city, and pushed for local marriages for his relatives.[6] Michelangelo was proudly Florentine, and the Florentines would later oblige his patriotism—or, more accurately, take it into their own hands—when they spirited the master's body away from Rome and constructed his tomb in Florence in the "pantheon-to-be" of Sta. Croce. Florentine sculptors, like Florentine sculpture, belonged to the ages but only, it seems, given the caveat of preeminent association with Florence.[7]

Michelangelo's extensive history of working in Rome might seem to stand aside from the more common, "within-the-walls" narrative of Florentine Quattrocento sculpture and thus signify a new reality for Cinquecento sculptural production.[8] Nevertheless, one scholar many years ago suggested that this kind of extra-Florentine activity was actually fairly common before Michelangelo. "The Italian sculptor of the fifteenth century," writes Charles Seymour Jr., "was likely to be mobile. He often moved from centre to centre as programmes of sculpture came into activity."[9] Supporting this point, Seymour includes a map of Italy on which he traces the working paths of key Quattrocento sculptors across the peninsula.[10]

The different emphases of Charles Avery and Charles Seymour—the former predominantly emphasizing patronage and production within Florence, the latter expanding that canon more purposefully to include the extension of the Florentine tradition beyond Florence—beg two questions. Were these scholars

examining the same Florentine tradition? If so, how might we reconcile Avery's predominantly "within-the-walls" canon with Seymour's geographically expansive mapping of sculptural production? In this essay I take up of the implications of Seymour's statement and map to illuminate the extent to which Florentine sculpture was an extramural enterprise for the benefit of foreign patrons. I do this by pointing to key examples of Florentine sculptors living and working beyond the boundaries of their city. At the same time I wish to take into consideration the extramural and intramural approaches of Seymour and Avery. Rather than affirming the validity of one over the other, I propose a third conceptualization for the complex and nuanced reality of Florentine Renaissance sculpture and its patronage that was at once local (Florentine), regional (Florentine Tuscany), and extra-regional (pan-Italic, wider European, Mediterranean, and Near Eastern contexts). Not unlike those artists who depicted recognizable images of Florence to stand in symbolically for both Florence and places beyond the city such as Jerusalem and Rome, I too shall construct an image of the city and its sculptural production in which Avery's intramural frame can include evidence from Seymour's extramural approach and vice versa.[11] Both Avery and Seymour point us in this direction, as when Avery observes that a history of commissions in Arezzo "probably influenced the choice of Bernardo [Rossellino]" for the tomb of Leonardo Bruni in Florence, and when Seymour remarks on a "double image" that emerges in Quattrocento sculpture "towards the formation or prolongation of local 'schools,' and … a counter-tendency towards unity through interchange and ceaseless movement [or artists] from one centre to another."[12]

Florence, Florentine Tuscany, and Florentines in the wider world

It is first important to establish just what Florence was—geographically, politically, and economically—in the fifteenth century. Florence was most immediately the city on the Arno surrounded by its late medieval walls and dominated by Arnolfo di Cambio's tower of the Palazzo della Signoria and Filippo Brunelleschi's dome of Sta. Maria del Fiore. Yet Florence, supported by its *contado* or immediate regional expanse, was also the center of a large territorial state. Between the mid Trecento and the mid Quattrocento, the city expanded its borders to encompass an area nearly equal to what we recognize today as modern Tuscany. This means that Florence was our modern-day Florence, but it was also a capital city with controlling relationships with its subject towns. Put another way, Florence was Arezzo, Pistoia, and Pisa, Montepulciano, Cortona, Livorno, and other towns that in various ways have long been suppressed or forgotten since these localities gained their independence well after the Renaissance.[13]

Quattrocento Florence was additionally the center of an international economic empire that extended across and beyond the Italian peninsula. Since the early thirteenth century, Florentines had spread out across the known and

unknown world. They went north to London, west to Spain, east to Jerusalem and the Orient, and south across the Mediterranean to North Africa. Florentine maps and a Florentine, Amerigo Vespucci, even contributed to the discovery and naming of the New World. A striking internationalism thus characterized who Florentines were as traders, manufacturers, bankers, and mapmakers. This internationalism was, in certain respects, as much a reality for the common woolworker as for the wealthiest guildsman. Across the social and economic spectrum of the city, traffic in international material and monetary exchange was directly or indirectly at the heart of Florentine identity.[14] So ubiquitous were Florentines from an early date that Pope Boniface VIII famously remarked in the early fourteenth century that the earth was made up of five elements: earth, water, air, fire, and Florentines.[15] Expressed in the language of the scholar, this ubiquity of Florentines of the pre- and early modern eras was registered by Fernand Braudel simply as *"passim"* when he indexed Florence and Florentines in his wide-ranging study of the Mediterranean world.[16]

"Passim" could equally serve as the indexical reference for fifteenth-century Florentine sculptors working in Florence, in Florentine Tuscany, and in the wider world. If the story of Florentine sculpture in the fifteenth century essentially ends with Michelangelo's St. Peter's *Pietà*—a work not actually produced in Florence—it effectively begins with the famous competition for a set of bronze doors for the city's Baptistery. Here we find this same within- and beyond-the-walls duality. The details and outcome of the Baptistery doors competition long ago became a collective milestone of Renaissance art history, employed in nearly all writings on the sculptural production of the period, and still rehearsed annually before countless undergraduates. Students learn that the competition came down to a contest between Filippo Brunelleschi and Lorenzo Ghiberti based on their reliefs on the theme of the Sacrifice of Isaac. What students are less often told, if at all, is that when the competition was announced, both masters were working on jobs for locations away from the actual city of Florence: Brunelleschi was engaged on a commission for the silver altar for the church of San Jacopo in the nearby Florentine subject town of Pistoia, while Ghiberti was further away, more or less "abroad," working on a fresco commission in Pesaro in the Romagna.[17] Largely because these artists went on to pursue careers in completely different media, these earlier activities have been relegated to the anecdotal periphery of Florentine art history. This overlooks what is suggested about Florentine art in the working lives of Florentine artists beyond the immediate walls of the city. Emerging out of a competition that drew hopeful sculptors, as Ghiberti boasted, "from all the lands of Italy," Brunelleschi's work "closer to home" and Ghiberti's work "abroad" can serve as starting points for drawing out more of what is known of sculptural activity beyond the walls of Florence in the Quattrocento. More fundamentally, the reality of the intra- and extramural activity of these artists can serve as a catalyst for reaching a new conceptualization of Florentine sculptural activity that synthesizes the approaches of Avery and Seymour.

Following Brunelleschi and Ghiberti beyond walled Florence

Florentine sculptors in the fifteenth century were active in receiving and completing major commissions for locations in the *contado* and territory. Indeed, it is difficult to identify a locality, major or minor, urban or rural in Florentine Tuscany that did not at one point engage the services or somehow acquire the work of a recognized Florentine sculptor or works obviously produced in Florence for the regional trade. Among the more notable examples of this phenomenon are Donatello and Michelozzo's exterior pulpit in Prato, Michelozzo's Aragazzi tomb in Montepulciano, Bernardo Rossellino's work in Arezzo, Luca della Robbia's shrine for the Madonna at Impruneta or his *Visitation* in Pistoia, the work of Antonio and Piero del Pollaiuolo and Andrea del Verrocchio in Pistoia, Andrea della Robbia's work at La Verna, and Benedetto da Maiano's Sta. Fina chapel in San Gimignano. It is important to stress that in all cases this work was not wholly secondary to work in the metropolitan center. Some localities were even better sources of employment for Florentine sculptors than was Florence, as Anne Markham Schulz suggests of the lucrative relationship of Bernardo Rossellino to Arezzo.[18]

It was not only through actual works of art that Florentine sculptors made their mark throughout the *contado* and territory.[19] Their recognized authority as sculptors of note meant that they were drawn into service as expert evaluators, as when Andrea del Verrocchio traveled to Prato to assess a pulpit by Antonio Rossellino in 1473.[20] Additionally, sculptors had non-artistic, or at least non-sculpture-related presences in the territory. Like other Florentines, sculptors could hail from localities within the territory, as in the case of Isaia da Pisa from the eastern reaches of Florentine Tuscany, or own land in the territory, as was true of the Pollaiuolo brothers in nearby Pistoia.[21] Michelozzo was commissioned by the Florentine Opera del Duomo in 1448 to supervise the building of a moat around the fortified town of Castellina in Chianti.[22] This commission to the sculptor as architect and military engineer certainly adds new meaning to Alberti's famous description that Brunelleschi's dome—the principal concern of this same Opera del Duomo and, arguably, the greatest example of sculptural architecture in the city—"cover[s] with its shadow all the Tuscan people."[23]

The above is but an abbreviated listing of sculptors, their work, and their ties and relationships in the territory. It suffices to indicate that Brunelleschi's early work in Pistoia was far from an isolated case. Similarly, like Ghiberti at Pesaro, Florentine sculptors regularly accepted commissions for patronage much further afield on the Italian peninsula and even well beyond.[24] For work on the peninsula, the list of sculptors includes members of the Lamberti family and Verrocchio in Padua and Venice, Ghiberti in Siena, Agostino di Duccio in Urbino and Rimini, Bernardo Rossellino, Filarete (Antonio di Piero Averlino), Mino da Fiesole, and Antonio and Piero del Pollaiuolo in Rome, Filarete and famously Leonardo da Vinci in Milan, Antonio Rossellino and Benedetto da Maiano in Naples, and Michelangelo in Bologna and Rome before his return

to Florence at the start of the new century. Among the better known and most prolific of artists executing commissions beyond Florence was certainly Donatello. As David Wilkins illuminates in his contribution to this volume, we have records that attest to interest in employing Donatello in Faenza, Ferrara, Mantua, Modena, Naples, Orvieto, Padua, Prato, Rome, Siena, and Venice, and that works by the master could be seen in at least six of these cities during his lifetime.[25] Lesser-known figures include Francesco Guardi, who left Florence to work in the area of Pisa; Michele di Giovanni da Fiesole, called Il Greco, who worked in Urbino on the sculptural decorations of the palace of Federico da Montefeltro c. 1460; and Adriano Fiorentino, a pupil of Bertoldo di Giovanni who in addition to work for court patrons in Naples, Mantua, and Urbino worked at the court of no less than Emperor Maximilian I.[26]

The work of some of the lesser-known Florentine sculptors may actually have led to overtures to better-known artists to accept patronage and commissions beyond Florence. Seymour observes that the choice of Donatello for work at Padua may have been connected with the earlier hiring of two Florentines, Antonio di Cristoforo and Niccolo Baroncelli, to make an equestrian statue of Niccolo III d'Este at Ferrara in 1441–42.[27] We should also be attuned to the possibility that our existing documents may not preserve the record of sculptors who actually did travel to and work in distant locales. Among the many suggestions of extra-Florentine experience and influence that run through the literature, Mary Bergstein suggests that Nanni di Banco may have had some familiarity with Rome even though we have no specific documentation of a Roman sojourn.[28] Similarly, Harriet McNeal Caplow argues persuasively for Michelozzo's considerable contact with north Italian sculpture by way of explaining evident influence of such work in the master's otherwise well-documented art.[29] In some cases, sculptors' travels and the fruits of such may not have been related entirely to sculptural commissions. At one point Donatello is reputed to have told Brunelleschi and others about an antique vessel that he had seen at Cortona.[30] We know that in 1455 Bernardo Rossellino obtained a certain antiquity from Pellegrino d'Antonio in Viterbo for shipment back to Giovanni de' Medici in Florence.[31] And in 1469 Antonio del Pollaiuolo, presumably on his way to or from Rome, paid a visit to the elderly Fra Filippo Lippi in Spoleto at which point a box of sweetmeats was purchased for the occasion.[32] So fundamentally common was the practice of Florentine sculptors working and/or traveling abroad that the tradition even entered into contemporary fiction. In writing about the hypothetical city of Sforzinda that he would build for the Milanese Duke Francesco Sforza, Filarete (himself just such an "itinerant" artist) not surprisingly lists a whole host of Florentine sculptors whom he would enlist in its fabrication.[33]

Among sculptors working more distantly from Italy, Dello Delli worked in Spain, Michelozzo worked for a period in Ragusa (Dubrovnik) and on the Greek isle of Chios, and Benedetto da Maino is recorded as having delivered a set of costly chests as gifts from Lorenzo de' Medici to King Matthias Corvinus of Hungary.[34] Andrea Sansovino was sent by Lorenzo

de' Medici to Portugal in 1491 on an architectural and perhaps sculptural mission.[35] Later, Pietro Torrigiano resided and worked first in Rome and then in the Netherlands, London, and Spain for much of his career after more notoriously breaking Michelangelo's nose when they were students in the Medici sculpture garden.[36] Michelangelo's work in the ambient of the Medici and their sculpture garden is generally referenced to affirm the Florentine nature of the artist's formative years and, fundamentally, of the artist himself. This, of course, is an unassailable interpretation, but it was also there in the Medici garden that Michelangelo and Torrigiano received their training in the rudiments of Florentine art that would stand them well in careers that took them well beyond their native city. Perhaps in the end they would have more in common in their extramural trajectories than whatever led them to fisticuffs at home. In other words, maybe there is something about the reality of extramural patronage and production of Florentine sculpture in works like Donatello's Santo altar in Padua, Michelangelo's Madonna in Bruges, and Torrigiano's tomb of Henry VII and Elizabeth of York in Westminster Abbey that illuminates an important aspect of Florentine art away from Florence that has not yet been fully explored.

Pietro Torrigiano's career was actually fairly typical of Florentine artists engaged with non-Florentine commissions in that he was working for non-Florentine patrons. This would seem obvious in all cases, but there was the exception of Florentine sculptors working for Florentine citizens residing elsewhere, either under circumstances of choice or of mandated exile. Of the former, we could point to Donatello's Frari *John the Baptist* for the Florentine community in Venice, and of the latter to Mino da Fiesole's *Bust of Niccolo Strozzi*, which was carved in Rome in 1454 for a member of the famous Florentine family in exile. Finally, not all work of Florentine sculptors for Florentine patrons away from Florence was necessarily related to artistic commissions. The cases of Ghiberti's accompaniment of Palla Strozzi on a diplomatic mission to Venice in 1424 and of Andrea Sansovino's later dispatching by Lorenzo de' Medici to Portugal open up an interesting avenue for research.[37]

Toward an interpretation of sculptural work beyond walled Florence

The city of Florence was always a powerful draw on the artistic talent of its immediate *contado*, the larger regional state, and the neighboring territories. This is evident from some of the better known migrations to the city (or interests in Florentine training and/or commissions) of artists like Jacopo della Quercia from Siena, Mino da Fiesole from the Casentino, Matteo Civitale from Lucca, Leonardo from Vinci, and Andrea Sansovino from Monte San Savino near the Sienese border.

It makes sense that patrons in rural areas and local communities throughout Tuscany would turn to the larger metropolitan city for sculptural wares. From the standpoint of the patron as customer, acquiring Florentine sculpture was a

logical act of locating sculpture and sculptural talent where they were generally available. For their part, Florentine sculptors, working in what was clearly a competitive local market, must have seen the advantages of attracting and accommodating clients beyond the walls of the city. Florentine sculptors were artists, but they were also business people in a long-standing local tradition of recognizing economic opportunity both near and far from home.[38]

Economic opportunity was clearly the major incentive for pursuing work in the territory and beyond, perhaps in some cases driven by a dearth of available work in Florence proper. Margaret Haines has suggested that an economic recession in the 1420s drew sculptors away from the city, and such may explain why that decade did not witness any major sculptural projects compared to previous and subsequent periods.[39] One of those who found work elsewhere was the little-known Andrea da Fiesole who, together with other Florentine masters, was at work since around 1420 on the monument to King Ladislas in S. Giovanni Carbonara, Naples.[40] War and the resulting disruption to the local economy, particular in the years before the general Peace of Lodi in 1454, may also have been an incentive to seek employment elsewhere. Michelozzo and Donatello were at some point drawn uncomfortably into the Florentine war with Lucca to the extent that they fled to Rome in order to avoid "further unpleasantness."[41]

While sculptural commissions and sales beyond the immediate confines of the city made good business sense, sound economics was not the only factor that stood behind the ever-expanding presence of Florentine sculptors and sculpture in the territory. Power politics were also in play. Relationships between Florence at the center and the city's subject towns throughout Tuscany were often in flux. By extending political, social, and economic patronage to subject towns, Florentine patricians built relationships and mutual loyalty between the metropolitan center and the controlled periphery.[42] It is not unlikely that works of art commissioned from Florentine sculptors for the territory played a role in marking the presence of Florence and the prominence and largesse of Florentine patrons. This was arguably a factor surrounding the installation of Luca della Robbia's tabernacle that was made to house the miracle-working Madonna of Impruneta.[43] This must certainly have been the case with Donatello and Michelozzo's pulpit in Prato, which was yearly used for the important display of that subject city's most important relic, the holy *cintola* of the Virgin.[44] Less symbolic than this Prato example, and much more involved in raw politics, was Lorenzo de' Medici's involvement in Verrocchio's Forteguerri monument in Pistoia. From the exchanges between the Pistoian authorities and Lorenzo, it is clear that the commission was highly politicized and was definitely an arm in Lorenzo's arsenal for controlling relations with that town.[45]

If Florentine sculptors were engaged with commissions for subject towns where relationships with the metropolitan center were more or less settled (as in Benedetto da Maiano's tomb of Santa Fina in the Collegiata at S. Gimignano), they could also be awarded commissions in connection with the vicissitudes

in the relationships between other towns and the dominant city. Volterra, which had come under Florentine sway as early as 1361, rose up against the dominant city in the early 1470s, and that revolt was infamously suppressed in 1472 by the Medici regime that employed the services of the *condottiere* prince Federico da Montefeltro. To commemorate their victory and acknowledge Federico's services, the Florentine *Signoria* commissioned Antonio del Pollaiuolo to produce a silver parade helmet as a gift to the *condottiere* prince, thus involving a Florentine artist in Medicean and Florentine power politics in the territory.[46] Artists did not need such "trophy" commissions to come into contact with territorial matters. Even the occasional work in Florence carried territorial overtones. One example is Bernardo Rossellino's tomb of Leonardo Bruni in Sta. Croce, a work commissioned by the state to commemorate the life and career of a distinguished chancellor of the city who had hailed from the subject town of Arezzo.[47] Another might be Mino da Fiesole's tomb of Count Hugo of Tuscany in the Badia (1469–81), a work that may have resonated with contemporaries in terms of the deeply historical politics of the territory of Tuscany over which Hugo's family had itself ruled in the early middle ages.

While Pollaiuolo's helmet was commissioned in response to a situation in the territory, this work was also an instance of international patronage for the artist, a subject I deal with later in this essay. In this immediate context, I would note that other similarly political, economic, and military connections between Florentine patrons and foreign powers and princes were likely factors that paved the way for sculptors to work abroad. The Medici bank's dealings with the Papacy doubtless aided circumstances for artists like Donatello, Michelozzo, Filarete, Mino da Fiesole, the Pollaiuolo brothers, and Michelangelo in receiving patronage in Rome, while the family's political and military ties with Milan from mid century onward clearly set the stage for Filarete and, later, Leonardo to seek and secure employment in that northern city. Military and diplomatic ties between Florence and foreign powers also constructed bridges for Florentine sculptors to work, or at least travel abroad, as in the case of Lorenzo de' Medici's relationship with Matthias Corvinus of Hungary.[48]

Finally, there is the matter of the artistic impact that Florentine sculptors exerted and the influences that they came under when working away from their hometown. Charles Avery, among others, makes reference to other areas being "converted" to the Renaissance as a result of the working sojourns of Florentine sculptors.[49] A well-known example is Donatello's impact in Padua and on northern Italy generally, but his influence there was not an isolated phenomenon. Charles Seymour regularly notes the importance of Florentine sculptors to first or second hand stylistic adaptation and change elsewhere around and beyond the Italian peninsula. In addition to learning of Donatello's influence in Padua, the Lamberti and Ghiberti in Venice, Mino da Fiesole in Rome, and Antonio Rossellino in Naples, Seymour's reader is reminded of the lesser-known impact of Florentine sculpture as a result of Dello Delli's work in Spain and the importance of Ghiberti's reliefs for the first

doors of the Florentine Baptistery for those sculptors working in Spain and Venice.[50] Surprisingly Seymour is silent on the effect of Leonardo on Milanese sculptural developments in the later fifteenth and early sixteenth centuries, though this may be because that influence came more through Leonardo's painting than from whatever sculpture he was able to produce during his Milanese period. Seymour does observe, however, that the Chapel of the Prince of Portugal in S. Miniato in Florence was "later copied almost precisely, element for element," in the tomb of Maria of Aragon in the Piccolomini Chapel of Sant'Anna dei Lombardi in Naples.[51] Antonio Rossellino was the link between the two commissions.

More recently, Stephen Campbell has gone one step further in discussing the relationship of Florentine sculptors to traditions beyond Florentine territory by reminding us that these artists could themselves be influenced by local traditions as much as they had an impact on them. Campbell notes that Antonio Rossellino's work in Ferrara gives evidence of how the artist came under the temporary sway of linear qualities in Ferrarese painting.[52] Anticipating Campbell's approach, Charles Seymour notes that Nanni di Bartolo, called Il Rosso, "readily adapted ... to local or regional demands in his work in North Italy and along the east coast of the peninsula."[53] Similarly, Harriet McNeal Caplow surmises that Michelozzo spent time in Verona, Padua, and Venice in the early 1420s for she detected North Italian influence in the design of Michelozzo and Donatello's Coscia, Brancacci, and Aragazzi tombs.[54] In this context, we can also point to the possible archaizing of style of Filarete's bronze doors for St. Peter's, which would have been rather out of place in contemporary Florence. Being abroad, as Filarete was, also presented opportunities for new subject matter, as in the master's bronze doors for St. Peter's or his bronze plaquette of *Cincinnatus at the Plough* from c. 1440.[55] Being away from Florence was not, however, the only way for Florentine sculptors to be influenced by non-Florentine art. Charles Avery makes the interesting observation that Antonio Rossellino looked closely at the shepherds in Hugo van der Goes' *Portinari Altarpiece* when carving similar figures for the tomb of Mary of Aragon, destined for the church of Sant'Anna dei Lombardi in Naples.[56]

As for sculptors working for patrons in Florentine Tuscany, they too were instrumental in spreading the Renaissance styles of the city of Florence, making it as much a regional as a metropolitan phenomenon. Indeed, some Florentine works, such as large-scale della Robbian altarpieces, actually appear to have been more popular with patrons in the territory than they were in the city center.[57] While subject towns in the territory were rarely able to resist the full weight of Florentine administrative dominance, it would appear that there were still opportunities to assert stylistic and formal independence. What is particularly interesting here is that Florentine artists at the administrative center of the territory, like masters of the della Robbia workshops, seem to have been collaborators in the assertion of this aesthetic independence.

Beyond the walls: the impact on Florence

The work that Florentine sculptors did beyond Florence was not without an impact on the practice of sculpture in the city. Sculptors who remained in Florence were afforded new opportunities or the space and the commissions to flourish in their own right. Anne Markham Schulz notes that when Donatello went to Rome in 1430, Bernardo Rossellino probably went to Ghiberti's employ and thereby came under the influence of a different Florentine idiom. Markam Schultz also argues that the Federighi monument in Sta. Trinita probably would have been commissioned from Bernardo Rossellino and not Luca della Robbia had Rossellino been in town at the time.[58] Charles Avery advances the theory that Bernardo Rossellino's period away as architect to Pope Nicholas V and subsequently to Pius II opened up avenues for Antonio Rossellino and Desiderio da Settignano to emerge as the dominant forces in the Rossellino workshop.[59] For the same reason, Seymour ventures that the commission for the Marsuppini tomb in Sta. Croce went to Desiderio da Settignano.[60] There has even been some suggestion that Desiderio may have been involved in working on, and perhaps completing, certain of Donatello's commissions like the Martelli *David* while the older master was away from Florence.[61]

Beyond simply opening up opportunities for other sculptors, the work that sculptors did away from Florence itself had an influence on certain aspects of Florentine sculptural production. Years ago Martin Wackernagel observed that a renewed interest among patrons in large-scale crucifixes in mid fifteenth-century Florence might be attributable to the distant influence of Donatello's large crucifix for Padua.[62] More tractable influences can be discerned in the changing oeuvres of sculptors who worked for varying lengths of time away from Florence and then brought what they had experienced back home. Absolutely foundational to the Florentine Renaissance was what Brunelleschi and Donatello learned in the early Quattrocento from their periods of residency in Rome. Without the experience of Roman architecture and architectural principles, the former sculptor Brunelleschi would not have developed his signature Florentine architecture, from the Old Sacristy at S. Lorenzo and the Hospital of the Innocents to his great basilican projects of S. Lorenzo and Sto. Spirito. Similarly, Donatello drew from the rich vocabulary of ancient sculpture in preparing some of his more inventive works in Florence such as the tabernacle that he designed for the Parte Guelfa at Orsanmichele, the *cantoria* for the Cathedral, the Cavalcanti *Annunciation*, and the bronze *David*.

Of course, a foreign sojourn could often mean an interruption of and, possibly, a change in direction for a Florentine commission, as in the case of Donatello's trip to Rome in the late 1420s and the carving of his *Habakkuk*. That trip explains the inordinately long, eight-year gestation of that work, which was begun in 1427 and was not completed until 1435. According to Seymour, the influence of Rome meant that when Donatello returned to the statue he invested it with "an increase of power in modeling and a slight shift of massing in favour of more Albertian proportions."[63] Donatello was unlikely

alone in bringing to bear on his Florentine works the experience of being abroad. Michelangelo's contact with the Bolognese sculptor Niccolò dell'Arca's dramatic art must have had some bearing on his work upon returning to Florence and in the various moments of his career in Rome. Can we not attribute some measure of the emotional intensity of Michelangelo's *David* or the stirring *terribilità* of the later *Moses* to the influence of Niccolò dell'Arca's notable sculptural forays into pronounced emotional depiction?

Some Quattrocento sculptors had careers that regularly took them away from and then back to Florence. Generally we see these movements as individual and related only to the career paths of the sculptor in question. However, a sculptor's movements might also have precipitated the movement of (and attendant influence upon) other sculptors. The Paduan sculptor Bartolomeo Bellano is assumed to have been affiliated with Donatello's workshop in Padua and to have returned with Donatello to Florence for a period after 1453. While Bellano would therefore have continued to fall under Donatello's sway in Florence, there is also the matter of what influence Bellano himself may have exerted on Florentine sculpture while resident in the city.[64]

Before passing beyond the subject of how Florentine sculptors working away from Florence influenced sculptural production in their hometown, it should be noted that this phenomenon was not universally well-received. A major problem was that sculptors could be problematically drawn away from other Florentine commissions and real obligations. In the early 1430s envoys were sent to Rome on at least two occasions in efforts to retrieve Michelozzo and Donatello so that those artists might fulfill their obligations to the Prato pulpit commission.[65] Later we know that as Leonardo was drawn to Milan and to the prospect of a major commission for the Sforza, he left behind unfinished works like the Uffizi *Adoration of the Magi*. Clearly the problems that Michelangelo's patrons, both in Rome and in Florence, had later in holding him indefinitely to one job and to one location were anticipated and preceded by the habits of his Quattrocento predecessors.

Making work in Florence for sites beyond Florence

The ease with which Andrea del Verrocchio could travel to Prato, conduct his business of evaluating Antonio Rossellino's pulpit, and then return to Florence, probably within one long day, brings forward the proximity of much of the work of Florentine sculptors in the territory. Much as marble could be transported to Florence from Carrara, north of Pisa, *pietra serena* from quarries just north of Florence near Settignano, or wood from the forests of the Casentino to the east of the city, so too could finished works of sculpture be transported outward from Florentine workshops to their destinations in the *contado* and territory. The well-known statement made by Leonardo Bruni that around 1430 he came upon the marbles of Michelozzo's Aragazzi tomb being transported from Florence to Montepulciano was probably not an isolated

case of the flow of sculptural art from the city center to sites beyond its walls.[66] Most likely the better part of commissions for the *contado* and territory were delivered from Florentine workshops.

Because work in Florentine Tuscany was in some respects little more than an extension of work in the city center itself, it might be a bit of a stretch to make an argument for the "influence" of this work on what masters were producing in their commissions in Florence, but one can point to certain examples. Sculptors like Verrocchio and Antonio del Pollaiuolo, who were interested in exploring anatomy and movement, doubtless knew the highly movemented figures on Donatello and Michelozzo's Prato pulpit. Much later, as Michelangelo was establishing the contrapposto pose of his *David*, he could draw on knowledge of the small Hercules-Fortitude figure on Nicola Pisano's Pisa Pulpit. And when Verrocchio set out to compose his *Christ and Doubting Thomas* for Orsanmichele, did he just look to earlier representations of this subject or might he also have taken a careful look at the poignancy of two sculptural figures interacting with one another in Luca della Robbia's *Visitation* grouping in S. Giovanni Fuorcivitas in Pistoia? While these points of influence may be conjectural, it is clear that a work such as Michelozzo's Aragazzi tomb in Montepulciano had a definite impact on later humanist tombs. Indeed, John Pope-Hennessy writes of the Aragazzi tomb that it was "the first tomb which consciously reflects the humane ideals of Renaissance life," and that with it "Michelozzo presided at the birth of the Renaissance monument."[67] The point here is that Florentine sculptors knew the works that had been and were being made by their predecessors and contemporaries, and we should not assume that circumstances of patronage and eventual installation outside of Florence necessarily removed these works from Florentine consideration.

Turning from works produced for the territory to those made for locations further away, it has long been recognized that key Quattrocento sculptors set up permanent or semi-permanent workshops in the locations of their commissions outside Florence. Donatello's Paduan residency and Mino da Fiesole's period in Rome come to mind. Additionally, sculptors could establish temporary workshops away from Florence for the production of work for even more distant locations. For example, by 1426 Donatello and Michelozzo had moved from Florence to Pisa where marbles for the Brancacci tomb in Naples were carved and shipped. This was obviously done to save on the transportation of materials from the quarries north of Pisa to the workshop and from there to the actual site in Naples.[68]

What should further enrich our understanding of the interrelationship between the Florentine and the extra-Florentine work of sculptors is the possibility that, much as in the case of commissions for the *contado* and territory, many foreign commissions may have been executed in whole or in part in Florence and then transported to their final destinations. We know that Donatello's *Feast of Herod* and Ghiberti's *Baptism of Christ* reliefs for the Siena baptismal font were produced in Florence.[69] Donatello's bronze figure of St. John the Baptist for Siena was produced in Florence. Portions of Donatello

and Michelozzo's Prato pulpit were made in Florence.[70] More ambitiously, the Donatello school tomb of Martin V in S. Giovanni Laterano was made in Florence and sent to Rome.[71] Benedetto da Maiano made an elaborate *lettuccio* for King Ferrante I of Naples in his Florentine workshop, and after 1494 he greatly expanded that same enterprise to accommodate a commission from Ferrante for over 80 marble figures.[72] Roughly at the same time that Benedetto da Maiano was at work for King Ferrante, marbles for Verrocchio's Forteguerri monument were carved in Florence (indeed, they were still there at the time of Verrocchio's death), and at the behest of Lorenzo de' Medici, Verrocchio executed commissions for Matthias Corvinus of Hungary in his Florentine workshop.[73] We also know that the wax model for Verrocchio's *Colleoni* monument in Venice was produced in Florence but then delivered to Venice where it could be used by the bronze casters.[74]

This last example of Verrocchio's *Colleoni* alerts us to the fact that many large-scale works may have been begun in sculptors' workshops in Florence but completed elsewhere by sculptors and assistants whose names are not generally associated with those works. This certainly happened in the 1420s with the gilding and polishing of Donatello's *Feast of Herod* relief in Siena after it was made in Florence and with Donatello and Michelozzo's Brancacci monument in Naples, certain portions of which were not actually carved into finished form until they arrived in Naples and were worked on by individuals in the artists' employ.[75] One wonders how often works were finished away from Florence by sculptors whose training and stylistic inclinations may have differed from those of the Florentine workshops where these works originated. Sometimes, major artists with kindred artistic sensibilities seem to have been engaged to complete and install works begun by Florentine masters. In this regard, Seymour reminds us that certain of Donatello's works in Siena were completed and installed by Vecchietta.[76] All of this points to the possibility, rarely entertained, that it may have been rather common that some Florentine artists may never have witnessed the completion and installation of their works for distant locations and that what we see in these works, such as Donatello and Michelozzo's Brancacci monument in Naples, may differ substantially from the original intensions of the Florentine sculptors who began the project. The literature on Florentine sculpture regularly notes the fairly mongrel nature of Michelangelo's Julius II tomb that was eventually set up in a highly modified and diminished form in the mid sixteenth century not in St. Peter's but in S. Pietro in Vincoli. Evidence from Quattrocento precedents suggests, however, that the eventual event of producing a modified and diminished form of the Julius tomb had any number of antecedents in works that were finished and assembled by hands other than the original sculptors.

Finally, we should imagine that many small-scale works were produced easily in Florence and then shipped or delivered to their foreign recipients or patrons. Probably into this category would fall a bronze medal of the English *condottiere* John Kendal that was cast in 1480 by Niccolò di Forzore Spinelli, called Niccolò Fiorentino.[77]

While other regional and long-distance examples could be listed, the point is that Florentine workshops were not strictly local enterprises. With multiple jobs for home and away in process simultaneously, these workshops must constantly have blurred the distinction between the Florentine and the extra-Florentine, with studio hands moving seamlessly from one project to another. The passage of influence between a Donatello bronze intended for Florence and one destined for a distant foreign location was measured not in miles or days or long periods spent elsewhere but in the split second of a glance or a comment or a few paces of walking to lay hands on different projects in process in the same workshop. We should also keep in mind that in certain studios this passage of work and influence between commissions occurred in environments that were specifically engaged in producing work for export. In this regard we can point to the many unattributable, relatively mass-produced plaster and terracotta sculptures that the city's workshops made and sold throughout Florentine Tuscany and abroad.[78] An example of this phenomenon would be the cargo of della Robbian sculptures that was sent from Florence to Lisbon in 1454.[79]

In a more selective vein, there is evidence of work being commissioned and sent abroad as diplomatic gifts, as in the case of Lorenzo de' Medici's gifts of sculpture to Matthias Corvinus of Hungary.[80] And we have already seen how in 1472, after the Florentines suppressed a revolt in Volterra, the Florentine *Signoria* commissioned Antonio del Pollaiuolo to produce a silver helmet to be given as a gift of appreciation to Federico da Montefeltro. While originating in circumstances of conflict between the metropolitan center of Florence and one of its territorial possessions, this commission points to the intertwined nature of center, province, and wider world in the Florentine Renaissance. It also raises the matter of how art could serve as an instrument of diplomacy and how the sculptural workshops of Florence, still local by their physical locations in the city, the predominance of their Florentine clientele, and the Florentine destinations of much of their work, were nonetheless also cosmopolitan enterprises playing their role in the deep internationalism and international connectedness of Florence in the Renaissance.[81]

Foreign buyers could also come to Florence to negotiate with local sculptors. One instance of this comes to us in the story of the Genoese merchant who visited Florence and was famously unsuccessful in acquiring a work by Donatello after the master felt insulted when the merchant quibbled over price. The Genoese merchant obviously hoped to acquire a work and take it home.[82] In other situations, foreigners commissioned works from Florentine sculptors, intending for those works to remain in Florence. The most famous example is the Chapel of the Cardinal of Portugal at S. Miniato, which was commissioned from an assemblage of Florentine workshops by the heirs of the deceased.[83] A major though little-studied antecedent of the S. Miniato commission is probably the tomb of the Patriarch of the Eastern Church, dating sometime after 1439 and located in Sta. Maria Novella. While it is known that Patriarch Joseph died in Florence in 1440 after the close of the

Council of Florence, it is not clear (though it is likely) that foreign instigation and money stood behind the commissioning of his Florentine tomb from a master in the circle of Donatello.[84] Of a much more modest and ephemeral nature were the foreign commissions of sculptural ex votos that patrons hired Florentine sculptors to make and install in the forecourt of the SS. Annunziata. The *condottiere* Gattamelata was one of these patrons.[85] Finally, there were cases in which Florentine sculptors actually turned away or deferred commissions from abroad or from the Tuscan territory in the interest of more pressing local commitments. Desiderio da Settignano reportedly did not accede to the requests from Francesco Sforza of Milan in 1462 that he produce three Madonnas, claiming himself "obliged [to work] for some time yet on certain works here in San Lorenzo."[86] Later, when Benedetto da Maiano received commissions simultaneously for the Santa Fina Chapel in San Gimignano and for work in the Florentine Palazzo della Signoria, he deferred the execution of the former in the interest of advancing his work with his local government.[87]

Apropos Desiderio's holding of Francesco Sforza's interests at bay and of Benedetto da Maiano's balancing of commissions for San Gimignano and the Florentine Signoria, mention should be made of a religious drama, presumably dating from the Quattrocento, that features a dialogue between Donatello and King Nebuchadnezzar.[88] The King wishes to be adored as a God on earth and requires his chamberlain to locate the best sculptor. Donatello is located, but in the exchange between Donatello and his would-be regal patron, the sculptor announces that he still has to finish the pulpit at Prato. So even in the fictive passages of contemporary literature did commissions for home and away come into the same conversations and, at times, into direct conflict with one another.

Regional and international commissions and sales did not always come directly to Florentine sculptors. Much as non-Florentine sculptors were attuned to sculptural opportunities in Florence (witness the participation of non-Florentines in the famous Baptistery doors competition of 1401), local sculptors were themselves aware of emerging commissions elsewhere and generated proposals and even sample works in the hopes of acquiring these lucrative engagements. The most famous example of this is Leonardo's letter to Ludovico Sforza of Milan informing the ruler that he was capable of doing any nature of tasks, including sculpture, but there are less boastful instances of Florentines seeking work elsewhere.[89] Antonio del Pollaiuolo, like Leonardo, seems to have been aware of the interest in Milan for commissioning an equestrian statue of Ludovico Sforza for he too produced a drawing that has been associated with that northern Italian commission. Much earlier, in 1461, Desiderio da Settignano, Andrea del Verrocchio, and Giuliano da Maiano competed when they submitted designs for work on the eventually-unexecuted chapel of the Madonna della Tavola in the Duomo at Orvieto.[90]

Finally, another way in which sculpture produced in Florence for foreign patrons had an impact on Florentine culture was in the arena of antiquities acquisition. The Quattrocento Florentine art dealer Bartolomeo Serragli is

recorded as exporting Florentine luxury goods to King Alfonso and other members of his court in Naples, most probably including sculptures by Desiderio da Settignano, and then turning around and importing antiquities from Naples to Florence. Interestingly, as Francesco Caglioti observes, this reciprocal traffic made virtual court artists of individuals like Desiderio.[91]

The above suggests that sculptors' workshops in Florence kept channels open to opportunities for work beyond the Florentine territory and that proposals for such work could similarly be completed alongside the production of work for local patrons. Similarly, Florentine sculptors working abroad kept close tabs on opportunities that might arise for commissions at home. Indeed, the beginning and end of our period are bracketed by just such cases: the awareness of Ghiberti from Pesaro of the coming competition for the Baptistery doors and, roughly a hundred years later, Michelangelo's readiness to return from Rome to secure the commission for the *David* in 1501.

Conclusion

I began by juxtaposing Charles Avery's predominantly intramural approach to Florentine sculpture with Charles Seymour's invitation to consider itinerancy and the production of sculpture by Florentines beyond Florence. While my goal has been to provide an overview of sculptural activity in the fifteenth century both in the territory and abroad, my larger objective has been to suggest that there was not in all cases a clear demarcation between intra- and extramural production. Not surprisingly, this is a middle ground that has been explored in a pioneering way by John Paoletti, himself a student of Seymour. Paoletti has paved the way in his work on the Florentine sculptors who produced panels for the Siena Baptismal font, on the architecture and sculpture of the Medici bank in Milan, on the proliferation of mass-produced plaster and terracotta Madonnas that were made in Florence and shipped beyond the city, and on the careers of Florentine sculptors at home and abroad. And not unrelated to this matter is Paoletti's more recent work on Michelangelo's *David*. That sculpture is now regarded as the quintessence of Florentine art of the early Cinquecento, but it began "life" most unpromisingly many years earlier as the abandoned initial attempt of Agostino di Duccio. Agostino di Duccio was perhaps the most itinerant of Michelangelo's Quattrocento predecessors and his career was an antecedent of Michelangelo's intra- and extramural career that brought the sculptor back to Florence from Rome for the *David* commission but then moved him again to Rome for initial work on the Julius II tomb.

Paoletti's example, no doubt forged years ago in his studies with Seymour (in whose "Foreword" to *Sculpture in Italy 1400 to 1500* Paoletti is acknowledged), suggests that this middle ground is actually more inherently Florentine and historically defensible than one more exclusively focused on sculptural production for the city or on one that merely catalogues the occasional excursions of Florentine sculptors beyond the city. That Florentine sculptors

themselves would have understood such a notion is amply suggested in the life of Antonio del Pollaiuolo. In 1494, toward the end of his life, Pollaiuolo actually engaged a foreign patron, the Roman nobleman and *condottiere* Gentile Virginio Orsini, to intercede on his behalf with Piero di Lorenzo de' Medici in Florence. Pollaiuolo's letter, in which the master then in Rome references his earlier work for the Medici and his Labors of Hercules canvases for the Medici Palace, remarkably communicates the fluidity in his working career of intra- and extramural activity.[92] This seamlessness is further communicated in the artist's last will and testament in which he stipulates that his wish is to be buried either in Florence or in Rome, depending on where he happened to die. Pollaiuolo actually died in Rome and was buried with his brother Piero in S. Pietro in Vincoli. While it is true that the tomb inscription underscores Antonio's Florentine origins and notes his training as a painter (something that Alison Wright observes that he only practiced in Florence), the presence of the tomb in Rome is itself proof not only that Antonio's last desire was fulfilled but that a Roman burial represented no permanent foreign exile for a cosmopolitan sculptor whose Florence and Florentine identity extended to and included his long-time residence and work in Rome.[93]

Unlike in Pollaiuolo's case, Florence would later call Michelangelo home from Rome for burial in Sta. Croce in a tomb that was orchestrated by the new Accademia del Disegno and that was loosely based on the master's *Florentine* architectural and sculptural work for the Medici at S. Lorenzo.[94] Yet if Michelangelo could thus be brought home, if rather awkwardly, for eternal rest among other Florentines, the image and reputation of his Roman work would less easily be assimilated into the culture of his hometown. In 1549, almost two decades before the master's death in Rome, a copy of his St. Peter's *Pietà* was installed in the Florentine church of Sto. Spirito where it remains to this day. Rather than meeting with local welcome, the copy was criticized as a "Lutheran caprice." In the end it seems that a gulf between the Florentine and the international had set in around Michelangelo's masterpiece and its copy, but it was a severance motivated more likely by subject matter and religious ideology than by artists and the erstwhile seamless flow of sculptors and their art between Florence and elsewhere.[95] It is perhaps not coincidental that just one year later Giorgio Vasari would publish the first edition of his *Lives of the Most Eminent Painters, Sculptors, and Architects*, a work that would initiate the long art-historical enterprise of categorizing art that traditionally has separated Florentine art within its walls from all the rest, even from that produced by Florentines themselves.

Notes

1 A selection of the extensive bibliography on fifteenth-century Florentine sculptors is cited within this article. For Nanni di Banco's relief, see Mary Bergstein, *The Sculpture of Nanni di Banco* (Princeton: Princeton University Press,

2000), 114–23; *The Fat Woodcarver*, see Guido Ruggero, "Mean Streets, Familiar Streets, or The Fat Woodcarver and the Masculine Spaces of Renaissance Florence," in *Renaissance Florence: A Social History*, ed. Roger J. Crum and John T. Paoletti (Cambridge and New York: Cambridge University Press, 2008), 295–310.

2 Charles Avery, *Florentine Renaissance Sculpture* (London: John Murray, 1970), foreword.

3 I am intentionally using Avery's conception of Florentine sculpture as a type, for it presents and represents the kind of narrative of predominantly local focus that has been influential in shaping contemporary understanding of the field. For a more monographic and biographical, and therefore less strictly local approach, see John Pope-Hennessy, *Italian Renaissance Sculpture* (New York: Vantage Books, 1985).

4 See Aileen June Wang, "Michelangelo's Signature," *Sixteenth Century Journal* 35 (2004): 447–73; Lisa Pon, "Michelangelo's First Signature," *Source* 15 (1996): 16–21; and Paul Barolsky, "As in Ovid, so in Renaissance Art," *Renaissance Quarterly* 51 (1998): 451–74. Michelangelo was not alone among Florentine sculptors who signed their works in ways that identified them as Florentine. See the inscription on Nanni di Bartolo's (called "Il Rosso") Brenzoni Monument in S. Fermo Maggiore in Verona ("QUEM GENVIT RUSSI FLORENTIA TUSCA JOHANNIS/ISTUD SCULPSIT OPUS INGENUOSA MANUS") and Donatello's inscription on the *Judith and Holofernes* ("OPUS DONATELLI FLO.").

5 See Vasari's biography of Michelangelo.

6 See Rab Hatfield, *The Wealth of Michelangelo* (Rome: Edizioni di storia e letteratura, 2002). See also William E. Wallace, "Michelangelo in and out of Florence between 1500–1508," in *Leonardo, Michelangelo, and Raphael in Renaissance Florence*, ed. S. Hager (Washington: Georgetown University Press, 1992), 55–88; William E. Wallace, "Michel Angelus Bonarotus Patritius Florentinus," in *Innovation and Tradition: Essays on Renaissance Art and Culture*, ed. Dag T. Andersson and Roy Eriksen (Rome: Edizioni Kappa, 2000), 60–74; William E. Wallace, *"The Greatest Ass in the World": Michelangelo as Writer* (The Norman and Jane Geske Lecture, Hixson-Lied College of Fine and Performing Arts) (Lincoln: University of Nebraska-Lincoln Press, 2006).

7 There is evidence in the writings of both Ascanio Condivi and Giorgio Vasari, Michelangelo's sixteenth-century biographers, that the master actually wanted to be buried in Rome, and indeed he was briefly interred there before the removal of his body from that city for eventual burial in Florence. See Philipp Fehl, "Michelangelo's Tomb in Rome: Observations on the *Pietà* in Florence and the *Rondanini Pietà*," *Artibus et historiae* 23 (2002): 9–27.

8 Contemporary with Michelangelo's extensive history of working away from Florence in Rome, one might also point to the concentration of Florentine sculptors working in Loreto in the late Quattrocento and through the sixteenth century. For the Quattrocento beginnings of this tradition with Benedetto and Giuliano da Maiano, see Doris Carl, *Benedetto da Maiano: A Florentine Sculptor at the Threshold of the High Renaissance* (Turnhout: Brepols, 2006), 39, 273–83.

9 Charles Seymour, Jr., *Sculpture in Italy 1400 to 1500* (Baltimore: Penguin Books, 1966), 19.

10 *Ibid.*, 18. The sculptors whose working careers are traced on the map are Jacopo della Quercia, the Lamberti, Lorenzo Ghiberti, Donatello, Isaia da Pisa, Il Rosso, Filarete, Agostino di Duccio, Mino da Fiesole, Giovanni Dalomata, Francesco

Laurana, the Gaggini, and Guido Mazzoni. It is notable that eight of these thirteen individuals/families are Florentine.

11 In two other contexts I have argued that Florentine art, including sculpture, was linked to the wider world, whether directly in the case of Michelangelo in Rome or more indirectly in the case of, say, Ghiberti's *Gates of Paradise* by virtue of the inherently international identity and *raison d'être* of Florence and Florentines. See my "The Florence of Cosimo 'il Vecchio' de' Medici: Within and Beyond the Walls," in *Artistic Centers of the Italian Renaissance: Florence*, ed. Francis Ames-Lewis (Cambridge and New York: Cambridge University Press, forthcoming); and "'Fuori le Mura': Opening up the 'Period Eye' on Florentine Renaissance Art," in *The Historian's Eye: Essays on Italian Art in Honour of Andrew Ladis*, ed. Hayden B. J. Maginnis and Shelley E. Zuraw (Athens: Georgia Museum of Art, 2009), 123–8.

12 Avery 1970, 101; Seymour 1966, 19.

13 For purposes of this essay I am defining "Florentine sculptors" as those artists who were born, lived, worked in or near metropolitan Florence and who occasionally worked further afield in areas that were administratively part of the larger Florentine state and whose works in those outlying areas I am classifying as part of the corpus of Florentine sculpture. For Florentine Tuscany, see William J. Connell and Andrea Zorzi, eds, *Florentine Tuscany: Structures and Practices of Power* (Cambridge: Cambridge University Press, 2000). See more generally the chapter on "The Formation of the Florentine Dominion," in Gene Brucker, *Florence: The Golden Age, 1138–1737* (Berkeley and Los Angeles: University of California Press, 1998), 157–89.

14 For Florentine internationalism, particularly as it was revealed via the city's economy, see Brucker 1998, 65–107.

15 George Holmes, *Florence, Rome, and the Origins of the Renaissance* (New York: Oxford University Press, 1986), 36.

16 Fernand Braudel, *The Mediterranean and the Mediterranean World in the Age of Philip II*, trans. S. Reynolds, 2 vols (New York: Harper and Row, 1972–73), 2: 1330. The international nature of Florence was both implicitly and explicitly at the center of a major exhibition of art and artifacts some years ago at the National Gallery of Art, Washington D.C. See Jay A. Levenson, ed., *Circa 1492: Art in the Age of Exploration* (Washington and New Haven: National Gallery of Art and Yale University Press, 1991).

17 For the work of Brunelleschi and Ghiberti prior to the Baptistery doors competition, see Richard Krautheimer, *Lorenzo Ghiberti* (Princeton: Princeton University Press, 1982). See more popularly, Paul Robert Walker, *The Feud that Sparked the Renaissance* (New York: HarperCollins, 2002). The other known artists in this competition were Niccolò Lamberti, Niccolò di Luca Spinelli, Simone da Colle, Jacopo della Quercia, and Francesco di Valdambrino. It is notable that Charles Seymour (1966, 37) makes note of the geographic and political origins of these sculptors, observing that Niccolò Lamberti came from Florence, Niccolò di Luca Spinelli from Arezzo, Simone da Colle from the Florentine territory, and Jacopo della Quercia and Francesco di Valdambrino from Siena.

18 Anne Markham Schulz, *The Sculpture of Bernardo Rossellino and his Workshop* (Princeton: Princeton University Press, 1977), 18–24.

19 Martin Wackernagel asserts that works by Andrea della Robbia were actually more popular in the countryside than in the city. See Martin Wackernagel,

The World of the Florentine Renaissance Artist, trans. Alison Luchs (Princeton: Princeton University Press, 1981), 80.

20 John Pope-Hennessy, *Italian Renaissance Sculpture* (New York: Vantage Books, 1985), 293.

21 Alison Wright, *The Pollaiuolo Brothers: The Arts of Florence and Rome* (New Haven and London: Yale University Press, 2005), 7–23.

22 Harriet McNeal Caplow, *Michelozzo* (New York and London: Garland, 1977), 47.

23 See Roger J. Crum and John T. Paoletti, "Introduction," in *Renaissance Florence: A Social History*, ed. Roger J. Crum and John T. Paoletti (2nd edn, New York: Cambridge University Press, 2008), 11.

24 Another tradition, related but beyond the scope of this essay, is that of sculptors who came from elsewhere to train or work in Florence and then carried their careers elsewhere. In the early Quattrocento, Giovanni di Turino, then working on the Sienese Baptismal font, made several trips to Florence. Notable also is the case of Matteo Civitale from Lucca, who trained in Florence and then went on to work in Lucca Pisa, Sarzana, and Genoa. For these sculptors, see John T. Paoletti, *The Siena Baptistery Font: A Study of an Early Renaissance Collaborative Program, 1416–1434* (New York and London: Garland, 1979), 78; Seymour 1966, 168; *Matteo Civitali e il suo tempo* (Milan: Silvana Editoriale, 2004).

25 David G. Wilkins, "Donatello and his Patrons."

26 Seymour 1966, 143; Levenson, 1991, 259.

27 Seymour 1966, 124.

28 Bergstein 2000, 25–6.

29 Caplow 1977.

30 Phyllis Pray Bober and Ruth O. Rubinstein, *Renaissance Artists and Antique Sculpture: A Handbook of Sources* (London: Harvey Miller, 1986), 31–2.

31 Laurie Fusco and Gino Corti, *Lorenzo de' Medici, Collector and Antiquarian* (Cambridge and New York: Cambridge University Press, 2006), 182.

32 Wright 2005, 13.

33 John Spencer, ed., *Filarete's Treatise on Architecture, being the Treatise of Antonio di Piero Averlino, known as Filarete* (New Haven: Yale University Press, 1965), 76–7.

34 For Dello Delli in Spain, see Seymour 1966, 65; for Michelozzo in Ragusa and Chios, see Caplow 1977, 2: 634–40; for Benedetto da Maiano's mission to Matthias Corvinus, see Wackernagel 1981, 281. According to Vasari, Benedetto's chests were largely ruined in transport before the artist could present them to King Corvinus. I thank Kathleen Christian for reminding me of this story.

35 Avery 1970, 155; Seymour 1966, 208.

36 Pope-Hennessy 1985, 304–5.

37 Gary M. Radke, "Lorenzo Ghiberti: Master Collaborator," in *The Gates of Paradise: Lorenzo Ghiberti's Renaissance Masterpiece*, ed. Gary M. Radke (Atlanta: High Museum of Art, 2007), 59; Margaret Haines, "Ghiberti's Trip to Venice," in *Coming About ... A Festschrift for John Shearman*, ed. Lars R. Jones and Louisa C. Matthew (Cambridge: Harvard University Art Museums, 2001), 57–63.

38 For Florentine workshop traditions generally, see Anabel Thomas, *The Painter's Practice in Renaissance Tuscany* (New York: Cambridge University Press, 1995). For the production of Italian art and its relationship to the larger Mediterranean economy, see Richard A. Goldthwaite, *Wealth and the Demand for Art in Italy 1300–1600* (Baltimore and London: Johns Hopkins University Press, 1993).

39 Margaret Haines, "The Market for Public Sculpture in Renaissance Florence," in *The Art Market in Italy, 15th–17th Centuries*, ed. Marcello Fantoni, Louisa C. Matthew, and Sara F. Matthews-Grieco (Modena: Franco Cosimo Panini, 2003), 75–93.

40 Seymour 1966, 88. In view of Florentine sculptors at work on Ladislas' monument, it is instructive to recall the role that Frederick Hartt constructs for Ladislas as a force of tyranny as opposed to Florentine republicanism in the genesis of early Quattrocento Florentine sculpture. See Frederick Hartt, "Art and Freedom in Quattrocento Florence," in *Essays in Memory of Karl Lehmann*, ed. Lucy Freeman Sandler (New York: Institute of Fine Arts, New York University, 1964), 114–31.

41 Seymour 1966, 89.

42 For relationships between the city center and the territory, see Connell and Zorzi, 2000.

43 John Pope-Hennessy, *Luca della Robbia* (Ithaca and New York: Cornell University Press, 1980), 50–54, 245–6.

44 Bonnie A. Bennett and David G. Wilkins, *Donatello* (Oxford: Phaidon, 1984), 54–6.

45 For Lorenzo and the Forteguerri monument, see Stephen J. Milner "The Politics of Patronage: Verrocchio, Pollaiuolo and the Forteguerri Monument," in *Artistic Exchange and Cultural Translation in the Italian Renaissance City*, ed. Stephen J. Campbell and Stephen J. Milner (Cambridge: Cambridge University Press, 2004), 221–45; Andrew Butterfield, *The Sculptures of Andrea del Verrocchio* (New Haven and London: Yale University Press, 1997), 137–57. A similar situation surrounded the construction and decoration of the Chiesina della Vergine di Piazza in Pistoia that involved Florentine sculptors, Lorenzo de' Medici, and the convergence of Florentine and Pistoian interests. See Stephen J. Milner, "The Chiesina della Vergine di Piazza in Pistoia: Antonio Rossellino, Andrea Verrocchio, and Antonio Pollaiuolo," forthcoming.

46 Wright 2005, 534. Sometime after the acquisition of Volterra in the mid fourteenth century, Florentine lions (*marzocchi*) were placed on the façade of that city's Palazzo dei Priori as an indication of the dominant city's centralizing control. See *Toscana* (Milan: Touring Club Italiano, 1974), 650. Though well over a hundred years old in 1472, these lions must have had a freshness of meaning for the citizens of Volterra as their subjugation to Florence was again powerfully impressed upon them. On the Florentine Marzocco, see Adrian Randolph, "Il Marzocco: Lionizing the Florentine State," in *Coming About … A Festschrift for John Shearman*, ed. Lars R. Jones and Louisa C. Matthew (Cambridge: Harvard University Art Museums, 2001), 11–18.

47 Schulz 1977, 32–51.

48 For Florentine and Medicean banking interests and pan-Italic political connections, see Raymond de Roover, *The Rise and Decline of the Medici Bank* (Cambridge and London: Harvard University Press, 1963); Nicolai Rubinstein, *The Government of Florence under the Medici (1434–1494)* (2nd edn, Oxford: Clarendon Press, 1997).

49 Avery 1970, 9–10.

50 Seymour 1966, 44 notes the influence of Ghiberti's first set of bronze doors for the Baptistery in Florence on the alabaster reliefs in the Cathedral of Valencia, Spain by the Florentine expatriate known as Julia lo Florenti; the main arch reliefs of the façade of St. Mark's, Venice by the Lamberti, and in the series of stone reliefs now in the Museo dell'Opera del Duomo in Florence which come from a pulpit originally in Castel del Sangro in the Abruzzi.

51 Seymour 1966, 143.

52 Stephen J. Campbell, "'Our eagles always held fast to your lilies': The Este, the Medici, and the Negotiation of Cultural Identity," in *Artistic Exchange and Cultural Translation in the Italian Renaissance City*, ed. Stephen J. Campbell and Stephen J. Milner (New York: Cambridge University Press, 2004), 138–61.

53 Seymour 1966, 69.

54 Caplow 1977, 38.

55 New York, Metropolitan Museum of Art, 1996,116.

56 Avery 1970, 115.

57 Wackernagel 1981, 80. A good selection of these is on view in the Bargello, Florence.

58 Schulz 1977, 3 and 12.

59 Avery 1970, 104.

60 Seymour 1966, 140.

61 Beatrice Paolozzi Strozzi, "Donatello and Desiderio: A Suggestion and Some Reflections on the *Martelli Saint John*," in *Desiderio da Settignano: Sculptor of Renaissance Florence*, ed. Marc Bormand, Beatrice Paolozzi Strozzi, and Nicholas Penny (Washington: National Gallery of Art, 2007), 61–73.

62 Wackernagel 1981, 75.

63 Seymour 1966, 87.

64 Pope-Hennessy 1985, 331; Volker Krahn, *Bartolomeo Bellano: Studien zur paduaner Plastik des Quattrocento* (Munich: Scaneg, 1988).

65 Seymour 1966, 90. See also David Wilkins' contribution to this volume.

66 Seymour 1966, 88. For the Aragazzi tomb, see Caplow 1977, 1: 210–349.

67 Pope-Hennessy 1985, 35.

68 Seymour 1966, 88.

69 Paoletti 1979.

70 H. W. Janson, *The Sculpture of Donatello* (Princeton: Princeton University Press, 1963), 111.

71 For the Martin V tomb and its Florentine fabrication, see Evelyn Welsh, *Art and Society in Italy 1350–1500* (Oxford and New York: Oxford University Press, 1997), 243; Arnold Esch, "La lastra tombale di Martino V ed i registri doganali di Roma," in *Alle origini della nuova Roma di Martino V (1417–1431)*, ed. M. Chiabo, G. d'Alessandro, P. Piacentini, and C. Ranieri (Rome, 1992), 625–41.

72 Carl 2006.

73 Butterfield 1997, 138, 156–7, 230–31. See also Francesco Caglioti, "Desiderio da Settignano: Profiles of Heroes and Heroines of the Ancient World," in Bormand, Paolozzi Strozzi, and Penny 2007, 97.

74 Seymour 1966, 176.

75 For the finishing the Donatello's *Feast of Herod* in Siena, see Paoletti 1979, 44; for the finishing of the Brancacci tomb in Naples, see Caplow 1977, 185.

76 Seymour 1966, 147.

77 Metropolitan Museum of Art, 2003.406.13.

78 Anthony Radcliffe, "Multiple Production in the Fifteenth Century: Florentine Stucco Madonnas and the della Robbia Workshop," in *The Thyssen-Bornemisza Collection: Renaissance and Later Sculpture*, ed. Anthony Radcliffe, Malcolm Baker, and Michael Maek-Gerard (London: Sotheby's Publications, 1992), 16–23; Patricia Emison, "The Replicated Image in Florence, 1300–1600," in Crum and Paoletti 2008, 431–53.

79 Pope-Hennessy 1980, 74. See also K. J. P. Lowe, ed., *Cultural Links between Portugal and Italy in the Renaissance* (Oxford: Oxford University Press, 2000).

80 Butterfield 1997, 154, 156, 157, 230–31.

81 For the use of art and artists for diplomacy in Renaissance Florence, see Caroline Elam, "Art and Diplomacy in Renaissance Florence," *Journal of the Royal Society of Arts* 136 (1988): 813–26.

82 Patricia Lee Rubin, *Giorgio Vasari: Art and History* (New Haven and London: Yale University Press, 1995), 336; and David Wilkins' contribution in this volume.

83 For the chapel and the complicated and intertwined international and Florentine circumstances of its commission, see Frederick Hartt, Gino Corti, and Clarence Kennedy, *The Chapel of the Cardinal of Portugal 1434–1459* (Philadelphia: University of Pennsylvania Press, 1964); and now Wright 2005, 192–204.

84 *Firenze e provincia* (Milan: Touring Club Italiano, 1993), 269–70.

85 Bennett and Wilkins 1984, 92–3.

86 Bormand, Paolozzi Strozzi, and Penny 2007, 29; John R. Spencer, "Francesco Sforza and Desiderio da Settignano: Two New Documents," *Arte lombarda* 13 (1968): 131–3.

87 Carl 2006, 1, 29–30.

88 Janson 1963, 112.

89 It is perhaps not insignificant to Leonardo's future ambitions *vis-à-vis* the Sforza appointment in Milan that the young artist was, as Charles Avery notes, in Verrocchio's workshop when materials were being sent forth from Florence to Venice in relation to the Colleoni equestrian commission.

90 Seymour 1966, 141.

91 Caglioti 2007, 93.

92 Wright 2005, 3–4.

93 *Ibid.*, 21–3. Unlike Pollaiuolo's willingness to be buried either in Florence or Rome, Donatello had earlier declared his commitment in the late 1450s "to

die and to live" in Siena "for the remainder of his life." He did, however, return to Florence. See Volker Herzner, "Donatello in Siena," *Mitteilungen des Kunsthistorischen Institutes in Florenz* 15 (1971): 161–86.

94 Karen-edis Barzman, *The Florentine Academy and the Early Modern State: The Discipline of Disegno* (New York: Cambridge University Press, 2000), 52; Zygmunt Wazbinski, *L'Accademia Medicea del Disegno a Firenze nel Cinquecento. Idea e istituzione* (Florence: Leo S. Olschki Editore, 1987).

95 Seymour 1966, 216. The copy is by Nanni di Baccio Bigio. I tend to differ with Seymour who writes that "what was attached in this unexpected criticism was probably not the Germanic origin of the *Vesperbild* ..., but its aestheticism, which stood in clear opposition to the norm of devotional images in much of sixteenth-century Tuscany."

Giambologna's equestrian monument to Cosimo I: the monument makes the memory

Sarah Blake McHam

Plans to erect a colossal equestrian monument to Cosimo I, the founder of the Medici Grand Duchy, may have been first broached as early as 1581,[1] but the statue was not commissioned until immediately after the accession in 1587 of Cosimo's son Ferdinando as Grand Duke.[2] Giambologna and his assistants prepared the models for it and in 1591 cast the bronze horse, then realized the statue of Cosimo I.[3] In 1594, as the monument's inscriptions twice record,[4] the horse and rider were erected on the marble base prepared for them (Figure 8.1) in the Piazza della Signoria, creating an ensemble that stood more than 7.2 meters tall. The group was not unveiled until the following year.[5] By 1598 the three large bronze relief sculptures commemorating signal events in Cosimo's long reign—his selection as head of the Florentine government, his triumphal entry into Siena, and his coronation as Grand Duke of Tuscany by Pius V— were cast and added to the monument's base.[6]

The documents that trace the monument's protracted execution raise an interesting, previously unasked question. Why was the horse and rider installed on its base in the piazza in 1594, before the sculpture of Cosimo was entirely finished and before the relief sculptures on the base were even begun? The sequence of its piecemeal installation suggests that there was an urgent need to install the figure in that year. The logical answer is that Ferdinando wished to commemorate the centenary of the Medici family's expulsion from power in 1494 by celebrating its reversal of fortune with a grand memorial to the man who had authoritatively restored the family's dominance by creating the Grand Duchy of Tuscany. The centenary marked the completion of 63 years of the Medici family's tenure as Dukes of Florence, a reign three years longer than the family had enjoyed when it controlled Florence in the fifteenth century. Ferdinando realized that the double inscription of the date 1594 would convey to future generations, who would never know that the equestrian statue had not been ready in time, the 100-year commemoration of the Medici's return to rule.

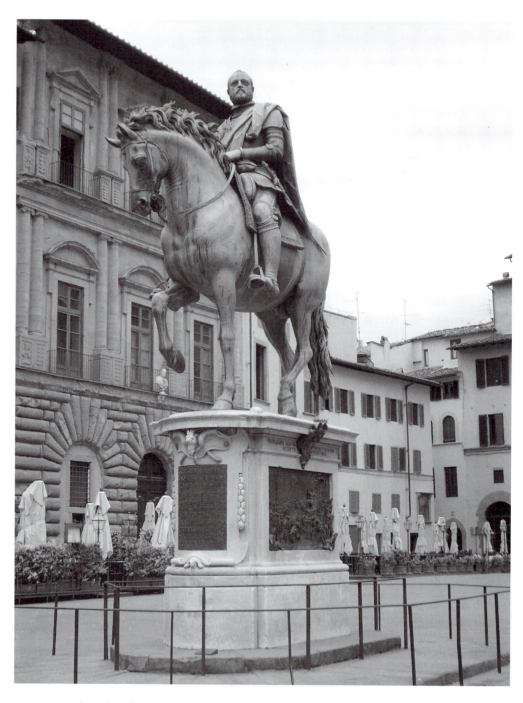

8.1 Giambologna, *Equestrian Monument of Cosimo I*. Piazza della Signoria

The monument has been undervalued in most discussions of Renaissance art. It is usually associated with the statue honoring Marcus Aurelius, but rarely analyzed beyond that; its relief sculptures have received limited attention.[7] Historians acknowledge its legacy throughout the courts of Europe, whose rulers in the immediate aftermath of the monument's success hired sculptors trained by Giambologna to recreate for them and their states versions of this ideal image of power.[8] Ferdinando's astute strategy in commissioning a sculpted memorial to his father more than two decades after Cosimo's death, and thereby forcing a public re-evaluation of Cosimo's accomplishments and promoting the dynasty's perpetuation, has been under-appreciated. Ferdinando recognized that a permanent statue on continuous view in the city's most public space offered the opportunity for a far more effective instrument of Medici promotion than any other sort of visual eulogy, inside the palazzo or elsewhere.

Ferdinando was a bold and shrewd patron of sculpture. He commissioned only one other major statue for a public square in Florence, and it was conceived as the twin to that of his father in Florence's civic center. This second sculpture was a colossal bronze equestrian monument to himself in the Piazza SS. Annunziata, positioned so that he seemed to be riding his steed toward the city's most prestigious religious center, the Piazza del Duomo.[9] The sculptures were the only two colossal monuments honoring contemporary figures in Florence at the time and very similar. Viewers inevitably linked them and understood their conjoined dynastic statement of generations of Medici power that Ferdinando intended to impress upon Florentines and visitors to the city. The intentionality of Ferdinando's message is made clear when we recognize that he was the patron of numerous other portraits of himself and his father, but they were all in the less expensive material of marble and commissioned for sites outside of Florence in the subject cities of the Medici Grand Duchy.[10]

This essay will analyze the first in this group of portrait commissions. It will investigate how Ferdinando, appreciating the uniquely influential role that a public monument could play in transmitting to posterity an apparently authoritative memory, cleverly revised and upgraded the record of his father's political career by several devices. He exploited the connotations of the statue's location and the potential for visual history-telling allowed by the novel feature of a sequence of narrative relief sculptures and drew on a number of previously unrecognized sources to associate Cosimo with more powerful rulers, even gods.

For two centuries the piazza had served as the city's political arena in which statues were visual interlocutors enacting the messages of successive regimes of Florentine government.[11] Although the piazza's two earliest sculptural monuments, the *Marzocco* and the *Judith*, installed there in the fifteenth century by the republican government, were about life-size, the four sculptures added to the piazza in the sixteenth century prior to the commission of Cosimo's statues were over life-size or even colossal.[12] Cosimo's monument matched the huge scale of the largest of them.

Michelangelo's *David*, a republican commission and the first extant colossal sculpture created in the Renaissance, set the oversized trend that was followed by Medici in all their commissions for the piazza.[13] Colossal sculpture's allure was not only its physically imposing size, but its reputation, as bequeathed to the Renaissance by Pliny the Elder and other authors, as the most highly regarded sculptural type in antiquity and a wonder of the ancient world.[14] Pliny's widely consulted *Natural History* was the best source on the ancient practice of representing gods and heroes on a colossal scale. As he made clear, such grandeur was deemed appropriate to the superior status of deities and celebrated legendary and historical figures, and consequently became synonymous with them. Pliny also recorded Nero's attempt to ensure his own fame by commissioning a colossal portrait of himself.[15]

These lessons were appreciated in sixteenth-century Florence and applied to Cosimo's monument. Vincenzo Borghini (1515–80), a leading historian and trusted advisor to Cosimo, described the heroic aura that colossal scale could convey. In his posthumously published essay on Florence's Roman foundations, Borghini repeated Pliny's descriptions about the connections between superhuman status and colossal scale in antiquity.[16] In the seventeenth century, Settimani recorded the awe that the size of Cosimo's monument occasioned in spectators. He reported that the horse and the rider were weighed prior to their installation in the piazza and offered the additional information that before the rider was put in place, at least 23 men, who climbed through the opening at the saddle, could fit inside the horse's belly. According to Settimani, Giambologna cast the colossal equestrian monument in one pour, a significant technical feat.[17]

Both Pliny and Pausanias had inaccurately claimed that ancient Greek sculptors had carved group sculptures like the *Laocoön* from a single block of marble, and the ideal became a challenge that Renaissance sculptors scrambled to meet. Casting a sculpture in one pour was considered the analogous achievement in bronze.[18] Not least of all, the monument to Cosimo I bespoke the power of money through its expensive bronze and marble materials. It used more bronze than any other sculpture in the piazza, thereby testifying also to Ferdinando's security in rule and to the *magnificenza*, or public-spirited generosity, that the Medici claimed as one of their most significant contributions to the city.[19]

Despite the initial suggestion in 1581 that Giambologna should create an equestrian statue to be placed opposite Michelangelo's *David*,[20] a different location was set even before formal planning for the monument was launched. Although the Bonsignori map of Florence printed in 1584 lacks measurements, it reveals that by then the location of the unexecuted statue was fixed approximately where it was ultimately erected—to the left of Ammanati's Neptune Fountain.[21] The site chosen was sufficiently distant from the palazzo so that it alone of all the sculptures in the piazza would capture the sun's spotlight throughout the day.[22]

The location also put the monument to Cosimo in a parallel line-up with Michelangelo's *David*, Bandinelli's *Hercules and Cacus*, and Ammanati's fountain. The alignment made it visually part of that group and emphasized its ability to rival the scale and artistic accomplishment of the other statues. A small oval plaque in lapis lazuli and other precious materials depicting the piazza, commissioned by Ferdinando, exaggerates the dominance of Cosimo's monument over those marble sculptures; the equestrian sculpture is only a tad taller than the giant figure of Neptune.[23] It did dwarf, however, the piazza's two earlier bronzes, Donatello's *Judith* and Cellini's *Perseus*, in the Loggia dei Lanzi at a right angle to the cohort of sculptures in front of the palazzo, demonstrating Giambologna's mastery of the medium considered to be the most prestigious in the period.

The installation in the piazza of an unprecedented, imposing portrait of the founder of the Medici Grand Duchy squelched any lingering associations that still attached the *Marzocco* or the *David* to the patronage of the Florentine Republic, or that *Judith* had accrued when reinstalled in the piazza by that government.[24] Ferdinando must have intended the likeness of Cosimo to give a face to the force behind the piazza's other impressive monuments and to focus viewers' attention on the long duration of Medici rule in Florence. To viewers in the 1590s, the coordinated ensemble of sculptures in the piazza hinted at an untruth: that from the time of the commission of the *Judith* in the mid fifteenth century to the commission of Cosimo's monument at the end of the sixteenth century the family had controlled the piazza, and hence the city.

The bronze rider was a recognizable, yet flattering image of Cosimo that conveyed a dynastic ideology crafted by Ferdinando and his advisors. Some viewers of the statue in the 1590s would have known the Grand Duke as an elderly man, before he died in 1574 at age 55, after a long illness. He was depicted in the bronze monument, however, in vibrant middle age and in easy control of his horse. Although his features are expressionless, smooth skin surfaces set off the shadows caught by deep-set enlarged eyes to emphasize his commanding presence.[25] Size and location suggested Cosimo's status as a hero or god. All the other statues in the piazza depicted universally acknowledged, but distant heroes sanctioned by shared religion or cultural heritage. The group that Cosimo's monument joined was entirely comprised of easily recognizable agents of God, drawn either from Christianity or from Greco-Roman legend and myth. Judith and David were heroes of the Jewish Bible who had been absorbed into the Christian canon, Neptune was a god, Hercules and Perseus sons of gods, and the legend of the Sabines foreordained by prophecy concerning Aeneas, the son of another god and founder of a nation. Associations with these sculptures suggested Cosimo's similarly divine and heroic status.

The equestrian portrait of Cosimo I is the first statue in early modern Europe to fulfill all the criteria for public monuments outlined by Pliny the Elder in the *Natural History*. Its form and visual language announce that it commemorates a worthy figure: it honors Cosimo with an equestrian portrait, a type associated by Pliny with triumph, and it is erected in a prime civic location, the site where Pliny

recorded that such statues were erected in ancient Greece and Rome. This is also the first Renaissance public monument to follow another of Pliny's transcriptions of ancient practice: to record the hero's worthy deeds in relief sculptures as well as inscriptions.[26] As Ferdinando knew well from Thucydides and other ancient historians, however, the *Tyrannicides*, the great public monument of the Athenian agora cited by Pliny as the prototypical example of the type, honored feckless youths who had botched their attempt to murder a tyrant, yet were eventually celebrated as the founders of Athenian democracy.[27] For Thucydides, the case was a paradigmatic example of how most people accept traditions "without applying any critical test whatever."[28] The shrewd Ferdinando commissioned a monument that he realized would construct a legacy about his father and his family dynasty that he wanted to be remembered.

The monument also engaged in a symbolic political discourse that stretched far outside Florence, even beyond the Italian peninsula. Ferdinando had achieved what his family's rivals for power had not. The example of the colossal equestrian of the Emperor Marcus Aurelius in Rome provided an ideal type of ruler image that many later princes aspired to emulate. Ferdinando was the second to succeed; he had masterminded an equestrian monument honoring his father, the founder of the family dynasty, which testified to the continuation of the Medici family's magnificent patronage in Florence—and to their domination of the city. Only the equestrian monument honoring Niccolò III d'Este, atop an arch attached to the Este Palace in the center of Ferrara, preceded it. The Ferrarese sculpture was the first and only equestrian group in Renaissance Italy prior to Ferdinando's project that was planned and paid for by a son and successor to honor the founder of his family dynasty. It was life-size, a mere fraction of the scale of Cosimo's sculpture. Created by Niccolò Baroncelli between 1443 and 1451, the monument to Niccolò d'Este was the first equestrian bronze statue erected in early modern Europe, slightly predating even Donatello's statue of the mercenary general Gattamelata in Padua. The ensemble, which was commissioned by the Savi of Ferrara at the instigation of Niccolò's son, Leonello, was completed during the reign of his brother and successor, Borso d'Este. Destroyed during the Napoleonic occupation of Ferrara, the statue is today replaced by a copy.[29]

In the late fifteenth century Ludovico Sforza had taken up the challenge and commissioned Leonardo to cast a colossal equestrian statue of his father Francesco Sforza, the founder of the Sforza dynasty, but its plaster model—the end stage of Leonardo's efforts in this project—disintegrated as a practice target for the French armies that invaded Milan and overthrew Sforza rule in 1499.[30] Around 1500 Ercole I d'Este planned an equally impressive sign of self-glorification to tower over the central square of the vast addition he incorporated into the city of Ferrara, but that project was never realized. As visual records of it indicate (Figure 8.2), Ercole aimed to surpass the precedent established by the equestrian statue honoring his father by commissioning a colossal portrait of himself and placing it atop a pair of tall columns mounted on a high plinth.[31]

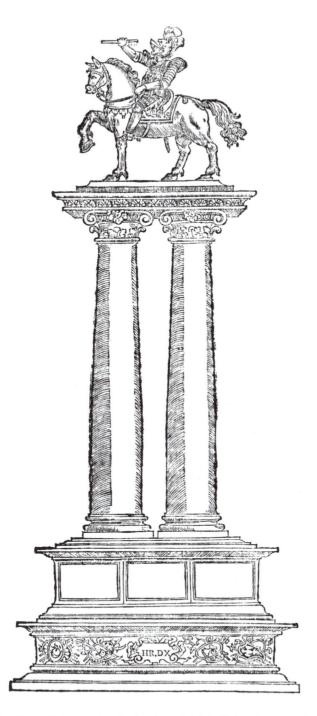

8.2 *Project for Equestrian Monument to Ercole I d'Este.* Woodcut from Alfonso Maresti, *Teatro geneologico et istorico dell'antiche et illustri famiglie di Ferrara*

Even Ferdinando's cousin Catherine de' Medici, who married a French king and commanded much more power and money than her Florentine relative, had proved unable to complete a project for an equestrian monument to honor the memory of her late husband, Henri II. Catherine had managed to

cajole Michelangelo into providing drawings and advice about it to Daniele da Volterra, who cast the horse, but never the King. The riderless steed languished in Rome for decades until the Cardinal Richelieu retrieved it to embellish the Place Royale in Paris.[32] Not even the agents of Phillip II and Pope Paul III were able to carry to completion the equestrian monument of the Holy Roman Emperor Charles V for which they asked Guglielmo della Porta to provide designs in c. 1559–60.[33] So Ferdinando's achievement in bringing to completion a colossal equestrian sculpture honoring his father is even more considerable when seen in light of earlier, abandoned projects.

The monument to Cosimo conjured up local associations as well. Many Florentines would have recalled that the city's most notable preceding equestrian sculpture was the column-statue of Mars that had once stood in the city's Temple of Mars. According to local lore, when the temple was converted into the Baptistery, the statue was moved for protection to a high tower on the Ponte Vecchio. Writers like Dante, Boccaccio and Villani attested to its status as a symbol of the city's legendary founder and its fearsome magical powers. Many legends recounted the consequences of the statue's irascibility, for example, how it caused Totila to destroy Florence because it was angry at being displaced from its temple. The statue fell into the Arno in 1178, but was recovered 20 years later and returned to its tower. The statue in its position on the bridge was regarded as a Florentine landmark and Dante cited it as a place marker in the *Paradiso*. In 1333 it fell again during a terrible flood and was totally lost, but not forgotten.[34]

These traditions concerning the city's history became a focus of urgent interest in the mid sixteenth century. In 1541 a dispute known as the precedence controversy broke out at the Holy Roman Imperial court concerning the relative status of Florence and Ferrara in courtly protocol. The quarrel continued to provoke angry debate for decades until Cosimo was made Grand Duke in 1570. Despite the ostensible settlement achieved by Cosimo's elevation in status, relations between the demoted Ferrarese and Florence continued to be hostile.[35] The controversy thrust the issue of the Roman origins of the Baptistery and its column-statue into the spotlight. To support Florence's claim to superiority over Ferrara in the face of the Este family's ancestral pedigree and long-established feudal privileges within their territory, historians like Borghini turned their attention to the history of Florence's Roman foundations.[36] The Baptistery's pre-history as the Temple of Mars offered the most concrete evidence for the claim.

Borghini spent several years vigorously defending the Roman origins of the building against a skeptical fellow intellectual, Girolamo Mei, in a series of writings. To prove his case, he painstakingly reconstructed the Baptistery's history through an examination of its inscriptions and physical remains, carefully measured drawings of its structure, and a comparative evaluation of early Christian churches. The historian's posthumously-published essay about Florence's Roman foundation depended on the archaeological evidence of the Baptistery. It was illustrated with woodcuts made from the measured drawings that he had commissioned to document the Baptistery's appearance in the Roman era.[37]

The controversy influenced the artistic program Borghini and Cosimo devised for Vasari's decoration of the Sala dei Cinquecento in the Palazzo Vecchio, which was unveiled in 1565. The visual enumeration of subject cities paying homage to Florence appears to have been a response to the Este's contention about the greater size of their territorial holdings.[38] Cosimo's decision to reject Borghini's proposal for a scene of Charlemagne's rebuilding of Florence after the city's destruction seems to have been calculated to emphasize the city's continuous settlement since Roman times. The painting of *Florence's Foundation by the Roman Triumvirate of Octavian, Antonius and Lepidus* (Figure 8.3) provides key visual proof of the city's ancient pedigree.[39] Vasari painted the three leaders conferring the *vexillum* with the symbol of the lily that would become the new city's emblem before a vast urban panorama of Florence, shown here under construction. At its center and already complete, thus emphasizing its priority in planners' minds, was the octagonal Temple of Mars. The building is open to the sky, which allowed a clear view of the column-statue of the equestrian Mars that protruded above its roof line. The corner pilasters of alternating white and green marble hinted at the building's later transformation in Christian times into the city's Baptistery.

Besides the equestrian monument's local resonance it, like all other Renaissance equestrian monuments, self-consciously looked back to the revered prototype of the Marcus Aurelius in Rome, newly reinstalled on the Campidoglio by Michelangelo in 1538.[40] Not only was the Roman equestrian monument one of the few extant examples of the type and hence an obvious point of reference, but the similarities between the bronze horses' colossal size and poses, and the installation of both monuments in the piazza outside their city's governmental buildings, necessarily conjured up in the minds of sophisticated viewers an association between Cosimo and the great philosopher-emperor who had ruled over a vast empire. To many, the link would have also evoked the associations with law and government that the equestrian monument to Marcus Aurelius had acquired during the Middle Ages.[41] Such symbolic associations lent a desired aura to the Florentine monument's portrayal of Cosimo and the dynasty he had reestablished.

The marble base of Cosimo's monument was calculated to reinforce these connections. The proportions and oval ends of an extant terracotta model for it (Figure 8.4) reveal that from the outset it was intended to imitate the base Michelangelo had created for the sculpture of Marcus Aurelius when he supervised its transfer to the Campidoglio.[42] The model also indicates, however, that, unlike the base created by Michelangelo, the base for Cosimo's monument was intended to display two narrative relief sculptures along its long sides. Only one other equestrian project, that commemorating the Holy Roman Emperor Charles V in Rome by Guglielmo della Porta, had taken the base of the Marcus Aurelius monument as its point of departure and planned to cover its curving ends with sculpted narrative reliefs and inscriptions. Della Porta's statue, however, was never executed (Figure 8.5).[43]

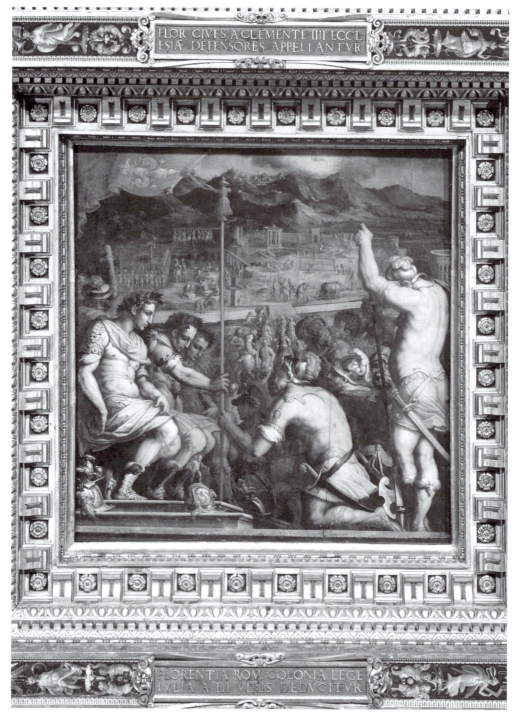

8.3 Giorgio Vasari, *Florence's Foundation by the Roman Triumvirate of Octavian, Antonius and Lepidus*. Sala dei Cinquecento, Palazzo Vecchio

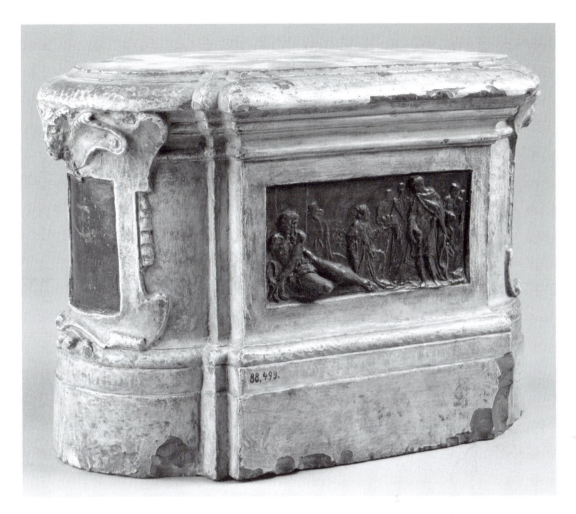

The connection that Ferdinando aimed to forge between Cosimo I and Charles V is crucial to the design of Giambologna's equestrian monument in Florence. It conjoins allusions to Marcus Aurelius to construct a brilliantly shaped, ideal image of the founder of the Medici Grand Duchy. The philosopher-emperor was much admired by Charles V, whose court historiographer Antonio Guevara wrote two commentaries on the Roman emperor's *Meditations* that went through numerous editions in the sixteenth century. Guevara interpreted the Roman emperor's stoic philosophy as a "mirror of princes," or a key to the principles of good rule, and elaborated on its modern political applications.[44] Since the Roman emperor had become a role model for sixteenth-century princes, and had been especially admired by Charles V, Ferdinando and his advisers had still other reasons to model the monument to Cosimo, who came to power as the vassal of the Holy Roman Emperor, after the most important surviving statue of the ancient Roman emperor.

8.4 Giambologna (?), *Allegory of the Signoria offering the Ducal Crown to Cosimo in 1537*, Terracotta Model for the Base of the Equestrian Monument of Cosimo I

8.5 Guglielmo
della Porta, *Sketch
of the Equestrian
Monument to
Charles V*

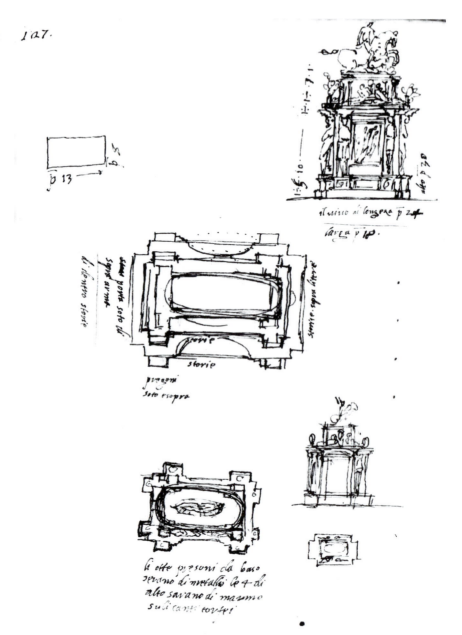

There are, however, also telling differences. Unlike Marcus Aurelius, Cosimo
is dressed in armor, even though he does not wear a helmet. Cosimo holds in
his right hand a field-marshal's baton of command supported against his leg,
while Marcus Aurelius extends his right arm in a commanding gesture of
authority, peace, and clemency.[45] These distinctions underscore that Cosimo is
portrayed in the guise of a determined Christian knight, as defined in treatises
of the period.[46] The repeated motif of the gold chain of the Order of the Golden
Fleece, represented on both sides of the base and proudly worn by Cosimo,

identifies the Grand Duke as a Christian knight of that elite order pledged to waging war against the Protestant and Turkish enemies of the Church.

The image that Ferdinando constructed of his father closely followed representations of the Holy Roman Emperor Charles V as a determined Christian knight. This interpretation of the emperor appeared repeatedly on temporary monuments in the cities of his empire, in printed encomia, and on the unexecuted tomb planned for him. The engraved title-page (Figure 8.6) to Antonio Francesco Oliviero's *Carlo Quinto in Olmo*, a long verse lauding Charles' triumph over the Protestant League published in 1567, offers a characterization of the equestrian emperor that is particularly close to Giambologna's representation of Cosimo.[47] Like the image of Charles in the print, Cosimo is shown in armor, but he is bare-headed and holds a field-marshal's baton loosely in his right hand so that it rests against his thigh and seems to support his arm. Oliviero's print of Charles passing through a triumphal arch in Ulm appeared twice in the volume which was dedicated to Phillip II. The text described the temporary triumphal arch and other decorations set up to honor Charles' *adventus* into the city and concluded with a long poem written in honor of "I gran fatti di Carlo Quinto nostro padre."[48] In dedicating to his own father an equestrian monument that characterized him as a Christian knight warring against heretics, Ferdinando was explicitly following imagery associated with the Holy Roman Emperor Phillip II's commemoration of his own father.

The base of Cosimo's monument is the first executed support for a public monument in early modern Europe that displays a sequence of large narratives. The lack of precedent made the genesis of the reliefs complicated, as comparison between the extant terracotta *modello* of the base and the executed version indicates.[49] During the planning process it must have become obvious that the proportions of the model's low base should be adjusted in order to raise it so that the narratives on its sides were displayed at maximum advantage and visibility—at just the appropriate height to invite the gaze of passersby in the piazza from whichever angle they approached.[50] The example of the projected tall base for the Charles V equestrian statue may well have contributed to this modification.

Whereas the *modello* indicated a plan for two narratives on the long sides and no other figurative ornament, the executed base has three narratives: two on the sides, a third on the back, and an inscription plaque on the front. The sculpted narratives were converted wholly to history, not allegory and history. The *modello*'s relief of Cosimo surrounded by figures representing the arts was dropped. Its other subject, an allegory of the inauguration of his reign (Figure 8.4), was changed into an event, *Cosimo's Election by Florentine Senators in 1537*, and moved from the side of the *modello* and converted into the tall, convex format demanded by its new position on the back of the oval base (Figure 8.7). New subjects representing the other two key events in his political career were introduced: *Cosimo's Triumphal Entry into Siena*, which celebrated the conquest that led to Cosimo's formation of a Tuscan state, and *Cosimo's Coronation as Grand Duke*, his long sought elevation to the status of Grand Duke. Rather than a balance of Cosimo's political and

8.6 Engraved title-page of first edition of Antonio Francesco Oliviero, *Carlo Quinto in Olmo*

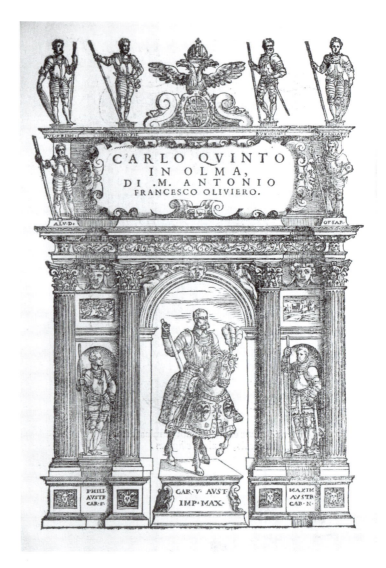

cultural roles as on the *modello*, the reliefs commissioned by Ferdinando presented to posterity a message of his father's consolidation of Medici dynastic rule.

The subjects allocated to the long sides, Cosimo's triumphal entry into Siena and Cosimo's coronation as Grand Duke of Tuscany by Pope Pius V, were presented on a huge scale (1 × 1.9 meters). Among the largest narrative bronzes created in early modern Europe, they included dozens of animated figures in complex and convincing three-dimensional interior and exterior spaces. In devising such complicated pictorial reliefs in bronze, Giambologna put himself in competition not only with the monuments in Florence's main civic space, but also with those in the city's other principal outdoor arena surrounding the Duomo and Baptistery and with the shrine of Florence's most

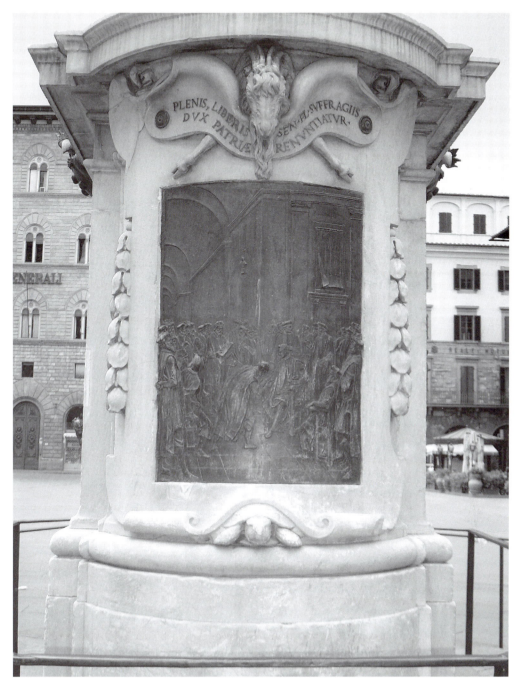

8.7 Giambologna, *Cosimo's Election by Florentine Senators in 1537*. Base of Equestrian Monument of Cosimo I

venerated native saint.[51] Ghiberti's second set of Baptistery Doors and Shrine of St. Zenobius in the Duomo, prestigious models that also suggested the seamless absorption of earlier Florentine history into the Grand Ducal period, provided many ideas for this compositional style.[52] Giambologna studied carefully and learned much from the innovations pioneered by Ghiberti, the long-acknowledged master of bronze relief. The sixteenth-century sculptor must have intended the greater scale, illusionism, clarity and dynamism of his narratives, and their more successful engagement of viewers, to trump Ghiberti's revered models.

The narratives are skillful articulations of the revisionist image of Cosimo's reign and of the Medici dynasty that Ferdinando intended to transmit to posterity. Recast from Ferdinando's perspective in the 1590s, they were calculated to restructure the memory of key events as Ferdinando wanted them immortalized. In order to accomplish this goal, the formats of the sculpted narratives were changed to make them seem firsthand, documentary visualizations that accurately reported what had happened. Rather than the *modello*'s format of a few large figures set in the foreground of an undefined space, the number of figures was increased and they were set into carefully detailed reconstructions of plausible settings. Figures of eyewitnesses, who validated the events, were added so that they overlapped the sculptures' boundaries and seemed to invite viewers' attention. To persuade spectators that the bronzes reported the events with painstaking accuracy even transient details like a curtain rippled by a breeze were introduced. At the same time, the compositions were ordered by linear perspective and figures arranged to make Cosimo seem to be the ineluctable center of a harmonious world and to convey that all participants agreed contentedly to the stages by which he gained control of a widening empire.

The relief on the back of the monument, showing the selection of the young Cosimo as head of the Florentine government in 1537, depicts groups of senators surrounding the seated youth, harmoniously united in their choice while one of their number pays him homage. Their numbers and the circle they form around Cosimo create a much more ceremonial and impressive rendition of the scene than Passignano's contemporary painting commissioned for the Salone dei Cinquecento by Ferdinando in 1597.[53] In the 1590s Ferdinando had no desire to recall, and certainly not to record for posterity, the frenzied politicking that ensued after the murder of Duke Alessandro, or the dissension about his successor, or any sign of the total control over the 17-year-old neophyte ruler that the Emperor Charles V intended to exert through his emissary in Florence, Cardinal Cibo, and a garrison of imperial troops. Instead, as Erben has shown, neither Cardinal Cibo nor Alessandro Vitelli, the commander of the garrison, is present. On the contrary, the narrative conflates into one event both Cosimo's election by the senators and the emperor's recognition of Cosimo as head of government many months later. The standing senator who gestures toward Cosimo, just behind the senator paying homage, holds a parchment that represents the

emperor's act of investiture.[54] The inscription affirmed the validity of what the scene falsely depicts: "He is proclaimed Leader of the Fatherland with a full and free vote." The Medici symbols of Capricorn and the tortoise frame the top and bottom of the relief and endorse its meaning.[55]

Cosimo's triumphal entry into Siena in 1560 covers the base's long south side. The event commemorates his victory of five years earlier, after a protracted war waged against the city on behalf of the emperor, and Cosimo's successful subsequent negotiation with Phillip II to rule Siena as a fief of the Spanish crown. Witnesses to the event described how Cosimo, Eleonora, and their sons Giovanni and Garzia, who entered Siena disbursing coins, were greeted by 50 children dressed in white carrying olive branches.[56] The relief instead shows Cosimo alone atop a triumphal cart towering over bound captives and surrounded by soldiers. A man in secular dress bends over a lion and she-wolf leashed together and pats the wolf as if to reassure Siena, the city she represents, that the lion of Florence is benign.[57]

The narrative is reconfigured as a triumphal procession *all'antica*, composed like Salviati's painting of Camillus's triumph inside the palazzo,[58] or like Scipio's victory procession in a famous tapestry series made for François I.[59] All follow the model of the ur-source of such triumphal imagery, the relief on the Arch of Titus in Rome. The inscription above, "Accepting the crushed Sienese enemies in surrender," confirmed the militaristic interpretation. The Medici shield framed by the chain holding the Order of the Golden Fleece is anachronistically topped by the crown with which Cosimo I was made Grand Duke ten years later and emphasizes his control over Tuscany.

Cosimo's *Coronation as Grand Duke of Tuscany* (Figure 8.8), was awarded the other highly prominent place on the base's north side. Like its counterpart on the other long side, the relief is surmounted by the Medici shield, emblem of the Golden Fleece, and crown. The relief's inscription, "Because of surpassing ardor for religion and devotion to justice," was taken from the inscription on the crown that was devised for the new rank, of which a design was included in Pius V's bull conferring the title. The bull explained that the Pope granted the rank because of Cosimo's service in fighting the Turks and in funding the wars against the Protestants.[60]

The relief depicts Cosimo kneeling before the pope receiving that crown before dozens of spectators who seem to testify to its accuracy; some even invite the viewer into their ambient. The crucifix on the altar at the perspective's vanishing point underscores the sacrality of the event.[61] This stately rendition of the event has nothing to do with the contemporary painted representation of it by Jacopo Ligozzi, commissioned by Ferdinando for the Sala dei Cinquecento in the palazzo.[62] Instead, the relief reflects a series of written and visual eye-witness sources to the event such as an engraving by Stradano, an illustration to a history of the Medici family published in 1583.[63] Not surprisingly, the visual records focus on Cosimo kneeling before the enthroned pope to the right of an altar and on the nearby spectators. Except for a drawing attributed to Passignano (Figure 8.9), they are tight close-ups of the group immediately

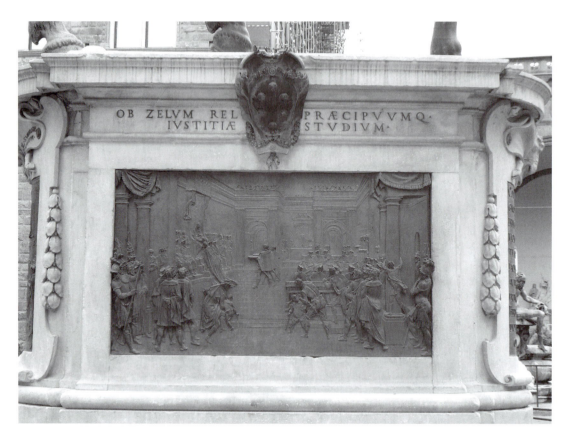

OB ZELVM REL PRÆCIPVVMQ·
 IVSTITIÆ STVDIVM·

8.8 Giambologna, *Cosimo's Coronation as Grand Duke of Tuscany*. Base of Equestrian Monument of Cosimo I

surrounding Cosimo and the pope. Passignano's drawing sets the core group within a longer view of the scene and includes many more members of the audience seated or standing on both sides of the chapel, while others crouch or dangle from columns in the foreground. He also opened up the vista by representing a full view of the chapel's rear wall.

The consistency of the representation of the central episode—Cosimo's coronation by Pius V—has camouflaged the fact that Passignano, and even more clearly Giambologna, depended on Raphael's fresco in the Vatican of the *Donation of Constantine* (Figure 8.10). Both animated their compositions by borrowing from the fresco excited onlookers such as the man who grabs a column for support as he leans forward to see better, or the small child barely restrained by his crouching mother. The horizontal field of Raphael's scene was well suited to Giambologna's long sculpted relief. There was room for a turning soldier on both sides of the relief who looks out to involve the passerby, a device that seems inspired by Raphael's elegantly dressed man at the right edge of the scene of Constantine. Giambologna used the painting's expansive setting as a model for the deep, wide space of the chapel in the *Coronation*. Both fresco and relief stage their scenes within a deep interior in linear perspective that recedes toward the altar. The height of the space is emphasized by repeated vertical supports within whose intervals spectators are posed.

Giambologna was inspired by the view of more figures behind the altar screen in the *Donation* to open up the rear wall of his chapel with the illusion of subsidiary spaces and still more attendees. He also adapted Raphael's motif of perching a bevy of spectators on the edge of the altar wall's large round window and posed crowds overlooking a balustrade atop the rear wall of the chapel where Cosimo's coronation takes place.

8.9 Attributed to Passignano, drawing of *Cosimo's Coronation as Grand Duke of Tuscany*

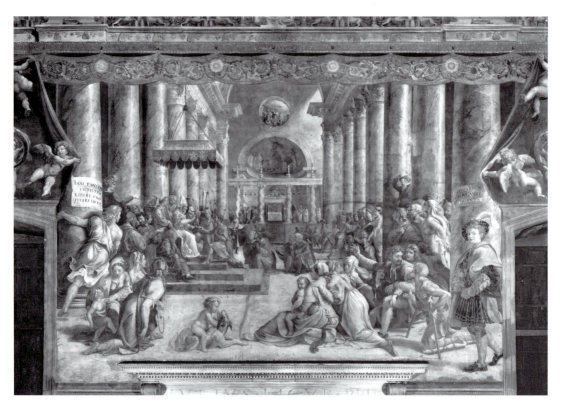

8.10 Raphael, *Donation of Constantine*

The allusions to the *Donation of Constantine* were self-consciously calculated: the episode was the single most famous encounter ever between a pope and a ruler. Their meeting involved the emperor granting Pope Sylvester (and his successors) the right to rule over the Papal States, a privilege inverted in the scene of Pius V's awarding to Cosimo the right to rule over Tuscany as Grand Duke. Raphael staged the legendary event in a setting that suggests St. Peter's; Cosimo's coronation was held in the nearby Sistine Chapel in the Vatican, by then the papal palace. Raphael's painting was part of the cycle in the Sala di Costantino in the Vatican. The papal and imperial connections to the donation, and its representation by Raphael, meant that references to it reinforced the presentation of Cosimo as a ruler of great status and validated the Grand Duchy he established. Nothing in the relief betrays that the pope actually had no power to grant this title, that it was the exclusive prerogative of the emperor, and that emperor only grudgingly acknowledged its validity five years later, after Cosimo's death.[64] The monument purposefully constructed a contrary scenario: above the coronation narrative dangles the chain of the Order of the Golden Fleece, emblem of the elite rank of Christian knights to which Charles V offered Cosimo I membership in 1546, decades before his disputed coronation as Grand Duke. Entwined around the Medici shield, it seems to lend its weight to the scene's version of events.

In commissioning this prominent public monument honoring his father Cosimo, Ferdinando aimed above all to celebrate and perpetuate the Medici dynasty's hold on power in Florence. Cosimo was commemorated as the founder of the Grand Duchy. The sculpted narratives on the statue's base marked the key stages in his accumulation of power that led to its establishment. Ferdinando had learned from ancient writers the hallmarks of monuments meant to immortalize gods and heroes—prominent civic sites, colossal scale, bronze or marble materials, identifying inscriptions and narratives—and that these had sometimes served to craft for mere mortals a glorified legacy to posterity. Accordingly, he appropriated to the depiction of Cosimo and the narratives a visual language that evoked Mars, the legendary founder of Florence, the Roman emperor Marcus Aurelius, and the Holy Roman Emperor Charles V. The crucial landmarks of Cosimo's political career were presented according to a revisionist perspective. Historical accuracy was secondary to ideological goals, but the fictional reworking of the episodes was disguised by the sculptures' reportorial presentation. Events were recast to make it seem as though Cosimo's course to coronation as Grand Duke was ineluctable, approved by contented citizens, and sanctioned by emperor and pope alike. Cosimo's commemoration as a Christian knight, an identification consonant with Counter-Reformatory ideals, was appropriated from the visual language that Charles V's advisers had devised for the emperor to create the image of a fearless, invincible military leader intent on preserving, even extending, the Christian empire. To validate this visual metaphor, the narratives on the statue's base recounted Cosimo's consolidation of a Christian empire in Tuscany, and his coronation by a pope grateful for his work on behalf of the Church. The inscriptions testified to the most long-lived interval of rule over Florence ever achieved by the Medici family, even as symbols like Capricorn and the coronation crown, which hung over the sculpted reliefs and inscriptions, suggested the dynasty's continuation through the centuries. The patron Ferdinando and his sculptor Giambologna collaborated to produce a sculptured memorial that revised the history of Medici Grand Ducal rule and continues to promulgate the dynasty's fame long after the demise of its dominion in Tuscany.

Notes

1 The letter of Simone Fortuna, the representative of the Duke of Urbino in Florence, written to the duke on October 27, 1581, divulged that Giambologna was casting a bronze horse that was to be twice as large as the steed ridden by Marcus Aurelius in his equestrian monument on the Campidoglio in Rome. The letter from Johann Wilhelm (Giovanni Gaye, ed., *Carteggio inedito d'artisti dei secoli XIV, XV, XVI* (Florence: G. Molini, 1840), 3: 440–44), was republished in Elisabeth Dhanens, *Jean Boulogne – Giovanni Bologna Fiammingo: Douai 1529– Florence 1608* (Brussels: Paleis der Academiën, 1956), 345–6. The letter does not indicate whom the monument was intended to honor. The sculpture was still in

the planning stages almost three years later; another letter from Fortuna to the duke dated April 2, 1583 revealed the continuing desire of Ferdinando's brother and predecessor, Duke Francesco I, to have Giambologna create a horse of that size. See Paola Barocchi and Giovanna Gaeta Bertelà, eds, *Collezionismo mediceo: Cosimo I, Francesco I e il Cardinale Ferdinando: documenti 1540–1587* (Modena: Franco Cosimo Panini, 1993), 180–83, for the first letter, which she dated to October 27, 1580, and 240–41, for the second letter.

2 Filippo Baldinucci, *Notizie dei professori del disegno da Cimabue in qua* (1681; reprint, Florence: S.P.E.S., 1974–75), 107; republished in Dhanens 1956, 384. On the date, see the additional documentary materials cited by John Pope-Hennessy, *Italian High Renaissance and Baroque Sculpture* (4th edn, London: Phaidon, 1996), 493, and Dietrich Erben, "Die Reiterdenkmäler der Medici in Florenz und ihre politische Bedeutung," *Mitteilungen des Kunsthistorischen Institutes in Florenz* 40 (1996): 355, doc. 1. See *ibid.*, 355–7, for excerpts or summaries of the most important already published documents concerning the monument.

3 Iodoco del Badia, *Della statua equestre di Cosimo I. de Medici modellata da Giovanni da Bologna e fusa da Giovanni Albergatti per le nozze Bellini Delle Stelle e Magnani; documenti inediti* (Florence: Bencini, 1868), doc. 1, and Hans Semper, "Dokumente über die Reiterstatue Cosimo's I von Giovanni Bologna," *Jahrbücher für Kunstwissenschaft* 2 (1869): 83–7, published the documents, which also indicated that the casting was supervised by the Venetian specialist Giovanni Albergetti.

4 The front of the base bears a prominent bronze eulogy in Latin, which can be translated: "To Cosimo, the first Grand Duke of Tuscany, pious, fortunate, unconquered, just and merciful, promoter of holy wars and of peace in Tuscany, Ferdinando, his son and third Grand Duke, erected this to the most excellent prince, his father, in 1594." The statue is also signed and dated on the reins held by Cosimo: "IHOAN BOLOG BELGA / ETA SUE A 65 AN 1594."

5 The dates were established by an entry in Francesco Settimani's diary, *Memorie fiorentine dell'anno MDXXXII … infino all'anno MDCCXXXVI …*, 5: fols 373r–v (Archivio di Stato, Florence, Manoscritti 125–47). The citation from Settimani's *Memorie*, 5: fols 373r–v was first published by Semper 1869, 83–4, and republished by Dhanens 1956, 276, n. 2 and by Erben 1996, 357, doc. 11.

6 Dhanens 1956, 361, published a letter written by Girolamo Seriacopo, the superintendent of the Florentine *castello*, which established that the narrative scenes were underway in 1596 and cast in 1598. Erben 1996, 357, doc. 13, first published a document that proved the inscription was also cast by 1598.

7 The examination of the sculpture by Mary Weitzel Gibbons, "Cosimo's *Cavallo*: A Study in Imperial Imagery," in *The Cultural Politics of Duke Cosimo I de'Medici*, ed. Konrad Eisenbichler (Aldershot and Brookfield: Ashgate, 2001), 77–95, added a different interpretation. She connected the poses of the rider and horse to the highly disciplined art of riding as it was practiced by the nobility in the sixteenth century, and to the symbolism of aristocracy and political control conveyed by such equestrian training. Erben 1996, 286–318, is important particularly for its insightful evaluation of the relief sculptures on the base.

8 For the legacy of the monument of Cosimo I, see Ulrich Keller, *Reitermonumente absolutistischer Fürsten. Staatstheoretische Voraussetzungen und politische Funktionen* (Munich: Schnell and Steiner, 1971).

9 On the equestrian monument that Ferdinando commissioned to honor himself, see Erben 1996, 332–45.

10 On Ferdinando's patronage of sculpture outside Florence, see Katherine T. Poole, "The Medici Grand Dukes and the Art of Conquest: Ruling Identity and the Formation of a Tuscan Empire, 1537–1609," Ph.D. dissertation, Rutgers University, 2007.

11 See Martha Alice Fader, "Sculpture in the Piazza della Signoria as Emblem of the Florentine Republic," Ph.D. dissertation, University of Chicago, 1977; Kathleen Weil-Garris, "On Pedestals: Michelangelo's *David* and Bandinelli's *Hercules and Cacus* and the Sculpture of the Piazza della Signoria," *Römisches Jahrbuch für Kunstgeschichte* 20 (1983): 377–415; and Sarah Blake McHam, "Public Sculpture in Renaissance Florence," in *Looking at Italian Renaissance Sculpture*, ed. Sarah Blake McHam (Cambridge: Cambridge University Press, 1998), 158–80.

12 On the *Marzocco*, see Geraldine A. Johnson, "The Lion in the Piazza: Patrician Politics and Public Statuary in Central Florence," in *Secular Sculpture, 1300–1500*, ed. Phillip Lindley and Thomas Frangenberg (Stamford: Shaun Tyas, 2000), 54–71. On the Republic's transfer of *Judith* from the Medici Palace to the Piazza and the new inscriptions carved onto its base, see Francesco Caglioti, *Donatello e i Medici. Storia del David e della Giuditta* (Florence: Leo S. Olschki, 2000), 1: 291–311.

13 Virginia Bush, *Colossal Sculpture of the Cinquecento* (New York: Garland, 1976), first analyzed the sixteenth-century Italian fascination with colossi, which she defined as twice life-sized (p. xxviii); see *ibid.*, 99–118, on the *David*. Of the sculptures in the piazza, she considered Bandinelli's *Hercules and Cacus*, Ammanati's *Fountain of Neptune*, and the equestrian monument to Cosimo as colossi; see *ibid.*, 119–30; 143–52; 194–7. Cellini's sculpture of *Perseus* and Giambologna's *Rape of the Sabines* use a vertical stacking of figures and high bases to create imposing sculpture ensembles that seem larger than life.

14 *Ibid.*, 7–11.

15 Plin. *NH* 34.39–46, offered a list of the gods honored with colossal sculptures that terminated with Nero's commission. Pliny noted approvingly that after the emperor's disgrace, the portrait was converted into a statue dedicated to the Sun. See Plin. *NH* 33–5, trans. H. Rackham (Cambridge: Harvard University Press, 1999), 156–61.

16 Vincenzo Borghini, *Discorsi* (Florence: Pietro Gaet. Viviani, 1755), 1: *Dell'origine della città di Firenze*, 168–9: "… colossi, e non soglian dire gigante, che tali, ed agl'Iddii, e agli Eroi per magnificenza, solevan porre quasi accennando che intanto fusser soprastati al valore degl'altri nell'animo, quanto ce gli rappresentavano maggiori nella statura del corpo." The reference was cited by Bush 1976, 4.

17 "E nel tempo che stette il Cavallo senza la statua, fecero esperienza quanti homini vi stavano dentro, e vi entravono fino al n.º 23 per dove è la sella, ed altri scrissero fino al n.º 24. Et il Cavallo fu gettato tutto di un pezzo nella via di Pinti …." The citation is from Settimani's *Memorie*, 5: fols 373r–v. See above, note 5. Settimani's account has never been questioned but it seems incredible. The horse is not large enough to accommodate more than 20 men and, to my knowledge, the casting of the horse in one pour has not been corroborated. Although Settimani presents it as eyewitness testimony, it may be hyperbolic flattery of Medici achievement.

18 Bush 1976, 25–38, cited a series of descriptions of supposedly monolithic colossi by ancient Greek and Roman authors such as Pliny the Elder, Pausanias, Strabo, Herodotus, and Diodorus, and sixteenth-century sculptors' efforts to rival that technical feat in marble and bronze.

19 Settimani provided the information that the horse and rider's weight was recorded by some as 28,200 *libbre*, by others as 23,154 *libbre*. See note 5.

20 Simone Fortuna's letter of October 27, 1581 (see note 1) described its intended location as "a fronte del gigante di Mich. Agnolo."

21 A letter by Gian Vettorio Soderini of December 21, 1587 confirmed the position indicated by the map. It specified that "Giambologna da Dovaia, che li spiegò l'intenso suo desiderio havuto sempre di voler fare un cavallo di getto, maggiore per ogni verso un terzo di braccio di quel di Roma [the Marcus Aurelius monument] da collocarsi sulla piazza della Dogana dirimpetto alla fronte." The Piazza della Dogana is the space in front of the Piazza della Signoria's north side outside the Cortile della Dogana. The excerpt of the letter was republished in Erben 1996, 355, doc. 1.

22 The map depicted the rider on a rearing horse. I pursue the investigation of the monument's site in a forthcoming article.

23 For the plaque, executed in 1599–1600 by Bernardino Gaffurri and Jaques Bylivelt, see the catalog entry by Martha McGrory in *The Medici, Michelangelo, and the Art of Late Renaissance Florence* (New Haven and London: Yale University Press, in association with the Detroit Institute of Arts, 2002), 257–8, cat. no. 114.

24 Although the *Judith* was likely originally commissioned by the Medici and stood in their palace for decades, it was transferred to the piazza by the republican government that overthrew the family.

25 Erben 1996, 300, noted the head's similarity to a bronze bust of Cosimo cast by Giambologna c. 1550, now in the Uffizi.

26 See Gibbons 2001, 86, and Sarah Blake McHam, "Donatello's Bronze *David* and *Judith* as Metaphors of Medici Rule in Florence," *Art Bulletin* 83 (2001): 36–8. Pliny was explicit about the didactic value of inscriptions on the bases of public monuments. In *NH* 34.17, he wrote:
 … the custom proceeded to arise [6th c. BC] of having statues adorning the public places of all municipal towns and of perpetuating the memory of human beings and of inscribing lists of honors on the bases to be read for all time, so that such records should not be read on their tombs only.
 His description of the usefulness of narrative reliefs in transmitting the fame and inspiring viewers to emulation is more indirect. For example, in *ibid.*, 36.19, he extolled the chryselephantine colossus of *Athena Parthenos* by Phidias and made clear his admiration for the narrative relief sculpture on its base "… on the pedestal there is carved what is entitled in Greek the Birth of Pandora, with twenty gods assisting at the birth …."
 In *ibid.*, 34.27, he recorded the practice in ancient Greece and Rome of erecting statues of heroes atop triumphal arches, monuments that were typically decorated with inscriptions and narrative relief sculptures. The reader could readily infer from the brief account that in these cases the triumphal arch functioned as a sort of pedestal that displayed in text and image the deeds worthy of transmission to posterity.
 For a sustained analysis of Pliny's influence on the art and theory of the Italian Renaissance, see my forthcoming book on the subject.

27 See McHam 2001, 36–8, for specific material about Pliny's discussion of the *Tyrannicides*. Herodotus and Thucydides gave them no credit. See Herodotus, *Histories*, trans. Robin Waterfield (Oxford: Oxford University Press, 1998), 6: 123, 395. Thucydides was scathing: "The Athenian public generally believe that Hipparchus was tyrant when he fell by the hands of Harmodius and

Aristogiton. They do not know that Hippias, the eldest of the sons of Pisistratus, was really supreme; that Hipparchus and Thessalus were his brothers; and that Harmodius and Aristogiton suspecting on the very day – indeed at the very moment fixed for the deed – that information had been conveyed to Hippias by their accomplices, concluded that he had been warned. They did not attack Hippias but, not liking to risk their lives and be apprehended for nothing, they fell upon Hipparchus near the temple of the daughters of Leos, and slew him as he was arranging the Panathenaic procession" (*The Landmark Thucydides: A Comprehensive Guide to the Peloponnesian War*, 1.20, trans. Richard Crawley, rev. ed. Robert B. Strassler (New York: Simon and Schuster, 1996), 14–15).

28 *Ibid.*, 1.20, 14.

29 See Charles M. Rosenberg, *The Este Monuments and Urban Development in Renaissance Ferrara* (Cambridge: Cambridge University Press, 1997), 54–82.

30 On the history of the monument, see Bush 1976, 165–70, and *Leonardo da Vinci's Sforza Monument Horse: The Art and the Engineering*, ed. Diane Cole Ahl (London: Associated University Presses, 1995).

31 See Rosenberg 1997, 153–72.

32 See Anatole de Montaiglon, *Notice sur l'ancienne statue équestre de Louis XIII* (Paris: Charavay Frères, 1874–96), 9–49 and Bush 1976, 175–9.

33 See Werner Gramberg, *Die Düsseldorfer Skizzenbücher des Guglielmo della Porta* (Berlin: Gebr. Mann Verlag, 1964), 1: 76–8, cat. no. 134; 81–4, cat. no. 141, and 118–20, cat. nos 223 and 224. In 1549 or 1550 agents of Pope Paul III and the Emperor Charles V had first asked Guglielmo to devise an equestrian monument to the emperor. Plans for that statue were revived after Charles' death in 1558 and expanded: the equestrian monument was to function as a tomb and be situated within a *tempietto*.

34 See Piero Degl'Innocenti, *Le origini del bel San Giovanni da Tempio di Marte a Battistero di Firenze* (Florence: CUSL, 1994), 76–81.

35 Venceslao Santi, "La precedenza tra gli Estensi e i Medici e *l'Historia de' Principi d'Este* di G. B. Pigna," *Atti e memorie della Deputazione Ferrarese di Storia Patria* 9 (1897): 37–122, and Robert Williams, "The Sala Grande in the Palazzo Vecchio and the Precedence Controversy between Florence and Ferrara," in Eisenbichler 2001, 163–80 (with additional bibliography).

36 See Robert Williams, "Vincenzo Borghini and Vasari's 'Lives,'" Ph.D. dissertation, Princeton University, 1989, 46–51.

37 *Ibid.*, 85–110. Borghini's examination of the Baptistry revealed that a single fluted column on the building's interior wall was a replacement substituted for a column moved to the Mercato Vecchio in 1429–30 to support Donatello's *Dovizia*. To prove his argument, Borghini also had that column measured; see his notes on this point, *ibid.*, 284–6, appendix 8. On the column's transfer to the Mercato, see Margaret Haines, "La Colonna della *Dovizia* di Donatello," *Rivista d'arte* 37 (1984): 348–59.

38 Williams 1989, 80–81, where the author also noted that the inclusion of the scenes of Cosimo's military valor and apotheosis in the center of the ceiling could have been a response to the Este's claims about their more venerable feudal titles. See Williams 2001, 169–79, for other influences of the precedence controversy on the program.

39 On Florentine claims to a Roman foundation as visualized in this painting, see Nicolai Rubinstein, "Vasari's Painting of the 'Foundation of Florence' in

the Palazzo Vecchio," *Essays in the History of Architecture Presented to Rudolf Wittkower*, ed. Douglas Fraser, Howard Hibbard, Milton Lewine (London: Phaidon, 1967), 64–74.

40 See James Ackerman, *The Architecture of Michelangelo* (Chicago: University of Chicago Press, 1986), 159–63. Note the reference to the statue in the documents planning Cosimo's monument (see note 1).

41 For a full discussion of the connotations of the statue's transfer to the site, see Wolfgang Liebenwein, "Antikes Bildrecht in Michelangelos 'area capitolina,'" *Mitteilungen des Kunsthistorischen Institutes in Florenz* 28 (1984): 1–32.

42 On the *modello*, see *Earth and Fire: Italian Terracotta Sculpture from Donatello to Canova*, ed. Bruce Boucher (New Haven: Yale University Press, 2001), 176–7, cat. no. 34. On Michelangelo's base, see Bruno Contardi, "Michelangelo, 1538," *Bollettino dei Musei Comunali di Roma* 6 (1992): 5–27.

43 Gramberg 1964, 1: 76–8, cat. no. 134 and 81–4, cat. no. 141. I thank Margaret Kuntz for bringing the monument to Charles V to my attention.

44 See Michael P. Mezzatesta, "Marcus Aurelius, Fray Antonio de Guevara, and the Ideal of the Perfect Prince in the Sixteenth Century," *Art Bulletin* 66 (1984): 620–33.

45 *Ibid.*, 621–4, discussed the interpretation and influence of Marcus Aurelius' gesture in sixteenth-century ruler portraiture.

46 John F. Moffitt, "The Forgotten Role of a 'Determined Christian Knight' in Titian's Depiction of Charles V, Equestrian, at Mühlberg," *Gazette des Beaux-Arts* 137 (2001): 37–51.

47 See *ibid.*, 46–50, where the engraving and text are related to Titian's *Portrait of Charles V* of 1548 (Prado, Madrid), not to the Cosimo I monument.

48 *Ibid.*, 48.

49 Boucher 2001, 176–7, cat. no. 34, argued reasonably that the *modello* must date c. 1590, early in the monument's planning and before the marble base was installed in the piazza. Excavations for the monument's substructure began in 1591, the marble base was commissioned in 1592, and the horse and rider installed on it in 1594. See the documents excerpted in Erben 1996, 355–7, docs 3–11.

50 The two sculpted narratives on the sides of the base measure approximately 1 × 1.9 meters. The reliefs on the front and back of the base are each about 1 × 0.75 meters. The base is 2.7 meters high, a bit more than 3 meters long, and 1.5 meters wide, so the narratives and inscription are easily read by viewers standing nearby in the piazza.

51 See James Holderbaum, *The Sculptor Giovanni Bologna* (New York: Garland, 1983), 293–304, for a careful stylistic analysis of these relief sculptures and the sixteenth- and seventeenth-century painted and sculpted sources on which Giambologna drew and which he influenced.

52 Mary Weitzel Gibbons, *Giambologna: Narrator of the Catholic Reformation* (Berkeley: University of California Press, 1995), 115–22, related the relief style Giambologna invented for religious narratives to Ghiberti's precedent on the Baptistry Doors.

53 See Ugo Muccini, *The Salone dei Cinquecento of Palazzo Vecchio* (Florence: Casa Editrice Le Lettere, 1990), 168; 179 (color illustration).

54 See Erben 1996, 304–9.

55 See Janet Cox-Rearick, *Dynasty and Destiny in Medici Art: Pontormo, Leo X and the Two Cosimos* (Princeton: Princeton University Press, 1984), 214–16, on Capricorn as Cosimo's symbol and its associations with Augustus and the birth of Christ, and 280, for his *impresa*, the tortoise and sail, also connected with Augustus. Capricorn overhangs the dedicatory inscription on the front of the base while the tortoise and sail support it.

56 See Agostino Lapini, *Diario fiorentino di Agostino Lapini dal 252 al 1596*, ed. Odoardo Corazzini (Florence: G. C. Sansoni, 1900), 130.

57 Erben 1996, 309, first made this observation.

58 *Ibid.*, 311, emphasized the relation to Salviati's painting of Camillus, an early Roman victor in Etruria, and so an apposite model for Cosimo's imagery.

59 The cycle of the *Triumphs of Scipio*, for which Giulio Romano provided the drawings, was finished by 1535. One of the most famous tapestry cycles of the sixteenth century and a commission of the French king, it likely influenced both Medici projects, Salviati's interpretation of Camillus's victory procession and Giambologna's sculpted relief of Cosimo's triumph. On the tapestry, see Janet Cox-Rearick, *The Collection of Francis I: Royal Treasures* (New York: Harry N. Abrams, 1996), 377–83.

60 For Ferdinando's commission of 1591 to Ligozzi, see Muccini 1990, 167, 169 (color illustration). The papal bull was accompanied by a drawing stipulating the appearance of Cosimo's Grand Ducal crown. It was published by John F. Hayward, "An Eighteenth-Century Drawing of the Grand-Ducal Crown of Tuscany," *Burlington Magazine* 97 (1955): 308–10. Erben 1996, 312, first connected the *Coronation* relief's *titulus* to the crown's inscription.

61 See Susanna Pietrosanti, *Sacralità Medicee* (Florence: Firenze Libri, 1991), 13, on the Medici rulers' lack of sacral authority. Her book traced how Cosimo, as a consequence, imitated throughout his career the rituals and symbols validated by legitimate rulers like the Holy Roman Emperor.

62 Erben 1996 logically accounted for the number and consistency of the visual sources in terms of the relatively recent date of the coronation. More important, however, in my opinion, was the coronation's role as the crucial episode establishing the Grand Duchy and the commissioner Ferdinando's own status as hereditary Grand Duke, hence the dependence on Raphael's canonical version of the papal/imperial theme in the *Donation of Constantine*.

63 See *ibid.*, 314–18, for illustrations of Stradano's engraving, a drawing by Passignano, and an illustration that copied Poccetti's version of the scene.

64 Pietrosanti 1991, 68–85.

Pirro Ligorio's Roman fountains and the concept of the antique: investigations of the ancient nymphaeum in Cinquecento antiquarian culture

Robert W. Gaston

Our contemporary studies of the patronage of sculpture during the Italian Renaissance often entail the attempt to "reconstruct" the acts and motivations of patrons from such fragmentary sculptural and textual evidence as survives.[1] While the intrinsically imaginative character of such reconstruction is seldom acknowledged, lest that undermine the historicity of the enterprise, it is fascinating to meditate on the strength we attribute to the metaphor of reconstruction, and how this uncannily mirrors the creative acts of reconstruction we tend to attribute to Renaissance sculptors and draftsmen confronted with the art of Roman antiquity. Reconstruction, understood as the creative re-making of the partially or temporarily "lost" world of classical antiquity, is also a term aptly applied in modern scholarship to describe the activity of the Renaissance antiquarian. He might have been a humanist scholar, otherwise gainfully employed in one of a variety of professions, but often was a craftsman who had daily experience with unearthing and trading the artifacts that came to light during the ruthless destruction of the buried fabric of the ancient city in the late Quattrocento and first half of the Cinquecento. Despite more than a century of brilliant research into this process, initiated by classical archaeologists seeking to "reconstruct" the edifices and monuments devastated in the building of early modern Rome, the task remains almost overwhelming in its complexity for scholars working in the modern disciplines.

Patronage of many kinds played a vital role in both the disinterment of the ancient city and its sculpture, and in the commissioning of palaces and villas that were to use those artifacts in their representational programs. Finding an intact group of sculptures could inspire a contemporary installation, developing the theme. Or fragments, with their tantalizing potential for imaginative restoration, could spark a programmatic reaction in sculptors

and antiquaries that could be communicated to a patron eagerly anticipating garden fountains, nymphaea, or sculpture courts displaying a sufficiently "authentic" classicism.[2]

One of the leading practitioners who worked on the creative borderlines between excavation, dealing in antiquities, and designing classicizing buildings and their sculpture gardens, was the Neapolitan artist Pirro Ligorio (1513–83), who arrived in Rome as a painter c. 1534.[3] In 1549 Ligorio became *antiquario* to Ippolito II Cardinal d'Este, the Cardinal of Ferrara, and from 1550 worked on designing the Villa d'Este and its gardens for more than a decade, with some interruptions. As architect to popes Paul IV and Pius IV, for whom he designed and built the Vatican garden Casino, Ligorio was involved in the siting and construction of villas and in the establishment of their water supplies, both for drinking and for waterworks in the gardens. He therefore had a professional interest in the debates regarding local waters and their characteristics. He saw the popes and cardinals recreating aspects of the Roman imperial water supply to the modern city, and to new suburban villas like the Villa Giulia. His defense of the qualities of the waters of Tivoli and Rome in his antiquarian volumes was patently connected with his ongoing commitment to his eminent patrons.

The labor entailed in preparing the *Edizione nazionale* of the antiquarian manuscripts of Pirro Ligorio, which is now in progress, is immense. There is not a volume untainted with the alleged forgery of coins and inscriptions, with an imperfect comprehension of Latin and Greek, the misidentification of iconography, and the imaginative reconstruction of excavated artifacts. Ligorio was an eyewitness in Rome (c. 1534–68) to the major sixteenth-century excavations of the ancient city and recorded in words and images hundreds of unearthed buildings and thousands of artifacts with their find-spots and collectors. But only in the past two decades have specialists in Greek and Roman epigraphy, numismatics, sculpture, and architecture become more open-minded about reassessing Ligorio's antiquarian manuscripts. Some classical archaeologists have moved away from the rigidly positivist model of the discipline developed by the editors of the *Corpus Inscriptionum Latinarum* (hereafter *CIL*) in the nineteenth century. A formerly despised antiquarianism has lately become a subject of serious historical investigation among the historical disciplines, and in this art history has led the way.[4]

While the art historians Erna Mandowsky and Charles Mitchell initiated the study of the internal logic of Ligorio's methods of "restoring" excavated Roman artifacts in his drawing process, Anthony Grafton's more recent work on the cultural psychology of Renaissance textual forgery, which has revealed how forgery paradoxically advanced philological method, may be used to facilitate a deeper exploration of Ligorio's alleged forgery of rediscovered antiques and inscriptions.[5] The neglected archaeological underpinnings of modern art history were originally forged in Ligorio's day. He contributed in his own planning of villas, their gardens and waterworks, to the formation of the influential paradigm that the antique stream in Renaissance visual

art was always a positive, inspiring force for artists. Artists doubtless had a professional interest in suggesting that the collecting habits of their patrons fed smoothly into the productive processes of Renaissance art. Yet Renaissance artists demonstrably had agonistic, troubled relations with excavated works of classical art.[6] Ligorio's antiquarian scholarship provides an historical ideology both for artist and patron, a rationale for excavating and collecting, and for the imaginative adaptation of antiques by artists creating in conscious competition with classical artifacts.

The manuscript of Ligorio I am editing, Biblioteca Nazionale, Napoli, cod. XIII. B. 9 (hereafter Naples 9), was Book 40 of Ligorio's first corpus of Roman antiquities.[7]

This manuscript is almost devoid of illustration, and while its title refers to "images of rivers and of fountains … and lakes" it contains scarcely any explicit information about Ligorio's activities in designing waterworks. Given that it was composed c. 1550–59, when he was formulating designs for Ipollito II d'Este's garden waterworks at Tivoli, stocking the cardinal's villa on the Quirinal Hill with antiques, and beginning work on the Vatican garden Casino "nymphaeum" for pope Paul IV, this silence is initially baffling. But we must pay attention to Ligorio's description of his book, which displays the several interlocking sub-systems that make up his logic of antiquarianism.

One subset is identifiable in the manuscript's title, which states that this book will deal with "some images of rivers and of fountains, and in particular will recount the names of them, and of lakes and other things worthy of memory among different nations." In modern terms it should encompass the Greco-Roman iconography of aquatic divinities and geographical nomenclature. But in keeping with Ligorio's emphasis on onomatology, many of the nearly 1100 entries in this alphabetical dictionary simply list the name of the water source, its geographical location, and a textual authority, mostly classical, for the latter. Other entries deal with the etymological, historical and mythological issues arising from the name itself. Here Ligorio overlays an imitated humanistic discourse that interrogates the orthography of manuscript and printed versions of classical texts, and explores their metamorphosis legends for the genesis of famous water sources. Ligorio sometimes adds an archaeological dimension to his analyses of images, saying that he has seen an artifact that represents a given type of image.

In all these patterns of investigative logic Ligorio follows the humanist philologists of his day. For humanists, names—with their numinous power inscribed in the Greco-Roman and Christian heritage of learning, and in the politics of a modern Rome dominated by families seeking their origins in the names and places of ancient Roman lineages—were symbols of a lost, lamented past, whose memory can somehow be resuscitated by the very act of naming.[8] Water names, place names, local divinities' names, Roman family names:[9] names embodied in sculptural figures or ensembles which visually represent the efficacy of ancient naming. Names inscribed on artifacts, either whole or fragmentary—these are for Ligorio testimony to the sacral presence of the

divine waters of the ancient Mediterranean cultures he seeks to reconstruct. Ligorio would have found confirmation of his approach in Vincenzo Cartari's *Le imagini con la spositione de i dei de gli antichi* (1556), where the humanist scholar connected the meanings attributed to the names of ancient water sources, the generation of their personifications, and their intrinsic physical properties.[10]

The impact of humanist geography on Ligorio can be measured in respect of his giving primacy to names in dealing with water sources. Ligorio cites Sebastiano Compagni's *Geographia ad Leonem X*, the manuscript completed in June 1509.[11] Compagni intended to set forth both the ancient and modern names of places and water sources, acknowledging that this was "an arduous and difficult, and one might say infinite, task," even when assisted by the classical geographers.[12] Compagni's work was modeled on Francesco Berlinghieri's *Geographia* (Florence, 1482), a vernacular poetic version of Ptolemy's *Geography* that appended an alphabetical index of place and river names at the close of each book.[13] This was predictive of the humanists who compiled encyclopedic dictionaries of Latin and Greek, from Niccolò Perrotti through to Henri Estienne, thus contributing to the emergence of the modern discipline of geography. One of Ligorio's key texts is Giovanni Boccaccio's *De montibus*, read by Ligorio in Niccolo Liburnio's translation (c. 1520), an alphabetical compilation naming many ancient water sources. Boccaccio recognized that the orthography of "the proper names of men, of places, of rivers" from the ancient world was available in corrupted forms, and that all he could rely upon were "the memories of the ancestors, and especially of the illustrious poets."[14] The humanist lexicographers also relied heavily on the texts of the *poeti illustri*. The genre of handbook compiled principally from such texts, the *dictionarium propriorum nominum*, such as that published by Robert Estienne (1541), and used repeatedly by Ligorio in Naples 9, ensured that the Greek and Roman "poetic" comprehension of waters would be safely enshrined in the linguistic consciousness of early modern geographers and antiquarians. Ligorio clearly felt licensed to use these dictionaries to relate his antiquarian vision of the lost or partially destroyed waterworks of ancient Rome, not that all of his supposedly discovered fountain structures in Naples 9 were fabricated from Greek and Roman literary examples.

Ligorio's prologue describes another of his logical subsets, which posits a metaphorical and theological comprehension of physical geography:

it is necessary to tell of the ... gods composed by men out of the marvelous nature of running waters, which, pouring from perpetual springs enrich the earth and bathe it and feed it as the veins to the human body, separating into branches, overflowing from the highest mountains, or being born from their roots, or spilling over broad fields, bring comfort to mortals from the abundance of crops; as pleased him who created all things, earthly and celestial, and gave all things to his creatures as universal Father; to whom I address my prayers that through his bounty he may grant me sufficient strength, that with my frail talent I might tell of all the springs and of all the rivers and ponds, which with their waters, as for ages past, will obey

the Creator, returning the waters to the sea, decorating the earth and yielding their abundance, whence they take it away, issuing from the hidden parts of the Earth holding its supports.[15]

In 1979 Marcello Fagiolo published an article fundamental to the study of water in Ligorio's antiquarian manuscripts.[16] Fagiolo argued that in Naples 9, and in later manuscripts, Ligorio developed an interpretation of water similar to the system used by scholastic theologians, giving water historical, tropological, allegorical, and anagogical meanings. Fagiolo rightly identified in Ligorio's proemium to Naples 9 "un crescendo retorico dalla fisica alla morale e alla metafisica" ("a rhetorical crescendo [passing] from the physical to the moral and to the metaphysical"). Using Ligorio's later manuscripts composed between 1568 and 1583 while he served the court in Ferrara, Fagiolo shows how Ligorio adapts the Greek and Roman idea of *Natura generante*: the waters continually feed the "macchina mundiale per generare le spetie de le sue grandi e maravigliose cose degne dell'opere di Dio Omnipotente" (machine of the universe to generate the species of its great and marvelous things worthy of the works of Almighty God). For Ligorio, water corresponds to the mythical "anima del mondo," and therefore a garden fountain can represent an allegory of human life, with a hierarchical descending system of rushing waters and basins. The perpetual cycle of waters in nature is interpreted anagogically as obeying the "misterioso disegno divino" (mysterious divine plan), and fountains in gardens similarly produce benefit and nourishment, which leads man to praise the ingenious inventive powers of both God and man. On the allegorical level, Ligorio links the mythical Graces with the notion of divine grace, viewed as an eternal fountain poured forth from inverted urns. The Graces are related to a "spatial cycle" of the waters operating between heaven and earth. In these later writings Ligorio views the ideal fountain as an image of the fluctuating opportunities and events of human life, now tempestuous, now tranquil, ebbing and flowing like the waters of nature. From this analytical base Fagiolo and Maria Luisa Madonna proceed to a series of brilliant studies of how such ideas underpinned Ligorio's planning of the garden fountains for the Villa d'Este and the Casino of Pio IV.[17]

In fact, however, as I will show in more detail in another publication, there is even more support for Fagiolo's argument in Naples 9 in respect of Ligorio's sacral logic of hydrology, and therefore even stronger written evidence for the presence during the 1550s of Ligorio's ideas about the mysterious nature of waters that become expressed monumentally in his designing of the Villa d'Este waterworks in those years. In a number of entries on ancient springs and rivers in Naples 9 Ligorio develops a consistent argument about cause and effect in nature, which may be drawn chiefly from Book Three of Seneca's *Quaestiones naturales*, a text readily available to him.[18] One of Ligorio's paradigmatic texts in Naples 9 is his entry on the river Anguis, the river in Arcadia whose Latin name Ligorio invents from the Greek Ophis (*serpente*). Ligorio claims that an image of the river-god appears on a reverse of a Severan

medal of the city Mantinea. There the river is shown "gnudo tutto eccetto che l'una coscia ha un poco di mantello sopraposto" (completely nude except for having a small amount of mantle covering one thigh). He continues:

The veil that they put from the waist downward on rivers in my judgment means the parts of the waters hidden under the mantle of the earth, and the nude part which is evident, and the folds of cloth the diversity of the earth and where it shows in the presence of men, just as the urn could mean the capacity and concavity that receives within the earth the water that perpetually gushes forth in the manner of a vase. For the ancients, not without reason or mystery made their images of the gods of water in such a way, denoting the uncertain part of the proper origin or principle to be covered under the earth, so as to demonstrate the difficulty that the secret and invisible things pose for uncouth men, which things are more evident to those who are inclined to study and speculation into the causes ordained by the eternal saving God. On account of this difficulty … the pagans discovered the way of exemplifying this example of the image of Jupiter half dressed and half nude, because as the Suda says, wishing to demonstrate that coarse and earthly men do not reach as high as they need with their intellect and intelligence, they represented Jupiter covered from the waist down in a mantle, and because the potency of He who governs and has created everything is well known to spiritual men, they made the body and chest uncovered, denoting that [to] the intellectuals the celestial force and potency whence they flow are not hidden.

Ligorio continues:

And they [the ancients] derive the goods given by the supreme deity, which though their bounty manifest their force in such a manner above the earth with the cause hidden within it, which nourishes and maintains every mortal thing, and provides and invests the soul with marvelous knowledge of the greatness of its creator and creative benefactor above all other perfection …[19]

In this passage, and in several others in Naples 9, Ligorio develops his theory of the often secret causes of the marvelous phenomena of the earth's flowing waters, that are cunningly represented in Greek and Roman iconography of the rivers, springs and lakes. While he nowhere says that he is currently applying such a theory in designing waterworks for his patrons, his patent concern in the volume with the qualities of the local waters that most directly connected with his water projects, at Tivoli and at the Vatican, is tacit evidence of his professional engagement with those significant projects. Ligorio is deeply committed to defending the potability of the Tiber, in support of most of the physicians working at the court of cardinal Alessandro Farnese, and in opposition to Giovanni Batista Modio, whose Il Tevere, of 1556, a work dedicated to cardinal Ranuccio Farnese, described the river as severely polluted and harmful to health.[20] Ligorio also explores in unprecedented detail in Naples 9 the qualities and characteristics of the various streams approaching, and passing Tivoli. In the case of the Tiber I would suggest that Ligorio perceives the potability of the river as a fundamental precondition of a healthy patronage market flowing from popes, cardinals, and other aristocrats who had intentions to build in the city and its suburbs, and to live there. Pope Julius III had water from Acqua Vergine conduits supplied to his villa on the

Via Flaminia (1551–55), but the supposedly beneficial qualities of the city's great river was manifestly an element of political propaganda, at least before Modio published.[21] Regarding Tivoli, Ligorio was obviously focused strongly on the plans of the cardinal of Ferrara to develop a princely estate with prodigiously expensive and brilliantly conceived waterworks. For these he had to identify the usability of the local water sources, develop a classicizing theory of waters emerging from distant or hidden sources, and frame all of that within an extreme consciousness of the specific Tiburtine locale, with its rich Roman history of rural villa life. Ligorio clearly set out to research the relationship of what we would call water and place.[22] If water meant the mysterious activity of divine sources that could either benefit or terrorize mankind, as they did for example in the spectacular Tivoli waterfalls, place meant the marvelous activity of local water gods, goddesses, and nymphs, whose lingering potency could be tapped by the modern patron, when illuminated by the natural philosophy of his learned antiquarian. After composing Naples 9 during the 1550s, and perhaps showing parts of it to his patron, one imagines, Ligorio's task, when the actual building program began after 1560, was to find sculptural forms *all'antica* that would represent the local pantheon of water divinities in action, as it were, summoning up the waters from the depths of the hills and spilling them forth in dramatic or amusing displays that symbolized their remarkable range of powers, on that very particular ancient site.[23] In Naples 9, composed when the cardinal had become governor of the territory, and when his antiquarian was already collecting excavated sculpture for the projected garden program, Ligorio was patiently laying the theoretical and scholarly foundation for his garden fountains, without actually showing his hand as the Villa d'Este mastermind. This silence was at once typical and uncharacteristic of him: typical in the sense that he never wrote in his antiquarian manuscripts about having planned every detail of the Casino at the Vatican until Pope Pius V began to dismantle its façade statues, and uncharacteristic because he was a pugnacious and egotistical antiquarian, always spoiling for a fight with the humanist "experts" on matters of ancient Roman topography.[24]

However, I must point out that in my preliminary study of Naples 9 I was mistaken in crediting to Ligorio himself the impressive range of competence in the classical texts displayed in the entries. I know now that most (but not all) of such information was plagiarized from humanist dictionaries, rather than arising from independent textual investigation. This is precisely what Antonio Agustín must have meant when he wrote to Fulvio Orsini in 1573, saying that Ligorio and other artist-antiquarians had, in citing many Greek and Latin books "utilize[d] the learning of others."[25] Ligorio did not name all the ancient and modern European water sources. Scarcely a single classical text has been searched systematically for its references to water. A number of famous rivers (for example the Nile) are omitted and some letters of the alphabet are overlooked. Several scholarly compilations of river, spring, and lake names available to Ligorio during the 1550s are not utilized.[26] And, curiously, the maps Ligorio produced during the years he composed Naples 9

(such as that of the Regno di Napoli) are considerably more detailed in their hydrography than the corresponding texts in Naples 9.[27]

Despite the paucity of drawing in Naples 9 it does have pronounced visual implications because, in his site descriptions, Ligorio combines the technical observation of an architect and cartographer with the philological techniques of humanistic geography. In treating Rome's water sources Ligorio departs from the list of rivers, lakes, bridges, ports, aqueducts, nymphaea and basins Onofrio Panvinio was proposing to describe in his *Epitome antiquitatum*.[28] In Naples 9 Ligorio avoids using the term "nymphaeum"—now universally used by classical archaeologists to denote waterworks that combine fountain and façade architecture—for any of the ancient Roman water structures he claims to have seen excavated. Ligorio refers to what modern scholarship calls the nymphaeum of Egeria as an *edificio*, "in the form of a temple … made of encrusted works, of minute stones and sea shells" ("di lavori incrostata, fatti di pietri minutissime et conchigli").[29] In speaking of a *fonte* on the Esquiline dedicated to a putative nymph Cypheniana, Ligorio refers to a sleeping nymph excavated nearby that Domenico del Nero gave to Pope Julius III, "who located it in *quel fonte de la villa Iulia*," again avoiding the term *ninfeo*.[30] In Naples 4, however, Ligorio used the term "lympheo del boschetto" ("of the little wood") to describe the *pallazzina* he began building in the Vatican gardens in 1558 for Paul IV and then completed for Pius IV.[31] The earliest document describing the project (April 30, 1558), however, referred to it as "una fonte con una loggia a canto et alcune camere" ("a *fonte* with a loggia and some rooms"), perhaps reflecting Ligorio's own initial preferred terminology.[32] Certainly Ligorio's later (Turin stage) explication of the interface between the terms *Musaeum* (a place dedicated to the Muses), *Lymphaeum* (places dedicated to nymphs presiding over *fonti*), and *Academie* (temples of the Muses such as Ligorio identified within the Villa Adriana complex)[33] represents a retrospective consciousness that the Vatican Casino, with its localized ancient Roman villa models and water-court, projected an *all'antica* authenticity that sought to exploit all levels of the Greco-Roman meanings of water allied with architecture.[34]

Why does Ligorio avoid the key term used by modern archaeologists for monumental fountain architecture in classical antiquity, and this in his volume specially devoted to water?[35] Ligorio certainly knew the regionary catalogues listing public "nymphaea" constructed in Rome by the later emperors.[36] He perhaps avoided the term early in his antiquarian research because he thought that *fons* was more appropriate in its latinity for describing water, spring, and fountain, including the fountain's architectural manifestations.[37] In Naples 9 Ligorio subtly differentiates the excavated Roman fountains he describes by the terms *fonte*, *fontana*, and *fonticello*, but it is often unclear what kinds of waterworks were involved. When he records an inscription it suggests the presence of architecture or a sculptural work bearing the inscription. Returning to the logic of Ligorio's antiquarian discourse, we note that in describing a *fonte* Asperiana discovered on the Esquiline hill, he says:

… there was an infinite number of such *fonti* in the houses of Rome, and there
would not have been a house without such *commodità* … and wherever we have seen
mention of them we have recorded them, because although they are not things of
importance to any necessity of history they deserve to be named to augment the grace
of the great name of Rome, which was decorated with *fonti* not only on the roads
and squares but within the small houses, being obtained from the waters conducted
to Rome at public expense and stored in its *castelli*, and distributed through small
canalleti to whomsoever wished to buy it. There were nineteen such *rivi* … as is
recorded by Iulio Frontone [*sic*].[38]

Ligorio here extrapolates from Frontinus, adapting from him the measurements
he says were stamped on the excavated lead pipes. All of Ligorio's aquarian
inscriptions reported in Naples 9 have been regarded by epigraphers, since
Lanciani investigated the topic in 1880, as forgeries.[39] They are, however,
informative forgeries. In his sole published volume on Roman antiquities, his
Antichità with the lengthy appendix, the *Paradosse* of 1553, Ligorio claimed that
his humanist rivals in antiquarian scholarship worked with flawed translations
and lacked his "sottile et giudicioso occhio" ("subtle and judicious eye") and
"vera cognition" ("true comprehension") for studying ruins and artifacts, that
was based on putting things "before the eyes with painting."[40] In Naples 9
Ligorio begins his account of each Roman waterworks site with the name of
the *fonte* and the name of the aqueduct from which it was tapped. The name of
the location is given, the name of which of the 14 regions it falls into, the name
of the road upon which it fronts, and the find-spot is specified in relation to
the names of surviving Roman buildings and churches, or its distance from
the city if near Rome. Sometimes the name of the *vigna* of a modern owner is
given. The inscriptions record the family name of the *fonte*'s ancient owner,
who is often a freedman or woman. Ligorio sometimes describes the condition
of the sculpture discovered: it may be intact, ruined, burned, fragmentary, or
completely destroyed after his inspection. One notes that Ligorio is uncannily
close in his method here to modern archaeology's excavation report, a
document often declared "scientific" in its cool descriptive accuracy and
thorough cataloguing of detail according to an agreed taxonomy.

In Naples 9 Ligorio assumes that artifacts found at or near the find-spot
belong to the ruined or lost *fonte* program; that perhaps every region of Rome
had such *fonti*; that private houses, suburban villas and temples had *fonti*; that
if a villa has a fountain, the genius of the villa will appear in the sculptural
program; that there is frequent Bacchic imagery because water was used to
temper wine; and that Greek and Roman rivers featured in Roman sepulchral
imagery. We recall that Claudio Tolomei had referred to the "ingenious
artifice newly rediscovered of making *fonti*, which one can already see used
in many places in Rome," in his letter of 1542 to Giovambattista Grimaldi, a
text directed to members of the Accademia del Virtù, the Vitruvian Academy
to which Ligorio belonged, and perhaps also to another academy with which
Tolomei and Ligorio were involved, the Accademia degli Sdegnati.[41] And
Tolomei's letter of 1542 to Conte Agostin de' Landi certainly sets out a program

to document "all the antiques" ("tutte l'anticaglie") and "every other kind of edifice of which any vestige remains" of ancient Rome, describing their location, date, function, and references to them in ancient literature. The architectural drawings would be detailed and accurately measured, and would in a sense "raise a dead Rome from the grave and give it new life." Tolomei's Vitruvian program called for the production of an accurate dictionary (*vocabolario*) of Latin and Greek terms relating to architecture, complete with derivations and etymology, and for the architects, painters, and sculptors "who do not have much knowledge of the Latin language" a new and more exact translation of Vitruvius "in the beautiful Tuscan tongue," with a similar *vocabolario*. This publication would show excavated remains "in figura," "thus "putting the image before the eyes," a phrase Ligorio adopted in his *Paradosse* of 1553. In calling for a compete cataloguing of free-standing and relief sculpture and of its iconography ("quel che significhi la tal figura"), and for the recording of all inscriptions from all kinds of monuments, Tolomei was opening the door to Ligorio's re-invention of buried ancient Roman fountains, their sculptures, and their inscriptions. Tolomei's prescription for studying afresh Frontinus' text and the aqueduct remains, concentrating on their locations, construction, conduction of water and end points, historical use and present condition, was particularly suggestive for Ligorio's project in Naples 9.

In Naples 9, however, Ligorio focuses on Tolomei's asking where the aqueduct waters go ("dove finivano"); that is, where they flowed into private usage in villas and houses. Apart from Frontinus, Ligorio's major literary source on this subject was Lucio Fauno's (Giovanni Tarcagnota) translation from 1544 of Flavio Biondo's *Roma triumphans*. Biondo had accurately visualized that ancient Roman houses were supplied with running water by "le fistule, i crateri, i canali," and that the urban villa normally had "a living and clear fountain, which drew its underground waters from some hidden conduits; and some little streams, that murmured gracefully as they trickled over a field they called *Euripi*, and some other streams, that would have been somewhat larger, that through a distant analogy they called *Nili*, and Marcus Tullius [Cicero] refers to both of these"[42] Biondo noted that contemporary *all'antica* urban villas, such as that owned by Prospero Colonna at Grotta Ferrata, belonged in his account of the ancient villa and its water supply. Andrea Fulvio, publishing his *Antiquaria Urbis* in 1527, had already remarked upon the many "little water spouts and conduits for pouring waters into nearby houses and [those of] neighbors" ("siphunculos & fistulis ad effundendas aquas vicinis domibus & accolis") that extended from pope Nicholas V's restoration of the ancient Aqua Virgine aqueduct.[43]

Ligorio completed the picture by connecting the excavated artifacts from sites in and around Rome with what he thought were private fountains he supposed had existed in the ancient city. This required the invention (in the senses of both discovery and forgery) of four essential things: the fountain/nymphaea structures themselves, their inscriptions, the families or individuals who commissioned them, and the iconography of their sculptural decoration

or adornment. Ligorio enthusiastically records in Naples 9 some 70 sites with waterworks, many of them with inscriptions that should, in his view, guarantee their credibility. He attributes names to the fountains and names to the families or individuals who paid for the water to be supplied and for the construction of the monuments. In many cases the iconography of the fountain flows directly from the names.[44]

Ligorio is remarkably clever in doing this. He constructs a hypothetical model for ancient Roman patronage of sculpture that has two objectives. One is to create historical precedent for the modern sculptor negotiating with the patron a theme for fountain iconography that connects the family name, or the place name, with the god, goddess or mythological creature that presides in sculptured form over the waterworks. In selecting private fountains, and particularly those founded by freedmen and women—in other words, by avoiding the familiar senatorial aristocracy and imperial families—Ligorio made it extremely difficult for the Cinquecento humanist, and for the modern archaeologist and epigraphy scholar, to detect his invention of patrons. When he does mention an identifiable temple having a fountain, as in the case of the Temple of Apollo on the Palatine, he cites all the ancient literary sources he can marshal, seeking to establish the principle that ancient temples had *fonti* installed in them.[45] He suggests, plausibly enough, that the fountain he claims to have seen in a room somewhere on the Via Prenestina belonging to the collegium (guild) of goldsmiths had within it a statue of Minerva, the tutelary goddess of craftsmen ("operatrice dell'arti d'ingegno").[46] Ligorio's assertion that "there was no inhabited place in Rome that did not have its particular fountain" ("non v'era luogo alcuno in Roma habitato che non havesse il suo particolar fonte") articulates his belief that the Romans had generated a patronage system of waterworks that observed decorous iconography indicating the function of the building. His weakness for etymology, however, encouraged him to invent names for fountains and accounts of their recent excavation in which the ancient patron is not present in person, but rather their premeditated iconographic intervention can be inferred from what remains. An example lies in the fountain tapped off the Aqua Vergine that Ligorio names Astillada, allegedly unearthed in the via Lata region near the church of S. Marcello. Ligorio writes:

This, as one sees, is so called from the [the property bearing the] name of the lineage where a nymph asleep on a small rock of Parian marble was found, which was crowned with reed fronds, and with one hand holds a pail, a figurine that Paolo Ponti of Genova possesses.[47]

One might credit this discovery in the sense of believing that such an image was indeed excavated and collected, but the fountain's name is patently invented from Ligorio's interest in the word *stillare* ("to drip": from the Latin, "stillo"). Here the quiet action of the water supervenes in Ligorio's mind as he contemplates it trickling over the smooth surface of sculpture. Elsewhere

in Naples 9 he fabricates sleeping nymph fountains and their private ancient patronage, perhaps as a means of demonstrating his familiarity with the type, for more than half a century popular in modern Roman garden fountains, but more specifically to show his reader that their iconography and patronage had verifiable ancient roots in tangible artifacts.[48]

By 1553 Ligorio was able to use genuine lead water-pipe inscriptions to estimate accurately the location of the lost Castrum Praetorium.[49] As Ginette Vagenheim has shown in her investigations of Ligorio's methods of forging inscriptions, he used his experience of excavation and identification of artifacts *in situ* to gain advantage over the "wholly book-based knowledge of his philologist friends." Thus he used genuine literary sources to invent inscriptions that depended on authentic extant exemplars, and, coupling this with references to having witnessed the excavation of inscriptions that were subsequently lost or destroyed, scattered examples throughout his antiquarian corpus of forged inscriptions that were new and plausible interpretations of genuine ones.[50] While Rodolfo Lanciani was surely correct in doubting the authenticity of all Ligorio's aquarian inscriptions in Naples 9, at no stage did he address the authenticity of the ancient waterworks described there by Ligorio. He merely listed, in often inaccurate transcriptions, the forged Ligorian inscriptions and fragments of text relating to their find-spots.[51]

The regionary catalogues, some genuine inscriptions, and the marble plan of ancient Rome document the existence of a number of public nymphaea of which traces have not survived.[52] Versions of the medieval *De mirabilibus urbis Romae* and the *Liber Pontificalis* (both known to Ligorio) mentioned the public fountains developed around Christian churches from the fourth century onwards.[53] Pomponio Leto drew attention to several ancient river god images extant in Rome, but offered no thoughts on their likely connection with nymphaea.[54] Bernardo Rucellai had read Frontinus and described the remains of the *castellum aquarium* constructed by Diocletian, later treated in greater detail by Ligorio.[55] Francesco Albertini's *Opusculum de mirabilibus novae & veteris Urbis Romae* of 1510 recorded the *fontes* constructed in the city by recent popes,[56] but in a telling passage noted that ancient Roman decorated baths and pleasure houses (*mutatoria*) had extended from imperial to private usage. Elsewhere he observed that in the bath of Agrippina "images of two marble Bacchus figures were discovered with a fountain and lead water pipes," with an inscription.[57] Albertini was writing at the time when there was intense interest in the Roman circle of Angelo Colocci and Johann Goritz in the links that could be established between the ancient sleeping nymph figure and Bacchic themes. The influence of these mystical and symbolic speculations by humanist scholars can be traced in both the Colocci and Vatican Belvedere nymphaea.[58] Ligorio developed his own theory of the relevance of Bacchus to ancient Roman fountain iconography, deriving from ancient literary evidence he has found regarding the tempering of wine with water, in his entry on the (otherwise unreported) fountain of Bassareus.[59]

On certain folios of Naples 9 Ligorio's sequential clusters of allegedly discovered ancient Roman *fonti* look suspicious in their neat internal consistency, and because the prosopography of their proprietors cannot be substantiated. The iconographic logic of the sculptural programs conforms with both Cinquecento fountain iconography in general and with Ligorio's own programs in the Vatican garden and at Tivoli in particular. Naples 9's fountain programs have the sleeping nymph (of the kind already used in the Roman fountain grottos of cardinal Rodolfo Pio of Carpi, of Angelo Colocci, and elsewhere), or the genius of the spring or the place represented, or the Graces, the Muses, Bacchus, centaurs, Cupids, Atlas, Apollo, Diana, Minerva, and Ganymede;[60] or particular local Roman gods or goddesses related to water-themes; or they have mythological water-themes derived openly from classical poets.[61] Speaking of a private fountain on the Aventine supposedly dedicated to Bacchuleia, Ligorio notes:

Infinite *canaletti* were discovered on this hill near where the Romans excavated to find building sand and ruined the ancient buildings and the hill [...] and there was mention of many Roman families who lived thereabouts, like the Sergia, the Aurelia, the Ulpia, the Venuleia, and Patricia. These lead pipes were sold to the Jews and broken up.[62]

Latter-day scholars are justifiably skeptical of Ligorio's argument from silence.[63]

Granted Ligorio's propensity for forgery and the imaginative restoration of antiques, and given the fact that the earliest Roman villa decoration themes of the Cinquecento—for example those planned by Raphael at the Villa Madama—were derived from such antique literary sources as Philostratus and Ovid, and from Livy and Vergil at the Villa Lante, it is tempting to assume that Ligorio's evidence for excavated ancient Roman fountains could have been forged entirely from literary prototypes.[64] Translated Greek and Roman texts describing ancient springs and their attendant nymphs became available to artists after 1500, and Italian literature from the Trecento onwards incorporated the classicizing fountain into vividly eroticized narratives.[65] Yet there is plentiful evidence that architects and fountain designers working in and around Rome after 1500 habitually took account of excavated or visible ancient remains in devising their schemes for nymphaea.[66] Such diverse classical sites as the Golden House of Nero, Hadrian's Villa near Tivoli (Ligorio witnessed and recorded the excavations), and the ruins of numerous imperial bath complexes in the city, yielded abundant indications of what interior and exterior waterworks had been like.[67]

Cardinal Pompeo Colonna's nymphaeum located below his castle at Genazzano, perhaps designed by Bramante, seems based on local ancient nymphaea types.[68] Yet Bramante eschewed complex ancient fountain models when he included "a very simple basin fountain" in the Gran Teatro of the Cortile of the Vatican Belvedere.[69] Vasari records how Giovanni da Udine, in creating the Elephant fountain at the Villa Madama "was inspired to imitate

remains found in the so-called Temple of Neptune on the Palatine, which ... Marliano records as being discovered in 1526," when Giovanni was working on the fountain.[70] The Villa Giulia, constructed for Pope Julius III between 1551 and 1555, had its sunken-court nymphaeum fed by the Acqua Vergine aqueduct, and its sculptural program combined new, classicizing figures by Ammanati, with excavated pieces judged thematically appropriate for installation in the antique-style water "theater," whose richly variegated marbles would rival any Roman imperial villa's waterworks.[71] In Naples 9 Ligorio records several antique sculptures passing from excavation into the Villa Giulia *fonte* program. It is instructive of his method to see how he proceeds from an entry describing a supposed *fonte* excavated in a "small private house" on the Esquiline—which featured a nymph Cypheniana, named after its (historically improbable) freedwoman patron "Cornelia Cyphenia," executed in Parian marble and sleeping on a shell, with water issuing from a nearby rock—to an otherwise undocumented discovery at the site of a fragmentary statue of Diana with the unlikely appellation "Cypheniana," to column bases that were excavated there by Domenico del Nero, and then, ultimately, to a find, "many years ago" of "that nymph who sleeps, most beautifully extended upon the earth, that he [Del Nero] gave to Pope Julius the third, which is located in that *fonte* of the villa Giulia."[72] Here the putative ancient patronage of the sculpture is a prototype, albeit at a lower social level, for the glorious contemporary patronage of the cardinal prince. Ligorio's low-key approach to archaeological precedence is carefully considered, and we should, I think, respect the ingeniousness of his *invenzione*, even if it leaves us with annoying problems of tracing antiques that could well have depicted other subjects. Another, more credible find passing into the Villa Giulia stems from an entry Ligorio invented to document a *fonte* in a "villa dell'Asidii" situated "a little below the Villa Hadriana Tiburtina," where three statues dressed in togas and a sphinx in Theban red marble were found, the latter "carried to Rome into the Villa Giulia."[73] Both entries parallel later ones in Ligorio's Turin encyclopedia, which embeds finds of fragmentary nymph statues and reliefs into carefully documented find-spots at nymphaea whose antique nomenclature is clearly forged.[74]

Ligorio's paradigm, that sculptural discoveries from ancient nymphaea were recognized as such and re-employed in *all'antica* nymphaeum programs is a perfectly reasonable one. However, we now know that excavated antiques were restored, interpreted, and displayed by their collectors from c. 1460–1560 in ways that often bore no relation to what modern archaeology presumes were their original functions in ancient contexts.[75] Ligorio's "purist" stance on fountain iconography, as argued in Naples 9 and in his treatise *On the Nobility of the Ancient Arts*, was slightly out of kilter with the practices of his age.[76]

Elisabeth MacDougall has argued plausibly that, given the paucity of remains of ancient gardens actually surviving from antiquity in Renaissance Rome, "the nature and form of decorations in sixteenth-century gardens are more of an invention, less reliant on ancient prototypes than were

their design or their owner's attitude to them."[77] She has suggested that "starting in the 1530s statues were placed in niches as the terminus of a view, on pedestals in prominent locations, or assembled in groupings in fountains. However, with rare exceptions, elaborate decorative schemes did not appear until the 1540s and 1550s." While a few statue groups from antiquity representing literary subjects had been excavated relatively intact, she notes, in contrast, sixteenth-century "statue groups were not literal," and "whether of ancient or modern statues were customarily assembled to create new scenes or narratives." It was "during the middle decades of the century," MacDougall argues, that "the most elaborate decorations with the most complicated allegories were popular," and she draws attention to the fact that while "the range of subject matter was limited" (compared with painted cycles of the time), "yet many different meanings and allegories were created by changing combinations of statues and their attributes." MacDougall looks to the Villa Giulia as exemplifying this "elaborate" mode of composition, of *concetti* which "relied on the use of readily identifiable statue types and conventional associations of meanings, but not on the use of a myth or poem in a literal way."

MacDougall is obviously correct in drawing attention to how a concept of appropriateness, of decorum, "required these gardens to be decorated with the deities and spirits found in pastoral poetry, or with mythological scenes in natural settings."

It seems probable, however, that Ligorio's personal understanding of the decorum of garden fountains will not fit comfortably into this general picture, so convincingly sketched by MacDougall. Indeed, Naples 9 offers some different perspectives for Ligorio, which are likely to have been later refined in his programs for the Vatican Casino and the Villa d'Este gardens. Ligorio's insistence in Naples 9 on his familiarity with the excavation of fountain sculpture *in situ* must have given him a dual attractiveness to contemporary patrons.

First, Ligorio could claim that he had actually seen numerous ancient Roman fountain programs, with identifiable iconography either intact or in fragmentary state, located in their original architectural settings. This "locatory" dimension of recognition (witnessed with the artist/antiquarian's *vera cognitio* as we have seen) was designed to endow his antiquarian writings with a level of professional knowledge that would give him an advantage over the humanist adviser wedded to classical texts.[78] Second, Ligorio could apply this locatory recognition to add nuances of what we would call "material culture" to his accounts of the ancient literary sources on water and its uses in garden settings. Whereas the humanist Annibal Caro could produce a "literary" program for a sculpture garden with nymphaeum for the Villa Giulia, Ligorio doubtless thought that his own programs offered a distinctive melding of eye-witness excavation and classical literary themes on the topic.[79] Ligorio's account of how he designed the Casino of Pius IV makes this claim explicit: it was to show by representational example how the

ancients understood the unity of waterworks design and decorative theme. Each and every piece of ancient sculpture used there had been personally selected by the designer, from excavation sites and named dealers, as being thematically appropriate.[80] It was this additional dimension of personal "archaeological" experience that allowed, or even required, Ligorio to develop an idiosyncratic notion of decorum that should be applied to fountain sculpture.

Naples 9 affords plentiful evidence that Ligorio developed, during the 1550s, a deeply researched comprehension of the thematics of ancient Roman waterworks that was in certain respects in conflict with those of his contemporaries. In Naples 9 Ligorio squabbles with numerous scholars about issues of water quality and geography, but does not engage on issues of iconographic decorum. Instead, as we have seen, he sets out his partly imaginative account of the discovery of scores of ancient Roman fountains, with their decorous sculptural programs. In short, he lets what we would call archaeology do the talking. In his *Trattato di alcune cose appartenene alla nobiltà dell'antiche arti*, however, composed c. 1573, when he had retreated to Ferrara from the horrors experienced in his brief tenure as architect of St. Peter's after Michelangelo's death in 1564, Ligorio unleashed his resentful fury against his detractors and rivals and, *inter alia*, stated his later theory of fountain decorum.[81] This formulation can now (thanks to the research of Anna Schreurs) be understood, in part, as being directed against a series of drawing projects executed by Tommaso Laureti for the design of what eventually became Giambologna's *Neptune* fountain, constructed for Pius IV in Bologna (1563–67), and referring to Ligorio's own unrealized fountain project for the same patron in Bologna, based on a learned reconstruction of the ancient Roman fountain near the Colosseum, the Meta Sudans. In the *Trattato*, Ligorio criticizes in the Laureti drawing for a Venus fountain, in an example that can stand for several, what he sees as ludicrous incomprehension ("*non bene applicata*") of the classical iconography of the deity, poor understanding of a water subject in general ("*al suggetto dell'acqua*"), and the introduction of a theme into a public fountain, the nudity of Venus, that will offend religious decency ("*una cosa sporca et obscena*"). Ligorio's objections to Laureti's perceived inaccuracies in classical mythology, leading to representation (as in the case of the *Hercules and Cerberus* design) of "*una favola falsa*," could have been offered by any humanist critic.[82] But his observations that the proposed fountain with the *Satyr Aegipane* was unfitting for the "*grandezza e magnificenza*" of the patron, and a technical disaster waiting to happen in its hydrology,[83] open two avenues of evaluation that scarcely appear at all in Naples 9. These comments arise from Ligorio's hands-on experience of fountain construction for princes of the church in the Vatican garden and at Tivoli in the preceding decade or so. While the fountains attacked in the *Trattato* certainly do not relate in a programmatic sense to Ligorio's fountain designs for the Vatican Casino and the Villa d'Este—quite the contrary, in fact—nevertheless the

criteria of fountain decorum Ligorio applies in his critique implicitly, but patently, had its roots in the antithetically decorous work he had carried out for those great patrons not long before. The reader was meant to visualize Ligorio's own fountains as perfected exempla of the ancient genre, recreated in modern guise. Ligorio's outrage at Pius V's dismantling and selling-off of the groups of statuary that he had painstakingly assembled for the Casino was partly based on what might be called his personal theory of provenance.[84] Ligorio's profound, but imaginative, knowledge of the ancient Roman iconography of waterworks, demonstrated on every page of Naples 9, was at least part of the deep background, as it were, to his process of acquisition and selection of statuary for his patrons' water projects.[85] That some of his iconography was at odds with modern identifications is troubling for today's scholars. But there was internal consistency to his system, predicated as it was on wide reading of classical texts and close observation of artifacts whose identification he believed he could verify, albeit sometimes through restoration and falsification.[86] In these processes, predicated on observation, iconography, attention to location and function, and then to provenance and collecting, as I have observed earlier, Ligorio was perhaps closer to the modern archaeologist than any of his contemporaries.[87]

It is especially ironic, then, to realize that recent archaeology has confirmed the accuracy of Ligorio's assumption regarding the ubiquity of private fountains and their aquatic iconography in and around ancient Rome. Pierre Grimal stated in 1984 that fountains were "an essential feature in almost every [Roman] garden. It even looks as if water supply lines to private houses and estates were primarily laid in order to make fountains play, as well as to create *nymphaea*, garden-*triclinia*, or even bigger waterworks, aiming at a visually and aurally refreshing effect in house or garden."[88] Robert Coates Stephens has lately argued that epigraphic evidence points to the existence of numerous private fountains and irrigated fields in the suburbs of ancient Rome fed by aqueducts. Why doubt the veracity of Frontinus' claim that about a third of the Roman water supply went to the suburban area?[89] Continuing excavation at Pompeii has confirmed an abundance of water available for and used in private cisterns, fountains, lavabos, and toilets.[90] And numerous excavation sites in Rome have recently given light to richly decorated nymphaea of the types described by Ligorio.[91]

The mellifluous appellations Ligorio gives his ancient Roman fountains— Aegiana, Alsia, Asseia, Astonia, Asidia, Asfidia, Aspredia, and so on—are replete with the Grecian-Latinate sounds that filled his imagination when he visualized an ancient Rome fully inhabited and fully reconstructed with the water supply of the aqueducts and their subsidiary networks of lead pipes. This lost Rome and its ingenious public and domestic waterworks were visible to his "artist's eye," a palimpsest revealed in the chaotic excavations of his own day. Here was a context in which only the relentless logic of his antiquarianism could rediscover, in what was destroyed, a semblance of the city's former glory.

Notes

* I should like to thank Kathleen Christian for her many helpful suggestions in preparing this study. It is dedicated to John Paoletti, one of the finest art historians I have had the privilege of calling a friend. His acuity in scholarship, intellectual generosity and leadership in the discipline have been exemplary. Friends living at opposite ends of the earth, we have disproved Erasmus' adage: *Non sunt amici, qui degunt procul.*

1 A fine example occurs in John T. Paoletti, "Medici Funerary Monuments in the Duomo of Florence during the Fourteenth Century: A Prologue to 'The Early Medici,'" *Renaissance Quarterly* 59 (2006): 1117–63, at 1118, where he argues that these commemorative monuments "allow us to reconstruct both a considerable patronage activity for the [Medici] family during this early time of their history in the city, and to suggest strategies used by the Medici to construct a public image marking their personal achievements and their family's continuing importance in the city."

2 As noted by Ginette Vagenheim, "Les inscriptions ligoriennes: notes sur la tradition manuscripte," *Italia medioevale e umanistica* 30 (1987): 199–309, at 295.

3 Among the broader contributions on Ligorio are the following: Erna Mandowsky and Charles Mitchell, *Pirro Ligorio's Roman Antiquities* (London: Warburg Institute, 1963); Robert W. Gaston, ed., *Pirro Ligorio: Artist and Antiquarian* (Milan: Silvana Editoriale, 1988); Anna Schreurs, *Antikenbild und Kunstanschauungen des Pirro Ligorio (1513–1583)* (Cologne: Walther König, 2000); David R. Coffin, *Pirro Ligorio: The Renaissance Artist, Architect, and Antiquarian with a Checklist of Drawings* (University Park: Pennsylvania State University Press, 2004).

4 A notable example of the fresh comprehension of "antiquarian" contributions to European culture is Peter N. Miller's *Peiresc's Europe: Learning and Virtue in the Seventeenth Century* (New Haven and London: Yale University Press, 2000).

5 See Mandowsky and Mitchell 1963; Anthony Grafton, *Forgers and Critics: Creativity and Duplicity in Western Scholarship* (Princeton: Princeton University Press, 1990); also James Hankins, "Forging Links with the Past," *Journal of the History of Ideas* 52, no. 3 (1991): 510–18.

6 Robert W. Gaston, "Sacred Erotica: the Classical *figura* in Religious Painting of the Early Cinquecento," *International Journal of the Classical Tradition* 2, no. 2 (1995): 238–64 and review of Leonard Barkan, *Unearthing the Past: Archaeology and Aesthetics in the Making of Renaissance Culture* (New Haven and London: Yale University Press, 1999), in *Art Bulletin* 82 (2000): 770–73. Barkan takes a similar view to my own.

7 See my initial thoughts on the manuscript in Robert W. Gaston, "Ligorio on Rivers and Fountains: Prolegomena to a Study of Naples XIII.B.9," in Gaston 1988, 158–208.

8 Anne Ferry, *The Art of Naming* (Chicago: University of Chicago Press, 1988), 30; Antonella Ranaldi, *Pirro Ligorio e l'interpretazione delle ville antiche* (Rome: Quasar, 2001), 88: "L'attribuzione di nomi antichi alle cose ed ai luoghi era per Ligorio la condizione primaria per recuperarne la memoria."

9 See Robert Bizzocchi, *Genealogie incredibili: scritti di storia nell'Europa moderna* (Bologna: il Mulino, 1995), 17–18; and the illuminating study by Kathleen W. Christian, "From Ancestral Cults to Art: The Santacroce Collection of

Antiquities," *Senso delle rovine e riusi dell'Antico. Annali della Scuola Normale Superiore di Pisa, Classe di Lettere e Filosofia. Serie IV, Quaderni 14*, ed. Salvatore Settis (2002), 255–72.

10 In the text, the original title: cited here from Vincenzo Cartari, *Le imagini de i dei de gli antichi*, ed. Ginetta Auzzas (Vicenza: Pozza, 1996), 230.

11 Naples 9, fol. 34v, *s.v.* Anioniana. Limitations of space have ruled out quoting Ligorio's text in the present study. My forthcoming edition will meet this need.

12 Biblioteca Apostolica Vaticana, Vat lat. 3844, fol. 1r [praef.] "… Opus quidem arduum ac difficile ne dicam infinitum …."

13 [*Septe giornate della*] *Geographia di Francesco Berlinghieri Fiorentino in terza rima et lingua toscana distincta con le sue tavole in varii siti et provincie secondo la geographia et distinctione dele tavole di Ptolomeo* (Florence: Nicolaus Laurentii, 1482), sign. aa i r.

14 *Opera dell'huomo dotto … Giovan Boccaccio … Dove per ordine d'Alphabeto si tratta diffusamente delli Monti: Selve: Boschi: Fonti: Laghi: Fiumi: Stagni: Paludi Golfi: & Mari. Dell'universo Mondo, Con le nature & tutte l'altre cose memorabili in quelli anticamente fatte, & da Poeti, Cosmographi, over Historici discritte …* (lacking date, place or press name, but printed in Venice, c. 1520), fol. LXVIII r.

15 Naples 9, fol. 1r.

16 Marcello Fagiolo, "Il significato dell'acqua e la dialettica del giardino. Pirro Ligorio e la 'filosofia' della villa cinquecentesca," in Marcello Fagiolo, ed., *Natura e artificio. L'ordine rustico, le fontane, gli automi nella cultura del Manierismo europeo* (Rome: Officia Edizioni, 1979), 176–89, at 177.

17 See, for example, Marcello Fagiolo and Maria Luisa Madonna, "La Casina di Pio IV in Vaticano. Pirro Ligorio e l'architettura come gieroglifico," *Storia dell'arte* 15–16 (1972): 237–81; Isabella Barisi, Marcello Fagiolo, and Maria Luisa Madonna, *Villa d'Este* (Rome: De Luca, 2003).

18 There were numerous editions of the work after 1500. Ligorio most likely had access to *L. Annei Senecae Naturalium quaestiunum* [sic] *libri VII. Matthaei Fortunati in eosdem libros annotationes* (Venice: In aedibus Aldi et Andreae Asulani, 1522). For a modern edition I have used Lucio Annea Seneca, *Questioni naturali*, ed. Rossana Mugellesi (Milan: BUR, 2004).

19 Naples 9, fol. 34r, *s.v.* Anguis.

20 Giovanni Battista Modio, *Il Teuere di M. Gio. Battista Modio. Doue si ragiona in generale della natura di tutte le acque, & in particolare di quella del fiume di Roma* (Rome: appresso à Vincenzo Luchino, 1556).

21 On the Villa Giulia, see Maria Cristina Basili, *s.v.* "Roma. Villa Giulia," in Vincenzo Cazzato, Marcello Fagiolo, and Maria Adriana Giusti, eds, *Atlante delle grotte e dei ninfei in Italia. Toscana, Lazio, Italia meridionale e isole* (Milan: Electa, 2001), 169–70. For neglected passages from Naples 9 on the (alleged) entry of excavated antiquities into the Villa Giulia program, see Gaston 1988, 199–200.

22 On the significance of "place" see Robert W. Gaston, "Sacred Place and Liturgical Space: Florence's Renaissance Churches," in J. Paoletti and Roger Crum, eds, *Renaissance Florence: A Social History* (Cambridge and New York: Cambridge University Press, 2006), 331–52, 566–82.

23 On the chronology of the building program and Ligorio's collecting of antiquities for it, see Coffin 2004, 83–105.

24 For Ligorio's claim to authorship of the entire Casino program, and his account of its dismantling, see Robert W. Gaston, "Pirro Ligorio, the Casino of Pius IV, and Antiques for the Medici: Some New Documents," *Journal of the Warburg and Courtauld Institutes* 47 (1984): 205–9; and Maria Losito, *Pirro Ligorio e il Casino di Paolo IV in Vaticano: L'"esempio" delle "cose passate"* (Rome: Fratelli Polombi, 2000).

25 Cited by Mandowsky and Mitchell 1963, 31–2, but without reference to dictionaries; cf. Schreurs 2000, 30–32, who similarly does not connect Agustín's criticism with Ligorio's reliance on dictionaries.

26 For example: Conrad Gessner's *Onomasticon …* (Basiliae: Per Hieronymum Curionem, 1544); also Zaccheria Lilio Vicentino, *Breve descrittione del mondo di Zaccheria Lilio Vicentino, tradotta per M. Francesco Baldelli. Con l'additione de' nomi moderni* (Venice: Giolito, 1551).

27 On Ligorio's map of the Regno di Napoli, issued 1556, 1557, and 1558, and its influence, see Roberto Almagià, "Pirro Ligorio cartografo," *Rendiconti delle sedute dell'Accademia Nazionale dei Lincei, Classe di Scienze morali, storiche e filologiche*, ser. 8, 11 (1956): 49–61, Almagià questions the accuracy of some of Ligorio's hydrography.

28 In the 60-book version, Book XVII of the first volume was to contain: "De aquis et earum ductibus, Tiberi, pontibus, Ostia, portu, Aniene fluvio et aquis Albulis, lib. 1." Liber XXVIII of the 100-book draft would have: "Thermae, gymnasia, balinea, nymphea, lacus, lavacra, labra …;" Jean Louis Ferrary, *Onofrio Panvinio et les antiquités romaines* (Rome: Ecole française de Rome, 1996), 173, 180.

29 Naples 9, fols 11v–12r.

30 Naples 9, fol. 123v.

31 Schreurs 2000, 332, dates MS Naples XIII. B. 4 to 1559–65, that is, in part later than Naples 9, some of which postdates the Arno's flooding of Florence in September 1557 (see fol. 47r). Giuseppe Lugli, "Nymphaea sive Musaea," *Atti IV Congresso nazionale di Studi Romani, I* (Rome: Istituto di Studi Romani, 1938), 155–168, at 155 argues that the Romans either confused or assimilated the Greek word *nymphaion* with the Latin term *lymphae*, "o fonti di aqua sorgiva, che scaturivano sempre in questi edifici."

32 See Losito 2000, 13.

33 See Maria Luisa Madonna and Marcello Fagiolo, "La Casina di Pio IV in Vaticano, Pirro Ligorio e l'architettura come gieroglifico," *Storia dell'arte* XV–XVI (1972): 237–81; "La Roma di Pio IV: la 'Civitas Pia,' la 'Salus Medica,' la 'Custodia Angelica,'" *Arte illustrata* 5 (1972): 383–402; Losito 2000, 85.

34 See Gaston 1984.

35 Norman Neuerburg, "L'architettura delle fontane e dei ninfei nell'Italia antica," *Memoria letta alla R. Accademia di archeologia, lettere e belle arti di Napoli* 5 (1965), 263–461; Salvatore Settis, "Esedra e ninfeo nella terminologia architettonica del mondo romano," in *Aufstieg und Niedergang des römischen Welt*, ed. Hildegard Temporini and Wolfgang Haase, I, 4 (Berlin and New York: De Gruyter, 1973), 661–740; Frank Joseph Alvarez, "The Renaissance Nymphaeum: Its Origins and Development in Rome and Vicinity," Ph.D. dissertation, Columbia University, 1981; Wolfram Letzner, *Römische Brunnen und Nymphaea in der westlichen Reichshälfte* (Münster: Lit, 1990); Pierre Gros, *L'architecture romaine du début du IIIe siècle av. J.-C. à la fin du Haut-Empire, I. Les monuments publics* (Paris: Picard, 1996), 418–43, "Fontaines monumentales, nymphées et sanctuaires de source;" Stefan

Morét, *Der italienische Figurenbrunnen des Cinquecento* (Oberhausen: Athena, 2003), 81, 239–43.

36 See Roberto Valentini and Giuseppe Zucchetti, *Codice topografico della città di Roma I* (Rome: Tipografia del Senato, 1940), 193–206 for a modern edition with references to Ligorio's knowledge. See also Vagenheim 1987, 298; Howard Burns, "Pirro Ligorio's Reconstruction of Ancient Rome: The ANTIQVAE VRBIS IMAGO of 1561," in Gaston, ed. 1988, 19–92, at 23–5, and Ferrary 1996, 70.

37 On the epigraphic and literary usage of *fons* to denote a divinity of a spring, the site of a cult, or a public fountain in ancient Rome see Letzner 1990, 96–8; Laura Chioffi, *s.v.* "Fons," in *Lexicon Topographicum Urbis Romae* 2, ed. Eva Margareta Steinby (Rome: Quasar, 1993).

38 Naples 9, fol. 54r, *s.v.* Asperiana. On the private use of Rome's water supply, both legal and illegal, see Frontinus, *De aquaeductu urbis Romae*, 3: 2; 11: 1–2; 75: 3; 78: 2; 87: 2; 88: 2; 94: 2–5; 101: 1–2; 103: 2; 106: 1–2; 112–13.

39 See Rodolfo Lanciani, *Topografia di Roma antica. I comentarii di Frontino intorno le acque e gli acquedotti. Silloge epigrafica aquaria* (Roma: Salviucci, 1880); Christer Bruun, *The Water Supply of Ancient Rome: A Study of Roman Imperial Administration* (Helsinki: Societas Scientiarum Fennica, 1991), 65; also by the same author, "Le fistule acquarie e i proprietari," in *SUBURBIUM. Il suburbio di Roma dalla crisi del sistema delle ville a Gregorio Magno*, ed. Philippe Pergola, Riccardo Santangeli Valenzani, and Rita Volpe (Rome: Ecole française de Rome, 2003), 485–7.

40 Pirro Ligorio, *Paradosse di Pyrrho Ligori Napolitano*, published with *Libro dell'antichità di Roma* … (Venice: Michele Tramezzino, 1553), 25v–26r. Marc Laureys and Anna Schreurs, "Egio, Marliano, Ligorio, and the Forum Romanum in the 16th Century," *Humanistica Lovaniensa* 45 (1996): 385–405, at 387–8 show that the scholar Benedetto Egio was probably visiting "various sites and collections" in Rome with Marliano's *Topographia Urbis Romae* (Rome: V. & A. Doricus, 1544) in hand (now BAV MS Ross. 1204), to test its accuracy, between 1544 and 1559, and sometimes doubtless accompanied by his (then) close friend Ligorio. Laureys and Schreurs (400) note that Ligorio's map of Rome published in 1553 appeared shortly before his *Paradosse*, and that "it may be inferred that the *Paradosse* were intended as a companion volume to the map, and both were meant to be consulted together."

41 *De le lettere di M. Claudio Tolomei lib[ri] sette* … (In Vinegia appresso Gabriel Giolito de Ferrari, 1547), 31r, to Giovambattista Grimaldi, 81–5, letter to Conte Agostin de Landi; on Tolomei and Ligorio in general see Maria Luisa Madonna, "L'*Enciclopedia del mondo antico* di Pirro Ligorio," in *I° Congresso Nazionale di Storia dell'Arte, Roma, 11–14 settembre 1978, Quaderni de "La ricerca scientifica"* 106 (Rome: CNR, 1980), 265–7; Schreurs 2000, 76–84; Ginette Vagenheim, "Pirro Ligorio e le false iscrizioni della collezione di antichità del cardinale Rodolfo Pio di Carpi," in *Alberto III e Ridolfo Pio da Carpi collezionisti e mecenati, Atti del Seminario (Carpi, 22–23 novembre 2002)*, ed. Manuela Rossi (Carpi: Museo Civico, 2004), 109–21, especially 120, n. 14.

42 *Roma trionfante di Biondo da Forlì, tradotta pur hora per Lucio Fauno di Latini in buona lingua volgare* (Venice: Michele Tramezzino, 1544), 319v.

43 Andrea Fulvio, *Antiquitates Urbis* (Rome: Marcello Silber, 1527), 43v; "Haec sola aqua ex omnibus hodie in usum bibendi in urbem fluit, et multos habet Siphunculos & fistulas ad effundiendas aquas vicinis domibus & accolis." Cf. Bartolomeo Marliano, *Antiquae Romae Topographia* (Rome: per Antonium

Bladum de Asola, 1534), 142r: … *opere deinde arcuato per Martium Campum deducta multis fistulis privatis aedibus & accolis commodissime aquam subministrat.*" On the terminology of such water conduits, see Fremiot Hernandez-Gonzalez, "Rivus, forma, canalis, tubus, tubulus y fistula en el vocabulario de la hidraulica en latin," *Tabona* 5 (1984): 377–95.

44 Space will not permit a full account, or even listing, of these entries in Naples 9.

45 See Naples 9, fol. 36v, *s.v.* Apollinaris.

46 Naples 9, fol. 56r, *s.v.* Asyntheta.

47 Naples 9, fol. 56r: "Questa, come si vede, viene appellata dal nome della casata dove fu trovata una nympha adormita su un poco di scoglio del marmo pario, la quale era coronata di frondi di canne, con una mano havea un secchia, la qual figuretta hebbe Paulo Ponti genuese."

48 See examples in Naples 9, fol. 11r, *s.v.* Aegiana; fol. 42v, *s.v.* Arethusa; fol. 123v, *s.v.* Cypheniana; fol. 143r, *s.v.* Helicone Fonte; fol. 188r, *s.v.* Naiada. Coffin 2004, 12–14, makes a credible documentary case that Ligorio was involved in the construction of Rodolfo Pio, cardinal of Carpi's famous garden grotto with the sleeping nymph at his villa on the Quirinal Hill: the best account of the villa's sculptural program for its fountains remains Christian Hülsen, *Römische Antikengärten des XVI. Jahrhunderts* (Heidelberg: Carl Winters Universitätsbuchhandlung, 1917), 49, 57–9, 66, 78.

49 Tancredi Carunchio, "L'immagine di Roma di Pirro Ligorio: proposta metodologica per lo studio dell'opera dell'antiquario napoletano," *La Città* 3 (1976): 25–36, 29; Burns 1988, 26.

50 Ginette Vagenheim, "La falsification chez Pirro Ligorio à la lumière des *Fasti Capitolini* et des inscriptions de Préneste," *Eutopia* 3, 1–2 (1994): 67–113.

51 Rodolfo Lanciani, *Topografia di Roma antica: I comentarii di Frontino intorno le acque e gli aquedotti, silloge epigrafica acquaria* (Rome: 1881 ; reprint edition, Rome: Quasar 1975); see the critique on transcription in Gaston 1988, 173–4. Cf. Heinrich Dressel "Fistulae urbane et agri suburbani," in *CIL* 15.2.1 (1899), 906–13. Dressel accepted just one of Ligorio's pipe inscriptions as genuine: *CIL* 15: 7320; for the recent scholarship, see Bruun 1991, 64.

52 See *Di Alberto Cassio Corso dell'acque antiche portate sopra XIV. aquidotti da lontane contrade nelle XIV. Regioni dentro Roma …*, 2 vols (Rome: Puccinelli, 1757), 2: 158–77 on the nymphaea in the catalogues; also Letzner 1990, 42–3, 222–4; Fanny Del Chicca, "Terminologia delle fontane pubbliche a Roma: *lacus, salientes, munera*," *Rivista di cultura classica e medioevale* 2 (1997): 231–53, at 231–40, shows that *lacus* was a frequently used term for a public fountain; cf. Letzner 1990, 63–75; Romolo A. Staccioli, *Acquedotti, fontane e terme di Roma antica* (Rome: Newton and Compton, 2002), 118–21.

53 See Roberto Valentini and Guiseppe Zucchetti, *Codice topografico della città di Roma 3* (Rome: Tipografia del Senato, 1946), 44–5; Ulrich Schulze, *Brunnen im Mittelalter. Politische Ikonographie der Kommunen in Italien* (Frankfurt am Main and New York: Peter Lang, 1994). On Ligorio's use of the Liber Pontificalis, see Carmelo Occhipinti, *Pirro Ligorio e la storia cristiana di Roma da Costantino all'Umanesimo* (Pisa: Edizioni della Normale, 2007).

54 Roberto Valentini and Guiseppe Zucchetti, *Codice topografico della città di Roma 4* (Rome: Tipografia del Senato, 1953), 424, 428; Giuseppina Florio, "Fontane e Ninfei nella Roma antica," in *Roma la città dell'acqua* (exh. cat. Biblioteca

Casanatense; Rome: De Luca, 1994), 83–7. On Pomponio Leto's topographic
scholarship, see Maria Accame Lanzillotta, "Pomponio Leto e la topografia di
Roma," *Journal of Ancient Topography* 7 (1997): 187–94.

55 *De urbe Roma*, in Valentini and Zucchetti 1953, 449.

56 Valentini and Zucchetti 1953, 542–3.

57 Francesco Albertini, *Opusculum de mirabilibus novae & veteris Urbis Romae*
(Romae: Per I. Mazochium, 1510), F iiv: "fuerunt reperta simulachra duo Bacchi
marmorea cum fonte et fistulis plumbeis, cum hac inscriptione: IN LAVACRO
AGRIPPINAE." Cf. Valentini and Zucchetti 1953, 473. On Ligorio's finds of
nymphaeum sculptures from baths in the Horti Lamiani, see Ruth Christine
Haüber, "Zur Topographie der Horti Maecenatis und der Horti Lamiani auf
dem Esquilin in Rom," *Kölner Jahrbuch für Vor- und Frühgeschichte* 23 (1990):
11–107. Bacchic themes are recorded in Roman nymphaea, but seem not to
have been common: see Letzner 1990, cat. 129: Minturno (Silenus); cat. 169:
Minturno (Silenus); cat. 317: Tarragona (Dionysius-Satyr-Nymph); cat. 362:
Dougga (Dionysius with pirates). For Ligorio's day one could cite, among
other examples, the youthful Bacchus with panther installed in the garden of
cardinal Cesi's palace, close by an ancient marble basin with both a satyr and
a Silenus figure connected to it (between 1540 and 1581): see Hülsen 1917,
20–21, and 37 for Aldrovandi's description made in 1550. Further, on this group
collected by the del Bufalo, see Henning Wrede, *Der Antikengarten der del Bufalo
bei der Fontana Trevi* (Mainz am Rhein: Philipp von Zabern, 1982), 5. Also, "Due
Bacchetti nudi con uve in mano et attorno il capo, assai più piccolo delle altre"
are recorded as decoration of one of the garden fountains at the Quirinal villa of
the cardinal of Ferrara in an inventory of 1568; see Hülsen 1917, 114.

58 See Otto Kurz, "*Huius nympha loci*: A Pseudo-Classical Inscription and a
Drawing by Dürer," *Journal of the Warburg and Courtauld Institutes* 16 (1959):
171–7; Edgar Wind, *Pagan Mysteries in the Renaissance* (new and enlarged edn,
London: Faber and Faber, 1968), 177–90, "A Bacchic Mystery by Michelangelo;"
Elisabeth MacDougall, "The Sleeping Nymph: Origins of a Humanist Fountain
Type," *Art Bulletin* 57 (1975): 357–65; Phyllis Pray Bober, "The *Coryciana* and
the Nymph Corycia," *Journal of the Warburg and Courtauld Institutes* 41 (1978):
223–39 and "Appropriation Contexts: Decor, Furor Bacchicus, Convivium," in
Antiquity and its Interpreters, ed. Alina Payne, Ann Kuttner, and Rebekah Smick
(Cambridge: Cambridge University Press, 2000), 229–43; also, Kathleen Wren
Christian, "The De Rossi Collection of Ancient Sculptures, Leo X, and Raphael,
" *Journal of the Warburg and Courtauld Institutes* 65 (2002): 132–200, at 143, 150 n.
66 (on *furor poeticus*), 166, 178 on antique Bacchus statuary entering the de' Rossi
sculpture garden.

59 Naples 9, fol. 74v: *s.v.* Bassareus fons. Ligorio's medical reasoning here differs
from that proposed by Elisabeth B. MacDougall, "Imitation and Invention:
Language and Decoration in Roman Renaissance Gardens," *Journal of Garden
History* 5 (1985): 119–34, at 127, for the presence of Bacchus and the faun at the
Villa Giulia, where they were paired with a Cupid playing with the arms of
Mars, to suggest "that the cares of state are to be laid down and the pleasures of
the country enjoyed under the protection of the sylvan deities and Hercules."

60 Ligorio, in Naples 9, fol. 147r, *s.v.* Gallus, relates the iconography of Ganymede
to this river, but does not refer (at least in this entry in this manuscript) to the
"Lacus Ganymedis" mentioned in the Regionary Catalogues: in Turin 10 (Ms.
a. III. 12 [Vol. 10], *s.v.* Laco di Ganymede), however, he mentions the discovery
in the baths of Trajan in the reign of Pope Julius II a statue of Ganymede which

was then removed to the palazzo Colonna, and then presented "al vescovo di Pavia governatore di Roma:" see Rodolfo Lanciani, *Storia degli scavi di Roma*, vol. 3, ed. Carlo Buzzetti (Rome: Quasar, 1998), 217 (with Lanciani's usual errors in transcription). Hülsen 1917, 92, shows that a "Ganimede" installed in a garden fountain at Cardinal Ippolito d'Este's villa on the Quirinal Hill was in fact a putto playing with a swan: cf. 113. In Turin 8 (Ms. a. III. 10 [Vol. 8], fol. 104v, *s.v.* Ganymede), Ligorio mentions that another ancient Ganymede figure "era a' Marini sul Tuscolano locato dal Signor Ascanio Colonna in un fonte," and yet another found "nell'Horti Domitii verso il Borgo nuovo di San Pietro, ove furono trovati quattro Cupidini pescatori, che attorno una antica pischiera soprastavano assisi," thereby connecting Ganymede again to the presence of waterworks. For the Atlas statue located by Ligorio in the collection of Stefano del Bufalo before1560, see Gaston 1988, 202; Ursula Korn, "Der Atlas Farnese: eine archäologische Untersuchung," in Gunter Schweikhart, ed. *Antiquarische Gelehrsamkeit und bildende Kunst* (Cologne: W. König, 1996), 25–44; Gustina Scaglia, "Three Drawings of Atlas and Nude Males by a Florentine in Rome in the Circle of Michelangelo," *Verona illustrata* 14 (2001): 35–43.

61 On the fountains of Rodolfo Pio and Colocci see the summary in David Coffin, *The Villa in the Life of Renaissance Rome* (Princeton: Princeton University Press, 1979), 164, 195–9; MacDougall 1975, 357–65. For ancient Roman sculptural programs associated with nymphaea, see Balázs Kapossy, *Brunnenfiguren der hellenistischen und römischen Zeit* (Zurich: Juris Verlag, 1969), and Letzner 1990, 258–62. I cannot cite all the Ligorian examples in the present study. They will be individually evaluated in the forthcoming edition of Naples 9.

62 Naples 9, fol. 72r.

63 Bruun 1991, 64.

64 See, for the earlier bibliography, Coffin 1979, 252–3; also Philip Jacks, "The Simulachrum of Fabio Calvo: A View of Roman Architecture All'antica in 1527," *Art Bulletin* 72, no. 3 (1990): 452–81, at 473–4; Sheryl Reiss, "'Villa Falcona': The Name Intended for the Villa Madama in Rome," *Burlington Magazine* 137 (1995): 740–42; and now Yvonne Elet, "Papal Villeggiatura in Early Modern Rome: Poetry, Spoils, and Stucco at Raphael's Villa Madama," Ph.D. dissertation, Institute of Fine Arts, New York University, 2007; also her unpublished paper, "The Role of Water at Villa Madama," delivered at the Renaissance Society of America meeting, Cambridge, UK, April 7, 2005.

65 The literature is too extensive to cite here, esp. that arising from the *Hypnerotomachia Poliphili*.

66 Vasari said as much in his introduction on architecture to his 1550 edition, Cap. V: Giorgio Vasari, *Le vite de' più eccellenti architetti, pittori, et scultori italiani, da Cimabue insino a' tempi nostri. Nell'edizione per i tipi di Lorenzo Torrentino Firenze 1550*, I, ed. Luciano Bellosi and Giovanni Previtali (Turin: Einaudi, 1986), 37. See Giuseppe Zander, "Il gusto degli antichi ninfei nella descrizione vasariana," in *Atti del XII Congresso di storia dell'architettura: l'architettura nell'Aretino, Arezzo 10–15 settembre 1961* (Rome: Centro di studi per la storia dell'architettura, 1969), 239–44.

67 See, for example, Larry F. Ball, *The Domus Aurea and the Roman Architectural Revolution* (Cambridge: Cambridge University Press, 2003), 133–8 on the "Nymphaeum suite;" Salvatore Aurigemma, *Villa Adriana* (Rome: Libreria dello Stato, 1984), 44–7, 75–6, 79–82, 164–6; Zahra Newby, "Sculptural Display in the So-called Palaestra of Hadrian's Villa," *Mitteilungen des Deutschen Archäologischen Instituts Römische Abteilung* 109 (2002): 59–82.

68 Christoph Frommel, "Bramantes 'Ninfeo' in Genazzano," *Romisches Jahrbuch für Kunstgeschichte* 12 (1969): 137–60; but see Christof Thoenes, "Note sul 'ninfeo' di Genazzano," in *Studi Bramanteschi: atti del Congresso internazionale, Milano, Urbino, Roma, 1970* (Rome: De Luca, 1974), 575–83; Coffin 1979, 243–5.

69 Egisto Ercadi, "La fontana del Cortile del Belvedere in Vaticano," *Monumenti Musei e Galllerie Pontificie: Bollettino* 15 (1995): 241–4. On Roman basin types see J. C. Varming, "Fontane romane, studi di quattro antiche vasche da fontane monolitiche," *Analecta Romana Instituti Danici* 3 (1965): 85–143; Debora Barbagli and Marco Cavalieri, "Alvei e labra in marmi colorati: tipologie e impiego," *Athenaeum* 90 (2002): 49–74. Antero Tammisto, "Sarcofagi, fontanelle, labrum, rilievi," in *Lacus Iuturnae I*, ed. Eva Margareta Steinby (Rome: De Luca, 1989), 233–63.

70 Coffin 1979, 252–3.

71 See Marcello Fagiolo, *Roma delle delizie. I teatri dell'acqua, grotte, ninfei, fontane* (Milan: F. M. Ricci, 1990), 171–7; Wolfgang Liebenwein, "Honesta Voluptas. Zur Archäologie des Genießens," in *Hülle und Fülle. Festschrift für Tilmann Buddensieg*, ed. Andreas Beyer, Vittorio Lampugnani, and Gunter Schweikhart (Alfter: VDG, Verlag und Datenbank für Geisteswissenschaften, 1993), 337–57; Maria Cristina Basili, "Roma. Villa Giulia," in Cazzato, Fagiolo, and Giusti 2001, 169–70.

72 Naples 9, fol. 123v, *s.v.* Cypheniana, text in Gaston 1988, 200, and Schreurs 2000, 487; cf. Tilman Falk, "Studien zur Topographie und Geschichte des Villa Giulia in Rom," *Römisches Jahrbuch für Kunstgeschichte* 13 (1971): 101–78, at 144 on del Nero.

73 Naples 9, fol. 54v, *s.v.* Asidia, text in Gaston 1988, 200. On the sphinxes in the inventories of the Villa Giulia, see Alessandro Nova, *The Artistic Patronage of Pope Julius III (1550–1555): Profane Imagery and Building for the De Monte Family in Rome* (New York and London: Garland, 1988), 93.

74 Turin, Archivio di Stato, Ms. a. III. 9 (Vol. 7), fol. 85r, text in Gaston 1988, 199–200.

75 Space dictates that I reduce the bibliography to some foundation studies and some significant recent contributions: Rodolfo Lanciani, *Storia degli scavi di Roma*, 4 vols (Rome: E. Loescher, 1902–12); Hülsen 1917; Mattias Winner, Bernard Andreae, and Carlo Pietrangeli, eds, *Il Cortile delle Statue. Der Statuenhof des Belvedere im Vatikan. Akten des internationalen Kongresses zu Ehren von Richard Krautheimer Rom, 21–23. Oktober 1992* (Mainz: Zabern, 1998); Sara Magister, *Arte e politica: la collezione di antichità del cardinale Giuiano della Rovere nel palazzo ai Santi Apostoli, Atti della Accademia nazionale dei Lincei. Classe di scienze morali, storiche e filologiche. Memorie*, ser. 9, 14 (2002): 385–631, esp. 502–3, 559–65, on the gigantic porphyry basin (described by Ligorio), now in the Sala Rotonda of the Musei Vaticani, and the antique fountain from the Palazzina delle Rovere, Palazzo Colonna, now in the Musei Vaticani; and three studies by Kathleen W. Christian, Christian 2002; "The Della Valle Sculpture Court Rediscovered," *Burlington Magazine* 145 (2003): 847–9; "Raphael's 'Philemon' and the Collecting of Antiquities in Rome," *Burlington Magazine* 146 (2004): 760–63; most recently, Anna Cavallaro ed., *Collezioni di antichità a Roma fra '400 e '500* (Rome: De Luca, 2007).

76 On Ligorio and the Tivoli villa see Isabella Barisi, Marcello Fagiolo, Maria Luisa Madonna, *Villa d'Este* (Rome: De Luca, 2003). For Ligorio's treatise and his critique of fountain sculpture, see Gaston 1988, 184–5; Anna Schreurs and Stefan Morét, "*Mi ricordo che, essendo proposto di volere fare un fonte … Pirro Ligorio und*

die Brunnenkunst," *Mitteilungen des Kunsthistorischen Intituts in Florenz* 38 (1994): 278–309; Schreurs 2000, 164–78; Morét 2003, 239–43.

77 The following quotations are all taken from MacDougall 1985.

78 I use "locatory" in the sense developed by Edward S. Casey, *The Fate of Place: A Philosophical History* (Berkeley: University of California Press, 1997).

79 On Caro's program see MacDougall 1985, 122–4.

80 See Gaston 1984.

81 The best account is Schreurs 2000, 121–35.

82 Schreurs 2000, 130 justly comments that numerous passages of text in Naples 9 support Ligorio's critique of *favola* as used in the *Trattato*: see also her excerpts 556, 573, 578, 581. In the *Trattato* (5r–v, ed. Schreurs 2000, 405), Ligorio objects to the fountain drawing showing Cerberus being killed by Hercules with his club, countering with textual evidence that Hercules "lo menò fuor' dell'abisso perlo antro Heracleota, che significa la immortalità sua che andò vico all'inferno et recuperò Perithoo, et menò via Cerbero, che secondo i gentili non è altro che fama dopo morte che ha fatte cose heroiche, e che vivente è stato huomo forte e virtuoso." We might also note in Naples 9, fol. 4v *s.v.* Acherusia, that Ligorio had laid the geographical and mythological foundation: "Il speco, o vogliamo dire caverna o antro, è celebrato presso di Heraclea, città di Ponto fabricata da Her<c>ole, figliuolo di Giove et di Alchmena, sul litto del mare Euxino. Et questa fabricò in memoria del suo ritorno dell'inferno, per che dalla detta spelunca vicino alla città uscì Hercole, secondo la favola, *quando egli condusse Cerbero, cane infernale, incatenato di catena adamantina,* ciò è di acciaio acciò che si vedessi tra gli huomini ... Questa è dunque la cagione, che li Heracleoti nella moneta loro hanno battuto Hercole con la spelunca, che da essa *mena seco Cerbero con la clava in spalla,* per haver loro presso la sudetta spelunca chiamata Acherusia, per la quale secondo i gentili et Greci si può andare alla palude et all'inferno." Cf. also Naples 9, fol. 188v *s.v.* Nara.

83 *Trattato*, 6r, ed. Schreurs 2000, 406.

84 See Gaston 1984, and Losito 2000, for the documents.

85 Schreurs 1994, 306, and 2000, 130, acknowledge this.

86 Ligorio, *Trattato,* 18v–19r, ed. Schreurs 2000, 419 ridicules painters who have not been curious enough to study Roman marbles, medals, gems, crystals, and other artifacts that would furnish them with correct iconography for ancient lakes, rivers, seas, and fountains, and so on.

87 The moral judgments in the *Trattato*'s accounts of fountains that result from Ligorio's response to the Council of Trent's ruling in 1563 against lascivious images are noticeably absent in Naples 9, which was completed before that date.

88 Pierre Grimal, *Les jardins romains à la fin de la république et aux deux premiers siècles de l'empire: essai sur le naturalisme romain* (3rd edn, Paris: E. de Boccard, 1984), 295–301, cited in Gerda De Klein, *The Water Supply of Ancient Rome : City Area, Water, and Population* (Amsterdam: Gieben, 2001), 79. See also Henri Lavagne, "Ninfei e fontane," in *Civiltà dei Romani I, La città, il territorio, l'impero,* ed. Salvatore Settis (Milan: Electa, 1990), 125–38.

89 Robert Coates-Stephens, "Gli acquedotti in epoca tardoantica nel suburbio," in *SUBURBIUM. Il suburbio di Roma dalla crisi del sistema delle ville a Gregorio Magno,* ed. Philippe Pergola, Riccardo Santangeli Valenzani, and Rita Volpe

(Rome: Ecole française de Rome, 2003), 427–34 and "The Water-Supply of Rome from Late Antiquity to the Early Middle Ages," *Acta ad archaeologiam et artium historiam pertinentia* 17 (2003): 165–86.

90 See Frank Sear, "Cisterns, Drainage and Lavatories in Pompeian Houses, Casa del Granduca (VII.4.56)," *Papers of the British School at Rome* 72 (2004): 125–66.

91 Ligorio was the first to recognize that the "Trofei di Mario" site on the Esquiline had been a nymphaeum, "un Castello d'acqua Martia & Augusta" (Ligorio 1553, 50v): see Giovanna Grisanti Tedeschi, I "Trofei di Mario": Il ninfeo dell'Acqua Giulia sull'Esquilino (Rome: Istituto di Studi Romani, 1977), and the review by Frank A. Lepper, *Journal of Roman Studies* 68 (1978): 211–13. Also, Maria Luisa Madonna, "La 'Rometta' di Pirro Ligorio in Villa d'Este a Tivoli: un incunabulo tridimensionale," in *Roma antica*, ed. Marcello Fagiolo (Cavallino di Lecce: Capore, 1991), unpaginated, and fig. 68, where, using Venturini's engraving of 1691, Madonna identifies Ligorio's inclusion among the Esquiline monuments in his *Rometta*, "il Castrum Aquarum che hoggidì falsamente si dice Trofè di Mario." See also Espen B. Andersson, "Fountains and the Roman Dwelling: Casa del Torello in Pompeii," *Jahrbuch des Deutschen Archäologischen Instituts* 105 (1990): 208–36. A full account of these discoveries will be given in the commentary to my edition of Naples 9.

Selected works cited

Ames-Lewis, Francis. *Tuscan Marble Carving 1250–1350: Sculpture and Civic Pride*. Aldershot: Ashgate, 1997.

Anderson, Jaynie. "Rewriting the History of Art Patronage." *Women Patrons of Renaissance Art, 1300–1600. Renaissance Studies* 10, no. 2 (1996): 129–38.

Avery, Charles. *Florentine Renaissance Sculpture*. London: John Murray, 1970.

——. *Donatello: Catalogo completo*. Florence: Cantini, 1991.

Ayrton, Michael. *Giovanni Pisano Sculptor*. London: Thames and Hudson, 1969.

Beck, James. *Jacopo della Quercia*. 2 vols. New York: Columbia University Press, 1991.

Bennett, Bonnie, and David G. Wilkins. *Donatello*. London: Phaidon, 1984.

Bergstein, Mary. *The Sculpture of Nanni di Banco*. Princeton: Princeton University Press, 2000.

Beyer, Andreas. "Funktion und Repräsentation: die Porphyr-Rotae der Medici." In *Piero de' Medici "il Gottoso" (1416–1469)*, edited by Andreas Beyer, 151–67. Berlin: Akademie Verlag, 1993.

Bober, Phyllis Pray, and Ruth O. Rubinstein. *Renaissance Artists and Antique Sculpture: A Handbook of Sources*. London: Harvey Miller, 1986.

Bormand, Marc, Beatrice Paolozzi Strozzi, and Nicholas Penny, eds. *Desiderio da Settignano: Sculptor of Renaissance Florence*. Washington: National Gallery of Art, 2007.

Boucher, Bruce, ed. *Earth and Fire: Italian Terracotta Sculpture from Donatello to Canova*. New Haven: Yale University Press, 2001.

Boucheron, Patrick. "Production de l'oeuvre et valeur sociale: le marché de la sculpture à Milan au 15e siècle." In *Economia e arte, secc. XIII–XVIII. Settimana di Studi dell'Istituto Datini*, edited by Simonetta Cavaciocchi, 611–25. Florence: Le Monnier, 2002.

Bullard, Melissa M. *Lorenzo il Magnifico: Image and Anxiety, Politics and Finance*. Florence: Olschki, 1994.

——. "Heroes and their Workshops: Medici Patronage and the Problem of Shared Agency." *Journal of Medieval and Renaissance Studies* 24 (1994): 179–98.

Burke, Jill. *Changing Patrons: Social Identity and the Visual Arts in Renaissance Florence*. University Park: Pennsylvania State University Press, 2004.

Bush, Virginia. *Colossal Sculpture of the Cinquecento*. New York: Garland, 1976.

Butterfield, Andrew. "Social Structure and the Typology of Funerary Monuments in Early Renaissance Florence." *Res* 26 (1994): 47–67.

———. *The Sculptures of Andrea del Verrocchio*. New Haven and London: Yale University Press, 1997.

Butters, Suzanne B. *The Triumph of Vulcan: Sculptors' Tools, Porphyry, and the Prince in Ducal Florence*. 2 vols. Florence: Leo S. Olschki, 1996.

Caglioti, Francesco. "Desiderio da Settignano: Profiles of Heroes and Heroines of the Ancient World." In *Desiderio da Settignano: Sculptor of Renaissance Florence*, edited by Marc Bormand, Beatrice Paolozzi Strozzi, and Nicholas Penny, 87–101. Washington: National Gallery of Art, 2007.

Caplow, Harriet. "Sculptors' Partnerships in Michelozzo's Florence." *Studies in the Renaissance* 21 (1974): 145–75.

———. *Michelozzo*. New York and London: Garland, 1977.

Carabell, Paula. "Image and Identity in the Unfinished Works of Michelangelo." *RES: Anthropology and Aesthetics* 32 (1997): 83–105.

Carl, Doris. *Benedetto da Maiano: A Florentine Sculptor at the Threshold of the High Renaissance*. Turnhout: Brepols, 2006.

Carli, Enzo. *Giovanni Pisano*. Pisa: Pacini, 1977.

Carrington, Jill Emilee. "Sculpted Tombs of the Professors of the University of Padua, c. 1358–1557." Ph.D. dissertation, Syracuse University, 1996.

Cassidy, Brendan. *Politics, Civic Ideals and Sculpture in Italy c. 1240–1400*. London: Harvey Miller, 2007.

Cavallaro, Anna, ed. *Collezioni di antichità a Roma fra '400 e '500*. Rome: De Luca, 2007.

Cecchi, Alessandro. "Giuliano e Benedetto da Maiano ai servigi della Signoria fiorentina." In *Giuliano e la bottega dei da Maiano. Atti del Convegno Internazionale di Studi, Fiesole 13–15 giugno 1991*, edited by Daniela Lamberini, Marcello Lotti, and Roberto Lunardi, 148–57. Florence: Franco Cantini, 1994.

Chelazzi Dini, Giulietta, and Giovanni Previtali, eds. *Jacopo della Quercia nell'arte del suo tempo*. Florence: Centro Di, 1975.

Comanducci, Rita. "Produzione seriale e mercato dell'arte a Firenze tra Quattro e Cinquecento." In *The Art Market in Italy, 15th–17th Centuries / Il mercato dell'arte in Italia, secc. XV–XVII. Atti del convegno, Florence 2000*, edited by Marcello Fantoni, Louisa C. Matthew, and Sara F. Matthews-Greico, 105–13. Modena: Franco Cosimo Panini, 2003.

Connell, William J., and Andrea Zorzi, eds. *Florentine Tuscany: Structures and Practices of Power*. Cambridge: Cambridge University Press, 2000.

Cooper, Tracy E. "Mecenatismo or Clientelismo? The Character of Renaissance Art Patronage." In *The Search for a Patron in the Middle Ages and the Renaissance*, edited by David G. Wilkins and Rebecca L. Wilkins, 19–32. Lewiston, Queenston, and Lampeter: Edwin Mellen Press, 1996.

Cornelison, Sally J. "The Tomb of Giovanni di Bicci de' Medici and the Old Sacristy at San Lorenzo." In *The Sculpted Object*, edited by Stuart Currie and Peta Motture, 25–42. Aldershot: Scolar Press, 1997.

Crichton, G. H. *Romanesque Sculpture in Italy*. London: Routledge and Kegan Paul, 1954.

Crum, Roger J. "Controlling Women or Women Controlled? Suggestions for Gender Roles and Visual Culture in the Italian Renaissance Palace." In *Beyond Isabella: Secular Women Patrons of Art in Renaissance Italy*, edited by Sheryl E. Reiss and David G. Wilkins, 37–47. Kirksville: Truman State University Press, 2001.

——. "The Florence of Cosimo 'il Vecchio' de' Medici: Within and Beyond the Walls." In *Artistic Centers of the Italian Renaissance: Florence*, edited by Francis-Ames Lewis. New York: Cambridge University Press, forthcoming.

Dressen, Angela. "Oliviero Carafa committente 'all'antica' nel Succorso del Duomo di Napoli." *Römische Historische Mitteilungen* 46 (2004): 165–200.

Drogin, David J. "Representations of Bentivoglio Authority: Fifteenth-Century Painting and Sculpture in the Bentivoglio Chapel, San Giacomo Maggiore, Bologna." Ph.D. dissertation, Harvard University, 2003.

——. "Bologna's Bentivoglio Family and its Artists: Overview of a Quattrocento Court in the Making." In *Artists at Court: Image Making and Identity, 1300–1550*, edited by Stephen J. Campbell, 72–90. Boston: Isabella Stewart Gardner Museum, 2004.

Erben, Dietrich. "Die Reiterdenkmäler der Medici in Florenz und ihre politische Bedeutung." *Mitteilungen des Kunsthistorischen Institutes in Florenz* 40 (1996): 287–361.

Even, Yael. "Artistic Dependence and Independence in Mid-Quattrocento Florence." *Fifteenth Century Studies* 14 (1988): 65–71.

Fader, Martha Alice Agnew. "Sculpture in the Piazza della Signoria as Emblem of the Florentine Republic." Ph.D. dissertation, University of Chicago, 1977.

Fagiolo, Marcello. *Natura e artificio: l'ordine rustico, le fontane, gli automi nella cultura del Manierismo europeo*. Rome: Officina, 1981.

Flaten, Arne R. "Portrait Medals and Assembly-Line Art in Late Quattrocento Florence." In *The Art Market in Italy, 15th–17th Centuries / Il mercato dell'arte in Italia, secc. XV–XVII. Atti del convegno, Florence 2000*, edited by Marcello Fantoni, Louisa C. Matthew, and Sara F. Matthews-Greico, 127–39. Modena: Franco Cosimo Panini, 2003.

Fraser Jenkins, A. D. "Cosimo de' Medici's Patronage of Architecture and the Theory of Magnificence." *Journal of the Warburg and Courtauld Institutes* 33 (1970): 162–70.

Fusco, Laurie, and Gino Corti. *Lorenzo de' Medici, Collector and Antiquarian*. New York: Cambridge University Press, 2006.

Gibbons, Mary Weitzel. *Giambologna: Narrator of the Catholic Reformation*. Berkeley: University of California Press, 1995.

——. "Cosimo's *Cavallo*: A Study in Imperial Imagery." In *The Cultural Politics of Duke Cosimo I de' Medici*, edited by Konrad Eisenbichler, 77–95. Aldershot: Ashgate, 2001.

Gnudi, Cesare. *Niccolò dell'Arca*. Turin: Einaudi, 1942.

Goldthwaite, Richard A. *Wealth and the Demand for Art in Italy 1300–1600*. Baltimore and London: Johns Hopkins University Press, 1993.

——. "Economic Parameters of the Italian Art Market (15th to 17th Centuries)." In *The Art Market in Italy, 15th–17th Centuries / Il mercato dell'arte in Italia, secc. XV–XVII.*

Atti del convegno, Florence 2000, edited by Marcello Fantoni, Louisa C. Matthew, and Sara F. Matthews-Greico, 423–44. Modena: Franco Cosimo Panini, 2003.

Gombrich, Ernst H. "The Early Medici as Patrons of Art." In *Norm and Form: Studies in the Art of the Renaissance I*, 35–57. London: Phaidon Press, 1966.

——. "Sculpture for Outdoors." In *The Uses of Images: Studies in the Social Function of Art and Visual Communication*, 136–61. London: Phaidon Press, 1999.

Grandi, Renzo. *I monumenti dei dottori e la scultura a Bologna (1267–1348)*. Bologna: Istituto della storia di Bologna, 1982.

Greenblatt, Stephen. *Renaissance Self-Fashioning: From More to Shakespeare*. Chicago: University of Chicago Press, 1980.

Guidotti, Alessandro. "Pubblico e privato, committenza e clientela: botteghe e produzione artistica a Firenze tra XV e XVI secolo." *Ricerche storiche* 16 (1986): 535–50.

Gunderscheimer, Werner L. "Patronage in the Renaissance: An Exploratory Approach." In *Patronage in the Renaissance*, edited by Guy Fitch Lytle and Stephen Orgel, 3–23. Princeton: Princeton University Press, 1981.

Haines, Margaret. "The Market for Public Sculpture in Renaissance Florence." In *The Art Market in Italy, 15th–17th Centuries / Il mercato dell'arte in Italia, secc. XV–XVII. Atti del convegno, Florence 2000*, edited by Marcello Fantoni, Louisa C. Matthew, and Sara F. Matthews-Grieco, 75–93. Modena: Franco Cosimo Panini, 2003.

Hartt, Frederick. "Art and Freedom in Quattrocento Florence." In *Essays in Memory of Karl Lehmann*, edited by Lucy Freeman Sandler, 114–31. New York: Institute of Fine Arts, New York University, 1964.

Hartt, Frederick, Gino Corti, and Clarence Kennedy. *The Chapel of the Cardinal of Portugal 1434–1459*. Philadelphia: University of Pennsylvania Press, 1964.

Hope, Charles. "Artists, Patrons, and Advisors in the Italian Renaissance." In *Patronage in the Renaissance*, edited by Guy Fitch Lytle and Stephen Orgel, 293–343. Princeton: Princeton University Press, 1981.

Janson, H. W. *The Sculpture of Donatello*. Princeton: Princeton University Press, 1963.

——. "The Equestrian Monument from Cangrande della Scala to Peter the Great." In *Aspects of the Renaissance: A Symposium*, edited by Archibald R. Lewis, 73–85. Austin: University of Texas Press, 1967. Reprint in *Sixteeen Studies by H. W. Janson*, edited by Patricia Egan, 157–88. New York: Harry N. Abrams, 1973.

Johnson, Geraldine. "Art or Artefact? Madonna and Child Reliefs in the Early Renaissance." In *The Sculpted Object, 1400–1700*, edited by Stuart Currie and Peta Motture, 1–24. Aldershot: Scholar Press, 1997.

——. "The Lion in the Piazza: Patrician Politics and Public Statuary in Central Florence." *In Secular Sculpture, 1300–1500*, edited by Phillip Lindley and Thomas Frangenberg, 54–71. Stamford: Shaun Tyas, 2000.

Keller, Ulrich. *Reitermonumente absolutistischer Fürsten. Staatstheoretische Voraussetzungen und politische Funktionen*. Munich: Schnell & Steiner, 1971.

Kempers, Bram. *Painting, Power, and Patronage: The Rise of the Professional Artist in Renaissance Italy*. Translated by Beverly Jackson. London and New York: Penguin, 1992.

Kent, Dale. *Cosimo de' Medici and the Florentine Renaissance: The Patron's Oeuvre*. New Haven and London: Yale University Press, 2000.

Kent, F. W. "Il ceto dirigente fiorentino e i vincoli di vicinanza nel Quattrocento." In *I ceti dirigenti nella Toscana del Quattrocento. Atti del convegno (Florence, 10–11 December 1982 and 2–3 December 1983)*, 63–78. Impruneta: Francesco Papafava, 1987.

——. "Individuals and Families as Patrons of Culture in Quattrocento Florence." In *Language and Images of Renaissance Italy*, edited by Alison Brown, 171–92. Oxford: Clarendon Press, 1995.

Kent, F. W., and Patricia Simons, eds. *Patronage, Art, and Society in Renaissance Italy.* New York: Oxford University Press, 1987.

King, Catherine. *Renaissance Women Patrons: Wives and Widows in Italy c. 1300–1550.* Manchester and New York: Manchester University Press, 1998.

Knox, Giles. "The Colleoni Chapel in Bergamo and the Politics of Urban Space." *The Journal of the Society of Architectural Historians* 60, no. 3 (2001): 290–309.

Krautheimer, Richard. *Lorenzo Ghiberti.* Princeton: Princeton University Press, 1982.

Lawrence, Cynthia. "Introduction." In *Women and Art in Early Modern Europe: Patrons, Collectors, and Connoisseurs*, edited by Cynthia Lawrence. University Park: Pennsylvania State University Press, 1997.

Lightbown, R. W. *Donatello and Michelozzo: An Artistic Partnership and its Patrons in the Early Renaissance.* 2 vols. London: Harvey Miller, 1980.

Lopez, Robert Sabatino. "Dal mecenatismo del Medioevo a quello del Rinascimento." *Quaderni medievali* 17, no. 34 (1992): 123–30.

Luchs, Alison. *Tullio Lombardo and Ideal Portrait Sculpture in Renaissance Venice, 1490–1530.* New York and Melbourne: Cambridge University Press, 1995.

Lydecker, J. K. "Il patriziato fiorentino e la committenza artistica per la casa." In *I ceti dirigenti nella Toscana del Quattrocento. Atti del convegno (Florence, 10–11 December 1982 and 2–3 December 1983)*, 209–21. Impruneta: Francesco Papafava, 1987.

Lytle, Guy Fitch. "Friendship and Patronage in Renaissance Europe." In *Patronage, Art, and Society in Renaissance Italy*, edited by F. W. Kent and Patricia Simons, 47–61. New York: Oxford University Press, 1987.

Lytle, Guy Fitch, and Stephen Orgel, eds. *Patronage in the Renaissance.* Princeton: Princeton University Press, 1981.

MacDougall, Elisabeth. "The Sleeping Nymph: Origins of a Humanist Fountain Type." *Art Bulletin* 57 (1975): 357–65.

Maddalo, Silvia. "Il monumento funebre tra persistenze medioevale e recupero dell'antico." In *Un pontificato ed una città: Sisto IV (1471–1484)*, edited by Massimo Miglio, Francesco Niutta, *et al.*, 429–52. Rome: Istituto storico italiano per il medio evo, 1986.

McHam, Sarah Blake. "Donatello's Tomb of Pope John XXIII." In *Life and Death in Fifteenth-Century Florence*, edited by Marcel Tetel, Ronald G. Witt, and Rona Goffen, 146–73. Durham: Duke University Press, 1989.

——. "Public Sculpture in Renaissance Florence." In *Looking at Italian Renaissance Sculpture*, edited by Sarah Blake McHam, 158–80. Cambridge: Cambridge University Press, 1998.

——. "Donatello's bronze *David* and *Judith* as Metaphors of Medici Rule in Florence." *Art Bulletin* 83 (2001): 32–47.

——. "Renaissance Monuments to Famous Sons." *Renaissance Studies* 19 (2005): 458–86.

——. "La tomba del doge Giovanni Mocenigo: politica e culto dinastico." In *Tullio Lombardo: scultore e architetto nella Venezia del Rinascimento. Atti del Convegno di Studi, Venezia, Fondazione Cini 4–6 aprile 2006*, edited by Matteo Ceriana, 81–98. Verona: Cierre, 2007.

Mehler, Ursula. *Auferstanden in Stein. Venezianische Grabmäler im späten Quattrocento.* Cologne and Weimar: Böhlau, 2001.

Milner, Stephen J. "The Politics of Patronage: Verrocchio, Pollaiuolo and the Forteguerri Monument." In *Artistic Exchange and Cultural Translation in the Italian Renaissance City*, edited by Stephen J. Campbell and Stephen J. Milner, 221–45. Cambridge: Cambridge University Press, 2004.

Moskowitz, Anita Fiderer. *Italian Gothic Sculpture c.1250 – c.1400.* Cambridge: Cambridge University Press, 2001.

——. *Pious Devotion – Pious Diversion. Nicola and Giovanni Pisano: The Pulpits.* London and Turnhout: Harvey Miller, 2005.

Nelson, Jonathan K. and Richard J. Zeckhauser, *et al. The Patron's Payoff: Conspicuous Commissions in Italian Renaissance Art*. Princeton and Oxford: Princeton University Press, 2008.

O'Malley, Michelle. "Subject Matters: Contracts, Designs, and the Exchange of Ideas between Painters and Clients in Renaissance Italy." In *Artistic Exchange and Cultural Translation in the Italian Renaissance City*, edited by Stephen J. Campbell and Stephen J. Milner, 17–37. Cambridge: Cambridge University Press, 2004.

——. *The Business of Art: Contracts and the Commissioning Process in Renaissance Italy.* New Haven and London: Yale University Press, 2005.

Olson, Roberta J. *The Florentine Tondo.* New York and Oxford: Oxford University Press, 2000.

Panofsky, Erwin. *Tomb Sculpture: Four Lectures on its Changing Aspects from Ancient Egypt to Bernini*, edited by H. W. Janson. New York: Harry N. Abrams, 1964; 2nd edn, London: Phaidon Press, 1992.

Panofsky, Gerda Soergel. *Michelangelo's "Christus" und sein römischer Auftraggeber.* Worms: Wernersche Verlagsgesellschaft, 1991.

Paoletti, John T. *The Siena Baptistery Font: A Study of an Early Renaissance Collaborative Program, 1416–1434.* New York and London: Garland, 1979.

——. "Fraternal Piety and Family Power: The Artistic Patronage of Cosimo and Lorenzo de' Medici." In *Cosimo "il Vecchio" de' Medici, 1389–1464*, edited by Francis Ames-Lewis, 195–219. Oxford: Clarendon Press, 1992.

——. "'… ha fatto Piero con voluntà del Padre …': Piero de' Medici and Corporate Commissions of Art." In *Piero de' Medici "il Gottoso" (1416–1469): Kunst im Dienste der Mediceer*, edited by Andreas Beyer and Bruce Boucher, 221–50. Berlin: Akademie Verlag, 1993.

——. "Familiar Objects: Sculptural Types in the Collections of the Early Medici." In *Looking at Italian Renaissance Sculpture*, edited by Sarah Blake McHam, 79–110. New York: Cambridge University Press, 1998.

Paoletti, John T., and Wendy Stedman Sheard, eds. *Collaboration in Italian Renaissance Art.* New Haven: Yale University Press, 1978.

Poeschke, Joachim. *Die Skulptur der Renaissance in Italien. Band 1: Donatello und seine Zeit*. Munich: Hirmer, 1990.

Pope-Hennessy, John. *Luca della Robbia*. Ithaca and New York: Cornell University Press, 1980.

——. *Italian Renaissance Sculpture*. New York: Vantage Books, 1985.

——. *Donatello: Sculptor*. New York: Abbeville Press, 1993.

Radcliffe, Anthony. "Multiple Production in the Fifteenth Century: Florentine Stucco Madonnas and the della Robbia Workshop." In *The Thyssen-Bornemisza Collection: Renaissance and Later Sculpture*, edited by Anthony Radcliffe, Malcolm Baker, and Michael Maek-Gerard, 16–23. London: Sotheby's Publications, 1992.

Radke, Gary M. "Lorenzo Ghiberti: Master Collaborator." In *The Gates of Paradise: Lorenzo Ghiberti's Renaissance Masterpiece*, edited by Gary M. Radke. Atlanta: High Museum of Art, 2007.

Randolph, Adrian W. B. *Engaging Symbols: Gender, Politics, and Public Art in Fifteenth-Century Florence*. New Haven: Yale University Press, 2002.

Rubin, Patricia Lee. *Images and Identity in Fifteenth-Century Florence*. New Haven: Yale University Press, 2007.

Schubring, Paul. *Die italienische Plastik des Quattrocento*. Potsdam: Akademische Verlagsgesellschaft Athenaion, 1924.

Schulz, Anne Markham. *The Sculpture of Bernardo Rossellino and his Workshop*. Princeton: Princeton University Press, 1977.

——. *Antonio Rizzo: Sculptor and Architect*. Princeton: Princeton University Press, 1983.

Settis, Salvatore. "Artisti e committenti fra Quattro e Cinquecento." In *Storia d'Italia, Annali IV. Intellettuali e potere*, edited by Corrado Vivanti, 701–61. Turin: Einaudi, 1981.

Seymour Jr., Charles. *Sculpture in Italy 1400 to 1500*. Baltimore: Penguin Books, 1966.

——. *Jacopo della Quercia, Sculptor*. New Haven: Yale University Press, 1973.

Starn, Randolph, and Loren Partridge. *Arts of Power: Three Halls of State in Italy, 1300–1600*. Berkeley: University of California Press, 1992.

Supino, I. B. *La scultura in Bologna nel secolo XV, ricerche e studi*. Bologna: N. Zanichelli, 1910.

Wackernagel, Martin. *The World of the Florentine Renaissance Artist: Projects and Patrons, Workshop and Art Market*. Translated by Alison Luchs. Princeton: Princeton University Press, 1981 (orig. edn 1938).

Warnke, Martin. *The Court Artist: On the Ancestry of the Modern Artist*. Translated by David McLintock. Cambridge: Cambridge University Press, 1993.

Wegener, Wendy. "Mortuary Chapels of Renaissance Condottieri." Ph.D. dissertation, Columbia University, 1989.

Weil-Garris, Kathleen. "On Pedestals: Michelangelo's *David* and Bandinelli's *Hercules and Cacus* and the Sculpture of the Piazza della Signoria." *Römisches Jahrbuch für Kunstgeschichte* 20 (1983): 377–415.

Welsh, Evelyn. *Art and Society in Italy 1350–1500*. Oxford and New York: Oxford University Press, 1997.

Wittkower, Rudolf. *Sculpture: Processes and Principles*. New York: Harper & Row, 1977.

Zuraw, Shelley E. "The Sculpture of Mino da Fiesole, 1429–1484." Ph.D. dissertation, Institute of Fine Arts, New York University, 1993.

Index

References to illustrations are in **bold**